TREVOR GODARD

Knight's

UP-TO-THE-MINUTE
ILLUSTRATIONS

Walter B. Knight

MOODY PRESS
CHICAGO

Dedicated, with esteem and affection, to Dr. Ralph M. Smith, beloved pastor of Hyde Park Baptist Church, Austin, Texas.

"Feed the flock of God which is among you, taking the oversight thereof, . . . and when the chief Shepherd shall appear, ye shall receive a crown of glory that fadeth not away" (1 Peter 5:2, 4).

© 1974 by
THE MOODY BIBLE INSTITUTE
OF CHICAGO

ISBN: 0-8024-4571-3

Second Printing 1977

Printed in the United States of America

FOREWORD

When I was a college student serving as a pastor, I found Walter B. Knight's book *Three Thousand Illustrations for Christian Service.* It was extremely helpful in my sermon preparation, especially since my background was so limited. Through the years I have found that the Reverend Mr. Knight's books are extremely helpful when I want to throw light on some doctrine I am trying to teach or when I am seeking to illustrate in a sermon.

In looking at the material of Mr. Knight's newest book, *Knight's Up-to-the-Minute Illustrations,* I am impressed with the fresh new illustrations he has compiled. These stories, poems, and quotes make a helpful anthology for preachers and other public speakers. The material is diversified and would be most helpful to any speaker or teacher.

Walter B. Knight is the master compiler and writer of illustrations. In this field he is without a peer. God has given him an unusual talent that has blessed thousands who read and use his materials.

Those who browse through the book for inspirational thoughts will not be disappointed. This is a valuable book that I heartily recommend.

RALPH M. SMITH

PREFACE

This is a day of visual and auditory aids. An apropos illustration is one of the best aids, a window through which comes light to make needed lessons and imperishable truths more understandable. How valuable are Bible-centered, Christ-exalting illustrations!

As *Knight's Up-to-the-Minute Illustrations* finds its way into the hands and hearts of teachers, ministers, writers, public speakers, and others, my prayer is that they will be challenged and inspired.

In the production of this book, my wife, Alice Marie, has worked hand-in-glove with me. Her handiwork is reflected throughout the book in her pertinent illustrations slanted to the understanding of children.

"Except ye be converted, and become as little children, ye shall not enter into the kingdom of heaven" (Matthew 18:3*b*).

In my books of illustrations, it has been my undeviating purpose to acknowledge, whenever possible, the source of the items I have used. I have tried to capture their pertinent, salient features and put them in up-to-the-minute language which is understandable to our generation—never, however, compromising the changeless, eternal Word of God.

5

CONTENTS

Abortion	9
Alcoholism. *See also* Drugs	11
Assurance	14
Atheism	16
Bible	18
Care, God's	24
Children. *See also* Youths	26
Choosing	29
Christian Living. *See also* Influence	31
Christmas	34
Church. *See also* Worship	35
Cigarettes	41
Citizenship—Patriotism. *See also* Freedom	43
Commitment	51
Communism	54
Conversion. *See also* Salvation	55
Cooperation	56
Courage	57
Cross, The	59
Death. *See also* Resurrection	63
Drugs. *See also* Alcoholism	67
Encouragement—Discouragement	71
Faith	72
Faithfulness, Our	75
Fear. *See also* Trust	76
Fellowship	77
Forgetting God	77
Forgiveness, God's	79
Forgiving Others	82
Freedom. *See also* Citizenship—Patriotism	83
Giving. *See also* Tithing	85
Gospel	87
Growth	89
Guidance	91
Heaven	93
Hell	96
Holy Spirit	97
Home	98
Human Relations. *See also* Love for Others	102
Influence. *See also* Christian Living	106
Jesus	107
Jews	112
Joy	113
Judgment	116
Kindness	118
Lawlessness	119
Light—Darkness	123
Lost	124
Love for Others	128
Love, God's	130
Missions	132
Mothers. *See also* Parental Responsibility	133
Nature	134
Obedience—Disobedience. *See also* Will of God	137

Old Age 139
Parental Responsibility.
 See also Mothers 142
Peace 143
Perseverance 144
Power 145
Prayer 147
Preachers 153
Presence, the Lord's 160
Pride—Humility 162
Repentance 165
Resurrection. *See also* Death 167
Revival 168
Riches 169
Salvation. *See also* Conversion 173
Second Coming of Christ 178
Self-control. *See also* Victory 180
Selfishness—Unselfishness 181
Service. *See also* Work 182
Sex 186
Sin 188
Small Things 192

Sorrow—Suffering 193
Soul-winning 197
Temptation. *See also* Victory 201
Testimony. *See also* Witnessing 202
Thought 205
Time 206
Tithing 208
Tongue 209
Trust 210
Truth—Untruth 211
Victory. *See also* Temptation 213
Vision 214
War 215
Will of God. *See also* Obedience 217
Witnessing. *See also* Testimony 218
Work. *See also* Service 220
Worship. *See also* Church 222
Youths. *See also* Children 223

ABORTION

Two People Involved

A brief by the American College of Obstetrics and Gynecology, stated: "Modern obstetrics has discarded as unscientific the concept that the child in the womb is but tissue of the mother."

Dr. Albert Libey, a signatory of the brief added, "Another medical fallacy that modern obstetrics discards is the idea that the pregnant woman can be treated as a patient alone. No problem in fetal health can any longer be considered in isolation. At the very least, two people are involved—the mother and her (unborn) child.

"This review of the current medical status of the unborn shows conclusively the humanity of the fetus by showing that human life is a continuum which commences in the womb. There is no magic in birth. The child is as much a child in those several days before birth as he is in those days after birth."

* * *

Euthanasia—Feticide

In a message to the National Baptist Convention, U.S.A., Dr. Joseph M. Jackson, president, equated euthanasia with feticide or planned destruction of the embryo in the mother's womb. He said, "Would it not be better to begin with people over sixty-five and eliminate the undesirables and clear the way for a new crop of human beings to come? Would it not be better to eliminate the confirmed criminals, dope addicts and dope peddlers, and all those who have had their chance in life and have sinned against the opportunity? Would it not be rather selfish for this generation to insist upon remaining while it eliminates the innocent and makes a place for the guilty and for those who have proved to be unworthy?"

* * *

Richard M. Nixon Affirmed

"From personal and religious beliefs, I consider abortion an unacceptable form of population control. Further, unrestricted abortion policies, or abortion on demand, I cannot square with my personal belief in the sanctity of human life—including the life of the yet unborn. For surely the unborn have rights also, recognized in law, recognized even in principles expounded by the United Nations."

* * *

"The Cloudy Area"

Dr. Carl Marlow, professor of psychiatry at the University of Miami Medical School, said, "More abortions performed for psychiatric reasons are at best recommended on the basis of peripheral psychosis but are generally performed for socio-economic reasons."

Dr. Sidney Bolton affirmed before the American Psychiatric Asociation, "Since pregnancy is seldom a serious threat to the life of the mother under modern medical management, it must follow that many of the recommendations for therapeutic abortion are on other than strictly medical grounds. It must follow also that these cases fall into the cloudy area of psychiatric indications for interruption of pregnancy and are, at best, of somewhat dubious legality."

* * *

"The Right to Live"

Dietrich Bonhoeffer said, "Planned destruction of the embryo in the mother's womb is a violation of the right to live which God has bestowed upon this nascent life."

* * *

Is the Unborn Baby a Person?

In a cogent argument recently presented to the New Jersey Legislature, Edwin H. Palmer, M.D., said:

"If the unborn baby is a person with a separate identity and is not just an appendage of the mother's body, then all the stirring arguments of the pro-abortionists apply not only to the mother, but also to the child within the mother. Then he, too, has rights that the mother may not interfere with. And his prime right is

9

the freedom to live. He is not just a 'thing' that a mother may dispose of like a tonsil or a scab. And the state's duty is to protect him against any unwarranted deprivation of his life and pursuit of happiness.

"The pro-abortionists speak eloquently about the rights of the mother in her private affairs and the unjustifiable interference by the government into the privacy of her bedroom."

* * *

Horrible to Nurses

"Most nurses find the destruction of life the very antithesis of what they believe," said Mrs. Cynthia Kinsella, Dean of the School of Nursing at City College, New York.

"The concept of euthanasia and abortion is very difficult for them to accept. Nurses in delivery rooms have been accustomed to making every conceivable effort to save babies, even those of one to three pounds. They have found that sometimes they are 'salting out' bigger babies than those they have worked to save!"

* * *

What Price Psychologically!

Dr. Julius Fogel of the Columbia Hospital for Women in Washington, D. C., said, "It (abortion) is not as harmless and casual an event as many of the pro-abortion crowd insist. A psychological price is paid. It may be alienation. It may be a pushing away from human warmth, perhaps a hardening of the maternal instinct. Something happens on the deeper levels of a woman's consciousness when the abortion destroys a pregnancy. *I know that as a psychiatrist!*"

* * *

Never Lost a Mother

Dr. John L. Grady, a gynecologist, affirmed, "I have never lost a mother (maternity patient) from any cause. Moreover, at the public hospital where I am a staff member, there are thousands of babies delivered, and to my knowledge, there has not been a single therapeutic abortion."

Stark Facts About Abortion

Dr. Richard V. Jaynes, a diplomate of the American Board of Obstetrics and Gynecology, and a fellow of the American College of Obstetricians and Gynecologists, said:

"I've performed two abortions. Both were accidents resulting from errors in diagnosis. In one of them, I had no idea there was a fetus inside the patient's uterus until I drew out a detached arm, still moving at the elbow. Personally it was one of the most sickening experiences I've had in [nineteen years of] practicing medicine.

"In standard abortion procedure, however, it's normal. There are two methods commonly used to destroy an unborn child: a suction apparatus procedure used up to about eight weeks after conception and curettage.

"The suction apparatus involves the creation of a powerful vacuum in the tube. The tube is inserted in the woman's uterus and what's inside is drawn through it into a bottle."

The vacuum is so powerful that the process is almost instantaneous. "You hardly see the fetus as it zips through the tube."

After about ten or twelve weeks, however, the developing child has grown too large and solid to pass through the suction apparatus.

"After that point curettage is generally used.

"A . . . spoon-shaped instrument called the curette . . . is inserted into the uterus. The child inside is cut into pieces and pulled or scooped out limb by limb.

"In order for members to be removed, . . . the doctor must stretch the uterine opening. It isn't dilating of its own accord as it would in a normal birth. . . . In order to pass larger parts like the head, they must be crushed"!

Los Angeles Tidings

* * *

The Psychological Aftermath

"We who . . . bury the dead with rites of Christian worship cannot possibly stand by while innocent human life is

10

forced from a mother's body, deposited in a surgical tray and burned with common debris in a hospital incinerator" said Rev. David W. Simons.

How stark are these facts about abortion! How inescapable is the psychological aftermath attendant upon the wanton destruction of unborn infants where no justifiable cause, such as rape, incest, or the saving of the life of the mother exists!

* * *

When Heart-Pumping Begins

Dr. Paul Ramsey, professor of ethics at Princeton University, said, "It is known that heart-pumping starts by the end of four weeks, at about the time the mother begins to wonder whether she is pregnant or not. The fetus is capable of its own spontaneous action at ten weeks, and it responds to external touch or stimulation much earlier. All essential organ formation, except limbs, is present at eight weeks."

"Tantamount to Mass Murder"

The Alberta (Canada) Presbyterian Church Synod declared in a resolution, "Abortion is the taking of a life. . . . We find that an appeal for abortion on demand is tantamount to mass murder."

* * *

Unborn Sacrificed in Personal Whim

Albert Outler, Paul Ramsey, and J. Robert Nelson—theologians of the United Methodist Church—and twenty-two professors and physicians recently issued this statement on abortion:

"How long can we meaningfully say that all men are created equal while the innocent unborn are sacrificed in personal whim or convenience, or in that new test of Americanism in our increasingly technologic and impersonal age, namely the qualification of being perfect, or being wanted, or being viable?"

ALCOHOLISM

Alcoholism Begins with First Drink

Christianity Today editorialized, "You can worry all you want about any future addiction to narcotics among our population, yet it will never be more than a small fraction of the problems we already have with addiction to alcohol.

"Government officials call alcoholism the nation's number one health problem, and it is getting worse. Researchers at George Washington University say there may be as many as nine million persons in America who are alcoholics, nearly one in twenty. The World Health Organization says the United States has the highest rate of alcoholism in the world. American industry alone loses an estimated $2 billion a year from the effects of alcohol. The cost of crime spawned by alcohol undoubtedly eclipses that figure. . . . Forty-four percent of all drivers at fault in two-car accidents are legally drunk, says the Utica Mutual Insurance Company. One driver out of every fifty, ac-

cording to a U.S. Department of Transportation study, is drunk."

Alcoholism begins with the first drink. Touch not! Taste not! Handle not!

* * *

A Trinity of Killers

According to the National Council on Alcoholism, only heart disease and cancer kill more persons annually in the United States than does alcohol. The statistics do not include the 30,000 persons who die annually in alcohol-related traffic accidents. Cancer and heart disease achieve their large "kill" by a major assist from nicotine. Alcohol and nicotine are dangerous drugs and are often fatal!

* * *

$21 Billion Annually for Booze

On the morning of December 24, 1965, in Phoenix, Arizona, a drunken man driving a pickup truck sped through two

11

red lights at eighty miles an hour. Seconds later, he veered across a center line and smashed head-on into a station wagon from Idaho.

In the car were a father and mother and two teenage children on their way to San Diego to meet a son returning from Vietnam. The parents were smashed against the instrument panel and died instantly! The two teenagers were hurtled from the car into the street, where they lay critically injured.

The drunken driver in the pickup truck was so entrapped in the twisted wreckage that it took rescuers with a blowtorch thirty-five minutes to extricate him. But that hardly mattered. He had died in the shattering impact!

After the tragedy, Eugene K. Mangum, Chief City Magistrate of Phoenix, said, "Ours is a society that drinks more than $21 billion worth of alcoholic beverages each year. An estimated seventy-five percent of all U. S. drivers drink and most of them drive after drinking. One major insurance company estimates that one out of every fifty cars bearing down on you on the highway is driven by a driver who has been drinking!"

* * *

A Professional Driver's Warning

"I am a pro driver, and we pros average 50,000 miles on the road each year," said Don Garlits, who was recently named to the first All-American Driving Team by the American Auto Racing Writers and Broadcasters Association.

"Out there on the highway, to guide a car safely through today's traffic requires skill, mental alertness and reflexes honed to a razor's edge. How does alcohol affect this? Well, in 1970, about 35,000 Americans were killed in crashes where drinking was involved! And the senseless slaughter continues because people persist in driving after they've had a few drinks. It's a daily gamble!

"I've been doing a lot of thinking about it lately. I've come to the conclusion that you shouldn't drive even if you have had only *one drink*. That's a pretty strong statement, but I think it's the only answer."

"Woe unto him that giveth his neighbor drink" (Hab. 2:15a).

* * *

Number One Drug Problem

Ted Connor, program counselor of The Texas Commission on Alcoholism, said, "Alcoholism is one of the four major health problems in the United States. It is the number one drug problem in the United States!"

* * *

The Greatest Danger

What is the greatest threat to the survival of young Americans? The war in Vietnam? Drugs? VD? Malnutrition? The correct answer, says psychologist Leon Goldstein, of the National Transportation Safety Board, is riding in automobiles.

A Safety Board study reveals that youths are especially likely to have fatal car accidents between the ages of sixteen and nineteen while driving at night, when driving conditions are most hazardous. Goldstein said he was astonished to discover that measurable alcohol had been a contributing factor in up to sixty percent of auto deaths involving youths between sixteen and twenty-four. That means at least one-tenth of one percent alcoholic content in the driver's blood—the equivalent for a 160-pound male of five shots of 100-proof whiskey guzzled on an empty stomach within an hour.

Time, Sept. 13, '71

* * *

What Industry Loses

James M. Roche, Board Chairman of General Motors, said in *Time* (Nov. '71), "U.S. industry loses $10 billion a year because of alcoholism. Ignoring the alcoholic until it is too late is not only a waste of human abilities and industrial funds, it is, in the long run, an inhumanity to the individuals involved."

Deadly Thief of Youth

"Aggies' DeNiro Killed!" said the newspaper headline in announcing the tragic death of Michael DeNiro, a football star at Texas A&M.

Michael was a passenger in a car which veered off a road into a canal. He was trapped in the submerged car and drowned!

The driver of the car was not injured. He was booked for driving while *intoxicated!*

"It is a terrible shock to all of us here at Texas A&M," said Coach Gene Stallings. Michael was certainly a credit to everyone who knew him. He stood tall for things he believed in."

The untimely death of this fine youth, who had great potential for good, was caused directly by the mighty destroyer alcohol.

* * *

The Merciless Wrecker

Said Ann Landers, "Alcoholism has wrecked more marriages, careers and healthy bodies than any other single element known to man."

* * *

Get Disturbed!

W. Y. Rowell, U.S. Department of Transportation, said, "More than fifty per cent of the 55,000 highway deaths in 1970 involved alcoholic beverages!"

* * *

No. 1 Health Problem in France

Under the caption "Alcoholism in France," *Newsweek* Feature Service said, "Frenchmen deny that the wonderful wines of France could possibly create alcoholism. Yet alcoholism does not simply exist in France, it is the country's No. 1 health problem. The same vines that bring in more than $50 million a year also bear some very bitter and little-publicized fruit:

"The average Frenchman drinks far more than the average citizen of any other country—a staggering sixty-five gallons of wine a year.

"More than 22,000 Frenchmen die of cirrhosis of the liver each year, which is ten times the death rate in the United States.

"One-third of all traffic accidents and two-thirds of all industrial accidents are caused by drunks.

"Alcoholism accounts for thirty to forty percent of all psychiatric beds, and heavy drinking is a major or contributing factor in thirty to fifty per cent of all non-surgical hospitalizations."

* * *

Beer and Bugs

The Vancouver Sun reported, "Employees of the Ontario Agriculture Department set out two containers, one filled with beer and the other with insect poison. More than 300 insects drowned delightedly in the beer. Only twenty-eight expired in the poison dish."

* * *

More Serious than Heroin!

Dr. Harry J. Johnson, medical director of the Life Extension Institute, New York, the country's largest health-examination facility, said, "A couple of years ago we studied the drinking habits of 8,000 executives who came to us for their annual health examination. We found that twenty-seven percent were heavy drinkers—imbibing six or seven ounces of whiskey every day, seven days a week. Now that is heavy drinking. Cirrhosis of the liver is now the No. 3 cause of death in New York City for people in the age bracket forty-five to sixty-five. It is outranked only by cancer and heart disease. Nobody knows the exact cause of cirrhosis, but it is identified very definitely with excessive intake of alcohol.

"The studies of the National Institute of Mental Health show that, in relative terms, the physical consequences of heavy drinking are far larger and more serious than those from the use of heroin. Further, we are told that the likelihood of death from acute alcoholism poisoning and in withdrawal from chronic alcoholism is much greater than from overdosage and in withdrawal from heroin addiction.

13

ASSURANCE

The use of a 'hard' drug like heroin . . . involves dangers that overindulgence of alcoholism does not, such as the crimes heroin addicts commit to get money to buy the drug, the unexpected infection from injecting heroin and the unanticipated overdosages."

* * *

Women Hit Bottom Faster

Said Harvey Fiske of the National Council on Alcoholism, "Today there are as many women alcoholics as men. They may be doing more damage and be even further away from help than men. We don't like to think of women as drunks. We don't want anyone but the mother taking care of the children. We don't think of women on skid row. That's because they are not there. They are behind the picket fence, the picture window."

Said Mrs. Mary Mann, founder of the National Council on Alcoholism, "A woman alcoholic is basically a hidden alcoholic. It may take ten years for a man to become an alcoholic. During that time he can lose his job, his family, his financial resources. A woman at home all day has more time to devote to drinking, and can hit bottom faster. The damage a woman can do to her family during that time, however, is immeasurable. Fifty-one percent of alcoholics are children of alcoholics. Fifty percent of juvenile delinquents are from alcoholic homes!"

* * *

It's Nobody's Business?

Said Oren Arnold, "One thing about the purveyors of alcohol is certain—they don't lack ingenuity. 'Beer belongs,' they say. Belongs where? 'Old Scotch gives great rewards,' proclaims another advertiser. Rewards to whom? Only the distillers and sellers.

"At least seventy percent of all crime is associated with the consumption of alcohol. 'It's nobody's business but my own that I drink,' is the empty boast of some. But the rest of us have to live with them, and it is hazardous!"

ASSURANCE

"The Joy of Certainty"

How admirable was the reaction of Mildred Cook, an executive secretary and teacher of Bible classes, when she heard the ominous words of her physician: "You have a malignancy! We will do major surgery as soon as it can be arranged."

Calmly she replied, "Well, I am glad at least to know. This must be the way the Lord wants it. I belong to Him—all of me!"

Instantly a wonderful thing happened! Although she had walked with the Lord for more than an half century, at that moment she was strengthened and cheered to an extent she had never known before.

Later she said to her surgeon, "Tomorrow, when you operate, over your skilled fingers will be another hand—the hand of the Lord Jesus Christ. I belong to Him. You will be working on His property!"

Mildred Cook attributed the all-pervasive quietness which enveloped her to three things: the Word of God, the Saviour, and the Holy Spirit. She had a fresh assurance about the things that matter most—a new joy of certainty.

The words, "the joy of certainty," impressed Mildred anew. They were the title of a commencement address she had given at the Moody Bible Institute when she represented the women of the graduating class of December, 1924.

Adapted from *Moody Monthly*

* * *

Present When It Occurred

Salvation is an experience: "We know that we have passed from death unto life, because we love the brethren" (I John 3:14).

Someone asked Melvin Trotter, who was a humanly hopeless alcoholic before

14

his conversion, "How do you know you are a Christian?"

Trotter replied, "I was there when it happened!"

DR. RALPH M. SMITH

* * *

"You're Mad"

A man told Dwight L. Moody, "You're mad!"

Moody replied, "Well, if I am mad, I have a good Keeper on the road: 'He is able to keep that which I have committed unto him against that day' (II Tim. 1:12b), and a good asylum at the end of the trip: 'For we know that if our earthly house of this tabernacle were dissolved, we have a building of God, an house not made with hands, eternal in the heavens' (II Cor. 5:1)."

* * *

The Sure Refuge

All creatures instinctively seek protection and refuge in times of danger. Around the world, fear-crazed people are looking to fall-out shelters for survival in the event of nuclear attack. But even fall-out shelters do not provide a *sure* refuge.

Recently the American Association for the Advancement of Science issued a statement that warned a massive nuclear war would immediately destroy the social structure of the United States; fall-out shelters would not make much difference in the outcome. "Any fall-out shelter program, short of one that places the entire nation's population and industry permanently underground, could be rendered ineffective by a larger attacking force. There is no scientific basis at present for a useful prediction of what kind of society, if any, would emerge from the ruins," said the scientists.

But there is one shelter into which everyone may flee for *eternal* safety: "The name of the Lord is a strong tower: the righteous runneth into it, and is safe" (Prov. 18:10).

God does not always give *physical* deliverance to his children in times of danger. He never fails, however, to provide *spiritual* deliverance. Man may destroy the body, but he cannot destroy the soul.

Rock of ages, cleft for me,
Let me hide myself in Thee.

* * *

The Real Thing

C. S. Lewis, a Welsh professor and former atheist, said, "I remember that once after I had given a talk to the Royal Air Force, a tough army officer stood and said, 'I *know* there is a God. I've *felt* Him. Alone in the desert at night, I've felt the tremendous mystery. And that's just why I don't believe in giving neat little dogmas and formulas about Him. To anyone who's met the real thing, they all seem so petty and pedantic.'"

To one who has experienced the miracle of regeneration, man-made creeds and ritual are powerless to satisfy the deep yearnings of the heart.

The Bible says, "The people that do know their God shall be strong and do exploits" (Dan. 11:32b).

* * *

Spurgeon's Mad Voyage

At one time, Charles Spurgeon was whelmed by doubt. *There is no God,* he thought, *and prayer is a meaningless exercise!* He had let go the anchor of faith and raised his sails to the winds of unbelief to set out on what he called his "mad voyage."

Later, he joyfully affirmed, "I have sailed that perilous voyage of unbelief. Now I have anchored my soul in the haven of rest. Now lashed to God's Gospel more firmly than ever, I am standing on the eternal Rock of Ages—Jesus. I defy the arguments of hell to move me!"

Adapted from
The Presbyterian Journal

* * *

Do You Know?

Sometime ago in Chicago a reporter for a radio station took a survey of thirty people at O'Hare Field. He asked the question, "Do you know for sure you are going to heaven when you leave this world?"

15

They all replied, "No." Two of those questioned indignantly exclaimed, "Why, of course, nobody could know such a thing as that! The very idea!"

The trustful believer in Christ can confidently affirm, "For we know that if our earthly house of this tabernacle were dissolved, we have a building of God, an house not made with hands, eternal in the heavens" (II Cor. 5:1).

How assuring is the promise of the Saviour, "I go to prepare a place for you . . . that where I am, there ye may be also" (John 14:2b, 3b).

* * *

Exit Santa Claus

With one historic stroke, the Roman Catholic Church officially abolished 41 saints, including Saint Nicholas (or Santa Claus), according to an announcement from Vatican City. The release said of him and the other obliterated saints, "They may never have existed."

The Apostle Paul called the Christian believers at Rome "saints" (Romans 1:7). All born-again believers are saints and eternally God's children. Jesus said, "I give unto them eternal life; and they shall never perish" (John 10:28).

* * *

"In the Hollow of His Hand"

Dan Crawford, for many years a missionary in Africa, vividly translated the verse, "My times are in thy hand," (Ps. 31:15) into the native language as follows: "My life's why's and when's and where's and wherefore's are in God's hands!"

How safe for time and eternity are God's children in the mighty Saviour's hands: "They shall never perish, neither shall any man pluck them out of my hand" (John 10:28).

* * *

I Don't Know Much

One asked George Beverly Shea, "What do you know about God?" Shea replied, "I don't know much, but what I know has changed my life!"

* * *

The Beginning of a New Life

During World War II, a prisoner wrote, "Sunday, April 8, 1945, Pastor Bonhoeffer held a little service which reached the hearts of all. He had hardly finished his prayer, when the door opened. Two evil-looking soldiers came in and barked: 'Prisoner Bonhoeffer, come with us!' These words meant only one thing—the scaffold. "As he bid his fellow prisoners goodby, he said, 'For me this is the beginning of a new life, eternal life!' "

* * *

Our Hand in God's Hand

In his new year's message to his people during the perilous days of World War II, King George IV quoted the following excerpt: "And I said to the man who stood at the gate of the year, 'Give me a light that I may tread safely into the unknown.' And he replied, 'Go out into the darkness and put your hand in the hand of God. That shall be to you better than light and safer than a known way!' "

ATHEISM

No Brains Required

Dwight D. Eisenhower said, "It takes no brains to be an atheist. Any stupid person can deny the existence of a supernatural power because man's physical senses cannot detect it. But there cannot be ignored the mystery of first life . . . or the marvellous order in which the universe moves about us. All of these evidence the handiwork of a beneficent Deity. For my part, that Deity is the God of the Bible and Christ, His Son."

The Bible says, "The fool hath said in his heart, There is no God" (Ps. 14:1a).

Shallow Digging

Many years ago, Charles H. Spurgeon appraised secular thinking thus: "In the dogmas of modern thought there is not enough mental meat to bait a mousetrap. As to food for the soul, there is none in it. An ant would starve on such small grain. No atonement, no regeneration, no eternal love, no covenant. What is there worth thinking about?"

* * *

Beyond the Silence

"The doctrine of atheism, not faith in God, is dying in the Soviet Union. It could close or level the churches but it was unable to exterminate belief. The human spirit intuitively reaches out for the support and the reassurance of the presence of a Supreme Being. Churches can be burned and pulpits silenced but above the ashes and beyond the silence the believer presses on."

—*New York Times News Service*

* * *

Latent Unbelief Surfaced

Dr. Robert Alley, Professor of Religion at the University of Richmond, Virginia, said, "We have students who are not going to pay lip service to the narrow orthodoxy of the past. Indeed our greatest concern is the [damaging] image of the ministry cast by preachers like Dr. A. W. Criswell." (His book *Why I Preach That the Bible Is Literally True* has exposed latent unbelief in some churchmen.)

Referring to the Book of Jonah, Dr. Alley said, "If the author of that story were to step into the world today and discover that anybody was accepting him word for word, I have a feeling that he'd just collapse from laughter!"

God's Son, Jesus Christ, placed His imprimatur upon the story of Jonah when He said, "For as Jonah was three days and three nights in the whale's belly; so shall the Son of man be three days and three nights in the heart of the earth" (Matt. 12:40). Would He not say to the unbelievers today: "O, fools, and slow of heart to believe all that the prophets have spoken" (Luke 24:25)?

God Has Left His Footprints

"How do we know there is a God?" asked a high school student of his father.

The father replied, "When you were a child, you read about Robinson Crusoe who believed that he was the only human being on the island. He discovered, however, in the sand on the beach a human foot track. He knew that the one who made that track was not far off, for the incoming tide had not yet reached the footprint. He knew that there was another human being on the island, although he had not seen him.

"God has left His footprints throughout His creation: 'The heavens declare the glory of God, and the firmament showeth his handiwork' (Ps. 19:1).

"The evidence of the existence of God, the omniscient, omnipotent Architect of the universe, is so overwhelming and conclusive that one denying it is either willfully blind or intellectually dishonest," said the father.

* * *

Completely Unworkable Today?

Dr. C. J. Curtis, Professor of Theology at De Paul University, Chicago, said, "The traditional Ten Commandments, conceived in a rural, nomadic society, are completely unworkable today."

The Ten Commandments are as morally binding and perceptive today as when first thundered from Sinai's rocky crags. Social and spiritual confusion ensue when they are regarded as passé. By going counter to them, we break not the commandments but ourselves: "The word of the Lord endureth for ever" (I Pet. 1:25).

* * *

Overwhelming Evidence

The British atheist and philosopher Bertrand Russell, winner of the Nobel Prize for literature, died at the age of 97. In commenting upon his death, *The Alberton* said, "Bertrand Russell was an orphan from the time he was three. His father specified in his will that the son was to be reared as an agnostic. A court set aside the will, and he was brought up by a grandmother who taught him to

17

cherish two Biblical texts: 'Enter not into the path of the wicked, and go not in the way of evil men' (Prov. 4:14), and 'Be strong and of good courage' (Josh. 1:6a).

" 'These texts,' said Russell in later years, "profoundly influenced my life and still seemed to retain some meaning after I ceased to believe in God.' "

It isn't easy to extirpate God's Word from the scroll of memory, nor is it easy intellectually to disbelieve in God, the omnipotent Creator of heaven and earth. The evidence of His existence is overwhelming: "The heavens declare the glory of God; and the firmament showeth his handiwork" (Ps. 19:1).

BIBLE

The Inextinguishable Beacon

A radar guidance system now enables pilots to "see" through fog and line up a descending plane accurately with the runway. Snowstorms and fogs are becoming no hindrance to landing.

God's "sure word of prophecy" enables His children to see through the mists and fogs which envelope this distraught world. It is an inextinguishable light "that shineth in a dark place" (II Peter 1:19b), and will shine until "the glorious appearing of the great God and our Saviour Jesus Christ" (Titus 2:13b).

* * *

As a Rose

A newspaper item recently said, "Vast quantities of sweet water buried deep beneath the Sinai and the Negev deserts have been discovered by Israeli geologists. Isotope examination of the water showed that it is ancient, thus proving that the present desert area was once subject to rainfall and was . . . inhabited."

Various Old Testament references affirm that the deserts and wildernesses of Palestine will someday be transformed. This transformation will require vast quantities of water.

Centuries ago the prophet Isaiah predicted, "The wilderness and the solitary place shall . . . blossom as the rose. In the wilderness shall waters break out, and streams in the desert. And the parched ground shall become a pool, and the thirsty land springs of water" (Isa. 35:1, 6, 7).

The Prairie Overcomer

Communists Acknowledge the Bible's Truth

On the second day of the 1968 Russian occupation of Czechoslovakia, the parliament gathered in the large government building in Prague. Most of the representatives of the country were there, including the vice president of the Communist Party of Slovakia, Andre Ziak. His background was Lutheran. Although he had been in the Communist Party for many years, deep down in his heart existed faith in God and the Bible.

At nightfall, it was not possible to leave the building which was surrounded by Russian tanks. As he got ready to retire for the night, Ziak got his Bible and began to read the 83rd Psalm.

"Comrade, what are you reading?" asked a fellow traveler.

"I am reading the Word of God, the Bible," he replied.

"Please read it aloud to me," the communist sympathizer said.

Others joined in the request, "To us also."

Quietly they listened. At the conclusion of the reading of different portions of the Bible, the group agreed in unison, "Yes, that is right!"

> "BROTHER ANDREW," a Dutch evangelist working behind the Iron Curtain

* * *

Thoroughly Authenticated

George W. Cornell, AP Religion Writer, said, "A swelling tide of discoveries through archeological and historical research have confirmed more and more of that ancient book—the Bible."

18

Dr. Baruch Ben-Yehudah, an Israeli mathematician and Bible scholar, affirmed, "A great deal of it (the Bible) has been thoroughly authenticated. Every day we're finding new things!"

"For ever, O Lord, thy word is settled in heaven" (Ps. 119:89).

* * *

Quick and Powerful

As a pickpocket mingled with a multitude in a New York City street, the bulging hip pocket of a man caught his lynx-like, greedy eyes. Sidling alongside his unsuspecting victim, he deftly removed the object.

In his room later the thief discovered that what he had thought was a pocketbook was a New Testament!

"How disgusting!" he fumed.

Curiously, however, he began to read it and made these personal discoveries: "Christ is a great Saviour; I am a great sinner; and my greatest need is His mercy and forgiveness."

Penitently and earnestly the pickpocket prayed, "God be merciful to me a sinner" (Luke 18:13b). Instantly he was transformed!

How powerful is God's Word to change deceitful and desperately wicked hearts. "For the word of God is quick and powerful, and sharper than any two-edged sword" (Heb. 4:12a); "The law of the Lord is perfect, converting the soul" (Ps. 19:7a).

RALPH M. SMITH

* * *

Memorize It!

Sir Wilfred Grenfell, medical missionary to Labrador said, "To me the memorizing of Scripture has been an unfailing help in doubt, anxiety, sorrow, and all the countless vicissitudes of life. I believe it enough to have devoted many, many hours to stowing away passages where I can neither leave them behind me nor be unable to get at them. Facing death alone on a floating piece of ice on a frozen ocean, I have found that the Bible supplied all I needed."

Can we too say, "O how love I thy law! it is my meditation all the day" (Ps. 119:97)?

* * *

Blow after Blow

Said Norman B. Harrison, "Watch the stonemason at his work. One blow, ten blows, twenty, thirty, forty blows—nothing happens. He strikes the 44th time and, lo, the stone cleaves in two. Yet it was not the last blow that did it. Rather, it was the cumulative power of the entire forty-four blows, under which the molecules gradually loosened their grip upon one another and readjusted themselves for the final cleavage.

"God's Word is like a hammer. Keep on prayerfully using it."

W. T. T. Shedd said, "Look not at the hardness of the human heart, but look to the hammer and the fire that break it in pieces."

The Bible says, "Is not my word like as a fire? saith the Lord; and like a hammer that breaketh the rock in pieces?" (Jer. 23:29).

* * *

"More to Be Desired . . . than Gold"

This precious Book I'd rather own
 Than all the gold and gems
That e'er in monarchs' coffers shone,
 Or on their diadems.
And were the seas one chrysolite,
 This earth one golden ball,
And diamonds all the stars of night,
 This Book were worth them all!

Ah, no, the soul ne'er found relief
 In glittering hoards of wealth,
Gems dazzle not the eye of grief,
 Gold cannot purchase health.
But here a blessed balm appears
 To heal the deepest woe,
And those who read this Book in tears
 Their tears shall cease to flow!

AUTHOR UNKNOWN

19

BIBLE

More to Be Desired

In the Tower of London lies the jewelled sword of state. Its beauty is dazzling and most valuable. Diamonds, sapphires, rubies and other precious stones adorn it.

Another Sword, however, surpasses in value the jewelled sword of state. It is the "sword of the Spirit, which is the word of God" (Eph. 6:17).

"The law of the Lord is perfect . . . more to be desired . . . than gold, yea, than much fine gold: sweeter also than honey and the honeycomb" (Psa. 19:7a, 10).

* * *

Gates to Hell

Long ago Martin Luther warned, "I am afraid the universities will prove to be the great gates to hell, unless they diligently labor to explain the holy Scriptures and engrave them upon the hearts of youths. I advise no one to place his child where the Scriptures do not reign paramount. Every institution where men are not unceasingly occupied with the Word of God must become corrupt."

"Wherewithal shall a young man cleanse his way? By taking heed thereto according to thy word" (Ps. 119:9).

* * *

Caught in the Crossfire

Billy Graham testified, "I dueled with my doubts, and my soul seemed to be caught in the crossfire. Finally, in desperation, I surrendered my will to the living God. I knelt before the open Bible and said, 'Lord, many things in this Book I do not understand. But Thou hast said that the just shall live by faith. All that I have received from Thee, I have taken by faith. Here and now, I accept the Bible as Thy Word. I take it all. I take it without reservations. Where there are things I cannot understand, I will reserve judgment until I receive more light. Give me authority as I proclaim Thy Word, and through Thy Word convict sinners and turn them to the Saviour.'"

Like a Mirror

The story is told of a nearsighted oldster who, proud of an imagined ability as a critic of art, strolled through an art gallery with a friend.

The old gent had left his glasses at home and was not able to see the pictures clearly. Standing near a large picture of a man, he began to point out the inartistic features of the picture.

He said, "The frame is altogether out of keeping with the subject, and as for the subject, the man is altogether too ordinary and lacking in character to make a good picture. What a mistake the artist made!"

The friend interrupted him, saying, "You are looking into a mirror!"

God's Word is like a mirror. Some criticize and reject it because it reflects the sinfulness of man's unchanged heart: "Deceitful above all things, and desperately wicked" (Jer. 17:9).

HARRY A. IRONSIDE

* * *

My Eternal Destiny

Isaac Watts said, "I believe God's promises so surely that I stake my eternal destiny on them!"

The Bible says, "He is faithful that promised" (Heb. 10:23b).

Myriads of God's children can testify with His ancient servant Joshua: "Not one thing hath failed of all the good things which the Lord your God spake . . . all are come to pass" (Josh. 23:14).

* * *

Saved from Death by the Book of Life

The Calgary Herald (Canada) told the story of Roger Pepin, who became involved in a heated argument with a man. Another person in the room blasted at Pepin with a sawed-off shotgun. Miraculously he survived with hardly a scratch. Here's why: inside his coat pocket was a hard-covered book, which absorbed most of the blast!

The headline of the news story read: "Saved from Death by the Book of Life."

Myriads have been saved from eternal death by the converting power of another Book—God's Word: "The law of the Lord is perfect, converting the soul" (Ps. 19:7a).

* * *

Mistreated Missive

You who treat the crown of writings
As you treat no other book,
Just a paragraph disjointed,
Just a brief impatient look,
Try a worthier procedure,
Try a broad and steady view,
You will kneel in joyous rapture
When you read the Bible through.

AUTHOR UNKNOWN

* * *

The Enduring Word

A century ago a newspaper printed some rules of the road which were given to passengers on the old Wells Fargo stagecoaches:

"Abstinence from liquor is requested, but if you must drink, share the bottle. To do otherwise makes you appear selfish and unneighborly. Buffalo robes are provided for your comfort during cold weather. Hogging robes will not be tolerated and the offender will be made to ride with the driver. Don't snore loudly while sleeping or use your fellow passenger's shoulder for a pillow. He or she may not understand. Forbidden topics of discussion are stagecoach robberies and Indian uprisings. If ladies are present, gentlemen are urged to forego smoking cigars and pipes as the odor of same is repugnant to the gentle sex. Chewing tobacco is permitted, but spit with the wind, not against it."

The stagecoach is gone, and its rules are passé.

Long ago God gave ten rules—the Ten Commandments. They are spiritually and morally changeless and their keeping is obligatory for the children of God from generation to generation: "For ever, O Lord, thy word is settled in heaven" (Ps. 119:89).

Vindicated

"Christianity does not lie in the realm of external verification. It is better to think of archaeology as illustrating or illuminating the Bible rather than confirming it. The spade of the archeologist has vindicated the reliability of its historical narratives," said Robert Mounce in *Eternity*.

"In Ephesians 2:14, Paul said, 'For he (Christ) is our peace, who hath made both one, and hath broken down the middle wall of partition between us.' We know that the source of Paul's metaphor was the low stone barrier which separated the court of the Gentiles from the inner court of the temple enclosure. The stone barrier was unearthed late in the 19th century by the French Orientalist, Clermont-Ganneau. An inscription engraved in capital letters forbade foreigners from entering within the barrier and added, 'Anyone who is caught doing so will be personally responsible for his ensuing death!' "

David said, "For ever, O Lord, thy word is settled in heaven" (Ps. 119:89).

* * *

The Living Word

Helen Keller said, "Somehow the mystery of language was revealed to me. I learned, for instance, that the word 'water' meant that wonderful cool something that flowed over my hand. Now I know the living Word—God's Word—awakened my soul, gave it light, hope, joy and set me free."

Peter said, "Being born again . . . by the word of God, which liveth and abideth for ever" (I Pet. 1:23).

* * *

Top Is Bottom—Bottom Is Top

A jumbled, confusing directive was recently issued by the British Admiralty. It read: "It is necessary for technical reasons that these warheads be stored bottom upside, that is, with the top at the bottom, and the bottom at the top. That there be no doubt which is the bottom,

and which is the top, each warhead has been labeled with the word 'top!'"

When any people doubt and reject the eternal verities of God's enduring Word, and "call evil good, and good evil" (Isa. 5:20), moral and spiritual confusion ensues: "Every man (does) that which (is) right in his own eyes" (Judges 17:6b).

In a time of deepest gloom and national disaster, God's servant, Daniel, praying for himself and for his nation Israel, said, "O Lord, righteousness belongeth unto thee, but unto us confusion of faces . . . to the men of Judah, and to the inhabitants of Jerusalem, and unto all Israel" (Dan. 9:7a).

DON DILLOW

* * *

Uncommon Horse Sense

Said a theological professor to his students, "Gentlemen, if you didn't learn enough in college, we will try to help you learn more. If you don't know enough Bible, we will help you do that here. But if you don't have common sense, neither we nor God can be of any help to you."

* * *

Spiritual Malnutrition

Said Catherine Marshall, "One morning my friend Carol confided to me, 'I feel tired all the time. Life has palled for me, and nothing is much fun any more. I have so little energy that no undertaking seems worth attempting. I'm discouraged about the world, our nation and the future. What's wrong? Can you help me find what's wrong?'

"Carol had problems, but not the usual ones. She had a happy marriage; no special troubles with her three children; her husband's career was zooming; and there was no health problem.

"As I sought the answer to her question, I thought, 'Spiritual undernourishment can be quite as real as physical starvation. Could it be that Carol's trouble was spiritual malnutrition? Wasn't it possible that her inner spirit was starving to death?'

"I said to her, 'We have three meals a day. We need spiritual food three times daily, too. Spiritual food is like an intravenous feeding of Jesus' Spirit to our spirit. Jesus said that His words are spirit and life indeed. The word *vitamin* really means 'life substance.'"

"I challenged Carol to try spiritual food in the form of lifegiving verses of Scripture three times a day for one month. My 'prescription' worked wondrously!"

The Bible admonishes, "As newborn babes desire the sincere milk of the word" (I Peter 2:2). Its fear-allaying, sorrow-assuaging and healing power are marvellous! Try it!

* * *

A Shabby Sexton of Splendid Tombs

Dr. Robert G. Lee said of the imperishable Scriptures: "The Bible is the Word of God; harmonious in infinite complexity; divine in authorship; human in penmanship; infallible in authority; universal in interest; eternal in duration; regenerative in power; immeasurable in influence; the miracle Book of diversity in unity! It is an oasis in a desert of despair!

"Though Nineveh with her pride is now a dirty doormat for irreverent feet, the Book lives on! Though Greece with her culture and art is now a crumb in history's rubbish, the Book lives! Though Egypt is now a shabby sexton of splendid tombs, the Book lives! 'Heaven and earth shall pass away, but my words shall not pass away' (Luke 21:33)."

* * *

She Followed Instructions

Recently a huge surface of jade, worth $250,000, was found by Mrs. Win Robertson in the rugged country near the southern end of Takla Lake in Canada.

In commenting upon the discovery, *The Detroit Free Press* said, "Mrs. Robertson discovered Canada's largest single jade deposit simply by following the instruction in a textbook on geology which suggested clues as to where the precious mineral might be found."

God's Word is the Christian's textbook and guide. It abounds in pricelessly pre-

cious gems which we are sure to discover when we follow its directive: "Search the scriptures" (John 5:39a).

* * *

Forever Free!

Said Horace Greeley, journalist, "It is impossible mentally and socially to enslave a Bible-reading people."

Jesus said, "And ye shall know the truth, and the truth shall make you free" (John 8:32).

* * *

Think!

A friend of Dr. R. A. Torrey once requested, "Tell me in a word how to study my Bible."

Dr. Torrey flashed back the admonition, "Think!"

* * *

A Bullet-Deflecting Bible

The Battle of Iwo Jima during World War II, was the deadliest in loss of life in U.S. history. Several thousand Marines died. Lt. Patrick F. Caruso was miraculously saved from death by a Bible.

Lt. Caruso testified, "As I zigzagged back to the command post, jumping into shell craters as I ran, a bullet cut through the front of my jacket and penetrated the Bible which I carried in my pocket. The steel shaving mirror which I used as a bookmark deflected the bullet. Without the Bible or the bookmark, the bullet would have gone through my heart!"

How great is the healing and saving power of God's Word: "He sent his word and healed them, and delivered them from their destructions" (Ps. 107:20); "Being born again . . . by the word of God, which liveth and abideth for ever" (I Pet. 1:23).

* * *

Our American Heritage

Said Justice William O. Douglas, "Our American public school system goes back to November 11, 1647, when Massachusetts provided that every town having 100 or more families or households should have a grammar school supported by the taxpayers. The preamble of the law re-

ferred to that 'auld deluder Satan,' who tries to keep man from knowledge of the Scriptures, and it stated that the purpose of training children is so they may know the Word first-hand and not be deceived by those who put 'false glosses' on it."

What was prescribed by law then is prohibited by law now. Greatly does youth need the restraining and cleansing power of God's Word: "Wherewithal shall a young man cleanse his way? By taking heed thereto according to thy word" (Ps. 119:9).

* * *

Old and New Testaments

The New is in the Old concealed,
The Old is in the New revealed,
The New is in the Old contained,
The Old is in the New explained.

* * *

The Tempered Times

Hammer away, ye hostile hands,
Your hammer's break—God's anvil stands!
"The word of the Lord endureth for ever" (I Pet. 1:25a).

* * *

It Shall Accomplish

For 20 years, the Moravian missionary Nathatus Stach labored among the people of Greenland. During that time, he was fiercely persecuted. His every move was misunderstood, and his effort to Christianize the people was repulsed with scoffing.

During these seemingly fruitless years, he translated portions of the Scriptures into the language of the natives.

Said he, "One day as I sat in my hut, I read aloud the third chapter of John. I did not know it but my chief persecutor stood behind me, listening. Suddenly he said, 'Read it again! Read it again!'

"I read and reread the chapter, especially emphasizing the 16th verse: 'For God so loved the world, that he gave his only begotten Son, that whosoever believeth in him should not perish, but have everlasting life.'

"Then the persecutor, deeply convicted

23

of sin, gathered others to hear God's Word. The convicting, converting power of the Holy Spirit fell upon the erstwhile blasphemers. Penitently they confessed their sins and called upon God for mercy, and humbly asked my forgiveness for their wrongs against me."

Thus God proved the genuineness of His sure promise: "My word . . . shall not return unto me void, but it shall accomplish that which I please, and . . . prosper in the thing whereto I sent it" (Isa. 55:11).

* * *

"Those That Published It"

On a global scale, a translation of at least one book of the Bible is available in more than 1,325 languages, and 242 of these have the whole Bible. Revision work is going on in about eighty percent of the languages that have the Bible in whole or in part.

"The Lord gave the word; great was the company of those that published it" (Ps. 68:11).

Christianity Today

* * *

Appalling Ignorance

Noting the results of tests given to students, Dr. Joseph Martin, associate professor in the Department of Bible and Philosophy at Westminster College, re-marked, "Appalling ignorance was seen not only in the students' inability to answer Bible questions correctly but also in the wide margin by which some of the answers missed the mark. Two New Testament books and also 'New Testament' were guessed to be the last book in the Bible . . . The author of many of the Psalms was identified as John, Paul, Saul, Luke, Peter, Jesus and 'shepards.' Asked to state the first commandment, one student wrote, 'Be faithful to your wife.' Another wrote, 'Thou shalt not believe in false kings.' Nominated for the brother of Mary and Martha were James, Mark, Zacharias, Levi and Magdeline!"

* * *

Bible Stops Bullet

U.S. Army Pfc. Roger Boe of Elbow Lake, Minnesota, learned that his Bible meant salvation for the flesh as well as for the soul. Here's how:

The 1st Infantry Division trooper was on a patrol near Lai Khe when North Vietnamese soldiers ambushed his unit. When the attack ended, Boe noticed smoke curling from his pocket. He discovered that an enemy rifle bullet had gone through his wallet and lodged in his Bible, just short of a loaded ammunition clip.

In commenting upon his narrow escape, Boe said, "That's as close as I want to come to death!"

CARE, GOD'S

Under His Wings

A mother hen senses the gathering storm as black, ominous clouds scud across the sky and the thunder rumbles. She clucks loudly and her baby chicks come running to her. Then she covers them safely under her wings. The storm cannot touch them.

This commonplace happening must have been in the mind of the psalmist when he wrote, "In the shadow of thy wings will I make my refuge until these calamities be overpast" (Ps. 57:1). It was also in the mind of the Saviour when He lamented over Jerusalem, saying, "How often would I have gathered thy children together, even as a hen gathereth her chickens under her wings, and ye would not" (Matt. 23:37b).

How safe are those who dwell "in the secret place of the most High (and) abide under the shadow of the Almighty" (Ps. 91:1).

Serendipity

The word "serendipity" means the faculty of happening upon fortunate discoveries when not in search of them. The word was coined by Horace Walpole in 1754.

God often showers blessings on His children when they are not expected. He often works wondrously for them when there is no outward evidence, staying "in the shadows, keeping watch above His own!"

The Bible says, "No good thing will he withhold from them that walk uprightly" (Ps. 84:11b).

* * *

The Everlasting Arms

A teacher read to her class the text, "My yoke is easy."

"Who can tell me what a yoke is?" she asked.

A boy said, "A yoke is something they put on the necks of animals."

Then the teacher asked, "What is the yoke God puts on us?"

A little girl said, "It is God putting His arms around our necks."

How safe we are when God's arms hold us!

"The eternal God is thy refuge and underneath are the everlasting arms" (Deut. 33:27).

ALICE MARIE KNIGHT

* * *

Security

When Mary Selleck of Chula Vista, California, neared her 100th birthday, she expressed poetically her trust in the provident care of God:

"I do not know what the future holds
 Of joy or pain,
 Of loss or gain,
Along life's untrod way;
 But I believe
 I can receive
God's promised guidance day by day,
So I securely travel on.

"And if, at times, the journey leads
 Through waters deep,
 Or mountains steep,

I know this unseen Friend,
 His love revealing,
 His presence healing,
Walks with me to the journey's end,
So I securely travel on."

* * *

Leave It Resting There

Cast thou thy care upon the Lord,
 The care that loads thy heart;
Take Him this moment at His Word,
 And let Him do His part.

The need is deep, the care is great,
 The burden hard to bear;
Roll it on Him with all its weight,
 And leave it resting there.

BISHOP HANDLEY MOULE

* * *

Back of the Loaf

Back of the loaf is the snowy flour,
 And back of the flour the mill,
And back of the mill the wheat and
 shower,
 And the sun and the Father's will.

AUTHOR UNKNOWN

"He giveth to the beast his food, and to the young ravens which cry" (Ps. 147:9).

* * *

Granny Sat Lightly

An elderly lady in West Virginia had never ridden in an airplane. Her grandson finally persuaded her to take an airflight. With fear and trepidation, she agreed.

After a short flight, the plane landed. As she deplaned, the grandson asked cheerily, "How did you like the flight, Grandma?"

"Well," she unenthusiastically replied, "I went up in the plane, but I never let down my weight during the whole flight!"

How like many of God's children was that fearful, distrustful grandma. They insist on bearing all their burdens and cares, though the Lord wants them to cast them upon Him: "Casting all your care upon him, for he careth for you" (I Pet. 5:7).

25

CHILDREN

God's "I Will."

I will bless thee—Gen. 12:2
I will not fail thee—Josh. 1:5
I will heal thee—II Kings 20:5

I will instruct thee—Ps. 32:8
I will teach thee—Ps. 32:8
I will deliver thee—Jer. 39:17

I will help thee—Isa. 41:10
I will strengthen thee—Isa. 41:10
I will uphold thee—Isa. 41:10

I will not forget thee—Isa. 49:15
I will comfort thee—Isa. 66:13
I will forgive—Jer. 31:34

I will be your God—Ezek. 36:28
I will put My Spirit within you—Ezek. 36:27
I will save you—Ezek. 36:29

I will manifest Myself—John 14:21
I will come again—John 14:3
I will sup with him—Rev. 3:20

CHILDREN

A Cry for Love's Return

"One year ago today," said a grief-stricken father, "I sat at my desk with a month's bills before me, when my bright-faced, starry-eyed boy of twelve rushed in and impetuously exclaimed, 'Daddy, today is your birthday! You are 55 years old! I am going to give you 55 kisses—one for each year!'

"Affectionately and joyously, he began to kiss me. I said, 'O, Andrew, don't do it now. I am too busy!' Silently he looked at me as his big blue eyes filled with tears. Apologetically I said, 'Son, you can finish tomorrow!' He made no reply, but was unable to conceal his disappointment. He quietly walked away.

"That same evening I said to him, 'Come and finish the kisses now, Andrew.' But he either didn't hear me, or was not in the mood. He did not respond to my invitation.

"Two months later, the waves of a nearby river closed over his body! We carried him to 'sleep' near the little village where he loved to spend his vacations. The robin's note was never sweeter than his voice, and the turtle dove that cooed to its nestlings was never so gentle as my little boy, who left unfinished his love-imposed task. If only I could tell him how much my heart is aching because of my unkind request, no man in all the world would be so inexpressibly happy as the one who sits today and thinks how he prevented an act that love

inspired, and grieved a little heart that was all tenderness and affection!"

Told by RICHARD W. DeHANN
in *Moody Monthly*

* * *

That Depends

The Sunday school lesson was on Moses' call and lifework. The teacher asked the class of junior boys, "What are you going to be when you grow up?"

The roughest boy in the class said, "I'm going to be a missionary!"

The boys snickered and said, "What, you a missionary?"

After some others had told what they wanted to be, the rough boy spoke again. He said, "Teacher, I'm going to be a gangster!"

Astonished, the teacher said, "Why, you said you were going to be a missionary. Now you say you are going to be a gangster. Which are you going to be?"

The boy said, *"That depends on who gets me first!"*

Each child is freighted with limitless possibilities, either for good or evil.

ALICE MARIE KNIGHT

* * *

Children Learn What They Live

If a child lives with tolerance,
He learns to be patient.
If a child lives with encouragement,
He learns confidence.
If a child lives with fairness,
He learns justice.

If a child lives with security,
He learns to have faith.
If a child lives with approval,
He learns to like himself.
If a child lives with acceptance and
friendship,
He learns to find love in the world.

DOROTHY LAW NOLTE

* * *

Your Answer, Please

Asked a little boy, "Mom, why did God put so many vitamins in spinach and hardly any in ice cream?"

* * *

Malnutrition

Said Nevin S. Scrimshaw, M.D., head of the Department of Nutrition and Food Science at Massachusetts Institute of Technology, "Within the first two years of life, the brain achieves 80 percent of its total development. Actually the first six to nine weeks are particularly critical to the child's future. During those weeks, three intertwined factors play destiny—malnutrition, infectious diseases, and social deprivation. If all three are present, the combination can damage the child's brain permanently. Malnutrition is a fact of existence for two-thirds of the children of the world!"

Spiritual food for children is equally essential! The earlier it is given, the better. An ancient question is relevant: "Whom shall he teach knowledge? and whom shall he make to understand doctrine? them that are weaned from the milk, and drawn from the breasts" (Isa. 28:9).

* * *

The Leader Led

I took a child by the hand
 To lead her on her way;
I told her of the love of God
 And taught her how to pray.

And as I searched for better ways
 Her guide and help to be;
I found, as we walked hand in hand
 That she was leading me.

MATTIE A. ADAIR

Kim Got the Point

The emphasis in the pastor's morning message was the need for every Christian to visit the unsaved, unchurched ones and invite or bring them to church.

Four-year-old Kim got the point as she listened intently to the sermon.

That evening, just before service, Mother suddenly missed little Kim. Hastily she went outside and began to search for her. Finally the parent found Kim two blocks away, standing outside a door, patiently waiting for her new friends to get ready to go to church with her.

"Dear, I was greatly worried when I couldn't find you!" said Mom.

Little Kim sweetly said, "But, Mom, I was just on visitation!"

How slow many of us are to obey the command: "Go out . . . and compel them to come in, that my house may be filled" (Luke 14:23).

* * *

"I Must Bury My Father"

A missionary won the friendship of an intelligent, rich young Turk. One day the missionary said to him, "It would be beneficial and broadening for you to visit other areas of the world and become familiar with different cultures."

The Turk answered, "Before I could do this, I must bury my father."

Instantly the missionary expressed sympathy, saying, "I was unaware of the death of your father."

Surprised, the Turk exclaimed, "No, no, my father is still alive. I meant that all duties to my father must be fulfilled before I can leave home."

Then the missionary understood what a man meant long ago when he responded to the Saviour's invitation to follow Him: "Lord, suffer me first to go and bury my father" (Luke 9:59).

* * *

Read and Weep

A United Press International correspondent captured the horror involved in the death of a child in Waco, Texas, when he wrote:

27

CHILDREN

"Little Ronald Curry got his prayers all wrong, so his father beat him and had him say them over again, police said Four-year-old Ronnie ended his second attempt at prayer with 'God bless Mommy and Daddy!' They were his last words! He died the next day from the beating his father gave him with an auto fan belt and a stick!

"Dr. Walter Krohn, a pathologist who testified at the trial, said the boy's bruises and cuts were too numerous to count. He said the only body he had seen in worse condition was that of the victim of an airplane crash."

Depraved, unregenerated man has a desperately wicked heart. He is capable of committing heinous crimes and atrocities which stagger the imagination.

* * *

Why Peter Didn't Cry

When little Peter was hospitalized for the first time for an operation, he was put in a room all by himself, next to a large men's ward. As mom and dad left him that night, they were worried, thinking that he would cry for them.

This didn't happen. When the nurse turned out the light in Peter's room and walked down the hallway, she heard a clear childish voice singing:

> Jesus loves me this I know,
> For the Bible tells me so!

The eyes of some of the patients who heard the song became moist with tears. They knew that Jesus was near to them, too.

ALICE MARIE KNIGHT

* * *

Angry at Scales

A little girl was showing the bathroom scales to a playmate. Said she, "I don't know what it is. All I know is, you stand on it and it makes you angry."

Watch your waistline and lengthen your lifeline!

"And put a knife to thy throat, if thou be a man given to appetite" (Prov. 23:2).

"Hush, Mommy, and Pray!"

"I will soon be sent to Vietnam," a husband told his wife. Filled with sadness, she began to weep.

Seeing her distress, little two-year-old Cindy walked to the table on which lay a Bible. She took it to her mother and said, "Hush, Mommy, and pray!"

Mother's sadness subsided. God seemed to say to her, "I will watch over and protect your loved ones and you!"

How assuring is the unfailing promise, "If I take the wings of the morning and dwell in the uttermost parts of the sea; Even there shall thy hand lead me, and thy right hand shall hold me" (Ps. 139:9, 10).

Adapted from *Home Life*

* * *

Just Playing Peekaboo

> How wonderful to see the world
> With baby's big bright eyes,
> For everything is new to him;
> Each toy a great surprise!
> The hours are filled with magic
> And a million things to see,
> And he expects the folks he loves
> To be as thrilled as he!

DOROTHIA MORTON

* * *

The Mouths of Babes

When my children were young, I encouraged them to put their trust in God.

One night as Donna was going to bed, I suggested that she pray for the end of the drought that was threatening the livelihood of everyone in the countryside.

"Mother," said Donna, "if I pray for rain, will you bring my dolls inside? I left them in the sandbox, and I don't want them to get wet!"

One night little Robin ran downstairs to kiss some visiting relatives good night. Admonished grandma, "Now be sure to say your prayers, Robin."

"I will," solemnly promised Robin. Then she asked the guests, "Anybody need anything?"

LUCILLE CAMPBELL

28

What's in a Name?

A recent newspaper article said that the capricious selection of names may militate against a child's happiness. A boy had a difficult time through school because no one believed that his true name was Tonsilitis Jones. When he tried to enlist in the navy, he encountered difficulty. Believe it or not, investigation disclosed the fact that Tonsilitis had three brothers whose names were Meningitis, Appendicitis and Peritonitis!

Said a psychologist, "Children often develop lifelong complexities because of their names. An introverted young woman whose moniker was Alpha Omega explained hesitantly, 'Mother didn't want me. She wished everyone to know I was her first and hopefully her last child.' "

The Bible says this about names: "A good name is rather to be chosen than great riches, and loving favor rather than silver and gold" (Prov. 22:1).

The greatest and most enduring bequest a father can bequeath to his sons and daughters is an untarnished, unsullied name!

CHOOSING

"Why Will Ye Die?"

During the Korean War, when Chinese Communists were launching their "human sea" attacks against the American forces, the wounded and dying were brought into the tent hospitals in great numbers. There were not enough doctors, nurses and equipment to treat them! The medics had to decide who was going to die in order that they might use their skills and limited medical supplies for those who had a chance to live. How grave was the choice they had to make!

Each one of us must personally decide as to whether he will live spiritually or die spiritually—without God and without hope.

God said to His ancient people Israel: "I have set before you life and death . . . choose life, that both thou and thy seed may live" (Deut. 30:19).

"Make you a new heart and a new spirit: for why will ye die . . .?" (Ezek. 18:31).

* * *

Inner Emptiness

Dr. Viktor E. Frankl, a renowned psychiatrist, once commented, "The patients crowding our clinics complain of an inner emptiness, a sense of total and ultimate meaninglessness of life—a new kind of neurosis, characterized by a loss of interest and lack of initiative."

How empty and meaningless is the life of those who reject the Saviour who said, "I am come that they might have life, and that they might have it more abundantly" (John 10:10b).

* * *

Saved by a Choice

A business executive was standing in line with other passengers to board a plane when his name was called over the loud-speaker for a phone call. Not responding to the call, he made his way toward the jetliner. When he was about to enter the plane, his name was called again.

Indecision seized the man as he thought, *The plane is ready to take off. If I answer the phone call, which may be urgent—about the sickness or death of a loved one—I will miss the plane, jeopardize a large business deal, and possibly lose a valued customer.*

The thoughts of possible peril or need of a loved one prevailed over all other considerations, and he responded to the phone call.

The jetliner taxied to the runway for takeoff. Then it streaked skyward. A moment later a terrific explosion occurred! The giant plane disintegrated, and the ground below was littered with debris and broken bodies of men, women and children!

29

CHOOSING

The business executive was saved from a horrible death by making a choice.

Long ago vacillating Pilate asked a frenzied mob a destiny-determining question: "What shall I do then with Jesus which is called Christ?" (Matt. 27:22).

Pilate made a disastrous choice in reference to the sinless Son of God. Because of it, he went at death into a lost hereafter.

What choice have you made about the momentous inescapable question: "What shall I do then with Jesus?"

Story told by BILL TOLAR

* * *

Uncommon

Said Dean Alfrange, a foreign-born, naturalized American who is a prominent lawyer and author, "I do not choose to be a common man. It is my right to be uncommon if I can. I do not wish to be a kept citizen, humbled and dulled by having the state look after me. I want to take the calculated risk, to dream and build, to fail and succeed. I refuse to barter incentive for a dole. I prefer the challenge of life to the guaranteed calm of Utopia. I will not trade freedom for beneficence, nor my dignity for a handout. It is my heritage to think and act for myself, to enjoy the benefit of my creations, and to face the world and say, 'This I have done!' "

* * *

Inundated By Trifles

Said Ralph Waldo Emerson, "At times the whole world seems to be a conspiracy to importune us into trifles. Amid the clamor of many appeals there is need for a high degree of selectivity; a genius for essentials to prevent the good from being the enemy of the best. We must choose lest we become inundated by trifles."

Who Will Survive?

Jean Bourgeis-Pichat, director of the French National Institute of Demagraphic Studies, observed, "We are on the eve of an era in which society will have to decide who will survive and who will die. The new medical techniques are becoming so expensive that it soon will be impossible to give the benefit of them to everybody. . . . We will soon be confronted with a problem of choice, a moral choice. Is our cultural state ready for that? This is open to doubt."

We may not always be able to determine our physical well being but each of us is the sole arbiter as to whether he will live spiritually and eternally. Each one may choose spiritual life in Christ, or choose to reject Him and go into a lost hereafter.

* * *

Wisdom Needed

Lt. William T. Reinders, the pilot of a jet fighter plane that crashed into a home and killed 13-year-old Cynthia Masters, said, "I could have made it past the house if I had been able to drop my fuel tanks, but I figured I probably would have hit two more houses with them and there would have been three fires instead of one."

Lt. Reinders was confronted with a choice. He had only a few seconds to choose between two courses of action.

God's children are free moral agents, endowed with the freedom of choice. Great is their need of spiritual enlightenment and heavenly wisdom to "know to refuse the evil, and choose the good."

* * *

Awaiting Genius

Said Michelangelo to a friend as he caressingly patted a large stone in his studio: "See? Moses! He is imprisoned in this stone. God put him there. He has chosen me to release him!"

30

CHRISTIAN LIVING

Leaning Christians

The Leaning Tower of Pisa is the bell tower of the Cathedral of Pisa in Italy. It is shaped like a cylinder, is made of white marble and has eight arcades one over the other. There is a spiral staircase which leads to the top of the structure.

Shortly after its completion, it was observed that the tower was not truly vertical and was beginning to lean. The ground below it was beginning to sink!

Through the centuries, the tower has steadily continued to lean. Today its deviation from the vertical is more than 14 feet. Many efforts have been made to arrest its leaning, but to no avail. Experts say that now it is not possible to restore the tower to accurate perpendicularity.

Many Christians today are like the Leaning Tower of Pisa. Why do they lean from spiritual rectitude?

With Demas, it was love of the world: "Demas hath forsaken me, having loved this present world" (II Tim. 4:10a).

With Peter, it was consorting with the enemies of Christ: "Peter sat down among them" (Luke 22:55b).

With the Laodicean Christians, it was spiritual pride and self-praise: ("We are) rich, and increased with goods, and have need of nothing" (Rev. 3:17).

In prayer, a minister once pled, "O Lord, prop us up on the leaning side!"

* * *

Miniskirted Jurors

Criminal District Judge Byron Matthews does not object to women jurors wearing miniskirts, but he thinks it would be better if they sat in the first row, behind the jury box railing.

He said, "It's been shown that women in miniskirts spend so much time tugging at their dresses, holding down the hems, that some of them can't concentrate on the testimony and that's the important thing."

The styles for women's clothes change frequently, but the directive given in God's Word for the adorning of Christian women is changeless: "Whose adorning . . . let it be . . . of the heart . . . the ornament of a meek and quiet spirit, which is in the sight of God of great price" (I Pet. 3:3, 4).

* * *

Four Things to Do

Four things a man must learn to do
If he would make his record true:
To think without confusion clearly;
To love his fellow-men sincerely;
To act from honest motives purely;
To trust in God and Heaven securely.

HENRY VAN DYKE

* * *

No Secret

When Lefty Gomez was asked how he achieved the World Series pitching record of six wins and no losses, he replied, "Clean living and a fast outfield."

* * *

"I Just Lived the Gospel"

After several years of service in New Guinea, a missionary returned home. A friend asked, "What did you find at your station in New Guinea?

The missionary replied, "I found something that was more hopeless than if I had been sent to the jungles to a lot of tigers. Why, those people were so degraded, they seemed to have no moral sense. They were worse than beasts. If a baby cried and annoyed his mother, she would throw him into the ditch and leave him there to die. If a man saw his father break his leg, he would leave him on the roadside to die. They had no compassion, no love, no pity for others!"

"Well, what did you do for such people? Did you preach to them?"

"No," replied the missionary, "preaching would do no good. *I just lived the Gospel!* When I saw a baby crying, I comforted him. When I saw a man with a broken leg, I mended it. When I saw people in distress, I pitied them. I took

them into my home. I cared for them. I lived that way, day by day.

"Finally, the people began to come to me and say, 'What does this mean? What are you doing this for?'

"Then it was that I had my chance to preach the gospel! They knew what I meant!

The friend asked, "Well, what happened? Did you succeed?"

"When I left, I left a church!"

ALICE MARIE KNIGHT

* * *

Ghandhi Was Eminently Right

Mahatma Gandhi, the man who led India to independence, once received a group of Christian ministers at 6:30 o'clock in the morning. After eating a breakfast of goat's milk in which sweet lime leaves had been boiled, they went up on the roof for a private conference. Mr. Gandhi was dressed in a loincloth and carried a dollar watch.

The ministers asked the mahatma about conversion, and he replied, "I believe in Christian conversion if it is genuine. On the other hand there is nothing worse than being something on the *outside* that you are not on the *inside*. If a man has really found God through discovering Jesus Christ, then he must be baptized and show the world that he is a follower of Jesus, or else he will be a living lie!"

How severely did Jesus denounce the deadly, soul-shriveling sin of hypocrisy: "Woe unto you, scribes and Pharisees, hypocrites! for ye make clean the outside of the cup and of the platter, but within they are full of extortion and excess" (Matt. 23:25).

BILLY GRAHAM

* * *

Disliked

A young woman, who was disliked by her fellow employees because she was mean, domineering, and destructively critical, was genuinely saved in a revival. Hearing about it, some with whom she

worked said, "Now that she's got religion, we'll see if it works and if she holds out."

To their surprise, the new convert went to those whom she had treated so meanly and said, "I long with all my heart to show my Saviour to you through my changed life. I am sorry for all the mean things I have said and done."

"Therefore if any man be in Christ, he is a new creature: old things are passed away; behold, all things are become new" (II Cor. 5:17).

* * *

Reflecting Christ

On the face of Stone Mountain in Georgia, the renowned sculptor Gutzon Borglum, with the help of stonecutters, carved a Confederate memorial. It is cut into an 800-foot wall of granite.

To begin the work, the sculptor needed to show on the face of the mountain the exact outline of the figures of the marching men in the Confederate Army. He tried different experiments but without success. Finally he constructed an enormous projection machine which weighed a ton and anchored it 800 feet from the mountain. Using a slide picture, he reflected on the rock a clear picture two hundred feet high. Then the stonecutters had a scaled plan to work by.

Through Christ-like Christians the indwelling Holy Spirit reflects on stony hearts the image of Christ, who is the Light of the world and the express image of the heavenly Father.

Told by FRANK S. MEAD

* * *

Without Trying

Said Henry M. Stanley of David Livingstone, "He made me a Christian and never knew he was doing it!"

How difficult it is for a non-Christian to be unmoved by a life lived consistently for God and others!

* * *

A Tip for Your Garden

Maxine DaDndres advised, "Plant five rows of *peas:* prayer, perseverance, pre-

paredness, politeness and promptness: three rows of *squash*: squash gossip, criticism, and indifference; five rows of *lettuce*: let us be faithful, unselfish, loyal, truthful and love one another; four rows of *turnips*: turn up in church, turn up with a smile and cheerfulness, turn up with new ideas and turn up with a helping hand."

"If ye know these things, happy are ye if ye do them" (John 13:17).

* * *

Acts Speak Louder

After spending four months with David Livingstone, Henry M. Stanley, journalist, wrote, "I grant you he is not an angel, but he approaches to that being as near as the nature of a living man will allow."

Later, in speaking of his conversion, Stanley said, "It was not Livingstone's preaching that converted me. It was Livingstone's living!"

* * *

The Power of Clean Living

Said a high school principal to a pastor, "The most popular student on our campus is not a football player. He is just an ordinary student, but he lives such a clean, wholesome and Christlike life before the students that he has raised the moral standards of the whole school. It is simply amazing!"

How helpful is a life which is lived cleanly and unselfishly for God and others!

* * *

Commit It to Life

Said Edwin Markham, "We have committed the Golden Rule to memory. Let us now commit it to life!"

* * *

Non Possumus

God's children cannot live wrong and pray right; nor can they live wrong when they pray right.

David pled, "Create in me a clean heart, O God. . . . Then will I teach transgressors thy ways; and sinners shall be converted unto thee" (Ps. 51:10, 13).

* * *

Because I Lived

When morning breaks and I face the day,
This, dear Lord, is what I pray:
That when the same day fades to gray,
Some child of yours may happier be,
May find himself more close to Thee,
Because I lived this day.

JULE CREASER

* * *

When Cup Overflows

Said Bud Robinson, "I'm not impressed by how high a shouting man jumps when his cup of joy overflows. I'm concerned about how he walks when he lands on terra firma."

Our daily walk either helps or hinders the Gospel: "See then that ye walk circumspectly, not as fools, but as wise, redeeming the time because the days are evil" (Eph. 5:15, 16).

* * *

Preaching Not Needed

Said Mohandas Gandhi, "A rose does not need to preach. Its fragrance is its own sermon."

* * *

Victorious

Lt. Gen. William J. Harrison said this about living the Christian life: "It is simply a matter of following the Bible and giving Christ the place that He asks in our lives. If we look to Him in all things, speak to God in prayer, study and heed His Word and remember that we are blood-bought bondslaves of Jesus Christ, our fellowship with Him will continue unbroken."

"But thanks be to God, which giveth us the victory through our Lord Jesus Christ" (I Cor. 15:57).

CHRISTMAS

"They Leave Me Cold"

Peter Marshall said, "I must confess that modern Christmas cards leave me cold. I cannot appreciate the dogs and cats and galloping horses, the ships in full sail, or any of the cute designs that leave out the traditional symbols of the star, the manger, the wise men on their camels."

* * *

The Wonder of Childhood

Charles Dickens wrote in *The Pickwick Papers,* "Happy, Happy, Christmas that can win us back to the delusions of our childhood days; that can recall to the old man the pleasures of his youth; that can transport the sailor and the traveler, thousands of miles away, back to his own fireside and his quiet home."

* * *

The Palace Versus the Stable

Said Hendrick Van Loon in *The Story of Mankind,* "It was the 753rd year since the founding of Rome. Gaius Julius Caesar Octavianus Augustus was living in the palace of the Palatine Hill, busily engaged upon the task of ruling the world.

"In a little village of distant Syria, Mary, wife of Joseph the carpenter, was tending her little boy, born in a stable of Bethlehem.

"This is a strange world! Before long, the palace and the stable were to meet in open combat, and the stable was to emerge victorious!"

* * *

We Honor His Birth

Jesus asleep in the manager,
 Joseph and Mary nearby,
Greeting the birth of our Saviour,
 Bright shines a star in the sky.

Shepherds on guard in the nighttime
 Listen to angels who sing,
"Glory to God in the highest,
 Peace in the name of our King."

Jesus asleep in the manager,
 Lowly God's Son came to earth,

Bringing us gifts beyond value,
 Grateful, we honor His birth.
GEOFFREY HALL

* * *

"Glory to God in the Highest!"

That song is sung by rich and poor,
 Where'er the Christ is known;
'Tis sung in words, and sung in deeds,
 Which bind all hearts in one.
Angels are still the choristers,
 But we the shepherds are,
To bear the message which they bring.
 To those both near and far:
"Glory to God in the highest,"
 The angels' song resounds,
"Glory to God in the highest!"
C. WHITNEY COOMBS

* * *

"We'll Bring Our Hearts"

The wise may bring their learning,
 The rich may bring their wealth;
And some may bring their greatness,
 And some bring strength and health;
We, too, would bring our treasures
 To offer to the King:
We have no wealth or learning,
 What shall we children bring?

We'll bring Him hearts that love Him,
 We'll bring Him thankful praise,
And young souls meekly striving
 To walk in holy ways:
And these shall be the treasures
 We offer to the King,
And these are gifts that even
 The poorest child may bring.
ANONYMOUS

* * *

"The Word Became Flesh"

O Word of God incarnate,
 O Wisdom from on high,
O Truth unchanged, unchanging,
 O Light of our dark sky;
We praise Thee for the radiance,
 That from the hallowed page,
A lantern to our footsteps,
 Shines on from age to age.
WILLIAM W. HOW

Church

Who is He in yonder stall,
At whose feet the shepherds fall?

'Tis the Lord! O wondrous story!
'Tis the Lord, the King of glory!
At His feet we humbly fall—
Crown Him! Crown Him, Lord of all!

Swept along on the wave of worldwide elation incident to the lunar landing of the U.S. astronauts and their safe return to earth, President Nixon said, "This is the greatest week since the beginning of the world! Nothing has changed the world more than this mission!"

While sharing the President's whelming enthusiasm as he praised the exploration of a heavenly body, we disagree with what he said. The greatest and most wondrous event in the world occurred when the angelic being announced long ago the hope-enkindling advent of the Saviour: "I bring you good tidings of great joy, which shall be to all people. For unto you is born . . . a Saviour" (Luke 2:10, 11).

Globe-girdling blessings were brought by His coming: "The people that walked in darkness have seen a great light: they that dwell in the land of the shadow of death, upon them hath the light shined" (Isa. 9:2).

Lead the Lost

"O Lord, look after all those who get lost at Christmas:

"Little folks lost in stores, running about in panic crying for their mothers, and big folks lost in the confusion of crowded parties and crowded lives, with drugs and drink and sex and mistaken goals. Send the cold, clean Christmas spirit soaring through us, Lord, so bright and high and shining that we won't need anything else.

"And husbands and wives lost to each other through habit and neglect and misunderstanding, and sons and daughters lost to their parents. And men lost in prison camps, and ships lost at sea. And pets who are lost and hungry out in the cold.

"Have mercy on all Your lost creatures, Lord: men and women, child and beast. Reach out your arms to us, lead us gently back into the warm shelter of the stable. Let us gaze upon the miracle of the manger. Let us become one with it, drawing new hope from it, and a sense of new worth so that we know we are all very dear to You, so that we are less likely to stray."

Who Am I, God?
© 1971, used by permission of Doubleday & Co., Inc.

A Crumbling Cathedral

Through the centuries, St. Paul's Cathedral in London, England, has survived many perils. It has been destroyed by fire several times. Oliver Cromwell used it as a cavalry barracks and stabled horses inside its massive walls. The Germans bombed and fire-bombed it during World War II.

Now St. Paul's is in serious danger. Its enemies are air pollution, vibration of heavy traffic passing alongside, and the eroding teeth of time. The damage is extensive and almost irreversible. Its walls bulge outward, and the twin bell towers are leaning away from each other. Cracks and faults run like jagged streaks of lightning down the outside walls.

The cathedral's chief surveyor, Berhhard Feilden, said, "The face of St. Paul's is literally washed away by erosion, which comes from sulphur dioxide. There is nothing we can do to change it. The only thing we can do is to stop it from getting worse."

In time, all stone-and-mortar edifices crumble into dust. The church which Jesus founded of born again believers—"lively (living) stones" (I Pet. 2:5)—will endure: "The gates of hell shall not prevail against it" (Matt. 16:18b).

CHURCH

A Self-Excusing Deacon

Two deacons from a rural church went fishing on a bright Sunday morning. As they sat in their boat, they heard in the distance the ringing of the church bell, calling the people to God's house.

One, conscience-stricken, said sadly, "Really, we ought to be in church today."

Self-excusing, the other said, "Even if I were at home today, I couldn't go to church, for my wife is ill."

How trivial are the excuses responsibility-shirking, backslidden Christians make!

* * *

A Summer Parable

Now it came to pass that as vacation time drew near, a certain church member bethought him of cool streams and hungry fish. The children thought of sandy beaches and motorboating, while his wife dreamed about a trip to the mountains.

Saith the man to the wife, "Lo, I have become weary, so come let us depart to a place where fishes bite and cool winds blow."

"These are the words of wisdom," saith the spouse, "but we must do some things ere we go."

"Yes," saith the husband. "I think of three things: Ask the neighbor to water the flowers, arrange for the grass to be cut, and have our mail forwarded."

"Nay," saith the wife. "There is one more thing—a fourth. Dig thou into thy purse and pay tithes to the church before we go, that the Lord's work does not suffer. *Do it now,* for verily thou hast more money in thy pocket *now* than thou wilt have when thou returnest!"

And so it came to pass that it was done and God's work did not suffer, and a sense of peace came over the vacationer!

"Go, and do thou likewise" (Luke 10:37).

Baptist Standard

* * *

Not Quite

Said a pastor to a friend, "Everybody in my church contributes freely!"

"You surely have a wonderful church," commented the friend.

"Not quite," said the pastor. "Some contribute their time and money. Others contribute criticism!"

* * *

To Love Is to Lift

Said Bishop J. A. Johnson, Jr., "The only way to lift is to touch: 'Simon's wife's mother lay sick of a fever . . . he (Christ) . . . took her by the hand and lifted her up' (Mark 1:30, 31); 'And he touched her hand and the fever left her' (Matt. 8:15).

"You cannot lift men without touching them. The church must not be locked in its stained-glass fortress where an anemic preacher preaches an anemic gospel about an anemic Christ to an anemic congregation. The church building must be a point of departure into the world, into a dirty here-and-now world to become a contemporary with Jesus in the ministry of suffering and humiliation, love and liberation."

* * *

Blasting Bats

Said Homer D. Henley, "God intended that we should lay aside the work of the sweat of the brow and for a little while each week return to Eden and enjoy and glorify Him. Some church services make it very difficult to do either. For instance, we may come a little early to meditate, and all of a sudden the organist tries to shake the bats out of the pipes with a ninety-decibel blast—not very conducive to meditation."

"But the Lord is in his holy temple: let all the earth keep silence before him" (Hab. 2:20); "In quietness and in confidence shall be your strength" (Isa. 30:15).

* * *

Don't Do It!

A self-righteous young man once said to Spurgeon, "When I find a perfect church, I'll join it!"

Spurgeon quipped: "Young man, there has never been a perfect church. I am sure my church is not perfect. If perchance you ever find a perfect church, I

36

would advise you not to join it, for then it would become an imperfect church!"

Not until the church is raptured into the presence of her divine Head, the Lord Jesus Christ, will the church be perfect. Paul said, "But we have this treasure in earthen vessels" (II Corinthians 4:7). Earthen vessels are weak and imperfect. Therefore admonished the writer of Hebrews: "Let us go on unto perfection" (Hebrews 6:1).

I think that I shall never see
A church that's all it ought to be:
A church whose members never stray,
Beyond the strait and narrow way.
A church that has no empty pews,
Whose pastor never has the blues,
A church whose deacons always "deak,"
And none are proud but always meek,
Where gossips never peddle lies,
Or make complaints or criticize,
Where all are always sweet and kind,
And all to others' faults are blind,
Such perfect churches there may be,
But none of them are known to me,
But still we'll work and pray and plan,
To make our church the best we can!

AUTHOR UNKNOWN

* * *

"One In Us" (John 17:21)

For God's children to expect spiritual strength by being unequally yoked together with unbelievers under the umbrage of ecumenism is like expecting two consumptives to get better by marrying.

How precious is the *spiritual unity* of God's true children, who are one in the Father and one in the Son, though not united denominationally. "That they all may be one; as thou, Father, art in me, and I in thee, that they also may be one in us" (John 17:21).

* * *

A Return Visit

Sam Levenson said, "My wife and children and I like to believe that God dwells in our house. So we feel it is only proper that on the Lord's Day we should return the courtesy by visiting Him in His house."

Long ago David said, "I was glad when they said unto me, Let us go into the house of the Lord" (Ps. 122:1).

* * *

Where They Worshiped

Said Philip Schaff, "Until about the close of the second century the Christians held their worship mostly in private houses, in desert places, at the graves of martyrs, and in the crypts of the catacombs."

God is everywhere: "If I take the wings of the morning, and dwell in the uttermost parts of the sea; Even there shall thy hand lead me, and thy right hand shall hold me" (Ps. 139:9, 10).

God's children may worship "in spirit and in truth" anywhere: "For where two or three are gathered together in my name, there am I in the midst of them" (Matt. 18:20).

There is no substitute, however, for the collective worship of His children: "And let us consider one another . . . Not forsaking the assembling of ourselves together, as the manner of some is; but exhorting one another: and so much the more, as ye see the day approaching" (Heb. 10:24, 25).

* * *

Equivocating

Radical militants have tried to bring their "new world" on us by burning and bombing, and have found that it won't come that way. Now they are uncertain about which direction to turn. Some may turn to us. Uncertain religious teachers have partially emptied their pews and their coffers with their equivocating, and some of them are now talking about "phasing out" their churches. Others are looking to us.

Decision

* * *

Helpfulness—The Mark of True Christianity

The leg of a member of a Plymouth Brethren church was crushed in an accident. He was rushed to a Roman Catholic hospital where the crushed limb was amputated by an Episcopal surgeon

37

CHURCH

While convalescing, he was cared for by a Presbyterian nurse. He ran an ad in a Congregational paper for an artificial limb. A Methodist widow, whose crippled husband had been a Baptist, took out of storage the artificial limb her deceased husband had used, and sent it to the hospital by a Lutheran neighbor.

When the grateful man was appraised of the involvement of people of many different churches, he exclaimed, "I guess I'm now a *United Brethren!*"

All true believers in Christ are united spiritually in Christ and the Father. Christ said, "That they all may be one; as thou, Father, art in me, and I in thee, that they also may be one in us" (John 17:21).

Mutual helpfulness is the hallmark of true Christians: "They helped every one his neighbour, and every one said to his brother, Be of good courage" (Isa. 41:6).

Starkly Irrelevant

In his book *A New Face for the Church* (Zondervan, 1970), Lawrence O. Richards said, "Measured against the divinely ordained pattern, much of our church life today stands out starkly as irrelevant, misshapen, and perverted. Like it or not, we have to agree that somehow, through all our forms and organizations and agencies, vital Christian personalities are not being grown. I am not suggesting a 'no church' movement in which small groups are the only form of gathered life. I am suggesting instead that the church must be reorganized!

"Many Christians dutifully attend services and meetings, yet are burdened by the meaninglessness and sameness of so much that is traditionally a part of our churches today.

"Today's church does not promote mutual ministry. The majority sit, silent and passive, listening to the Word, and prod the professional staff to 'preach the gospel' to the saints, who alone fill our churches, while a disinterested world passes by.

"The major deliberations of church leaders focus on organizational problems while the biblical values we profess are seldom actually discussed. Is the Sunday school growing? Is the budget up? If so, the church is doing fine!"

* * *

"God? Who's That?"

The following letter from a grief-stricken mother appeared in the Warsaw, Indiana, *Times-Union:*

"Three months ago, I sat in a courtroom and heard a judge say, 'Twenty years!' He was pronouncing punishment on my twenty-one-year-old son, a penalty for drinking, gambling and committing robbery which ended in the almost-fatal shooting of a man.

"The sentence might have been less but my son had a sneering, defiant attitude all through the trial. The shocking climax came when the judge sternly asked, 'Young man, don't you believe in God?'

"My son laughed loudly as he answered, 'God? Who's that?' I think everyone in the courtroom turned and looked at me.

"I went to Sunday school when I was small and learned about God. After I married, I decided to go again and take my children with me. I went regularly for a year. Then I occasionally skipped a Sunday. Soon I skipped two or three Sundays in a row. Then I went only on special occasions.

"If only I had those years to live over! Night after night, I've paced the floor with my son's words, 'God? Who is that?' echoing in my ears.

"I am sick with shame. So many say they do not believe in making a child go to church if he doesn't want to, but how many children would go to school if they weren't *made* to?"

* * *

Gnats and Camels

Said Leighton Ford, vice president of the Billy Graham Evangelistic Association, "While revolution was raging in Petrograd in 1917, the Russian Orthodox Church was in session a few blocks away having an animated debate about what color vestments their priests should wear. God help us if we strain at gnats while camels of revolution are marching!"

38

Beneficial to Health

A Johns Hopkins University medical researcher has just discovered what the Presbyterian Ministers' Life Insurance Fund has known for more than two centuries: attending church is good for your health.

The risk of fatal heart disease is almost twice as high for the non-churchgoer than for men who attend once a week or more, according to a study made by Dr. George W. Comstock of the university's Department of Epidemiology. The doctor also observed that the "clean life" associated with regular churchgoing appears to be statistically related to a lower incidence of other major diseases, adding that "going to church is a very favorable input."

We shortchange ourselves when we habitually absent ourselves from God's house without cause. We become cold, calloused and critical.

"Enter into his gates with thanksgiving, and into his courts with praise: be thankful unto him, and bless his name" (Ps. 100:4).

Adapted from *Christianity Today*

* * *

Indolent All Week

Dr. Warren R. Guild of the Harvard Medical School, and President of the American College of Sports Medicine, warned, "If you are soft and indolent all week, a massive weekend effort is foolhardy."

It is spiritually hazardous for God's children to exercise their souls and partake of spiritual food only on weekends. To maintain spiritual health and grow in grace they must daily commune with God and partake of "the sincere milk of the word" (I Pet. 2:2).

* * *

A Passionate Devotion

Said Paul Moore, Jr., Bishop of the Episcopal Diocese of Washington, D. C., "The church is to function as a religious institution, not merely a social-service agency however important that may be. Today our faith is in a crisis. Only a clearer understanding of the content of our faith and a more passionate devotion to Jesus Christ will renew the church."

* * *

A Record-Breaker

When Congressman Charles E. Bennett (D-Fla.) started his nineteenth consecutive year of not missing a single record vote in the House of Representatives, it was said that his 2,242 votes cast without a single miss had broken all previous records in the 180-year history of Congress.

One of the greatest lacks among God's children is faithfulness in church attendance. The ancient question is relevant: "Why is the house of God forsaken?" (Neh. 13:11). How often is God's directive disobeyed: "Not forsaking the assembling of ourselves together, as the manner of some is" (Heb. 10:25a)!

* * *

Amazing, Isn't It?

A demonstration by seven young people occurred during the 1969 Minnesota Conference of the United Methodist Church in St. Paul, meeting in the Hamline Methodist Church. Three of the demonstrators carried rifles. Two of them went to the balcony. Five went to the podium and brandished rifles at the officials and the audience. After the reading of each of eight criticisms of churches for silence on social issues, a blank was fired from a rifle in the balcony!

As the group left, the audience applauded. The presiding bishop received a standing ovation for saying the demonstration had accurately brought the agony of the world into the church. Later the bishop commented, "Those young people called the church to judgment. I wouldn't have used guns in the church had I organized the demonstration, but I didn't organize it!"

Adapted from *Christian Herald*

CHURCH

Spiritual Renewal

Entering a church in historic Plymouth, a discouraged, distraught worshiper read on a plaque these words:

"Who'er thou art that entereth here,
Forget the struggling world and trembling fear."

It was during the great depression of the 1930s, and, at first, the worshiper thought, "The words suggest a cowardly retreat from a stricken, needy world."

Then as he thought more deeply about the words, he opined, "Retreating to God's house for prayer and communion with Him is the kind of withdrawal I need to acquire spiritual renewal of soul to enable me to mount above the strain and stress of these testing times."

How sustaining is God's unchanging promise: "But they that wait upon the Lord shall renew their strength" (Isa. 40:31a).

* * *

Do You Agree?

Said Rev. Robert L. Roxburgh, pastor of the Killarney Baptist Church, Calgary, Alberta, "Most of our churches are loveless. . . . The old families look on newcomers as second-class members or intruders. People in the neighborhood are seen as statistics instead of human beings with needs only Christ can meet."

Greatly does the church need a heart-searching reappraisal of its mission—the salvation of the lost ones, and the edification of its members. It should be endowed with unfeigned concern for the temporal and spiritual welfare of all people.

* * *

Lilies and Blisters

Some church members are like lilies: "they toil not, neither do they spin."

Some are like blisters: they never show up until the work is over.

RALPH M. SMITH

If We Fail

Warned the late J. Edgar Hoover, "Never have the churches lived in a time of greater opportunity to exhibit the importance of faith in God and of obedience to His will. If they fail to do so, nothing could be more calamitous."

* * *

Modern Man Can Believe

Said W. A. Criswell, in his presidential message to the Southern Baptist Convention, "America and Christian civilization lie in the balance. If we fail here, we fail everywhere. If we fail now, we, for our part, have failed for all time. Armageddon is at the door! Every church should be shocked out of its complacency and lethargy. Modern men are weary with being told they cannot believe. They want to know what they can believe. They are not interested in an emasculated, anemic, denatured Christianity!"

* * *

Exemplify the Truth

Said Edward R. Dayton, "The church doesn't need a message that is relevant to the world. It needs Christians who are relevant to the message."

The daily lives of Christians should exemplify the changeless truths of the Gospel.

* * *

Where Christ Is

One has said, "You can't keep Jesus in a church. He is there, to be sure, but you can't keep Him there. Enshrine Him, ritualize Him, as you may, He will not stay only in the church. No! He walks the meanest avenues of life and imparts His touch of beauty. Wherever there is sorrow, suffering, sin and shame, there you will find Him. The only way to keep Him is to share Him."

* * *

Losing Ground

A denominational executive sat in his office on whose walls were success charts

40

about promotional missionary enterprises. On the shelves were many "how-to-do-it" books. He confessed to me his inner pessimism. Pointing to graph lines, he said, "We can tell the world we are growing, but we are losing ground! The secular is swallowing up the sacred. Television has made our homes a cheap burlesque show. It is becoming common to serve alcoholic cocktails at dinners in many of the homes of prominent members. The number of unwed mothers among our young people is increasing. Anything puritanic is for the 'dear dead days beyond recall!' "

VIRGIL A. OLSON
in Eternity

* * *

What an Indictment!

Said Gus Hall, national secretary of the Communist Party in the United States, "Communism and the liberal church share so many goals that they ought to exist for one another. We can—we should—work together for the same thing!"

Serve with Abandon

Said Rev. W. Thomas Younger, "A church must risk itself and its status quo for greater ministry. It must serve with the abandon of a football player who will not stop short of the goal line. A principle which God has held before me is indicated in this verse: 'There is that scattereth, and yet increaseth; and there is that withholdeth more than is meet, and it tendeth to poverty' " (Prov. 11:24).

* * *

Causes of Apathy

Professionalism and spectatorship are among the chief causes of apathy and weakness in the church today. The early church began as a lay movement, each person telling what the Lord had done for him. But now the church program has deteriorated into a kind of propaganda, financed by silent spectators. We hire preachers to deliver our sermons and read the Bible for us, and engage professional singers. The laity sits back and pays the bills, and some just sit back.

RALPH SOCKMAN

CIGARETTES

Too Late!

A humanly hopeless victim of throat cancer sent the following plea to Richmond Barbour, a news columnist: "Please tell your readers not to smoke. I'm going to the hospital for a throat cancer operation. I've smoked for thirty years. I do not have emphysema. My heart and blood vessels are in good condition. I used to boast that I was one person cigarettes would not hurt. I was wrong.

"My throat cancer developed slowly. I knew I had a sore throat a year ago. But I did nothing about it. Gradually my throat got worse. A surgeon looked at it four days ago. He says it may be too late, because the cancer covers such a large area. I've been a fool to have smoked! I should have known I'd get caught, one way or another. Please tell your readers about me. I want them to profit from my terrible experience. Tell them not to smoke!"

Tobacconists Misrepresent Facts

U.S. Surgeon General Jesse L. Steinfield affirmed, "The tobacco industry has marshaled witnesses in its behalf before congressional committees and before television cameras, but even these witnesses seldom say categorically that cigarettes are not hazardous. . . . They undercut the efforts of parents and teachers to dissuade young people from taking up smoking and they imperil the health of present smokers by seeming to suggest that it is not serious danger to keep on smoking."

* * *

Unsuccessful Pregnancies

U.S. Surgeon General Jesse L. Steinfeld affirmed, "There is a substantial body of evidence that women who smoke while pregnant may be exerting a retarding influence on fetal growth. They have twenty percent more unsuccessful pregnancies than those who do not smoke. While

41

CIGARETTES

there has been an appreciable drop in smoking among men, there has been no comparable drop among women. Advertising has exerted a considerable impact in encouraging women to smoke. My staff counted a total of thirty advertisements currently carried in eight leading magazines aimed exclusively at women."

* * *

The Younger, the Greater the Danger

Said Dr. H. N. Colburn, "The younger a person starts to smoke cigarettes, the greater are his chances of dying of some smoking-related disease such as lung cancer, emphysema, or heart and circulatory disease."

* * *

Smokes Like a Chimney

A teen-age boy wrote, "Recently Mom got out of the hospital after a serious case of pneumonia and a heart attack. Mom is coughing her head off this very minute and well she knows why—she smokes like a chimney, against the doctor's order. My sister and I have resolved never to smoke. Seeing Mom cough herself purple in the face and nearly go into convulsions is lesson enough for us!"

Bravo!

* * *

Death in the Air

Nikolai Blokhin, Russian cancer research specialist, warned that lung cancer in nonsmokers can often be traced directly to inhaling cigarette fumes from smokers. "There is a time bomb ticking away in the lungs of children as the result of repeated exposure to smoking parents!"

* * *

"I Object, Your Honor!"

William Talman, who played the perennially losing role of district attorney in the "Perry Mason" television series died in August, 1968, of lung cancer. He smoked three packs of cigarettes a day for more than 30 years, and the doctors were ninety-nine percent sure that was the cause of his death.

Before Talman died, he recorded the following one-minute anti-smoking message which was sent to more than 500 TV stations:

"You know, I don't really mind losing those courtroom battles, but I am in a battle right now I don't want to lose at all because, if I lose it, it means losing my wife and those kids you just met. I've got lung cancer.

"So take some advice about smoking and losing from someone who's been doing both for years. If you haven't smoked, don't start it. If you do smoke, quit. Don't be a loser!"

* * *

No Longer Any Scientific Doubt

In addressing a Rotary Club, Dr. Tom Kirksey, heart and lung surgeon, said, "There is no longer any scientific doubt that smoking cigarettes leads to lung cancer. Since the Surgeon General's conclusive report, tobacco companies have spent huge amounts of money on advertising in efforts to discount it. I am alarmed at the tobacco industry's approach to the present controversy about smoking and its effect on health!"

* * *

Death On Installment Plan

Said the American Cancer Society, "Heavy cigarette smokers forfeit 8.3 years of their lives!"

* * *

Unconvinced

Bert Lawrence, Minister of Health for Ontario, said, "I am in complete agreement with the former health minister in demanding a complete ban on cigarette advertisement."

Then he lit a cigarette and said, "But that's not going to stop *my* smoking!"

CITIZENSHIP—PATRIOTISM

Callousness

Leon Jaworski, who served as a member of President Johnson's Crime Commission, spoke more realistically and prophetically than he realized: "A moral callousness to the preservation of what we now consider to be right and decent, reminiscent of the days of the fall of the Roman Empire, may well follow."

* * *

Will Suddenly Disappear!

General Dwight Eisenhower warned, "Without a moral regeneration throughout the nation, there is no hope for us! We will suddenly disappear in the dust of a terrific atomic explosion!"

* * *

The Diplomat

A diplomat is one who thinks twice before saying nothing.

* * *

Not Basically Different

Though our time is fraught with peril and perplexity, it is not essentially different from the peril of other times.

At Valley Forge, the fate of the nation hung precariously in the balance. A third of Washington's men had deserted. A third had died from malnutrition. The scant third which survived fought valiantly, and the American Revolution was won.

Think what would happen in our nation today if an appreciable number would turn brokenheartedly to God and acknowledge, as did God's dead-in-earnest servant Jehoshaphat long ago, "O our God, wilt thou not judge them? for we have no might against this great company that cometh against us; neither know we what to do: but our eyes are upon thee" (II Chron. 20:12).

Divine Plan

A. J. Toynbee, world renowned historian, said, "History is the masterful and progressive execution of a divine purpose, which is revealed to us in fragmentary glimpses and transcends our human powers of vision and understanding."

We do understand that God is still on the throne, "keeping watch above His own," ruling and overruling and causing all things to work for His glory and for the good of His children.

Long ago a pagan king confessed, "He (God) doeth according to his will in the army of heaven, and among the inhabitants of the earth: and none can stay his hand, or say unto him, What doest thou?" (Dan. 4:35b).

* * *

I, Too, Am Sick

And old-fashioned, patriotic American sounded off as follows:

"There are those who claim ours is a sick society . . . that our country is sick . . . that we are sick. Well, maybe they're right. I submit that I, too, am sick, and maybe you are, too.

"I am sick of having policemen ridiculed and called 'pigs,' while cop-killers are hailed as some kind of folk heroes.

"I am sick of being told that religion is an opiate of the people but that marijuana should be legalized.

"I am sick of commentators and columnists canonizing anarchists, revolutionaries and criminal rapists, but condemning law enforcement when such criminals are brought to justice.

"I am sick of being told that pornography is the right of the press, but freedom of the press does not include being able to read the printed Bible in public schools.

"I am sick of Supreme Court decisions which turn criminals loose on society, while other decisions try to take away means of protecting my home and family.

"I am sick of pot-smoking entertainers

43

deluging me with their condemnation of my moral standards on late night television.

"I am sick of the riots, marches, protests, demonstrations, confrontations, and other mob temper tantrums of people intellectually incapable of working within the system.

"Yes, I may be sick, but if I am sick, I can get well. I can help my country to recover and get well."

Adapted from *The Austin (Texas) American Statesman*

* * *

Righteousness, Not Pride

A gospel soloist from America sang to a British audience the song, *It Took a Miracle.*

A lady in the audience misunderstood the words, "It took a miracle to hang the world in space." She thought the soloist had sung, "It took *America* to hang the world in space."

"Ugh, more Yankee boasting!" she muttered.

It is good to be proud of one's native land, but love for country should never beget a feeling of superiority over other people, and cause one to look upon them with arrogant disdain.

It is righteousness, not pride, that exalts a nation and engenders its perpetuity: "Righteousness exalteth a nation: but sin is a reproach to any people" (Prov. 14:34).

Told by LANDRUM LEAVELL

* * *

Still a Civilization

Said Romain Gary, novelist and former diplomat, "Of the three gigantic world powers, America is the only one capable of a bad conscience. That is why it still is a civilization."

* * *

America for Me

'Tis fine to see the Old World, and travel up and down

Among the famous palaces and cities of renown,
To admire the crumbly castles and statues of the kings,—
But now I think I've had enough of antiquated things.

So it's home again, and home again, America for me!
My heart is turning home again, and there I long to be,
In the land of youth and freedom beyond the ocean bars,
Where the air is full of sunlight and the flag is full of stars.

Oh, London is a man's town, there's power in the air,
And Paris is a woman's town, with flowers in her hair;
And it's sweet to dream in Venice, and it's great to study Rome,
But when it comes to living there is no place like home.

I like the German fir-woods, in green battalions drilled;
I like the gardens of Versailles with flashing fountains filled;
But, oh, to take your hand, my dear, and ramble for a day
In the friendly western woodland where Nature has her way!

I know that Europe's wonderful, yet something seems to lack:
The Past is too much with her, and the people looking back.
But the glory of the present is to make the Future free,—
We love our land for what she is and what she is to be.

Oh, it's home again, and home again, America for me!
I want a ship that's westward bound to plough the rolling sea,
To the blessed Land of Room Enough beyond the ocean bars,
Where the air is full of sunlight and the flag is full of stars!

HENRY VAN DYKE

Here I Stand!

Bill Pierson, a husky football star, recently stood alone for three hours, defending the U.S. flag from 150 campus demonstrators intent on lowering the flag to half-staff in support of their defiant cause.

Since the heroic incident, Pierson has received hundreds of telephone calls, letters, and telegrams commending him for his heroic stand.

In commenting later upon the incident, the 6-foot-10, 250-pound exsailor said, "I am overwhelmed! I was born under that flag. I fought for that flag and what it stands for. I wouldn't have moved if they had moved!"

In giving him a "Citation for Meritorious Service," the American Legion said, "This community, yes, this nation, owes Bill Pierson a debt of deep gratitude!"

* * *

Frightening Statistics

Michael Harrington commented, "The government of the United States has carefully classified and computer-taped all the outrages about which it does so little. The statistics would frighten a Jeremiah. But do they arouse us from our lethargy? Military needs rank above civilian needs; private interests rank above public interests; claims of the affluent outrank those of the poor. Will we settle for a gilded captivity, or will we join the exodus toward new priorities?"

* * *

Scoring a Bull's-eye

How timely are the courageous words of the Reverend R. F. Pynchon of Walla Walla, Washington, given in *The Spokesman-Review!*

"For too many years, we have been forced to listen in impotent silence to the evolutionists, the atheists, the Marxists, and the entire left wing socialists conglomerate.

"We have permitted the neo-moralists to blandly assure us that God was in a jocular mood when He gave His Law to Moses at Sinai. With a minimum of resistance we have allowed the situationists to come in free with their bald assertions that a little adultery could be beneficial if kept within a context of mutual responsibility. The grim lessons of Sodom and Gomorrah are so far away they have faded out of our minds.

"Our freedoms have almost been lost by default as we have stepped deferentially aside and cleared a path for the long hairs, the pot addicts and the acid heads. In shocked silence we have been nonvocal witnesses to the success of the bathless brigades as they stormed and forced the universities to their knees in weak and cowardly submission!"

* * *

A Bellyful

A gracious hostess said to her dinner guest, "Do have some more!"

The guest replied, "I am full up to the neck!"

Said the hostess to the guest's little boy, "Growing boys need a lot of food. Do have some more!"

The boy blurted, "I'm like Mom. I have a bellyful!"

How aptly does the inelegant word *bellyful* describe the fed-up, revulsive feeling that millions of upright, America-loving citizens have toward the demonstrations which are so often infiltrated by America-hating Communists whose avowed purpose is not to redress grievances lawfully, but to enfeeble and destroy our nation.

A heaven-sent spiritual awakening among our people would do infinitely more to heal the hurts of our nation than all the alleged panaceas which fail to reckon with mankind's desperately wicked heart and God's power to change it.

"If my people . . . shall humble themselves, and pray . . . and turn from their wicked ways . . . I . . . will forgive their sin, and heal their land" (II Chron. 7:14).

* * *

Good and Bad Men

A good man on horseback is a better index of progress than a brutal man in a supersonic jet plane.

CITIZENSHIP—PATRIOTISM

A Twofold Relationship

Said Barry M. Kelley, "Christ lived in an occupied country that was under the iron heel of the Romans, who ruled by coercion and armed might. Yet He obediently paid taxes to that power, healed a Roman officer's servant, and enjoined His disciples to go the extra mile with a Roman messenger."

Christ's changeless dictum accurately defines a man's relationship to God and to the country in which he lives: "Render . . . unto Caesar the things which are Caesar's; and unto God the things that are God's" (Matt. 22:21).

* * *

The Little Red Hen

The following caricature of the modern welfare state from the *Saratose Herald-Tribune* is an amusing parody of the well-known story of *The Little Red Hen*.

Once upon a time there was a little red hen which scratched about and uncovered some grains of wheat. She called her barnyard neighbors and said, "If we work together and plant this wheat, we shall have some fine bread to eat. Who will help me plant the wheat?"

"Not I," said the cow.

"Not I," said the duck.

"Not I," said the pig.

"Not I," said the goose.

"Then I will," said the little red hen. And she did.

After the wheat started growing, the ground turned dry and there was no rain in sight.

"Who will help me water the wheat?" said the little red hen.

"Not I," said the cow.

"Not I," said the duck.

"Not I," said the pig.

"Equal rights," said the goose.

"Then I will," said the little red hen. And she did.

The wheat grew tall and ripened into golden grain.

"Who will help me reap the wheat?" asked the little red hen.

"Not I," said the cow.

"Not I," said the duck.

"Out of my classification," said the pig.

"I'd lose my ADC," said the goose.

"Then I will," said the little red hen. And she did.

When it came time to grind the wheat into flour, the little red hen asked, "Who will help me grind the wheat into flour?"

"Not I," said the cow.

"I'd lose my unemployment compensation," said the duck.

When it came time to bake the bread, "That's overtime for me," said the cow.

"I'm a drop-out and never learned how," said the duck.

"I'd lose my welfare benefits," said the pig.

"If I'm the only one helping, that's discrimination," said the goose.

"Then I will," said the little red hen. And she did.

She baked five loaves of fine bread and held them up for her neighbors to see.

"I want some," said the cow.

"I want some," said the duck.

"I want some," said the pig.

"I demand my share," said the goose.

"No," said the little red hen. "I can rest for a while and eat the five loaves myself."

"Excess profits!" cried the cow.

"Capitalistic leech!" screamed the duck.

"Company fink!" grunted the pig.

"Equal rights!" honked the goose.

And they hurriedly painted picket signs and marched around the little red hen, singing, "We shall overcome." And they did.

When the farmer came to investigate the commotion, he said, "You must not be greedy, little red hen. Look at the oppressed now. Look at the disadvantaged duck. Look at the underprivileged pig. Look at the less fortunate goose. You are guilty of making second-class citizens of them!"

"But . . . but . . . but," clucked the little red hen, "I *earned* the bread."

"Exactly," exclaimed the wise farmer. "That is the wonderful free enterprise system! Anybody in the barnyard can earn as much as he wants. You should be happy to have this freedom! In other barnyards, you would have to give all five loaves to the farmer. Here, you give four loaves to your suffering neighbors."

46

And they lived happily ever after, including the little red hen. She smiled and clucked, "I am grateful! I am grateful!"

But her neighbors wondered why she never baked any more bread.

Are we passionately pursuing Pied Piper to the mountain of promise where all men will soon be so equal that, whether or not we "scratch," we all will have as much right as the little red hen to one of her loaves?

* * *

Needed: Paul Reveres

In addressing the Overseas Press Club, Dr. Harry Schwartz, author of *Russia's Soviet Economy,* said, "I often feel that the most important thing one can say in the present situation is that we need a lot of Paul Reveres telling America to wake up! We're in a fight and if we don't wake up we can be licked!"

"Righteousness exalteth a nation: but sin is a reproach to any people" (Prov. 14:34).

* * *

Will Never Forego

Premier Kruschchev affirmed, "We shall never forego our ideological principles. We are waging and shall wage an implacable struggle for the Marxist-Leninist ideology for the triumph of the ideals of communism."

* * *

Home-Grown Barbarians

Perhaps Lord Macaulay, the English historian, essayist, poet and statesman of a century ago, foresaw our day of self-assertive democratic decadence when he wrote of the United States:

"Your republic will be pillaged and ravaged in the twentieth century, just as the Roman Empire was by the barbarians of the fifth century, with this difference: the devastators of the Roman Empire, the Huns and Vandals, came from abroad, while your barbarians will be the people of your own country and the products of your own institutions."

The Prairie Overcomer

Gaining the Moon—Losing the Earth

Apollo 11 aroused awe. Apollo 12 evoked curiosity. Apollo 13 ran into trouble, had to forego a lunar landing, and caused great anxiety. Apollo 14, once it was well on its way, stimulated considerably less interest.

One commentator affirmed that space travel has cost the United States roughly $325 a mile, or a total of $25 billion. Thanks to the Apollo 14 crew—a Bible now reposes on the moon's surface.

The question is pertinent: What is our nation profited if it gains the moon and loses the earth through its failure to meet human need, so alarmingly existent in our near-bankrupt cities and throughout the land?

* * *

You Are Right, Barabbas

The following imaginary conversation between Christ and the scofflaw Barabbas is relevant today and thought-provoking:

"Barabbas, you are right. The Roman system is putrid. It's racist, prejudiced, bigoted, militaristic, materialistic, polytheistic, godless. The system is no good. But, Barabbas, what are you going to change it with? If you burn it down, what are you going to replace it with? Don't you understand, Barabbas, that you're going to replace the putrid Roman system with your own messed-up kind of system and that there is no difference between a corrupt white man and a corrupt black man?

"I have come to create a new kingdom. I've come to start a new race and it's going to be built upon Me, Barabbas. It's going to be built upon the fact that I'm the Christ, the Son of the living God. It's going to be built upon the second Adam, as the leader of a new creation."

Adapted from *Christianity Today*

* * *

Our Only Hope

Said Col. Charles Lindbergh, "Spiritual truth is more essential to a nation than mortar is to its cities' walls. For when the actions of a people are unguided by

47

spiritual truths, it is only a matter of time before the walls themselves collapse. We must draw strength from the almost forgotten virtues of simplicity, humility, contemplation, prayer. It requires a dedication beyond science, beyond self, but the rewards are great and it is our only hope!"

"Righteousness exalteth a nation: but sin is a reproach to any people" (Prov. 14:34).

* * *

A Snicker in Heaven

Once upon a time there was a nation. That nation spent $75 billion each year to defend itself against possible attack; spent $330 million in one year for chemical warfare; spent $14 billion in one year for alcoholic beverages—more than twice as much as it spent for religious and welfare activities. But on every one of these dollars that nation printed "In God We Trust!" And from somewhere in heaven there was heard a snicker!

O God, mercifully help us to undeceive ourselves, lest we perish!

W. E. REES

* * *

An Unashamed Irishman

In a social gathering, attended by representatives of different nations, a Frenchman, an Englishman, and an Irishman were chosen to speak for their respective nations.

The Frenchman spoke of the grandeur of his nation—its scientific achievements, art and architecture. "I am proud to be a Frenchman," he said. "However, if I were not a Frenchman, I would be an Englishman."

The Englishman stood and spoke glowingly of his nation's contribution to literature and its representative form of government.

Not wanting the Frenchman to be more gracious than himself, he concluded by saying, "But if I were not an Englishman, I would want to be a Frenchman."

The Irishman stood and quipped, "If I were not an Irishman, I would be ashamed of it!"

How relatively few Americans prize sufficiently the greatness and grandeur of our nation, with its freedoms and limitless opportunities. The obscurest and poorest may reach the highest pinnacle of greatness and achievement for God and man.

Breathes there a man with soul so dead,
Who never to himself hath said:
"This is my own, my native land!"

* * *

"Save Us from Ourselves"

Some 17 years ago, Conrad Hilton helped produce the following prayer entitled "America on Its Knees":

Our Father in Heaven:

We pray that You save us from ourselves! The world that You have made for us to live in, in peace, we have made into an armed camp. We live in fear of war to come.

We are afraid of "the terror that flies by night, and the arrow that flies by day, the pestilence that walks in darkness and the destruction that wastes at noonday."

We have turned from You to go our selfish way. We have broken Your commandments and denied Your truth. We have left Your altars to serve the false gods of money and pleasure and power. Forgive us and help us.

Now, darkness gathers around us and we are confused in all our counsels. Losing faith in You, we lose faith in ourselves.

Inspire us with wisdom, all of us, of every color, race and creed, to use our wealth, our strength, to help our brother, instead of destroying him.

Help us to do Your will as it is done in Heaven and to be worthy of Your promise of peace on earth. Fill us with new faith, new strength, and new courage, that we may win the battle for peace.

God's ancient promise for our spiritual healing has not been abrogated or rescinded: "If my people . . . shall humble themselves, and pray, and seek my face, and turn from their wicked ways; then

will I hear from heaven, and will forgive their sin, and will heal their land" (II Chron. 7:14).

* * *

Up Not Down

Old Glory—Run it up, not down!

* * *

State of Nervous Collapse

A British writer predicted that by 1972 "the American nation will be in a state of nervous collapse—something like the French in May 1789 but with the illness more deep-seated."

Tom Stacey, writing in London's *Daily Telegraph,* said, "The extremes of right and left are now gathering emotional force like popular opposites . . . In the middle lies the depressiveness; the mania floods from the extremes. In the lumpen middle there is no longer any conviction, courage, hope; no strength or direction at all. What is left of these things in the United States belongs to the extremes!"

How great is our need of God! The only way out is up! The only hope is God! We plead, "O Lord . . . in wrath remember mercy" (Hab. 3:2).

* * *

The Typical American

A UPI survey thus defined the typical American: "He is a twenty-seven-year-old who does not read one book a year. He is materialistic, satisfied with small pleasure, and bored with theological disputations. Although he may attend church twenty-seven times a year, he is not interested in the supernatural. He is not concerned with heaven or hell and has no interest whatever in immortality. His principal interests are football, hunting, fishing and car-tinkering."

* * *

God a Necessity

Said George Washington, "It is impossible to govern the world without God!"

"Except the Lord build the house, they labour in vain that build it: except the Lord keep the city, the watchman waketh but in vain" (Ps. 127:1).

Only in the Lord

Said John Calvin, "We are subject to the men who rule over us, but subject only in the Lord. If they command anything against Him, let us not pay the least regard to it."

The Bible says, "We ought to obey God rather than men" (Acts 5:29).

* * *

Destruction of the U. S. A.

Dr. J. H. Jackson, president of the National Baptist Church, which is comprised of a membership of more than six million Negroes, said that James Forman's *Manifesto* represents "as firm a message for the destruction of the United States of America as has ever been given!"

"If the foundations be destroyed, what can the righteous do?" (Ps. 11:3).

* * *

Helping a Lovely Lady

A little girl named Carol, while crossing New York harbor with her father on a ferryboat, looked in wonder at the Statue of Liberty as it disappeared into the fog and shadows of approaching darkness.

That night, Carol was restless as she lay in bed.

"What's the trouble, honey?" asked Daddy.

"Oh, Daddy," she exclaimed, "I've been thinking about that lovely lady out there in the darkness all alone. She needs someone to help her hold up her lamp in the dark!"

Each American is needed to uphold the cherished and blood-bought freedoms we enjoy and too often accept with a thankless matter-of-factness and deadly indifference.

ALICE M. KNIGHT

* * *

A Falling Nuclear Bomb

Said Orange County (Fla.) Juvenile Court Judge J. Chester Kerr, "The United States is roaring toward an ultimate destiny with the speed of a falling nuclear bomb! The cumulative effect of

49

drugs, alcohol, pornography, lawlessness and godlessness will achieve within this nation what no foe has ever managed to achieve in our history! That's really the hidden message our children are screaming at us via the drop-out process. We so lose ourselves in bickering, that we totally lose sight of the big picture. Some adults I've met in court are very sick people indeed!"

* * *

Faith of Our Fathers

Said J. Edgar Hoover, "The men who laid the foundations and reared the soaring arches of our great nation had a vigorous, indomitable, and all-encompassing faith in God. Faith permeated their thoughts, words and deeds.

Said Thomas Jefferson, "I have sworn upon the altar of God eternal hostility against every form of tyranny over the mind of man."

When the fires of hope flickered to embers, George Washington knelt in the snow at Valley Forge and importuned for divine help.

* * *

We'll Do It Again!

Said Oren Arnold, "America is at the crossroads. Right! But then, she always was, and always will be. There is no greater crisis now than at any other time in her history, but we do have to look ahead and guide her through. We've done it before! We'll do it again!"

* * *

Income Tax Forms

America is the only country in the world where it takes more intelligence to fill out the income tax forms than it takes to earn the income.

* * *

Divinely Guided Leaders

Only a nation with divinely guided leaders can be trusted with guided missiles.

In addressing the House of Commons, Clement Attlee said, "The problem with the world is not the bomb. The problem of the world is man!"

"The Moral in City of Sybaris"

Editorialized *The Austin American*, under the caption "The Moral in City of Sybaris": "An important chapter in archeology could be developing in southern Italy, with the announcement that American and Italian archeologists digging there are convinced they have found the burned ruins of Sybaris.

"Sybaris made its mark in the ancient world as a fun city, a place where pleasure seekers could spend a lifetime devoted to the pursuit of leisure. It was reportedly one of the rules of Sybaris social life that invitations to state affairs had to be sent a year in advance to give the ladies sufficient time to prepare themselves for the festivities.

"Eventually enemies attacked the city and found it soft and unable to defend itself. Sybaris was burned to the ground. Its exact location has been forgotten.

"Ancient history is filled with cities like Sybaris which pursued pleasure so completely they soon lost the ability to defend themselves. If a moral hasn't been learned from these lessons by now, digging up one more ruin will count for little."

In his master book, *The Decline and Fall of the Roman Empire*, Edward Gibbon gave the following reasons for its fall: The rapid increase of divorce; higher and higher taxes and the spending of public money for free bread and circuses for the people; the mad craze for pleasure and sports which became more brutal; and the building of gigantic armaments.

Will America heed history's warning? Shall we go on to disaster, refusing to repent and turn to God for spiritual healing? Multitudes are "lovers of pleasures more than lovers of God" (II Tim. 3:4).

* * *

When Ideals Die

Francois Guizot, the French historian and statesman, asked James Russell Lowell, "How long do you think the American Republic will endure?"

Lowell flashed, "So long as the ideals of its founding fathers continue to be dominant."

Prayer for All in Authority

Many years ago I had occasion to visit the mayor of the city in which I was residing. Before I left, I asked to pray with him. He graciously said, "Certainly." When the prayer was ended, there were tears in his eyes. Later he told one of my deacons, "In twenty-five years in this office, thousands of people have asked me for many things. Your pastor is the *first* *one* to ask if he might pray with me."

I resolved then that I would never visit with one in governmental authority without asking if we might have prayer. This request has never been refused, even by non-Christians. Throughout the world, I have prayed with mayors, councilmen, governors, congressmen, prime ministers, cabinet members, rulers, and with the President of the United States. Greatly do those in governmental authority need the prayers of Christians!

HERSCHEL H. HOBBS

COMMITMENT

Channels Only

After Dr. E. Stanley Jones, a missionary to India, entered into his work, his health began to fail and he had to return to America.

As he sought to regain his health, he wondered what he should do. Then God seemed to say to him, "I want you to return to India and carry to completion the work to which I have called you."

"But, Lord, I am not able to do it. My strength has failed," he said.

The Lord said to him, "I don't want you to do it. I only want you to be available to Me. I will do the work through you!"

Stanley Jones returned to India; and, for twenty years, God worked through him as he told benighted ones of the saving and sanctifying power of the mighty Saviour.

God's children are conduits through which the water of life flows to sin-seared, spiritually thirsty souls.

Told by RALPH M. SMITH

* * *

"Lord, What's Wrong?"

Said Wallace E. Johnson, one of America's most successful builders, "I once heard a philosopher say something to this effect: 'The man who asks God to help him in his business is praying wrong. He is simply trying to use God for his own profit.'

"If this is true, then I have been praying wrong for a long time. For it is my practice to take everything to the Lord in prayer—problems concerning my health, family, friends, church and the $4,000,000 loan I need to construct a new housing development. I admit quite openly that I am totally dependent on God for help in everything I do. If I kept Him out of my business I honestly believe it would start to fall apart in a matter of months.

"Some will surely say, 'It is all right to include your business in your prayers, but you shouldn't pray for financial success.' When I surrendered my life to Jesus Christ some years ago, I turned everything over to Him: money, possessions, goals, dreams, business. Any success I have achieved since is the Lord's success. All money earned is His money. How can I separate the different areas of my life and pray for some and not the others? I haven't always felt this way, however. The turning point in my life came in 1939 when I was a building supplies salesman earning $37.50 a week. I was frustrated and discouraged. Nothing seemed to go right.

"One night I prayed more specifically, 'Lord, I've tried to make a go of it as a salesman, but I am not doing very well. What have I been doing wrong? Show me, Lord, the direction I should go, the people I should see.' From that moment I ceased trying to accomplish everything

51

with my own resources. Things were different. Names of people I should see and places I should go popped into my mind. Where did these suggestions come but from God?"

* * *

A Give-and-Take World

We live in a give-and-take world. Few Christians, however, are willing to give what it takes to fully follow Christ—total dedication. They fail to say with Paul: "I count all things but loss for Christ . . . for whom I have suffered the loss of all things, and do count them but dung" (Phil. 3:8).

* * *

"Take Myself—Give Me Thyself"

Pleaded Nicholas of Flüe, Swiss holy hermit, "O Lord, take from me what keeps me from Thee; give me what brings me to Thee; and take myself and give me Thyself!"

"I seek not yours, but you" (II Cor. 12:14).

* * *

Total Dedication

A beginning Christian asked A. W. Tozer, "What does it mean to be crucified with Christ?"

Dr. Tozer replied, "To be crucified with Christ means three things. First, the man on the cross faces in only one direction: 'I press toward the mark for the prize of the high calling of God in Christ Jesus' (Phil. 3:14).

"Secondly, it means not going back: 'If any man draw back, my soul shall have no pleasure in him' (Heb. 10:38).

"Thirdly, it means ceasing to have personal plans, and living only to bring glory to Christ: 'Lord, what wilt thou have me to do?' (Acts 9:6); 'Christ shall be magnified in my body, whether it be by life or by death' (Phil. 1:20b)."

Spiritual life begins in full-orbed blessedness when we say, "I am crucified with Christ: nevertheless I live; yet not I, but Christ liveth in me" (Gal. 2:20).

Thy Humble Slaves

Raymond Lully, fourteenth century missionary martyr, had unfeigned love for the Muslims of North Africa and a burning zeal for their souls. In his prayer of dedication, he said, "To Thee, Lord God, do I now offer myself and my wife and my children and all that I possess! Since I approach Thee humbly with these gifts, may it please Thee to condescend to accept all that I give and offer up now for Thee, that I and my wife and my children may be Thy humble slaves!"

"I seek not yours, but you" (II Cor. 12:14).

* * *

"I Have No Silver or Gold"

Deeply burdened for unsaved ones in the vast stretches of earth where Christ was unknown, Alexander Duff prayed thus: "O Lord, Thou knowest that I have no silver or gold to give to this cause. What I have I give unto Thee. I offer Thee myself. Wilt thou accept the gift?"

"And this they did . . . (they) first gave their own selves to the Lord, and unto us by the will of God" (II Cor. 8:5).

* * *

"To Make Them Thine"

Tennyson said, "Our wills are ours, we know not how. Our wills are ours, to make them Thine."

On the last day of his life David Livingstone wrote in his diary, "My Jesus, my King, my life, My All, I again dedicate my whole self to Thee."

Spiritual life begins in full-orbed blessedness when we say:

"Take my life and let it be
Consecrated, Lord, to Thee."

F. R. Havergal

* * *

Now Is the Time To Move

After visiting Nigeria, Stanley Burke returned to Canada and resigned his $30,000-a-year position as announcer on the CBS national television news to devote his time to help bring to an end Nigerian civil war which was then raging.

Burke said, "I have the profound conviction that . . . if enough people are willing to make a commitment, we can end this nightmare. More than a million Biafrans have already died and another million live under an almost certain sentence of death!"

Myriads in Nigeria and Biafra "sit in the darkness and in the shadow of (spiritual) death" (Luke 1:79).

How different it would be today with nations around the world if Christ's church, since its beginning, had been totally committed to carrying out His directive, "Go ye into all the world, and preach the gospel to every creature" (Mark 16:15).

* * *

Only Thee

Oh hide this self from me, that I
No more, but Christ in me, may live!
My vile affections crucify,
Nor let one darling lust survive.
In all things nothing may I see,
Nothing desire or seek, but Thee!

GERHARD TERSTEEGEN

* * *

Make Me Thy Fuel

Jim Elliott, one of four missionaries murdered by the Auca Indians in 1956, wrote in his diary: "He makes His ministers to be a flame of fire. Am I ignitable? Deliver me from the dread asbestos of other things. Saturate me with the oil of Thy Spirit that I may be a flame. But flame is transient—often short-lived. Canst thou hear this, O my soul? Short life? But in me there dwells the Spirit of the great Short-Lived, the One whose zeal for His Father's house consumed Him. Make me Thy fuel, O flame of God!"

* * *

What Can I Give Him?

Millions of Americans have reacted with mixed emotions to the advertisement of a finger-pointing Uncle Sam who says: "I want *you*: U.S. Army."

To each one of His children, God pointedly says, "I seek not yours, but *you*" (II Cor. 12:14).

The gift of yourself is the gift God wants most: "And this they did . . . (they) first gave their own selves to the Lord, and unto us by the will of God" (II Cor. 8:5).

* * *

No Tengo Mas Que Darte

A most fascinating and intriguing story is told by Robert Stenuit (*National Geographic*, June 1969) of a ring that he recovered from the sea off the rugged coast of northern Ireland.

The Spanish galleass *Girona* was a forlorn survivor of the so-called Invincible Armada, which Spain sent against England in 1588 and which was destroyed by the English Navy and by storms.

When the *Girona*, with its 1,300 passengers and crew sailed for refuge in Scotland, a young nobleman was among them. He wore a betrothal ring, given to him on the eve of his departure from Spain by his young lover. It was a symbol of the gift of herself to him.

The *Girona* never reached Scotland. Caught in the jaws of a raging storm, it was dashed to pieces on the jagged rocks off the coast of Ireland. All aboard, except five men, perished, including the young nobleman.

Centuries later, Robert Stenuit located the site of the wreck. He and four companions began to search the ocean bed for relics of the *Girona*. The engagement ring was found in a cranny!

"Safe aboard our boat," said Stenuit, "it glowed softly in the pale Irish sun. Carved upon it was a tiny outstretched hand and these words: *'No tengo mas que darte'*—'I have nothing more to give!'"

The gift which God most desires from each one of His children is the gift of self: "I seek not yours, but you" (II Cor. 12:14).

53

COMMUNISM

Gun-Barrel Diplomacy

In his *Little Red Book*, Mao Tse-tung affirmed, "A revolution is an insurrection, an act of violence by which one class overthrows another. . . . Every Communist must grasp the truth that political power grows out of the barrel of a gun. . . . War is the highest form of struggle for resolving contradictions. According to the Marxist theory of the state, the army is the chief component of state power . . .

"Yes, we are advocates of the omnipotence of revolutionary war. That is good, not bad. It is Marxist that only with guns can the whole world be transformed . . .

"People of the world, unite and defeat the United States . . . and all their running dogs! People of the world, defy difficulties and advance wave upon wave. Then the whole world will belong to the people!"

* * *

An Enigma

Sir Winston Churchill described the Soviet Union thus: "A riddle wrapped in a mystery within an enigma."

* * *

Other Than Military Means

Some years ago Max Eastman wrote, "To Communists, what we call peace is merely war conducted by other than military means. To them war, whether fought with military hardware or with nonviolent, political and psychological instruments, is a simple thing. 'Hot' and 'cold' are simply phases of the intensity of the same war."

* * *

Down with Love!

Anatole Lunarcharsky, former Russian Commissar of Education, said, "We hate Christians and Christianity. The best of them must be considered our worst enemies. They preach love of one's neighbor and mercy, which is contrary to our principles. Christian love is an obstacle to the development of the world revolution. Down with love! What we want is hate. Only then can we conquer the universe."

* * *

Not Moved by Morality

Dean Acheson, the former Secretary of State who had more confrontations with the Soviet Union than any other man, declared, "The Soviets are not moved by argument, nor by exhortation, nor by considerations of morality. They are moved only when their calculations lead them to believe that it is more advantageous to make a deal than not to do so."

* * *

A Worldwide Vacuum

Said Dr. Arthur F. Glasser, dean of the Fuller Theological Seminary School of World Mission and former home director of the Overseas Missionary Fellowship, "I believe that increasingly there is going to be a worldwide vacuum within the Communist world. In Communist Russia, there is far more neglect of the great Communist texts, far more cynicism, far more frustration on the part of intellectuals than elsewhere. Communism does not have the answer for alienation, finitude, restlessness. The longer the Communist movement is in the world, the greater will be the spiritual hunger of the world, because Communism does not have the answers."

How spiritually thirsty and starved are those who spurn the invitation of the Saviour: "If any man thirst, let him come unto me, and drink" (John 7:37b).

"I heard the voice of Jesus say,
　'Behold I freely give
　The living water, thirsty one,
　　Stoop down and drink and live!' "

H. BONAR

CONVERSION

"I Really Got Mad"

In telling of his conversion, Jack Wyrtzen, founder of Word of Life Camps, testified, "A friend invited me to go to a meeting with him. Dr. Brower spoke on hellfire and damnation. He made me very, very uncomfortable. When, at the end of the meeting, the minister asked those who repented of sin to come forward. I really got mad and ducked out.

"At home that night, I couldn't sleep. I kept thinking about what the preacher said. Finally, in the middle of the night, I got on my knees and confessed my rebellion to God. Then I asked the Lord to forgive me and save me.

"The next morning, I called my friend and said, 'George, I got converted!'

"'You got what?' he asked.

"'I got converted,' I reiterated.

"Then George exclaimed, 'Wyrtzen, you're the last guy in the world I would have ever thought would get converted!'"

* * *

Evidence

After living for years in spiritual darkness, the artist Camillo painted a picture of Christ, called "The Man of Sorrows."

Each time Camillo looked at the painting the sorrowful penetrating eyes of Jesus distressed him. They seemed to say, "Make reparation to those whom you have wronged. Buy back your salacious paintings and destroy them."

Sometime later, Camillo penitently confessed his sins to Christ and sought to undo the evil he had done.

A sure indication of the genuineness of one's conversion is the willingness to make amends for past wrongs: "Behold, Lord, the half of my goods I give to the poor; and if I have taken any thing from any man by false accusation, I restore him fourfold" (Luke 19:8).

* * *

When Human Argument Failed

Said Billy Graham, "In August of 1949 I was so filled with doubts about every-thing that when I stood to preach and made a statement, I would say to myself: *I wonder if that is the truth. I wonder if I can really say that sincerely.* My ministry had gone.

"Then I took the Bible up into the high Sierra Nevada mountains in California. I opened it and got on my knees. I pled, 'Father, I cannot understand many things in this Book. I cannot come intellectually all the way, but I accept it by faith to be the authoritative, inspired Word of the living God!'

"A month later in Los Angeles I found that this Book had become a sword in my hand. Where human argument had failed, the Word of God did its work."

* * *

"Since Jesus Came Into My Heart!"

Leighton Ford said, "We need a great spiritual awakening that will cause men to sing:

'I have light in my soul for which
 long I had sought,
 Since Jesus came into my heart!
I have concern for the poor as I
 didn't before,
 Since Jesus came into my heart!
I have love for all mankind as I
 didn't have before,
 Since Jesus came into my heart!
I have wept for our cities as I didn't
 before,
 Since Jesus came into my heart!' "

"Therefore if any man be in Christ, he is a new creature: old things are passed away; behold, all things are become new" (II Cor. 5:17).

* * *

Spitites, Clayites, Touchites

Illustrative of the trivial quibblings which divide God's children, a make-believe story tells about a heated argument between three men to whom Christ gave sight.

One said, "The Saviour spit on my eyes, and my sight was restored, and I

'saw every man clearly' " (Mark 8:25b).

The second man said, "That wasn't the way the Lord gave me sight. He 'spat on the ground, and made clay of the spittle, and he anointed (my) eyes with the clay' (John 9:6)."

The third man said, 'The Lord touched my eyes, and said, 'According to your faith be it unto you' (Matt. 9:29). Instantly I received my sight!"

Because the Lord used different methods in giving sight to the three blind men, three sectarian groups emerged: The Spitites, the Clayites and the Touchites!

In imparting His healing and salvation, the Saviour is not slavishly committed to any stereotyped method. People differ temperamentally and emotionally.

Lydia's heart turned to Christ as quietly as the sunflower turns its face to the rising sun. Paul's conversion was catastrophic. Two factors, however, enter into the conversion of each one: "repentance toward God, and faith toward our Lord Jesus Christ" (Acts 20:21).

Told by RALPH M. SMITH

* * *

John Wesley's Conversion

Years ago, a ship bound for America was caught in the jaws of a mighty storm in mid-Atlantic. The voyagers were filled with fear. It seemed certain that all would go down into a watery grave.

Aboard the ship was a young minister, John Wesley, enroute to Georgia to convert the Indians.

As the storm raged in its fury, Wesley observed that a small group of Moravian missionaries appeared calm and confident, having no fear. He said to them, "Are you not afraid? Our lives are in grave peril!"

Calmly they replied, "We have no fear whatever. Our lives are hid with Christ in God. He is our Saviour and nothing will ever separate us from Him!"

One of them asked Wesley, "Do *you* know Christ as your personal Saviour?"

Wesley replied, "I fear that I do not."

Later he had a vital, experiential confrontation with Christ. Then he said, "Think of it! I was going to Georgia to convert the Indians when I myself was not converted!"

After preaching to the Indians, John Wesley returned to England and began to proclaim the transforming Gospel of Christ. Revival fires began to glow throughout England.

Told by RALPH M. SMITH

COOPERATION

A Blend of Brotherhood

The mosaic sidewalks of Rio de Janeiro, one of the most beautiful cities in the world, greatly impress visitors. The sidewalks are paved with stones of variegated colors. When visitors look closely, they see different shapes and colors of individual stones. As they look farther away, they observe that the separate stones blend into one spectacular geometrical pattern.

What a lovely and invincible geometrical pattern do God's children make when each individual "living stone" blends with others, united in heart and hand!

Of God's children long ago it was said, "So all the men of Israel were gathered against the city, knit together as one man" (Judges 20:11). In such a stance, Christians are invincible.

* * *

God and You

A minister said to a farmer who had converted a veritable rock pile into a crop-producing farm, "God and you are getting along very well here!"

"Yes," the farmer replied, "but you should have seen the place when God was handling it alone!"

God likes to use human instruments to perform His work on earth: "For we are labourers together with God" (I Cor. 3:9a).

Needed: Our Hands

Said George Eliot. " 'Tis God's skill, but it needs our hands."

* * *

Getting Nowhere Fast

How attention-holding is a fable tinctured with humor! In addressing the Texas Baptist Evangelism Conference, the Reverend Carlos McLeod used this one:

"One day a lifesaver heard a woman's frantic cry, 'Help! Help! Help!'

"Swimming out to the thrashing figure, he grabbed her by the leg. On reaching shore, he saw that he had brought in a cork leg. He swam out again and grabbed the woman by the arm. Back on the shore, he found that he had brought to safety an artificial arm.

"Swimming to the woman a third time, he grabbed her by the hair. Seeing that he was holding a wig in his hand, the would-be rescuer said, 'Woman, if you want to be saved from drowning, you had better begin to cooperate with me!' "

We get nowhere fast when we detach ourselves from others and fail to unite heart and hand in cooperative teamwork.

COURAGE

One and God

A contemporary of Martin Luther said, "The whole world is against you, Martin."

The intrepid reformer said, "Then it is God and Luther against the whole world!"

Long ago, as the apostle Paul stood almost alone against a pagan world, he asked, "If God be for us, who can be against us?" (Rom. 8:31).

One and God constitute a majority.

* * *

Why They Loved Him

Halford E. Lucock said, "We are tempted to make adjustments where a Christian has no right to get adjusted. It is said of a statesman, 'They loved him for the enemies he made!' "

* * *

Serenity . . . Courage . . . Wisdom

Reinhold Niebuhr, theologian and philosopher, prayed, "God grant me the serenity to accept things I cannot change, courage to change things I can, and wisdom to know the difference."

* * *

We Are Going to Conquer You!

In 1942 George Leigh Mallory and a party of Englishmen attempted to scale Mount Everest. After enduring incredible hardships, they reached a base camp at 25,000 feet. From this point two of them set out for the summit, but their heroic attempt failed. Today Mallory and his companion, Irvine, lie buried under the eternal snows of that Himalayan peak. Their colleagues returned to England to tell their story. One of them addressed a large London audience. He stood before an enlarged photograph of Mount Everest. After he had described the difficulties and tragedies of their expedition, the man turned and addressed the mountain.

"Everest," he said, "we tried to conquer you once, but you overpowered us. We tried to conquer you a second time and again you were too much for us. But Everest, I want you to know that we are going to conquer you, for you can't grow any bigger, but we can!"

Endued with power from on high, God's children can triumph over humanly impossible difficulties, "more than conquerors through him that loved (them)" (Rom. 8:37).

Told by J. ALLAN PETERSEN

* * *

"Tossed To and Fro"

Carl Sandburg told of a chameleon which became famous by adjusting moment by moment to his environment until it crawled across a piece of Scotch plaid. There it died of frustration trying to adapt itself to the varicolored plaid!

How like that chameleon are compromising Christians who lack the courage

to remain unchanged by the changing currents which swirl about them and are "tossed to and fro, and carried about with every wind of doctrine, by the sleight of men, and cunning craftiness" (Eph. 4:14).

* * *

The Standing Army

Henry Van Dyke said, "Courage is the standing army of the soul which keeps it from conquest, pillage and slavery."

* * *

Not Appropriate for the Elite

In preaching to an audience of courtiers and noblemen, John Wesley used the text, "O generation of vipers, who hath warned you to flee from the wrath to come?" (Matt. 3:7).

At the close of the service, a friend reprimanded him for speaking so bluntly to the elite group. "That sermon would have been quite appropriate for the down-and-outers," he said.

"No," said Wesley. "If I had been speaking to them, my text would have been, 'Behold the Lamb of God, which taketh away the sin of the world'" (John 1:29).

Both the wealthy sinner and the poverty-stricken sinner need God's mercy and forgiveness.

* * *

The Greater Challenge

The Matterhorn has been called a killer. Though hazardous to mountainclimbers, courageous ones still climb it.

In a little graveyard in Zermatt lie the bodies of men who forfeited their lives in their effort to scale the forbidding peak.

Ice axes which no one disturbs lie on the graves of some.

A shaft of black marble commemorates three young Oxford students who some years ago started climbing and died together on the great mountain. An inscription on the memorial reads: "We who lie here scorned the lesser peaks!"

They chose a greater challenge, though they knew it might cost them their lives.

Brave and Composed He Died

The camp doctor who saw Bonhoeffer executed by the Nazis wrote:

"Through the half-open door in one of the huts, I saw Bonhoeffer kneeling on the floor praying fervently to his God. I was deeply moved by the way this lovable man prayed, so devout and so certain God would hear his prayer. At the place of execution he again said a short prayer and climbed the steps of the gallows, brave and composed!"

* * *

"If I Knew"

Martin Luther said, "If I knew the world would come to an end tomorrow, I'd plant my apple seed today."

The Bible says, "He that observeth the wind shall not sow; and he that regardeth the clouds shall not reap" (Eccl. 11:4).

* * *

A One-way Mission

On April 18, 1952, Col. Jimmy Doolittle led a flight of sixteen B-25's from the deck of the carrier *Hornet* for the first air raid on the Japanese mainland. Each plane carried a crew of five men, eighty men in all. The remarkable thing about this air raid was that each man was a volunteer and had been told that there would be no place to which to return. It was a one-way mission and they were told they would have to crash land on either the Japanese mainland or at sea!

LANDRUM P. LEVELL

* * *

Regardless of Consequences

Said Sherwood Eddy, "Faith is not trying to believe something regardless of the evidence. It is daring to do right regardless of the consequences."

* * *

So Much to So Few

In his tribute to the British pilots who turned back Germany's Luftwaffe during the Battle of Britain in 1940, Sir Winston Churchill said, "Never in the course of human conflict has so much been owed by so many to so few!"

How great is our debt to the heroes of the faith throughout the centuries. Many of them "sealed with their blood the testimony of their lips."

* * *

A Disastrous Cul-De-Sac

Sir Malcolm Muggeridge resigned as rector of Edinburgh University because of his disagreement with the Student's Representative Council. The students demanded that contraceptive pills be made available to students on request.

Said Sir Malcolm, "The so-called permissive morality of our time will, I am sure, reach its apogee. When birth pills are handed out with free orange juice and consenting adults wear special ties and blazers, when abortion and divorce are freely available, then at last, with the suicide rate up to Scandinavian proportions and the psychiatric wards bursting at the seams, it will be realized that this path is a disastrous cul-de-sac."

Adapted from *The Christian*

* * *

Tragic Apathy

Said Martin Luther King, "It may well be that the greatest tragedy of this period of social transgression is not the noisiness of the so-called bad people, but the appalling silence of the good people. It may be that our generation may have to report not only the diabolical actions and vitriolic words of the children of darkness, but also the crippling fears and tragic apathy of the children of light."

Said Edmund Burke, British states-man, "The only thing necessary for the triumph of evil is for good men to do nothing."

* * *

London in Hearts of People

Arrogant Adolph Hitler boasted when his Luftwaffe rained death and destruction upon London, "I will bomb the world into submission!"

Walking 'midst the rubble of demolished buildings, Sir Winston Churchill courageously said, "They have bombed the heart out of London, but they cannot bomb London out of the hearts of the people!"

"Be strong and of good courage" (Josh. 1:6a).

* * *

Bravo!

The adult Bible class of Union Church in Guatemala City met to decide whether to study the Bible during class sessions or to discuss politics, world conditions, and social reform.

Ambassador Mein, a Christlike, humble Christian, was the first to speak. He said, "I come to Sunday school to study the Bible."

No one else spoke. What the ambassador said, backed by his exemplary Christian life, settled peaceably a question which could have occasioned divisive discussion.

We can say of the greatly loved and respected assassinated ambassador, "He being dead yet speaketh'" (Heb. 11:4b).

Told by ALICE M. BRAWAND
Wycliffe Bible Translator

CROSS, THE

The World's Costliest Bridge

How interesting are some of the famous bridges!

At a cost of $7 million, London Bridge was disassembled, stone by stone, into 10,246 numbered pieces, moved from its original site on the Thames and transported to Lake Havasu City, Arizona, where it was reassembled.

The Golden Gate Bridge, spanning the entrance of San Francisco Bay, was built at a cost of $35 million. It has a span of 4,200 feet between its main towers.

The San Francisco-Oakland Bay or Transway Bridge is the world's longest. With its approaches it is eight and one-fourth miles long. It cost $77,200,000.

The George Washington Memorial

Bridge is the third greatest suspension bridge. It spans the Hudson River between New York City and Fort Lee, N. J. It was opened in 1931 and cost $60,000,000.

The world's costliest bridge was not composed of steel and cement, but of the flesh and blood of the Saviour. In His atoning death, Jesus Christ spanned the great gulf between sinful mankind and God's mercy and forgiveness!

> *O the love that drew salvation's plan!*
> *O the grace that brought it down to man!*
> *O the mighty gulf that God did span*
> *At Calvary!*
>
> W. R. NEWELL

The Bible says, "For ye know the grace of our Lord Jesus Christ, that, though he was rich, yet for your sakes he became poor, that ye through his poverty might be rich" (II Cor. 8:9).

* * *

Death's Shadow

In the Birmingham City Museum and Art Gallery hangs William Holman Hunt's famous picture "The Shadow of Death." The artist shows Jesus as a youth in Joseph's shop just as the sun, sinking in the western sky, sends its slanting rays through the open door. Jesus has risen from work and is stretching out His tired arms. As He does this, the rays of the setting sun throw His shadow on the wall behind Him so as to suggest a man on a cross.

This picture implies the truth that Christ lived all of His life in the shadow of the cross, knowing that the cross embodied God's will in His life: "Now is my soul troubled, and what shall I say? Father, save me from this hour: but for this cause came I unto this hour" (John 12: 27).

ALICE MARIE KNIGHT

What's Ahead?

Dr. Wilbur Smith was asked, "What do you see ahead for evangelical Christianity?"

Smith replied, "I am not a prophet, but if we lose confidence in the Scriptures, evangelicalism is going to decline. If there is a rebirth of confidence in the Scriptures, then the evangelical cause will flourish again. I don't think there is any other way to be reconciled to God than through the blood of the cross. I am disturbed by new versions of the Bible that substitute the words 'death of Christ' for 'blood of Christ' in a number of places. This is tampering with very important terms, and it is all wrong."

* * *

No Other Way

In Dallas, a little boy became lost. Frightened and confused, he could tell the officer little or nothing about where he lived. In an effort to get some inkling about the boy's home, the officer asked, "Is there anything you can tell me that will help us find your home?" Pointing to a distant towering cross atop a church, the boy replied, "If you will take me to the cross, I can find my way home."

Long ago Christ died on the cross a vicarious death for the sin of mankind. All who enter the eternal home, heaven, must needs go by way of the cross.

Told by RALPH M. SMITH

> *I must needs go home by the way of the cross,*
> *There's no other way but this;*
> *I shall ne'er get sight of the Gates of Light,*
> *If the way of the cross I miss.*
>
> JESSE BROWN POUNDS

* * *

Made a Curse

The cross was the lowest plane of shame and of indescribable suffering: "Christ hath redeemed us from the curse of the law, being made a curse for us: for it is written, Cursed is every one that hangeth on a tree" (Gal. 3:13).

60

Amen! Amen! Amen!

As the life of Daniel Webster was ebbing to its close, the attending physician asked, "May I quote the verse of a great hymn to you?"

"Do," feebly said the dying statesman. The physician recited with feeling:

"There is a fountain filled with blood
Drawn from Immanuel's veins;
And sinners, plunged beneath that
flood,
Lose all their guilty stains!"

As he concluded the stanza, Webster exclaimed, "Amen! Amen! Amen!"

Though the preaching of the cross is "unto the Jews a stumblingblock, and unto the Greeks foolishness" (I Cor. 1:23), all who have experienced its heart-transforming and character-ennobling power can exclaim:

When I survey the wondrous cross,
On which the Prince of glory died,
My richest gain I count but loss,
And pour contempt on all my pride.

ISAAC WATTS

* * *

The Christian

Paul Warren Allen said, "The Christian who considers himself to be crucified with Christ has no ambitions—so nothing to be jealous about; has no reputation—so nothing to fight about; has no possessions—therefore nothing to worry about; has no rights—therefore cannot suffer wrong; is already dead—so no one can kill him!"

Jesus, I my cross have taken,
All to leave and follow Thee;

.

Perish every fond ambition,
All I've sought, and hoped, and known;
Yet how rich is my condition,
God and heaven are still my own!

HENRY F. LYTE

I Believe It!

A self-righteous woman said to Dr. Harry A. Ironside, "I don't believe in forgiveness of sin through the blood of Christ."

Dr. Ironside replied, "I believe it with all my heart. I believe, as the Bible says, 'But he was wounded for our transgressions, he was bruised for our iniquities' (Isa. 53:5a). The world needs cleansing. It is morally and spiritually defiled. Long ago God's prophet said, 'In that day there shall be a fountain opened . . . for sin and uncleanness' (Zech. 13:1). The world needs the transforming power of the cross."

* * *

The Price of World Revolution

Billy Graham said, "Some time ago millions of young Chinese Red Guards were marching through the streets of Peking, chanting the words, 'Without the shedding of blood, there will be no revolution!'

"This seems to be the belief of the Communists. When I was in Moscow some years ago, I asked the Intourist guide who was showing us around, 'What does the five-pointed star in your flag signify?'

"She replied, 'The five points stand for the five continents of the world. The red represents the blood that will have to be shed to bring the revolution to the world!' "

The shedding of the blood of the sinless Son of God was necessary to redeem man from sin and eternal death: "Ye were not redeemed with corruptible things . . . but with the precious blood of Christ" (I Pet. 1:18, 19a).

* * *

Heel Bone and Rusty Nail

When man devised crucifixion as a means of execution, man's inhumanity to man sank to a new and lower depth of cruelty. The Romans learned it from the Carthaginians. Part of the punishment was the burden of bearing the cross to

61

the scene of execution. The ordeal was so great and exhaustive that another had to "bear his (Jesus') cross" (Mark 15: 21). The arms of the crucified were nailed to the crossbeam, not through the palms but through the wrist bones. Often there was a block of wood to support the body and another to support the feet.

In 1968, as workmen bulldozed a rocky hillside in Jerusalem, they turned up an ossuary wherein reposed thirty-five human skeletons. One skeleton had a rusty seven-inch nail piercing a heel bone.

Israeli scholars studied that find and concluded that it was the skeleton of a young man who was crucified between A.D. 7 and A.D. 70.

Time commented, "What they uncovered and authenticated is the first firm physical evidence of an actual crucifixion in the ancient Mediterranean world."

Of Christ, who was crucified for our sins, the Bible says, "He is not here (in the grave): for he is risen as he said" (Matt. 28:6).

* * *

A Self-Deluded One

Sometime ago Brother Andrew began a self-appointed, wearisome trek. He left Key Largo, Florida, to walk to Maine, pulling behind him a seventy-five pound wooden cross mounted on wheels. Self-deluded, he believed he was obeying the command of the Saviour, "If any man will come after me, let him deny himself, and take up his cross, and follow me" (Matt. 16:24).

The irony of this exhibition was the fact that Brother Andrew had a wife and five children who were on public relief in Maine. If he had really wanted to obey Jesus, he would have been at home working and providing the necessities of his wife and children. God's Word says, "But if any provide not for his own, and specially for those of his own house, he hath denied the faith and is worse than an infidel" (I Tim. 5:8).

Told by JAMES PLEITZ

Still An Offense

Centuries ago an English soldier was taken prisoner in a Moslem country. In prison, he sketched various designs on paper. His guards were impressed by his skill. The soldier was promised his freedom if he would sketch a mosque, and he began to make a blueprint of a majestic mosque. Upon its completion, his captors were greatly pleased.

Before the soldier's liberation, however, it was detected that he had cleverly fitted into the design of the mosque the shape of a cross—a symbol hated by Moslems. Displeased and angry, his captors put him to death!

The cross is an offense to those who reject its message and refuse to believe that "without shedding of blood is no remission" (Heb. 9:22).

Told by T. B. RENDALL

* * *

Christ Died for Me

A news reporter, sitting with other journalists in the editorial office, spoke thus of Billy Graham: "The evangelist said that Christ died for sinners. Why, he said that Christ died for *me*! The moment he said that, light went on in my soul and mind. At that very moment, I was converted, as the wondrous truth gripped my soul!"

* * *

Nothing Else Is Sufficient

After hearing a sermon on the vicarious death of Christ, an unbeliever asked the minister, "Do you really believe that the death of Christ some two thousand years ago can be a substitute for the punishment of my sin?"

The minister answered wisely, "I hope so, because if it does not, nothing else is sufficient."

The atoning death of the Saviour is sufficient for all, deficient for none, but efficient only for those who believe.

"Unto you . . . which believe he is precious" (I Pet. 2:7a).

Not an Afterthought

Said Dr. William Culbertson, "Calvary was not God's afterthought. It was His forethought. Calvary was not optional in God's plan. It was obligatory: 'Ought not Christ to have suffered these things, and to enter into his glory?'" (Luke 24:26).

Peter said, "Ye were . . . redeemed . . . with the precious blood of Christ . . . Who verily was foreordained before the foundation of the world" (I Pet. 1:18, 19).

DEATH

Never Alone

Herbert A. Wirth, 73, had no known relatives, so he had prepaid his funeral expenses. Recently he died unexpectedly.

In life, Herbert feared that no one would be present at his funeral, though for some 25 years he had met thousands of persons as he walked through the streets of Indianapolis, selling pot holders, washclothes, shoe laces and other small items.

A news dispatch told about Herbert's fear. That brought response! More than a thousand men and women walked through a snow-covered Indianapolis cemetery to attend the graveside rites of the door-to-door peddler who once feared that he would be forgotten.

In his remarks in the cemetery Presbyterian Minister Gerald Johnson said, "In this large and sometimes cold and uncaring world, how gratifying it is to observe this outpouring of affection!"

In death, God's children need not fear that they will be alone. The Bible says, "Yea, though I walk through the valley of the shadow of death, I will fear no evil: for thou art with me" (Ps. 23:4).

* * *

"Bury Me If You Can Catch Me!"

Before Socrates drank the lethal hemlock, a friend asked him, "Where do you want to be buried, Socrates?"

Socrates quipped, "Bury me if you can catch me!"

* * *

A Trapdoor into Nothingness

A lawyer, who was an agnostic and a man of wealth, supervised the building of his own mausoleum before his death. On the beautiful marble structure the following lines were carved at his direction: "Is there beyond this silent night an endless day? Is death a door that leads to light? We cannot say. The tongueless secret is locked in fate. We do not know. We hope and wait."

Long ago Job asked, "If a man die, shall he live again?" (Job 14:14). How fear-allaying is his answer to this ancient question: "For I know that my Redeemer liveth, and that he shall stand in the latter day upon the earth . . . In my flesh shall I see God" (19:25, 26b).

If Christ had not triumphed over the tomb, death would be a trapdoor into nothingness. Because He lives, God's children will live eternally with Him! Hallelujah!

* * *

Made for Immortality

President Abraham Lincoln said, "Surely God would not have created man with an ability to grasp the Infinite to exist only for a day. No, no, man was made for immortality!"

As God's children come up to the opal gates of death, they can confidently exclaim, "For we know that if our earthly house of this tabernacle were dissolved, we have a building of God, an house not made with hands, eternal in the heavens" (II Cor. 5:1).

* * *

Miserable Joy

Dr. Walter Alvarez, a member of the staff of Mayo Clinic, said, "When a man or woman looks me in the eye and asks, 'What did you find?' I feel morally and

legally bound to tell the truth. I have known old men, on being called back to life after a coma that looked almost like death, to be distressed to think that they would have to go through the miserable joy of dying all over again."

God has an appointed time to promote his children from earth to glory: "It is appointed unto men once to die" (Heb. 9:27a).

In death, the believer is ushered instantly into the presence of his Lord: "Absent from the body . . . present with the Lord" (II Cor. 5:8); "To die is gain and to be with Christ . . . is far better" (Phil. 1:21, 23).

* * *

Man's Inhumanity to Man

Years ago some workmen were repairing a medieval castle in Europe. They were horrified when they discovered a human skeleton between two walls. An ancient legend said that a wealthy baron, who lived in the castle centuries before, had forced an enemy to stand still while masons built a wall around him! What horror and anguish must have gripped that helpless victim as he was encased in his tomb alive! Death brought relief to him.

Often the body of a Christian is ravished by disease and riven with pain. Relief comes when he moves out of his "earthly house," and goes to be forever with his Lord in Glory. Then death, pain and sorrow are forever banished: "And God shall wipe away all tears . . . there shall be no more sorrow, nor crying, neither shall there be any more pain" (Rev. 21:4). Hallelujah!

* * *

"How Are the Mighty Fallen!"

The mighty dictator Nikita Krushchev was toppled from power in 1964 after his comrades judged him and found him wanting. No officials were present at his funeral in 1970 and only a skimpy reference was made of his death in *Pravda*.

His body was interred in Rovodevichy Cemetery in September.

An old woman, wearing a slate-colored smock, putters around the gate of the cemetery, sweeping leaves with a broom of twigs. Unconcernedly she replies to questions of sightseers.

"Where is Khrushchev buried?" they ask.

With a wave of her arm, she says, "Down there. Straight on to the end."

"Do many come here to see his grave?"

"Not so many," she mumbles.

The grave of the once mighty dictator is neglected. Pools of rainwater are cupped in the bare earth around it. A compost heap of dead flowers has been piled against the wall a few yards away. Beyond the cemetery wall a freight train rattles by. A cold wind sighs a dismal dirge through the branches of nearby birch trees.

On the ninth day after Krushchev's interment his son Sergel came to the grave. Most Russians have forgotten the reason for this ninth-day graveside visit. In the Russian Orthodox Church, it is believed that the soul, having been judged, is consigned either to heaven or hell on the ninth day. Since Khrushchev was a blatant atheist, the son's observance of this custom was empty of any religious significance.

How quickly do the ephemeral glories of the world pass: "For all flesh is as grass; and all the glory of man as the flowers of grass" (I Peter 1:24).

Adapted from the *Austin* (Texas) *American Statesman*

The boast of heraldry, the pomp of power, And all that beauty, all that wealth ever gave, Await alike the inevitable hour: The paths of glory lead but to the grave!

SIR THOMAS GRAY

* * *

Ike Was Ready

Just before General Eisenhower died, Billy Graham was invited to visit him at Walter Reed Hospital in Washington, D. C. He was told he could stay thirty minutes. When he went in, the general was wearing his usual big smile, even

though he knew he didn't have long to live.

Later, Billy Graham told what happened:

"When the thirty minutes were up, he asked me to stay longer and said to me, 'Billy, I want you to tell me once again how I can be sure my sins are forgiven and that I'm going to heaven, because nothing else matters now.'

"I took out my New Testament and read him several Scriptures. I pointed out that we are not going to heaven because of our good works, or because of money we've given to the church. We are going to heaven totally and completely on the basis of the merits of what Christ did on the cross. Therefore he could rest in the comfort that Jesus paid it all!

"After prayer, Ike said, 'Thank you! I'm ready!'"

Are you ready for death? Are you sure? Jesus said, "Be ye also ready: for in such an hour as ye think not the Son of man cometh" (Matt. 24:44).

* * *

A Bloody Conflict

To many, death is a fearsome, dreadful thing—a trap door into nothingness!

John Donne, an English divine and poet, said, "Death is a bloody conflict and no victory at last; a tempestuous sea, and no harbor at last; a slippery height and no footing; a desperate fall and no bottom!"

Aristotle confessed, "Death is a dreadful thing, for it is the end!"

Rousseau bluntly affirmed, "He who pretends to face death without fear is a liar!"

Dr. Samuel Johnson, lexicographer and author, said, "No rational man can die without uneasy apprehension."

Trustful Christians have no fear of dying. They confidently say at the portals of death, "Yea, though I walk through the valley of the shadow of death, I will fear no evil: for thou art with me" (Psa. 23:4a).

God Present at Obsequies

As an aged Negro walked leisurely along a country lane, he heard the dull thud of a falling sparrow. Stepping aside, he saw the creature feebly move its wings and gasp its last breath. Then it was gone!

The Negro knelt and began to pray silently.

A passerby, observing his lips moving, asked, "What on earth are you doing.?"

He replied, "My heavenly Father attends the funeral of every falling sparrow. I am thanking Him for His watchful, loving care of me and His creatures."

"Are not two sparrows sold for a farthing? and one of them shall not fall on the ground without your Father" (Matt. 10:29).

RALPH M. SMITH

* * *

Last Wish

If death and I met suddenly,
And I were given choice,
Of all the sounds I've ever heard,
I know I'd choose your voice.

If second choice were given me,
Of all the things through space,
To look upon in fond farewell,
I'd choose your eyes, your face.

But if these must be canceled for
One wish down through the years,
I'd choose this: After I am gone—
I'd come and dry your tears.

KERMIT SHELBY

* * *

"They . . . Rest From Their Labors"

Sleep on, beloved, sleep, and take thy rest,
Lay down thy head upon thy Saviour's breast;
We love thee well; but Jesus loves thee best—
 Good night!

Only "good night," beloved, not "farewell."
A little while, and His saints shall dwell
In hallowed union, indivisible,
 Good night!

65

DEATH

Until the shadows from this earth are
cast,
Until He gathers His sheaves at last,
Until the twilight gloom is overpast,
 Good night!

Until the Easter glory lights the skies,
Until the dead in Christ shall arise,
And He shall come, but not in lowly guise,
 Good night!

 SARAH DOUDNEY

"Blessed are the dead which die in the
Lord from henceforth: Yea, saith the
Spirit, that they may rest from their
labors; and their works do follow them"
(Rev. 14:13b).

* * *

The Great Perhaps

As his life came to its close, Thomas
Hobbs, an outspoken agnostic, said, "I
commit my spirit to the great Perhaps!"

At death's portal, the Christian can
confidently say, "Father, into Thy hands
I commend my spirit!"

 Told by RALPH M. SMITH

* * *

A Fraction of Rubber

When Britain's Princess Anne visited
the Smithsonian Institute in Washington,
she was intrigued by the space suits of
the astronauts. She asked astronaut Neil
Armstrong: "Is there any danger of a
rip?"

He replied, "The difference between
eternity and life is about one-hundredth
of an inch of rubber!"

As David fled from wrathful Saul, he
exclaimed, "Truly as the Lord liveth . . .
there is but a step between me and death"
(I Sam. 20:3).

* * *

Cancerettes

Editorialized *Christianity Today,* "Some
churchmen often gather in smoke-filled
rooms to draft resolutions protesting the
useless waste of life in Vietnam, and ig-
nore completely smoking's heavy contri-
bution to 75,000 deaths a year in the
United States, more than twice the num-
ber of Americans killed in the entire
Vietnam conflict."

Uncertain and Fragile

During a heavy rainstorm about noon
on a Sunday, a light aircraft crashed into
the cold waters of Lake Travis, Austin,
Texas. A father, mother and their teen-
age daughter in the plane sank to their
death in twenty feet of water.

Death was probably a remote thought
when they enplaned for the pleasurable
flight on that Lord's Day.

Life is uncertain: "Thou knowest not
what a day may bring forth" (Prov. 27:1);
and fragile: "It is even a vapor, that ap-
peareth for a little while, and then van-
isheth away" (Jas. 4:14). The years
glide swiftly by: "We spend our years as
a tale that is told" (Ps. 90:9); "My days
are swifter than a weaver's shuttle" (Job
7:6a).

To be momentarily ready for death is
consummate wisdom: "Be ye also ready;
for in such an hour as ye think not the
Son of man cometh" (Matt. 24:44).

* * *

Suicide

Suicide is the tenth most common
cause of death for all Americans. It is in
fourth place among teenagers, and in sec-
ond place among college students. The
occupations of law and medicine are as-
sociated with a high rate, and within
medicine, psychiatrists have the highest
rate. There are approximately three male
suicides for every female suicide. At-
tempted suicide presents a different pic-
ture: women outnumber men about three
to one.

 MERVILLE O. VINCENT
 in *Christianity Today*

* * *

The Ultimate in Folly

Said the Greek philosopher Epicurus,
"While I am, death is not; and when
death is, I am not. Therefore death is no
concern to me."

Life is fleeting. It is sheer folly to fail
to make peace with God through Jesus
Christ—the One who conquered death
and gives everlasting life: "I give unto
them eternal life and they shall never
perish" (John 10:28).

Going to Sleep

Little Kenneth was very sick. He felt that he was not going to get well. As his mother sat by his bedside, he asked, "Mother, what is it like to die?"

Mother was filled with grief, and she didn't know how to answer him. She said, "Kenneth, I must go to the kitchen. I'll be right back."

Hurrying into the kitchen, Mother prayed, saying, "Lord, show me how to answer Kenneth's question." Immediately she knew how to do it.

Returning to Kenneth, Mother said, "Kenneth, you know how you have often played hard and gotten very tired in the evening? Then you have come into my room and climbed up on my bed and gone to sleep. Later your father carried you in his arms and put you in your own bed. In the morning you have wakened and found yourself in your own room, without knowing how you got there."

Kenneth said, "Yes, Mother, I know about that."

Then Mother continued, "Kenneth, death is something like that for God's children. Jesus spoke of death as sleep. God's children go to sleep when they die. Then they awaken in heaven where they will be forever with Jesus. Heaven is a wonderful place, Kenneth!"

The boy smiled and said, "Mother, I won't be afraid to die now. I'll just go to sleep and wake up in heaven. I know God will take care of me."

The Bible says, "Then shall the dust return to the earth as it was: and the spirit shall return unto God who gave it" (Eccl. 12:7); "Having a desire to depart and be with Christ; which is far better" (Phil. 1:23).

RALPH M. SMITH

DRUGS

A Tiger in the Blood Stream

Diane, the twenty-year-old daughter of TV personality Art Linkletter plunged to her death from the kitchen window of her sixth-floor apartment, driven to the darksome deed by "a tiger in her blood stream"—LSD!

Said Linkletter, "From the fifth grade up, children should be grounded as thoroughly in the danger of putting chemicals into their bodies as they are in the danger of walking across a superhighway with their eyes shut. Since this has happened to Diane, you cannot imagine the number of people who have called, wired, written me—important people, well-known people—who have daughters in sanitariums, children who have killed themselves. They have hushed this up as a terrible family secret. All of a sudden they're coming out and telling me. Yes, many are lawyers, bankers, so-called community pillars of decency, journalists. . . ."

Is any sorrow as poignant as parental sorrow?

"And the king wept . . . O my son Absalom, my son, my son Absalom! would God I had died for thee, O Absalom my son, my son" (II Sam. 18:33).

* * *

Needed: Example More Than Advice

Senator Harold E. Hughes (D-Iowa), after telling how he began drinking alcoholic beverages in his teens, said, "In high school, I was a wild spree drinker. I'd drink and drink, and drink. In college, the sprees increased. I regularly lost control of myself. I was hooked!"

For some fifteen years, Senator Hughes has been a teetotaler. Realistically he said, "Many people think alcohol is a stimulant. Others call it a depressant, but it's a drug—dirty, vicious and brutal. It's the mainstay drug of the American built society. The kids get lectures about pot from their parents, but the kids are smart and know hypocrites when they see them—the anti-pot adults are the same ones who can't even get through a day or face the night without the most dangerous drug of all—alcohol!"

DRUGS

Alcoholic Pushers

In addressing the Texas Baptist Christian Life Commission, Art Linkletter said. "We don't have a drug problem primarily at all. We have a *people problem*—a sick society. Christ is the only real answer. With Christ, youths will have a friend who will stay with them and fill the emptiness which so often leads to experimentation in drugs."

Linkletter referred to alcohol "as a drug problem more dangerous than heroin in its effect on the human body and the lives it takes.

"While visiting in a home of a celebrity," said Linkletter, "I was offered a cocktail. Instantly, I said, 'I didn't know you were a *pusher!*'

"The celebrity remonstrated with me heatedly, but I held to my position, saying, 'You are no different from the drug pusher who tries to push his wares on the people he meets!' "

Linkletter spoke with a tear in his heart, for his beautiful daughter, while tripping on LSD, plummeted from an upstairs window to her death!

* * *

"Please, Oh, Please Help!"

Said Art Linkletter, whose daughter Diane became a victim of hallucinatory drugs and committed suicide, "My eyes filled with tears when I read this letter from a desperate mother in Santa Ana, California:

" 'My Dear Mr. Linkletter: Please, oh, please help me! My son is a drug addict and tried to commit suicide twice last week. I do not know where to turn for help. Please, please, can you help me save my son? He said he is too much trouble to me and that this was the best way. I love him so much, and we, his family, need him. My son is 19. He is a wonderful boy. He is intelligent, with an IQ of 137, plays the guitar beautifully, and once was in love with life.

" 'He held jobs from the time he was 15. He bought himself a new car, surfboard and guitar equipment. Then came the drugs, and everything went! He now has nothing. We have kept up the payments on the car but everything else is gone. I never know if he is alive or dead. When the phone rings, I don't know what the news will be! I pray. That is all I can do. Please help my son! Please! Oh, tell me how to help him!' "

Is any sorrow so poignant as parental sorrow?

"O my son Absalom, my son, my son Absalom! would God I had died for thee, O Absalom, my son, my son!" (II Sam. 18:33).

* * *

In Wildest Nightmare

Said Dr. Harry Ramer, director of Study for Special Problems, "Heroin is now the most readily available drug on the streets. In my wildest nightmares, I never dreamed of what we are seeing!"

* * *

Two Havoc-Working Evils

A youth wrote the following letter to Ann Landers:

"Why do you make a blanket indictment of pot and remain silent about alcohol? You call pot a copout. Everyone knows that alcohol is the biggest copout of all, yet you didn't even mention it.

"My parents are professional people. They are smart and successful. They get gassed nearly every weekend. Both my brother and I smoke pot. We are sixteen and seventeen. We're in a lot better shape on Monday morning after a pot party than Mom and Dad after a night of drinking."

The columnist replied:

"Anyone who has the impression that I have been silent on the subject of alcohol must be deaf, dumb and blind. Booze has been one of my principal targets.

"It is an undeniable fact that alcohol is a horrendous problem to a great number of people. . . . There are about eight million alcoholics in this country and another two million who are flying on pills. I don't want to add to that dismal picture another eight million who are stoned on pot. If the older generation cops out with

68

booze and pills and the younger generations cops out with pot, who is going to run this country in fifteen years?"

* * *

The Psalm of an Addict

An unknown addict, lost in the dream world of heroin, wrote the following completely hopeless psalm:

"King Heroin is my shepherd. I shall always want. He maketh me to lie down in gutters. He leadeth me beside the troubled waters. He destroyeth my soul. He leadeth me in the paths of wickedness for effort's sake. Yea, I shall walk through the valley of poverty and will fear all evil for thou, Heroin, art with me. Thy needle and capsule try to comfort me. Thou strippest my table of groceries in the presence of my family. Thou robbest my head of reason. My cup of sorrow runneth over. Surely Heroin addiction shall stalk me all the days of my life and I will dwell in the House of the Damned forever!"

The above psalm was found by a Long Beach, California, police officer in a telephone booth. On the back of the card was written this postscript:

"Truly this is my psalm. I am a young woman twenty years of age, and for the past year and one-half, I have been wandering down the nightmare path of the junkie. I want to quit taking dope and try but I can't. Jail didn't cure me. Nor did the hospitalization help me for long. The doctor told my family it would have been better, and indeed kinder, if the person who first got me hooked on dope had taken a gun and blown my brains out! And I wish to God she had. My God, how I wish it!"

Austin American-Statesman

* * *

The Sun Is Always Down

In an essay on "Why I Should Not Use Drugs," Caren Sellers, a sixteen-year-old high school student, wrote:

"Look around. I mean really look. The world is all yours. Life is so short. There is so little time to see and absorb all of the wonders that actually belong to you.

These things exist for you. Absolutely nothing can replace the beauty of a freshly opened rose or the splendor of a golden sun setting on the horizon.

"Then there is another world. Here the sun is always down and there is never a chance to see it rise. It is a world that consists of pills, capsules and syringes. It is the world of drugs—a filthy, polluted world that encourages crime, hatred, and mental dangers; a world that includes constant fear and attempts to escape, but has no assurance or hope for the future. Where does it all lead to? Is this the answer to long-searched-for bliss and happiness? Is having hallucinations while lying in a gutter your lifelong ambition? It is not mine.

"Ahead of me, there is a wide, wonderful world that I am anxious to tour and study. I am not about to ruin my plans for some cheap thrill. There would be a difference if there were no choice of how to spend my first life and try for a better one the second time. But there is not a second chance! So I plan to make the best of my first!"

Limitless potentials for good are inherent in young people who, in life's morning, submissively plead:

Jesus, Savior, pilot me
Over life's tempestuous sea;
Unknown waves before me roll,
Hiding rock and treach'rous shoal,
Chart and compass come from Thee,
Jesus, Savior, pilot me.

EDWARD HOPPER

* * *

What Is Known About Marijuana?

Dr. Keith Yonge, president of the Canadian Psychiatric Association and chief of the Department of Psychiatry at the University of Alberta, said:

"Mind-altering drugs—including marijuana—induce changes in personality functioning, and there is some evidence that they may include lasting changes in the chemical processes of the brain cells. While we don't know whether such drugs will cause genetic damage in human beings, the results of research with hamsters and rabbits are frightening!

DRUGS

"Among nearly a thousand youngsters hooked on hard drugs with whom I have worked, all but one started with marijuana. That doesn't necessarily mean that today's pot-user is tomorrow's heroin addict, but it certainly makes him a prime candidate!"

Dr. Walter G. Lehmann, director of the VITAM Rehabilitation Foundation of Norwalk, Connecticut, asserts:

"It is difficult to believe that people who say marijuana isn't harmful have ever worked with young people who are using the drug regularly. Having treated a couple of thousand youngsters over a five-year period, I have found that marijuana can cause muscular incoordination, distort perception of time and space, impair the memory as well as the ability to make judgments and decisions!

"Take enough of it, and it can induce hallucinations every bit as intense as LSD. Marijuana, though not physically addictive, can quickly lead the user to become psychologically dependent on it, and it can induce paranoiac and schizophrenic responses needing emergency psychiatric care!"

* * *

If

Said Peter L. Ream in *Home Life*, "If alcoholism is a disease, it is the only disease that is contracted by an act of the will; the only disease that requires a license to propagate it; the only disease that is bottled and sold; the only disease that promotes crime; the only disease that is habit-forming; the only disease that is spread by advertising; and the only disease that is given for a Christmas present."

* * *

The Greatest Drug Problem

Dr. Jimmy R. Allen, president of the Baptist General Convention of Texas, said, "The greatest drug problem in our nation is beverage alcohol. It constitutes seventy-five percent of the drug problem. It is socially approved, but leaves in its wake the six to eight million crushed lives of alcoholics and problem drinkers, destroys 27,000 Americans a year on our highways, and heightens violence in our society with taverns providing the stage for thousands of murders a year. It deepens distress in families, with many marriages ending in divorce."

Alcoholism begins with the first drink: "Touch not; taste not; handle not" (Col. 2:21).

* * *

Forfeiting Twelve Years of Life

Said Dr. Marvin A. Block, chairman of the American Medical Association's Committee on Alcoholism, "Ours is a drug-oriented society, largely because of alcohol. Because of its social acceptance, alcohol is rarely thought of as a drug. But a drug it is, in scientific fact. Many diseases have alcohol as their base, along with excessive smoking and lack of nutrition. Long-time use may result in liver damage, bronchitis, pneumonia, tuberculosis and other respiratory infections, as well as heart trouble, high blood pressure and intestinal difficulties. Losses due to job absenteeism, illness resulting in custodial care, shortening of life through alcoholism—*twelve years less than the non-alcoholic*—\$2 billion per year lost to industry through alcoholism and about half the automobile casulties and some 800,000 injuries, alcohol related,—these are among the negative facts of alcoholism."

* * *

Alcoholics and Mental Hospitals

In a report to the Texas Mental Health Retardation Department, Dr. Daniel M. Sheehan affirmed, "Alcoholism and drug addiction are the fastest growing causes of admissions to state mental hospitals. Alcoholism is today the largest primary diagnosis of hospital patients. Increased admissions for alcoholism, which many physicians declare is a form of drug addiction, account for almost all of the total increase in mental hospital admissions."

70

The Nation's No. 1 Drug Problem

In an editorial, *The Austin Statesman* (Austin, Tex.) said, "Alcoholism is a drug—the number one drug problem in the United States, according to the American Psychiatric Association. The problem is so prevalent because alcohol is an addictive drug which is legal, easily obtainable, and relatively inexpensive as compared to other drugs.

"Alcoholism is a costly problem. It cost industry in the United States $7.5 billion annually due to poor job performance and excessive absences. It is relatively inexpensive to establish treatment facilities when the cost is compared to the tremendous property damage through drunken driving, the overflow of jails, welfare received by alcoholics, and the many divorce and child abuse cases.

"Alcoholism is a disease (?). It is the third major health problem in the United States, trailing cancer and heart disease."

God's Word says, "Woe unto him that giveth his neighbor drink, that puttest thy bottle to him, and makest him drunken also, that thou mayest look on their nakedness!" (Hab. 2:15).

Alcoholism begins with the first drink! Beware! Abstain!

ENCOURAGEMENT—DISCOURAGEMENT

Steppingstones

A little girl climbing a mountain with her brother became weary and discouraged. She said, "This mountain is nothing but a pile of rocks!"

"But the rocks are steppingstones for us," said the brother. "They help us climb the mountain!"

* * *

Tribulation

Two intrepid mountain climbers, Warren Harding, age forty-seven, and Dean Caldwell, age twenty-seven, scaled El Capitan, the 3,000-foot granite monolith in Yosemite National Park.

They almost didn't make it, not because of the difficulties and hazards in climbing the sheer face of the peak, but because of friends and loved ones who wanted to rescue them.

After the climb had been underway for twenty-one days, an army helicopter, manned by fifteen men with rescue gear, offered to rescue them. The climbers refused their help and continued to inch their way to the summit of El Capitan.

Sometimes the upward, heavenly way seems steep and rugged to God's children. It is said of the Israelites long ago, "The soul of the people was much discouraged because of the way" (Num. 21:4b).

God's Word says, "We must through much tribulation enter into the kingdom of God" (Acts 14:22b).

Tell Him Now

If with pleasure you are viewing
Any work a man is doing,
If you love him or you like him
Tell him now!
Don't withhold your approbation,
Until the parson makes oration,
And he lies with snowy lilies on his brow,
For no matter how you shout it,
He won't really care about it,
He won't know how many teardrops you
 have shed,
If you think some praise is due him,
Now's the time to ease it to him,
For he cannot read his tombstone
When he's dead!

More than fame and more than money,
Is the comment kind and sunny,
And the hearty warm approval of a
 friend.
For it gives to life a savor,
And it makes you truer and braver,
And it gives you hope and courage to the
 end.
If she earns your praise, bestow it,
If you love her, let her know it,
Let the words of true encouragement be
 said,
Do not wait 'til life is over,
And she's underneath the clover,
For she cannot read her tombstone when
 she's dead!

AUTHOR UNKNOWN

71

FAITH

Look After Your Peanuts

Distressed and discouraged because of the sin, sorrow and suffering in our morally and spiritually sick world, Dr. George Washington Carver went into his garden to pray.

As he prayed, God seemed to address to him a question which He asked His ancient, distraught servant Job, "Where wast thou when I laid the foundations of the earth? Declare, if thou hast understanding" (Job 38:4). "George," the divine command seemed to say, "you look after the peanuts, and I'll look after the world."

With evil seemingly triumphant—"truth forever on the scaffold, wrong forever on the throne,"—let God's children encourage themselves in the fact that God is still on the throne, and that "He doeth according to his will in the army of heaven, and among the inhabitants of the earth: and none can stay his hand" (Dan. 4:35).

This is My Father's world,
O let me ne'er forget;

That though the wrong seems oft so strong,
God is the Ruler yet!

MALTIE B. BABCOCK
Told by LEWIS TIMBERLAKE

* * *

The Wrong Guys Won

The disillusionment of many in our day is well expressed in a few words from the "Theatre for Ideas," which was held in New York City, in March, 1969.

Said Robert Lowell: "The world is absolutely out of control now, and it's not going to be saved by reason or unreason!"

Said Norman Mailer: "Somewhere, something incredible happened in history—the wrong guys won!"

How dismal and dark is the outlook of those who do not have an experiential knowledge of the Light of the world—Jesus whose promise is unfailing: "He that followeth me shall not walk in darkness, but shall have the light of life" (John 8:12b).

FAITH

Face Without Works

"Daddy, I want a watch, so I can tell the time," pleaded little Jimmy.

"Very well, son, I'll get you a watch."

Going to a five-and-ten-cent store, Daddy bought the watch. Jimmy was especially delighted because the face of the watch was colorful.

Before Jimmy retired that night, he set the watch at 8 o'clock and put it under his pillow.

The next day was Sunday, and the family usually got up at 8 o'clock to get ready for Sunday school and church. When Jimmy awoke, he looked at his watch. It was 8 o'clock. He leaped from his bed and ran downstairs. Seeing his mommy and daddy sound asleep, he shouted, "Get up, sleepyheads! It's 8 o'clock!"

Daddy looked at his wrist watch. It was only 5 o'clock. He said, "Go back to bed, Jimmy!" Then he told Jimmy the sad news: his new watch didn't keep time. It had no works to make it move.

In the morning church service, the minister's text was "Faith without works is dead."

"Why, Daddy," whispered Jimmy, "he's preaching about my watch!"

"Your watch?" asked Father in surprise.

"Yes, Daddy. He said, 'Face without works is dead!' "

How like Jimmy's watch are some people. They put on a good face or front before people, but within them there is only spiritual deadness. They don't believe in Jesus and love Him.

ALICE MARIE KNIGHT

What Faith Isn't

Faith is not taking a blind plunge into the dark. Faith is not relying upon some illusive emotional hope in the heart. Faith is reliantly trusting in God's unfailing promises. Faith exclaims, "Hath he not said, and shall he not do it? or hath he spoken, and shall he not make it good?" (Num. 23:19).

"If thou canst believe, all things are possible to him that believeth" (Mark 9:23).

* * *

Undiluted Faith

Astronaut James B. Irwin affirmed, "I have encountered nothing on Apollo 15, or elsewhere in this age of space and science, that dilutes my faith in God."

* * *

Contaminated

Christer H. Johnson said, "If your faith isn't contagious, it must be contaminated."

* * *

Not What, But Whom

Not what but Whom I believe,
That in the darkest hour of need
Hath comfort that no mortal creed
To mortal man may give—
Not what, but Whom I believe.

AUTHOR UNKNOWN

It is essential for God's children to know *what* they believe and to be able to "give an answer to every man . . . a reason of the hope that is in (them)" (I Pet. 3:15b). It is also essential for them to know experimentally *Whom* they believe: "I know whom I have believed" (II Tim. 1:12).

"The people that do know their God shall be strong, and do exploits" (Dan. 11:32).

* * *

Near Spiritual Collapse

In the preface of the *Living History of Israel*, Ken Taylor says, "I am horrified at the God-ordained slaughter you will read about in the early pages of this book. As a pacifist, I am devastated that God is a God of war and judgment and vengeance."

Some Christians will undoubtedly be troubled by this confession. Some may even regard this as a lack of faith. Not so! This is true faith, honest faith which stares the mystery of God's way in the face and still trusts. . . . It refuses to dismiss difficulties. It accepts them. And where it cannot explain, there it worships.

"I know that no one who comes to God is turned away," Taylor says. "So I will spend my life helping them to find the universal solution for all troubled hearts— the Lord Jesus Christ. And I shall weep for those who cannot find Him."

We exclaim, "O the depth of . . . both the wisdom and knowledge of God! how unsearchable are his judgments, and his ways past finding out!" (Rom. 11:33).

BRUCE SHELLEY in
United-Evangelical Action

* * *

Ideas Come from God

Dr. Albert Einstein, the renowned scientist, expressed faith in God. He said with reverence, "Ideas come from God."

As he pondered the conclusions of his cosmic investigations, he soliloquized, "Could this be the way God created the universe?"

How profound is the awesome declaration: "In the beginning God created the heaven and the earth" (Gen. 1:1).

* * *

Believest Thou This?

The resurrection and the life am I,
And whosoe'er believeth shall not die,
But reign with me in glory by-and-by,
 Believest thou this?

I am the door by which ye enter in,
I am the One who sav'st thy soul from sin,
I, the Good Shepherd, gave My life for men,
 Believest thou this?

I am the bread of life which ye may eat,
I am the living water, rich and sweet,
Partake of Me, and life will be complete,
 Believest thou this?

FAITH

I am the One of whom the prophets told
So long ago, in language clear and bold,
One day ye shall in heav'n my face
behold,
 Believest thou this?

Lord, I believe; help Thou mine unbelief!
I trust Thee, though life should be filled
with grief,
To whom else can I go for sweet relief?
 O Lord, I believe!

<div align="right">

ELIZABETH KIEKE
(a blind poet)
</div>

* * *

Cream and Skim Milk

Henry Ward Beecher said, "It is not good to pray cream and live skim milk."

Expect great things *from* God and undertake great things *for* God.

* * *

Seeing Is Believing

How can you look into the heart of a flower without seeing the face of its Creator and yours? How can you pause at the song of a bird without hearing the strains of celestial choirs? How can you breathe the fragrance of spring without inhaling the essence of life itself? How can you feel the joy and sorrow of living without sharing your joys and shedding your sorrows? If, as they say, you are what you see and hear and smell and feel, then you can't help but believe in an Infinite Being bestowing blessings on you.

Belief in God is the beginning of all beliefs. It leads you into other beliefs, like belief in your country, belief in the goodness of people, belief in the progress of your community, and belief in your own strength of character. Belief in all things good is practical and profitable. It brings you riches beyond belief, treasure on earth and in heaven. It raises your sights from the finite to infinity.

Yours is a rich full life when you sense the presence of God at your place of worship this week.

<div align="right">

Austin American-Statesman
</div>

One of Saddest

Dr. Harry Emerson Fosdick, outstanding spokesman of liberalism, said sometime before his death, "One of the saddest sights of this generation is to see Christians who have cast off the old faith and have retained no faith at all!"

It is inevitable that no faith remains when God's Word is fictionized or allegorized, and the basic doctrines of the Bible are rejected.

* * *

"If Thou Wouldest Believe"

In his book *Testament of Vision*, Henry Zylstra affirms, "We believe in order that we may know, for belief is the condition of knowledge. We know whom we have believed, and in His name we appropriate the whole of His reality."

Believing does precede knowing. Jesus said to the sorrowing Bethany sister: "Said I not unto thee, that, if thou wouldest believe, thou shouldest see the glory of God?" (John 11:40).

Augustine said, "If you do not believe, you will not understand."

* * *

The Quintessence

During World War II, some escaped prisoners of war hid for some time in a cellar in Cologne, Germany.

They wrote on the wall this inscription:

I believe in the sun, even when it
 is not shining;
I believe in love, even when feeling it not;
I believe in God, even when He
 is silent.

Thus was expressed the quintessence of faith. The Bible says, "Now faith is the substance of things hoped for, the evidence of things not seen" (Heb. 11:1).

* * *

Living Faith

Doubt sees the obstacles,
 Faith sees the way;
Doubt sees the darkest night,
 Faith sees the day.

Doubt dreads to take one step,
Faith soars on high;
Doubt questions, "Who believes?"
Faith answers, "I."

AUTHOR UNKNOWN

* * *

I Believe

In a breakfast prayer meeting in Washington, Billy Graham and the late president John F. Kennedy were present.

Said Kennedy to Graham, "Billy, I want to tell you something. I am a Catholic, but I want you to know that I believe as you preach!"

* * *

Believing the Incredible

In 1845, in the First Baptist Church of Augusta, Georgia, the Southern Baptist Convention was organized. As a tribute to the faith of the founding fathers, the church placed this inscription in the building: "Men who see the invisible, hear the inaudible, believe the incredible, and think the unthinkable!"

FAITHFULNESS, OUR

How He Got His Name

During a fierce battle with the Union Army, the tide of battle was going against the Confederates. Many of them were retreating.

There was one who refused to turn his back to the enemy—General Thomas Jonathan Jackson. Observing the fearless general, a soldier exclaimed, "There stands Jackson like a stonewall!" Thereafter the intrepid general was called "Stonewall" Jackson.

God's command to his battle-weary children today is, "Watch you, stand fast in the faith, quit you like men, be strong" (I Cor. 16:13).

* * *

What the Lord Doesn't Do

A little boy asked, "Mommy, do you think I could ever have a bank like General Brady?"

Mother replied, "If you want a bank someday, my boy, you'd better pay particular attention to your dusting and your dish washing now. The Lord never puts little boys and big jobs together. He gives the little boys a chance at little jobs and those who do the little jobs faithfully and well grow to be big men who do the big jobs well."

Our Best

A teacher asked her pupils to bring to class something which reminded them of Jesus, the Saviour.

A little girl brought a loaf of bread.

"How does a loaf of bread remind us of Jesus?" asked the teacher.

"It reminds us that Jesus is the Bread of life," said the girl.

A little fellow brought a match.

"How does a match remind us of the Saviour?" asked the teacher.

The boy replied, "It reminds us that Jesus is the Light of the world."

A third child brought a bantam egg! All wondered how a small bantam egg could remind them of Jesus.

The teacher said, "We all are curious to know how a small bantam egg can remind us of Jesus. Can you tell us?"

The boy said, "She has done what she could!"

Could more be said of the Saviour? Surely He has done what He could! He came to earth and paid the supreme sacrifice for our redemption. Joyfully we sing:

"I am redeemed, but not with silver;
I am bought, but not with gold:
Bought with a price, the blood of Jesus,
Precious price of love untold!"

JAMES M. GRAY
Told by RALPH M. SMITH

75

FEAR

Forget It

"Never worry about or fear anything that is past," said Herbert Hoover. "Charge it up to experience and forget the trouble. There are always plenty of troubles ahead, so don't turn and look back on any behind you."

There are two things God's children should never worry about: things they can help, and things they can't help.

Longfellow said:

Trust no future, howsoever pleasant,
Let the dead past bury its dead;
Act, act, in the living present,
Heart within and God o'erhead.

* * *

Glued to TV

Carl F. H. Henry warned, "We applaud modern man's capability but forget that nations are threatening each other with atomic destruction; that gunsmoke darkens our inner cities, and that our near-neighbors walk in terror by day and sleep in fear by night. We sit glued to television sets, unmindful that ancient pagan rulers staged Colosseum circuses to switch the minds of the restless ones from the realities of a spiritually-vagrant empire to the illusion that all was well."

"Awake thou that sleepest . . . and Christ shall give thee light" (Eph. 5:14a).

* * *

Two Tents

All the world lives in two *tents—content* and *discontent*.

How blessed are those who can say with the Apostle Paul, "I have learned, in whatsoever state I am, therewith to be content" (Phil. 4:11b).

How fearful and miserable are those who lament as did discontented and fear-craven Israel of old: "In the morning thou shalt say, Would God it were even! and at the even thou shalt say, Would God it were morning! for the fear of thine heart wherewith thou shalt fear" (Deut. 28:67).

* * *

Queen Elizabeth's Appraisal

Billy Graham asked Queen Elizabeth, "How do you summarize the world situation?"

"Terrifying!" was her Majesty's terse reply.

* * *

The Sure Remedy

A cross section of the American public was recently asked this question: "What is your greatest or most distressing problem?"

The reply of an overwhelming majority was: "Anxiety or tension."

The Bible gives the sure remedy for taut nerves and overwrought minds: "In returning and rest shall ye be saved, in quietness and in confidence shall be your strength" (Isa. 30:15).

* * *

God Keeps His Appointments

Said Dean Inge, an outspoken liberal of the past generation, "There never was a time when the fear of God played so small a part as it does now. We are not afraid of God's judgments as were earlier generations. The decay of fear as an element in vital religion is one of the most significant features of our time. The disappearance of threats from the pulpit is a very remarkable phenomenon, however we may account for it. The modern churchgoer is not much afraid when he listens to the warnings of God's judgment."

Whether believed or disbelieved, God's judgment is certain: He "hath appointed a day, in the which he will judge the world in righteousness by that man (Christ) whom he hath ordained" (Acts 17:31).

God always keeps His appointments.

FELLOWSHIP

Gregariousness

Dr. Leonard Cammer, a psychiatrist who has specialized for thirty years in treating depressed persons, said, "The human being is the only species that can't survive alone. The human being needs another human being—otherwise he's dead! A telephone call to a depressed person can save a life. An occasional word, a ten-minute visit, can be more effective than twenty-four hours of nursing care. You can buy nursing care. You can't buy love."

When man began his trek down the corridors of time God, who knew the needs of man, said, "It is not good that the man should be alone" (Gen. 2:18a).

How sweet and mutually helpful is the fellowship of Christlike Christians! "It is like to that above!"

* * *

Slavishly Routinized

In his book, *The Inner Chamber and the Inner Life,* Andrew Murray warned, "There is a terrible danger faced inwardly. You are in danger of substituting prayer and Bible study for living fellowship with God, and thereby losing the living interchange of giving Him your love, your heart and your life, and receiving from Him His love, His life and His Spirit."

How easy it is for God's children to become slavishly routinized in a busy sched-ule and thereby to thwart the primary purpose.

* * *

I Wish

I wish I had been in that multitude,
 Which Jesus so bountifully fed,
I would like to have been that little lad
 Who gave of his fishes and bread.
Yet even today I can go to Him,
 Away from the turmoil and strife,
And ask Him food for my fainting soul,
 And partake of the Bread of Life!

I wish I'd been there when He healed the sick,
 And seen Him give sight to the blind,
I'd like to have heard all His wondrous words,
 So tender and loving and kind.
Yet even today He restores the sight
 Of those who in darkness grope,
And speaks gentle words to my aching heart,
 Reviving my faith and my hope!

I wish I'd been one of the chosen twelve,
 Who walked with the Lord day by day,
And heard His instructions, His words of love,
 His promise to lead all the way.
Yet even today I can walk with Him,
 Can sit at His feet and be still,
And learn from His Word to trust and obey,
 To joyfully bend to His will!

ELIZABETH KIEKE
(a blind poet)

FORGETTING GOD

Only Ten Years Left

On May 9, 1969, Secretary General U Thant of the United Nations somberly said, "I do not wish to be overdramatic, but I can only conclude from information available to me as secretary general that the members of the United Nations have perhaps ten years left in which to subordinate their ancient quarrels and launch a global partnership to curb the arms race, improve the human environment, defuse the population explosion, and sup-ply the required momentum to world-development efforts.

"If such a global partnership is not formed within the next decade, I very much fear the problems I have mentioned will have reached such staggering proportions they will be beyond our capacity to control!"

How disappointing are man's efforts to "improve the human environment" apart from God!

77

FORGETTING GOD

When We Forget

When we forget God and try to live without Him, we soon discover that we cannot long live peaceably with ourselves or with others.

* * *

"If I Had Only Known"

As a husband and wife began their marital life, they dedicated themselves to God and His church. For some time they served Him faithfully. Then prosperity came. They lived in affluence and forgot God and forsook the place of worship.

One Sunday in Chicago the husband said to his wife, "Business demands that I stay in the city for several days. I want you to return by train to our home in New York."

A fearful train wreck occurred. Many passengers were killed outright. Others were pinned helplessly beneath overturned coaches and twisted steel. Among them was the homeward-bound wife. Piteously she plead with a doctor who came to administer morphia to her, "O, do save my life. Don't let me die!"

"I regret exceedingly that I am unable to do what you ask," said the doctor.

Then the dying woman said remorsefully, "If I had only known this would happen, I would have given myself fully to Jesus Christ!" Soon she was gone!

It is hazardous for God's children to allow the perishing things of this world to divide their allegiance to Christ. To live radiantly and triumphantly, He must have first place in our hearts.

RALPH M. SMITH

* * *

"Goodbye, America!"

In an editorial entitled "Goodbye, America," John Jeter wrote an astounding, thought-provoking "obituary" in which he said:

"Goodbye, America! You forgot God and God forgot you. You had your trials and triumphs for almost two centuries and then, with Utopia just ahead, you turned from God and died! The computer had its print-outs on crime, but you were blind. You preferred comfort instead of concern, and that was the beginning of the end. The people grew indifferent, content and bogged down in their sins.

"America's tragedy was the tragedy of all tragedies. Men and women who loved God fled in earlier centuries from religious oppression to form little settlements in the wilderness. They penned a document, declaring that 'all men are created equal, that they are endowed by their Creator with certain unalienable rights,' and that among these are life, liberty and the pursuit of happiness. Equality among men didn't emerge.

"People gathered in large numbers in churches, but it was to be comforted instead of being disturbed. They insisted on the chant of a clergyman instead of the cry from a prophet.

"So it was that a nation formed to 'establish justice, insure domestic tranquility, provide for the common defense, promote the general welfare and secure the blessings of liberty' collapsed from the weight of its own sins! *Some said that it couldn't happen, but it did!*"

Mightily existent in our nation today are many of the corrosive ills and sin diseases which wrought havoc in mighty nations in the long ago!

The hour is late, but not too late. The divine alternatives are still extended: "Repent or Perish!"

Baptist Standard

* * *

Anything Except Prosperity

Said the German poet and dramatist Goethe, "A nation can endure anything except prosperity."

In times of prosperity, men and nations often forget God. Warningly God said to His ancient people Israel, "And when thy herds and thy flocks multiply, and thy silver and thy gold is multiplied . . . then thine heart be lifted up, and thou forget the Lord thy God" (Deut. 8:13, 14).

Ill fares the land, to hastening ills a prey,
Where wealth accumulates, and men decay.

OLIVER GOLDSMITH

O Lord, Send Adversity

A pastor told of a businessman in Florida who faithfully put the Lord and His church first in his life. But then the man began to prosper in business and became the owner of five flourishing stores. Gradually he began to cut the services of his church. His pastor became greatly concerned about him, and went to see him in his office.

After the exchange of greetings, the pastor said, "You have been greatly missed from church. What's the trouble?"

The young man replied, "My stores demand more and more of my time, but I don't fail to see that my usual weekly offering of $100 reaches the treasurer. You doubtlessly know I give more to the church than any other member.'

The pastor listened with a heavy heart. He had unfeigned concern for the spiritually impoverished man.

"Before I go," he said, "let's kneel and pray."

Fervently the pastor importuned, "O God, our brother is too prosperous. He has forgotten You and forsaken Your house. Send adversity to him. If necessary, Lord, let his stores be burned to the ground, so he can have time for You and Your house!"

As the pastor concluded his earnest prayer, the man weepingly said, "I want to pray, too, pastor. I see it now."

Broken-heartedly he pled, "God, forgive me for shortchanging You and neg-

lecting my soul's welfare. I will do differently now."

The following verses are relevant: "But thou shalt remember the Lord . . . for it is he that giveth thee power to get wealth" (Deut. 8:18); "If riches increase set not your heart upon them" (Ps. 62:10b).

Told by RALPH M. SMITH

* * *

Cold and Calloused

One day a stranger asked John Wyeth, "Are you a Christian?"

Sadly Wyeth replied, "I used to be, but I have become cold and calloused. I have wandered far from God!"

The questioner didn't comment but began to sing softly the hymn, "Come, Thou Fount of Every Blessing."

Deeply touched, Wyeth cried, "I wrote that hymn!"

When God's children lapse into indifference and cease loving Christ first, they forfeit their Christian joy and fellowship, and they become defeated and dejected.

How tedious and tasteless the hours,
When Jesus no longer I see!
Sweet prospects, sweet birds, and
sweet flow'rs
Have all lost their sweetness to me!

JOHN NEWTON

Long ago David pled, "Restore unto me the joy of thy salvation; and uphold me with thy free spirit" (Ps 51:12).

Told by RALPH SMITH

FORGIVENESS, GOD'S

Thank God!

How productive of gratitude is the thought expressed on a church bulletin board: "No one gets all he deserves! Thank God!"

God, in mercy, "hath not dealt with us after our sins; nor rewarded us according to our iniquities" (Ps. 103:10).

Depth of Mercy

Depth of mercy! can there be
Mercy still reserved for me?
Can my God His wrath forbear,
Me, the chief of sinners, spare?

There for me the Saviour stands,
Shows His wounds and spreads His hands,
God is love! I know, I feel;
Jesus weeps and loves me still.

CHARLES WESLEY

FORGIVENESS, GOD'S

The Unpretentious Queen

In welcoming Emperor Hirohito of Japan on his visit to England in 1971, Queen Elizabeth said, "We cannot pretend that the past did not exist. We cannot pretend that the relations between our two peoples have always been peaceful and friendly. However, it is precisely this experience which should make us all the more determined never to let it happen again!"

We cannot forget the fact that "we ourselves also were sometime foolish, disobedient, deceived, serving divers lusts and pleasures, living in malice and envy, hateful, and hating one another" (Titus 3:3), "Dead in trespasses and sins" (Eph. 2:1). But we can rejoice in the fact that God in mercy has forgiven and forgotten our guilty past: "For I will be merciful to their unrighteousness, and their sins and their iniquities will I remember no more" (Heb. 8:12).

* * *

Come Boldly

In the vestry of St. Peter's Cathedral in Rome is a doorway marked with a cross. Every twenty-fifth year the Pope and his attendants demolish the door. Then the multitude passes into the cathedral and comes up to the altar by a way which the majority never entered before and will never enter again.

Suppose that the way to God's throne of grace was accessible only once in twenty-five years!

People of any clime, color or condition may go at any time to "the throne of grace, (and) . . . obtain mercy, and find grace to help in time of need" (Heb. 4:16).

* * *

A Sincere Wish

I would like to go back o'er life's pathway,
And retrace every footstep I've trod,
And remove the rough spots where I stumbled,
Erase every footprint and clod.

I would like to go back o'er life's journey,

And call back each harsh word I've said,
Recall every wrong deed or action,
Causing sorrow, or tears to be shed.

I would add many words left unspoken,
And retract many words idly said,
And heal every heart, bruised or broken,
By replacing kind words in their stead.

Then, when at the end of life's journey,
I am asked my past story to tell,
There'd be no rough spots on my pathway,
No trace where I stumbled and fell.

ELIZABETH KIEKE
(a blind poet)

* * *

Needlessly Wretched

In speaking of God's willingness to forgive the sins of all who penitently come to the Saviour, Dr. James Pleitz said, "I recently visited a greatly disturbed lady in one of our hospitals. Her face showed great anguish as she said, 'For the past several nights, I have had repeatedly the same frightful dream. In it, the Saviour has appeared and said to me, "You have sinned so long and so much, you can never be forgiven!"'

"I opened my Bible and read to her God's sure promise: 'If we confess our sins, he is faithful and just to forgive us our sins, and to cleanse us from all unrighteousness' (I John 1:9).

"Then I asked her, 'Will you accept what the Bible says, or continue to be wretched and emotionally distressed?'

"Thoughtfully she replied, 'I will accept what the Bible says!' "

The moral and the immoral sinner both need God's forgiveness, for "all have sinned, and come short of the glory of God."

* * *

God Wastes Nothing

Said Phillips Brooks, "You must learn; you must let God teach you that the only way to get rid of your past is to make a future out of it. God will waste nothing."

Dost thou behold thy lost youth all aghast?

80

FORGIVENESS, GOD'S

Dost reel from righteous retribution's blow?
Then turn from blotted archives of the past
And find the future's pages as white as snow!

<div align="right">

WALTER MALONE

</div>

Pleadingly God importunes sin's slaves, "Come now, and let us reason together, saith the Lord: though your sins be as scarlet, they shall be as white as snow; though they be red like crimson, they shall be as wool" (Isa. 1:18).

* * *

How Grand the Promise!

White as snow! How grand the promise
For the heavy-hearted breast;
When by faith the soul receives it,
Weariness is changed to rest.

Red like crimson, deep as scarlet,
Scarlet of the deepest dye,
Are the manifold transgressions
Which upon the sinner lie.

White as snow! Can *my* transgressions
Thus be wholly washed away,
Leaving not a spot behind them,
Like a cloudless summer day?

Yes, at once, and that forever,
Through the blood of Christ, I know,
All my sins, though red like crimson,
Have become as white as snow!

<div align="right">

JUDY BRAUER

</div>

(a polio victim in early childhood, who afterward entered her eternal home to be forever with her Lord, whom she loved devotedly and served faithfully)

* * *

Why Christ Was Manifested

A minister, standing at the bedside of a terminally ill man, asked, "Is there anything I can do for you?"

The patient replied, "No, sir, not unless you can undo my sordid, sinful past."

The minister replied, "I am powerless to do that, but long ago God sent the Saviour to blot out our sins. His Son, Jesus, came not to condemn us but to give eternal life to anyone who penitently looks to Him for mercy and forgiveness."

How grateful we are that "the Son of God was manifested that he might destroy (undo, loose) the works of the devil" (I John 3:8b).

* * *

What Only God Can Do

Sometime ago Governor Frank G. Clement of Tennessee commuted the death sentence of five convicts to ninety-nine years imprisonment. He acted less than twenty-four hours after the State House of Representatives, by a 48-to-47 vote, rejected his plea to abolish the death penalty by statute. The Senate had earlier approved its abolition by a 27-to-7 vote.

Facing the condemned men who were behind barred doors, the governor said, "I personally have studied and prayed over this matter, and I hereby commute your sentence from death to ninety-nine years."

Rube Sims, scheduled to die that very day for murder, was the first to speak. Joyfully and tearfully, he exclaimed, "Praise the Lord! Thank you, governor. Thank You, God!" The others joined in a chorus of gratitude.

The governor spoke further, saying, "I can commute your sentences. I have saved your lives, but I cannot pardon your sins. Only God can do that. Now I tell you to devote yourselves to prayer behind these prison walls. Try to do something for the good of mankind and look to the Lord who can and will forgive your sins and remember them against you no more!"

<div align="right">

Adapted from
New York Times News Service

</div>

* * *

One Thing God Forgets

A good memory is a valuable asset. To face the future courageously and triumphantly, however, we must also have a good "forgetter": "Forgetting those things which are behind . . . I press toward the mark for the prize of the high calling of God in Christ Jesus" (Phil. 3:13, 14).

<div align="center">

81

</div>

FORGIVING OTHERS

In goodness God has expunged from His memory our sins and failures: "I have blotted out, as a thick cloud . . . thy sins" (Isa. 44:22); "Their sins . . . will I remember no more" (Heb. 8:12). Shouldn't we forget them, too?

* * *

Tashlich

Said Dr. John Piet, "The Jews have a quaint custom called *Tashlich*. On the second day of the new year, they gather at a river or lake and cast bread crumbs into the water to signify that their sins have been cast from them. *Tashlich*, the name of the custom, comes from Micah 7:19: "Thou wilt cast all our sins into the depth of the sea."

The sins of all who penitently forsake them and turn in faith to the Saviour are graciously forgiven: "For I will be merciful to their unrighteousness, and their sins and their iniquities will I remember no more" (Heb. 8:12).

* * *

If God Has Forgiven You, Shouldn't You?

A businessman who had sinned greatly came into my study, dejected and discouraged.

I told him how God graciously forgives those who penitently turn from their sin to the Saviour. Long ago the Saviour said to one who had committed a sin which was punishable by death under the Mosaic Law, "Neither do I condemn thee: go, and sin no more" (John 8:11).

We knelt and prayed. Then the man left my study rejoicing in God's mercy and forgiveness.

A month later he returned with his face looking like a blownout lamp. Despondently, he said, "The more I think about the sin I committed, the greater is my unwillingness to forgive myself. How could I ever have done such a thing?"

In reply, I recalled a scene from his childhood days, saying, "Often as a child when out playing, you hurt yourself. Then you ran crying into the outstretched arms of your mother. She held you caressingly and soothed you. Then she kissed the hurt place, and you ran back to play, forgetting that you were hurt."

Who ran to help me when I fell,
And would some pretty story tell,
Or kiss the place to make it well?
My Mother!

"Just so, when we flee to our kind heavenly Father for help and healing from sin, He forgives and forgets our sins. He has said, 'And I will be merciful . . . and their sins and their iniquities will I remember no more' (Heb. 8:12). If God has forgiven you, shouldn't you also forgive yourself?"

A smile wreathed the man's face. Joyfully he said, "I see it now, pastor. I'll face the future with the past sin forgiven and forgotten!"

Told by RALPH M. SMITH

FORGIVING OTHERS

God Is Not the Enemy of Our Enemies

After languishing for months in Hitler's prison, Martin Niemoller emerged saying, "It took me a long time to learn that God is not the enemy of my enemies. He is not even the enemy of His enemies!"

The Bible says, "When we were enemies, we were reconciled to God by the death of his Son" (Rom. 5:10a).

Except

"I suppose careful, painstaking nursing can cure almost anything," said a patient to a nurse.

The nurse quipped, "Yes, almost anything except a grudge!"

The Bible says, "Grudge not one against another . . . lest ye be condemned" (Jas. 5:9).

Hugging Resentment

Peter Marshall said, "If you hug to yourself any resentment against anybody, you destroy the bridge by which God would come to you."

The Bible says, "Forbearing one another, and forgiving one another, if any man have a quarrel against any: even as Christ forgave you, so also do ye" (Col. 3:13).

* * *

Cobwebs

Professor Robert A. Bjork, a University of Michigan psychologist, said, "Efficient remembering is clearly related to efficient forgetting. The mind must set aside information it no longer needs to prevent it from interfering with new information."

The minds and hearts of many of God's children are cluttered with the cobwebs of envy, strife, divisions, pride, greed and unforgiveness. How Spirit-grieving and growth-stunting are these sins! A spiritual head and heart cleansing is desperately needed among God's children.

"Let us cleanse ourselves from all filthiness of the flesh and spirit, perfecting holiness in the fear of God" (II Cor. 7:1).

* * *

One Thing Never Tried

A convicted deserter stood before the Duke of Wellington expecting to hear his death sentence. The general said, "I am extremely sorry to pronounce the sentence of death. We have tried everything to improve you—discipline and penalties—but have failed in our effort."

Then the general gave the soldier's comrades an opportunity to speak. One said with great feeling, "Please, your Excellency, there is one thing that hasn't been tried—forgiving him!"

The general, deeply impressed, said, "You are right! I will try that! I will forgive him."

The habitual deserter was filled with deep gratitude. He became exemplary in his conduct, and dutiful in the discharge of orders.

How filled with gratitude we should be because God has graciously blotted out "as a thick cloud (our) transgressions, and, as a cloud, (our) sins" (Isa. 44:22a).

* * *

Suicide on the Installment Plan

It is a physiological fact that hating people can cause ulcers, heart attacks, headaches, skin rashes, asthma, and even death!

Our hating anyone is like burning down our house to get rid of rats.

Said Booker T. Washington, "No man is able to force me so low as to make me hate him."

FREEDOM

Make Me a Captive, Lord

Make me captive, Lord,
And then I shall be free;
Force me to render up my sword,
And I shall conqueror be!
I sink in life's alarms,
When by myself I stand;
Imprison me within Thine arms,
And strong shall be my hand.
GEORGE MATHESON

* * *

Free Choice

Said Dr. George W. Truett, "If I could raise my little finger coercively in the name of Christ, I wouldn't do it."

What Crimes!

As Madame Roland bowed to the clay Statue of Liberty standing near the guillotine, she exclaimed accusingly, "O Liberty, Liberty, what crimes are committed in thy name!" Then she placed her head on the block and paid with her life for all her opposition to Danton, Robespierre and the fellow Terrorists of the French Revolution.

* * *

A Birthright

Immanuel Kant, the German philosopher said, "Freedom is the birthright of man. It belongs to him by right of his

83

FREEDOM

humanity, insofar as this consists with every other person's freedom."

Jesus said, "If the Son therefore shall make you free, ye shall be free indeed" (John 8:36).

* * *

Privileges Taken for Granted

Sometime ago the editorial page of *The New York Times* carried an article entitled "God Bless America." It was written by Janina Atkins, a Polish immigrant.

"Just six years ago I came with my husband to this country with $2.60 in my purse, some clothes, a few books, a bundle of old letters, and a little eiderdown pillow. I was an immigrant girl hoping for a new life and happiness in a strange new country.

"There is something in the air of America that filled my soul with a feeling of freedom and independence. This begot strength. There is no one here to lead you by the hand and order you about. We believed in the future and the future did not disappoint us.

"Today my husband is studying for his doctorate. We live in a comfortable apartment.

"I love this country because when I want to move from one place to another I do not have to ask permission. When I want to go abroad I just buy a ticket and go.

"I love America because I do not have to stand in line for hours to buy a piece of tough, fat meat. I love it because, even with inflation, I do not have to pay a day's earnings for a small chicken.

"I love America because America trusts me. When I go into a shop to buy a pair of shoes, I am not asked to produce my identity card. When I visit with friends, it is not reported to the secret police.

"You have only to live in the darkness of tyranny for a little while to realize how wonderful freedom really is! Few men in all history have lived with the privileges that we take for granted!"

* * *

Called unto Liberty

Before America became a nation, Obadiah Holmes preached against the established church and some of its practices. For this "offense" he was publicly flogged with a three-corded whip, receiving thirty lashes!

After the shameful ordeal, he exultingly said, "The outward pain was so removed from me that I am unable to declare it to you!"

His courageous stand for religious freedom inspired others to stand for the God-given right of freedom in religious choices: "Ye have been called unto liberty; only use not liberty for an occasion to the flesh, but by love serve one another" (Gal. 5:13).

* * *

Washington Wept Here

They weren't even Americans—not yet. Just simple colonials!

A weary, frozen, scared, starving band of ordinary people on their way to an extraordinary achievement: *The United States of America!*

If they could last the Valley Forge winter, their cause, freedom, would not be lost.

George Washington wept for them. The pitiful huts, the nonexistent food and the incredible scarcity surrounding them would test any man.

They won! Over winter . . . over the foe . . . over every obstacle that stood in the way of their self-determination.

Now, maybe you think you're just an ordinary person, that nothing you can do would help Freedom's cause too much.

But do it anyhow. Write that letter you never got around to writing. Read. Listen. Learn. Tell. Encourage. But don't ignore Freedom.

You'd be surprised how ordinary people can produce extraordinary results!

It's how America happened. Freedom! Ignore it and maybe it will go away.

Upward

* * *

Fire on the Floor

If Liberty with law is fire on the hearth, liberty without law is fire on the floor.

84

Paul said, "For, brethren, ye have been called unto liberty; only use not liberty for an occasion to the flesh, but by love serve one another" (Gal. 5:13).

* * *

We Can't Survive If . . .

No government can survive if the rabble-rousers have all the freedoms. Their screams of protest can drown out the speaker in any forum. Their threats of violence can barricade him from the people with whom he must communicate. Our democracy is built in large part upon freedom. But it is stupidly extreme to argue that one can hire a hall and others monopolize the platform and give a mob freedom to chant threats of murder, destruction and other violence.

Democracy depends upon respect of the governed for those in authority. The White House is no shrine before which the people bow, but it must be a symbol of authority, of deference and esteem.

JOHN J. HUNT
in *Baptist Standard*

* * *

To Bed a Slave—Awakened Free

Mark Twain wrote about a slave who lived in Missouri on a narrow neck of land that jutted out into the Mississippi River. The current ran swiftly at that point and gradually cut through the neck of land. One night it completely severed it.

According to the law, as soon as the land was cut free from Missouri, it became part of Illinois. Hence the slave who had gone to bed in Missouri awakened a free man, for Illinois was a free state.

This is what God does for us in Christ. We come to Him defiled and unclean, but when we claim His salvation, we are "made the righteousness of God in him" (II Cor. 5:21).

CHARLES N. PICKELL

GIVING

Expendable

It was said of General Charles Gordon, "At all times and everywhere, he gave his strength to the weak; his substance to the poor; his sympathy to the suffering; and his heart to God!"

* * *

To God Be the Glory

A friend asked Mrs. Thomas A. Edison, "Have you ever asked your husband where he gets all the ideas that make him so famous?"

Thoughtfully Mrs. Edison replied, "Yes, I did ask him once. He didn't say anything. He just pointed upward and smiled!"

Let us all gratefully acknowledge: "All things come of thee, and of thine own have we given thee" (I Chron. 29:14b).

"Go break to the needy sweet charity's bread;
For giving is living," the angel said.
"And must I be giving again and again?"
My peevish and pitiless answer ran.
"Oh no," said the angel, piercing me through,
"Just give till the Master stops giving to you!"

ANONYMOUS

* * *

A Cadillac Available

A minister had a washing machine which he wished to give to a needy family. It needed some minor repairs. He took it to a repairman, told him what he intended to do with it, and suggested that he might wish to repair it without charge.

GIVING

The suggestion wasn't agreeable to the repairman. In his effort to justify his selfishness and callousness toward the poor, he pointed to an old ramshackle car in front of his workshop and said, "Look at what I have to ride in."

The minister said, "Man, if you were honoring and serving God, you might be riding in a Cadillac instead of that junky vehicle."

God delights to bestow rich blessings upon those who serve and honor Him. The promise is *sure*: "The Lord will give grace and glory: no good thing will he withhold from them that walk uprightly" (Ps. 84:11).

* * *

Begging

One day, when Sir Walter Raleigh made a request of Her Majesty Queen Elizabeth I, she petulantly said, "Raleigh, when will you leave off begging?"

Sir Walter replied, "When your Majesty leaves off giving!"

The Queen was greatly pleased with his reply, and his request was granted.

God delights to bestow the best of gifts upon his children "according to his riches in glory by Christ Jesus" (Phil. 4:19).

Thou art coming to a King
Large petitions with thee bring;
For His grace and pow'r are such,
None can ever ask too much.

AUTHOR UNKNOWN

* * *

Hippie Haven

"I want to deed my thirty-one-acre hippie haven to God," said Folksinger Lou Gottleib of Santa Rosa, California, to the recorder of deeds.

"What!" exclaimed the incredulous official.

"Yes, that's right," said Gottleib, as he showed the recorder of deeds a coin on which were the words "In God We Trust," adding, "As for taxes, for God's sake, I'll pay them!'

Hesitantly, the recorder acquiesced to the singular request.

Sometime thereafter, an Oakland woman sued God for $100,000 for the destruction of her home by lightning. The suit charged God with "careless and negligent" operation of the universe.

Her attorney believes he can win his case by attaching Gottleib's ranch, "property owned by God."

The title deed to the whole earth reposes with God: "The earth is the Lord's, and the fulness thereof: the world, and they that dwell therein" (Ps. 24:1).

The gift which each one of us is privileged to give to God is the gift of ourself: "I beseech you . . . by the mercies of God, that ye present your bodies a living sacrifice . . . unto God, which is your reasonable service" (Rom. 12:1).

* * *

We Don't Count the Cost

As David Clark entered a cathedral in Mexico, his attention was drawn to a golden statue. He said to a Mexican girl, "The golden statue is dazzlingly beautiful! What did it cost?"

With a puzzled look on her face, the girl replied, "Cost? When it is for our God, we don't count the cost!"

Clark thought, "O that more of God's children felt toward their Lord as did that Mexican girl, and deemed no sacrifice too dear that His cause might prosper and His gospel speed on its way to the ends of the earth!"

Told by RALPH M. SMITH

GOSPEL

Diffuse the Truth

One hundred and fifty years ago Daniel Webster said: "If religious books are not widely circulated among the masses in this country, I do not know what is going to become of us as a nation. If truth be not diffused, error will be. If the evangelical volume does not reach every community, the pages of a corrupt and licentious literature will.

"If the power of the Gospel is not felt throughout the length and breadth of the land, anarchy and misrule, degeneration and misery, corruption and darkness, will reign without mitigation or end!"

The words of a century and a half ago had a strangely prophetic ring.

* * *

Muted

"Great Paul," a mammoth seventeen-ton bell in one of the towers of St. Paul's Cathedral, London, was silent for seven years because of manpower shortage. But in May, 1971, England's largest bell, with its 1,350-pound clapper, returned to life. It is now rocked by two powerful motors. On a still summer evening, it can be heard seven miles away. Twice daily the sound of Great Paul rises above the din of traffic with a resonant E flat.

The centuries-old Gospel bell has been silent too long in some churches. The good news that "Christ died for our sins . . . was buried, and . . . rose again the third day" (I Cor. 15:3, 4), has been muted, with resultant moral and spiritual decay and confusion.

* * *

After Doubt and Suffering

When God's Word began to penetrate the mind and soul of Leo Tolstoi, Russian novelist and philosopher, he testified: "After all this fruitless search and careful meditation over all that had been written for and against the divinity of the doctrine of Jesus—after all this doubt and suffering—I came back face to face with the mysterious Gospel message. It was only after I had rejected the interpretations of the wise critics and theologians, and accepted the words of Jesus, 'Except ye be converted and become as little children, ye shall not enter into the kingdom of heaven' (Matt. 18:3), that I suddenly understood what had been so meaningless."

Childlike trustfulness and receptivity are prerequisites to receiving God's eternal truths. 'Thou hast hid these things from the wise and prudent, and hast revealed them unto babes" (Matt. 11:25).

* * *

Why They Perish

Martin Luther wrote in his *Open Letter to the Christian Nobility*, "The young folk in the midst of Christendom languish and perish miserably for want of the Gospel, in which we ought to be giving them constant instruction and training."

* * *

Its Revolutionary Power

If Christ favored the wearing of long hair, it was because long hair was the custom of the time. He did not wear it as a symbol of non-conformity. His individuality did not reside in external forms, such as a growth on the chin, a medallion around His neck, or a picket sign waved above His head. Christ's purpose was not to winnow away the chaff of custom. There was nothing conspicuous about His personage. It was Christ's message that was revolutionary.

His heart-transforming, character-ennobling Gospel is still the "power (dynamite) of God unto salvation to every one that believeth" (Rom. 1:16).

BARRY M. KELLEY

GOSPEL

Not a Ritual

Christianity is not a system of philosophy, or a ritual, or a code of laws. It is the impartation of a divine vitality. Without the Way there is no going; without the Truth there is no knowing; without the Life there is no living.

Jesus said, "I am come that they might have life, and that they might have it more abundantly" (John 10:10b).

LORY HILDRETH

* * *

Enslavement

Tom Skinner, a black evangelist, said, "Any gospel that does not speak on the issue of enslavement, that does not want to set the oppressed free in the name of Jesus Christ, is not the gospel."

Jesus came to "preach the gospel to the poor . . . to preach deliverance to the captives . . . to set at liberty them that are bruised" (Luke 4:18b).

* * *

Civilization's Debt

The veteran missionary James Chalmers said, "I have had twenty-one years of experience with the natives. I have seen the semi-civilized and the uncivilized. I have lived with the Christian natives. I have lived and slept with the cannibals. For nine years I lived with the savages of New Guinea. Wherever there has been the slightest spark of civilization in the southern seas, it has been because the Gospel has been preached there!"

* * *

Share Your Faith

Evangelist Leighton Ford said, "We cannot identify our Gospel only with the past, and oppose all change. God is not tied to 17th-century English, 18th-century hymns, 19th-century architecture and 20th-century cliches. God is constantly prodding us, as He did the people of Israel, and saying, 'Strike your tents and move on.' Let us tell God's people to get out and share their faith, to take the Gospel message where the people are. Jesus did."

Eternally Relevant

A Chinese Christian, who was formerly a Buddhist and is now a professor in a graduate school in America, expressed deep concern about the present emphasis of the church on "involvement" and its effort to make the Gospel "relevant" to the world. He lamented that the shift from proclaiming God's changeless message to spiritually impoverished souls is causing untold confusion both in the church and the unbelieving world.

The heart-transforming Gospel is still "the power of God unto salvation to every one that believeth, to the Jew first and also to the Greek" (Rom. 1:16b).

* * *

Burning Hearts

Said John Henry Jowett, "The Gospel of the broken heart demands the ministry of burning hearts."

Long ago the erstwhile distraught Emmaus disciples asked with deep emotion. "Did not our heart burn within us while he (Jesus) talked with us by the way, and while he opened to us the scriptures?" (Luke 24:32).

* * *

Different Facets

Said J. S. Bonnell, "The social and the individual aspects of the Gospel are but different facets of one precious stone. Let it be remembered, however, that the Scriptures give precedence to the spiritual aspects."

* * *

Its Society-Changing Power

Said Bishop Moule, "Christianity never flattered the oppressed, nor inflamed them. It told impartial truth to them and to the rich and to the poor. It laid the law of duty on the slave and his master. It bade the slave consider his obligations rather than his rights. It sowed the seed of salutary and ever-developing reforms."

Wherever the Gospel has been proclaimed and received, ancient wrongs have been righted.

Not Giraffes but Sheep

A minister admonished his people thus: "Friends, to make our church services what they ought to be, you must bring with you three books: a Biblebook, a hymnbook and a pocketbook." He spoke wisely.

Yet another book could be useful in some church services: a dictionary.

Long ago the Saviour, who spoke so simply that little children could understand Him, admonished His disciple: "Feed my lambs." His meaning is clear. We should put the spiritual food so low that little ones can reach and understand it. Then the older sheep of His pasture can get it too.

GROWTH

None Perfect

In an early American Indian tribe, when a princess came of age she was given a basket and instructed to pick the best ears of corn in a given row. There was one condition: She must choose the ears as she went along. She could not turn back, retrace her steps or select ears she had passed by.

Many a princess failed this test of judgment. She would marvel at the high quality of the corn, as she felt the firm ears on the stalks and she would be tempted to pluck them. Then, thinking that perhaps there were better ears on the stalks ahead, she would wait to see. Suddenly to her surprise and bitter disappointment, she would find herself at the end of the corn row with her basket empty. While looking for perfection, she had missed gathering any ears at all.

How like ourselves was that Indian princess! We look for perfection in ourselves and others, and fail in our search. Why? The nearer we approximate perfection, the greater is our ability to discern our imperfections. Then we confess with God's servant of old, "Not as though I had already attained, either were already perfect" (Phil. 3:12a).

The Bible challenges us thus: "Let us go on unto perfection" (Heb. 6:1a).

Told by CLAUDE A. FRAZIER
in *The Presbyterian Journal*

* * *

Leaden Feet

Of Lot's wife, it has been said, "She walked backward through today, that she might see yesterday's face. She did not know where the change came and she stood solid in one place!"

Some seek to view the future through a rearview mirror. Some stumblingly inch forward on leaden feet when they could "mount up with wings as eagles" (Isa. 40:31).

Hesitant, irresolute ones incur God's displeasure: "Now the just shall live by faith: but if any man draw back, my soul shall have no pleasure in him" (Heb. 10:38).

* * *

Contrary Winds

The desire to undertake difficult and seemingly impossible ventures is inherent in man.

Mount Everest is the world's highest mountain. Scaling its heights has for years challenged brave and intrepid mountain climbers.

In 1971, a party started their ascent to reach Everest's top. Later, the leader of the party, Col. Hector Gativa Toloso, reported by radiotelephone that winds of 100 miles per hour made it impossible for them to continue their upward climb.

In life, God's children are often buffeted by stormy gales and contrary winds. The ascent to heaven is rough and rugged: "We must through much tribulation enter into the kingdom of God" (Acts 14:22b). This causes God's children to become discouraged.

That is what happened long ago: "The soul of the people was much discouraged because of the way" (Num. 21:4b).

God does not want His children to re-

treat: "If any man draw back, my soul shall have no pleasure in him" (Heb. 10: 38b). His command is: "Let us go on unto perfection" (Heb. 6:1a).

* * *

Upward and Onward

Lt. John A. Macready of the Army service set a new altitude record when he reached a height never before attained by an airplane pilot to that date. In a test flight over Dayton, Ohio, he pushed his plane to 40,800 feet above sea level—nearly eight miles. Macready used oxygen above 20,000 feet, but near the ceiling of the flight, when ice accumulated in the oxygen tube, he had to resort to an emergency tank that he carried strapped to his body.

"Upward and onward" must ever be the motto of God's children. Long ago Paul said, "I press toward the mark for the prize of the high calling of God in Christ Jesus" (Phil. 3:14).

* * *

Love Nudges Us Onward

One day William F. Danforth, of the Ralston Purina Company, was climbing a steep mountain trail with his little five-year-old grandson. As they were toiling upward, he asked, "Are you tired, Jimmy?"

Jimmy quickly answered, "My feet are tired, but myself isn't!"

Jimmy was tired physically and longed to sit down and rest, but his will made his feet plod on.

The Presbyterian Journal

* * *

Quo Vadis?

Oliver Wendell Holmes said, "I find that the great thing in this world is not so much where we stand as where we are moving to."

David Livingstone said, "I'll go anywhere provided it is forward!"

Getting Nowhere Fast

Rowland Hill said to a child astride a rocking horse, "My dear child, you remind me of many Christians—plenty of motion but no progress."

God's command to His children is, "Let us go on unto perfection" (Heb. 6:1).

* * *

Maturity Is Not There

Lt. Gen. Beverley E. Powell, a staunch supporter of good schools and colleges said, "Our present academic society doesn't bother with responsibility. The forced-feeding type of education has not taught maturity. It deals in theory.

"In the past we equated maturity with education, but now maturity is not there. The young have had no responsibility. Everything has been dished out to them. They have the education. Now we must teach them responsibility."

How it must grieve the heavenly Father when His children fail to grow up and become mature, responsibility-assuming individuals.

The Bible says, "It is good for a man that he bear the yoke in his youth" (Lam. 3:27).

* * *

Long Enough

Doc Hall could hardly believe his eyes when he flew his plane low and saw a black bear with a 20-pound coffee can stuck fast on its head. The bear was walking around in circles in the area of Devil's Creek, Alaska. In rummaging 'midst castoff garbage, the bear had stuck its head inside the can and could not extricate it.

Hall said, "The bear must have walked more than 500 miles in circles. It had made six worn smooth circular paths in the thick blanket of leaves and twigs which covered the ground."

A rescue party was flown into the area to liberate the creature. After they had fired several tranquilizers into the bear, the rescuers cut the can from the bear's head. Soon it was on its feet, walking in a straight line.

Sometimes God's children are enmeshed by an endless daily round of marginal activities which contribute little or nothing to their growth into Christlikeness. They produce one hundred percent motion, and zero progress. Long ago God said to His people: "Ye have compassed (circled) this mountain long enough: turn you northward" (Deut. 2:3).

* * *

A Birthday Wish

Health enough to make work a pleasure;
Wealth enough to support your needs;
Strength enough to battle with difficulties and overcome them;
Grace enough to confess your sins and forsake them;
Patience enough to toil until some good is accomplished;
Charity enough to see some good in your neighbor;
Love enough to move you to be useful and helpful to others;
Faith enough to make real the things of God;
Hope enough to remove all anxious fears concerning the future.

GOETHE

GUIDANCE

Serendipity

Serendipity is the faculty for making desirable discoveries by accident. To illustrate, in searching for a direct route to Asia, Columbus stubbed his toe on America.

What miracles of God's guidance God's children discover as they daily walk in the pathway of God's choosing.

While searching for his father's straying asses, Saul was anointed to be the king of Israel.

While tending the sheep of his father-in-law on the back side of the desert, Moses received from God a history-changing assignment.

"O the depth of the riches both of the wisdom and knowledge of God!" (Rom. 11:33).

* * *

Signpost Reversed

As an old man lay near death, he was manifestly troubled. When asked the reason for his distress, he replied, "One day, when I was young, I was playing with some other boys at a crossroad. We reversed a signpost so that its arms were pointing in the wrong direction, and I've never ceased to wonder how many people were sent in the wrong direction by what we did!"

Each one of God's children should be a signpost pointing others to "the Lamb of God, which taketh away the sin of the world" (John 1:29b).

ALICE M. KNIGHT

* * *

Missiles Not Needed

Said Gen. David M. Shoup, U. S. Marine Corps, "If in this troubled world we can produce enough God-guided men, we won't need guided missiles!"

* * *

"I Never Really Knew"

Said Dr. George Boyd, professor emeritus of journalism at Syracuse University, "I never really knew what Christianity was all about until I searched for myself and read the Bible with an open mind. I have found God's Word to be a guidebook for life."

Long ago the psalmist said, "The entrance of thy words giveth light; it giveth understanding to the simple" (Ps. 119:130).

* * *

Life Is a Voyage

On January 8, 1971, the French ship *Antilles* ran aground on an uncharted submerged reef near the Caribbean island Martinique. After striking the reef, the 19,828-ton vessel burst into flames! The 635 voyagers on board were rescued, but

GUIDANCE

the luxury liner, valued at $14.4 million, was considered a total loss.

Life is a voyage. With Christ at the controls of our life we are sure to make the heavenly haven: "He bringeth them unto their desired haven" (Ps. 107:30b).

Jesus, Saviour, pilot me
Over life's tempestuous sea;
Unknown waves before me roll,
Hiding rock and treacherous shoal;
Chart and compass come from Thee,
Jesus, Saviour, pilot me.

EDWARD HOPPER

* * *

I Securely Go

Not for one single day
Can I discern my way,
 But this I surely know:
Who gives the day
Will show the way
 So I securely go.

JOHN OXENHAM

* * *

"I Shall Arrive"

I see my way as birds their trackless way,
I shall arrive! What time, what circuit first,
I ask not: but unless God send his hail
Or blinding fireballs, sleet or stifling snow,
In some time, His good time, I shall arrive!
He guides me and the bird. In His good time.

ROBERT BROWNING

* * *

The Desired Haven

Astronaut John Glenn compared divine guidance to the compass in an aircraft. He said, "All who fly stake their lives on the compass. They read it in full faith that it will guide them where they want to go. Likewise the Christian places his life in the hands of God, assured of arriving at the desired destination by his personal faith in the guiding influence of Christ."

The Bible says, "So he (God) bringeth them unto their desired haven" (Ps. 107:30b).

Only One Way

One day Mark, age seven, was out hiking with his dad in the woods near their cabin. Farther and farther they went into the dense woods.

Mark began to feel a little uneasy. He asked, "Dad, are you sure you know where we are?"

Mark's fear deepened as it began to rain and the booming of thunder was heard.

After a while, Dad confessed that they were lost!

Finally they saw a small cabin. Dad called, "Hello! Is anyone at home?"

A bewhiskered old mountaineer came out. Dad asked, "How do we get back to our cabin from here?"

The oldster grinned and replied, "You can't get there from here. There ain't no path."

"I know that," said Dad, "but I've got to get back."

Said the mountaineer, "There's only one way you can get there and that's for me to take you!" *He became the way!*

Mankind is lost without God, blindly groping on the darksome, downward way. God in mercy sent the Saviour to be our guide—"the way, the truth, and the life" (John 14:6). Millions through the ages have proven the genuineness of His promise: "He that followeth me shall not walk in darkness, but shall have the light of life" (John 8:12).

ALICE M. KNIGHT

* * *

Where She Failed

Miss Margaret Sangster became greatly interested in a boy from a poor family who was badly crippled after an accident. Believing that surgery would help him, she spoke to an orthopedist about the lad. The surgeon agreed to perform several needed operations without cost, and a banker agreed to pay the hospital bill.

After several operations, the boy was able to walk and run. How pleased Miss Sangster was!

As the boy grew into manhood, he got into crime. He was tried, convicted of five horrible crimes and sentenced to die.

Hearing of the tragic end of the young man, Miss Sangster said self-accusingly, "I helped the boy to walk, but I failed to teach him *where* to walk."

How great will be our accountability to God if we fail to divert youthful feet from the dark, downward way and guide them into right paths.

RALPH M. SMITH

Equal Joy

While place we seek or place we shun,
The soul finds happiness in none;
But with a God to guide our way,
'Tis equal joy to go or stay.

MADAME GUYON

HEAVEN

A Crown Well Won

At a verdant site on the campus of Bob Jones University is the tomb of Dr. Bob Jones, Sr., founder of the university.

The epitaph on his tomb is a paraphrase of the words of the apostle Paul, "I have fought a good fight, I have finished my course, I have kept the faith. Henceforth there is laid up for me a crown of righteousness" (II Tim. 4:7, 8). It triumphantly proclaims:

A FIGHT WELL FOUGHT
A RACE WELL RUN
THE FAITH WELL KEPT
A CROWN WELL WON

Will you be able to say at journey's end, "I have fought a good fight. I have kept the faith"?

So live that others will say of you,

Servant of God, well done!
Thy glorious warfare's past;
The battle's fought, the race is won.
And thou art crowned at last!

CHARLES WESLEY

* * *

Not Medals But Scars

Elbert Hubbard, author, said, "God will not look you over for medals, degrees or diplomas, but for scars."

How many of us can say with the apostle Paul, "I bear in my body the marks (scars of service) of the Lord Jesus"? (Gal. 6:17b).

* * *

"Ah! 'Tis Heaven At Last!"

Said Martin Luther, "I would not give one moment of heaven for all the joy and riches of the world, even if they lasted thousands and thousands of years!"

* * *

What Appeals Most?

Dr. George W. Truett asked a widow who was left with the care of several small children, "As you think of heaven, what about it appeals most to you?"

The toilworn woman put aside her sewing and said, "O, sir, that I will rest when I get over there. I am so tired. These children must have my care at all hours of the night. Their father is gone, and I have to be the breadwinner. When I am out of work, I have to go from place to place, seeking work. I get so tired in body, mind and spirit. The most appealing thing to me is that I will rest in heaven!"

The Bible says, "There remaineth . . . a rest to the people of God" (Heb. 4:9).

* * *

Calvinistic or Arminian?

Much has been said about the Whitefield-Wesley dispute. Too much, in fact, for it lasted only a short while and was soon forgotten by them.

Whitefield was strongly Calvinistic, and Wesley was equally strong in his Arminian belief. Yet in the pulpit, they had unanimity of belief on the changeless requisite for salvation: "Ye must be born again."

One day a friend, who was a strong adherent to the Calvinistic belief, asked Whitefield, "Do you expect to see Wesley in Heaven?"

Thoughtfully Whitefield replied, "I

93

fear not. He shall be *so near the throne of God*, and we shall be at such a distance from it, that we shall hardly get sight of him!"

In heaven all denominational badges will drop off!

* * *

How Bright!

Ralph Waldo Emerson wrote, "If a man carefully examines his thoughts, he will be surprised to find how much he lives in the future. His well-being is always ahead."

How bright is the future for God's children: "It doth not yet appear what we shall be: but we know that, when he shall appear, we shall be like him; for we shall see him as he is" (I John 3:2).

* * *

Eternal Spring

Said the German poet and dramatist Goethe, "Winter is on my head, but eternal spring is in my heart. The nearer I approach the end, the plainer I hear around me the eternal symphonies of the worlds that invite me. For half a century I have been writing my thoughts in prose, verse, history, drama, philosophy. I have tried them all. Yet I have not said a thousandth part of what is in me!"

* * *

Enfolded in His Love

A sorrowing widow asked her pastor, "Where are the souls of those who have passed away? The day before my husband died, he said, 'I am Christ's and Christ is mine!' I know he was saved, but where is his soul now? The Bible tells about the future resurrection of the redeemed, but it also says that the saved ones go directly to be with the Lord. Where is my loved one now?"

The pastor replied, "If we believe that God loves us, we do not need to know the answer. Jesus said, 'I go to prepare a place for you . . . that where I am, there ye may be also' (John 14:3). If we are with Him, does it matter *where* that is? Paul said, 'Neither . . . things present nor things to come . . . can separate us from the love of God, which is in Christ Jesus

our Lord' (Rom. 8:38, 39). Your husband is with Christ, enfolded in His love and care. He is forever blessed and is at rest!"

I know not where His islands lift
Their fronded palms in air,
I only know I cannot drift
Beyond His love and care.

<div align="right">Whittier</div>

* * *

Where Physical Limitations End

Upon the death of Anne Sullivan, her patient, painstaking teacher, Helen Keller said, "I look forward to the world to come where all physical limitations will drop from me like shackles; I shall again find my beloved teacher, and engage joyfully in greater service than I have yet known!"

What joyous surprises await God's children when they awaken with Christ's likeness in heaven: "Eye hath not seen, nor ear heard, neither hath entered into the heart of man, the things which God hath prepared for them that love him" (I Cor. 2:9). There we will be like Him, "for we shall see him as he is" (I John 3:2b).

In heaven, we will be fully satisfied and have full-orbed knowledge: "I shall be satisfied, when I awake, with thy likeness" (Ps. 17:15); "Then shall I know even as also I am known" (I Cor. 13:12).

In heaven, we will be eternally united with our loved ones who died in the Lord: "But now he is dead . . . can I bring him back again? I shall go to him, but he shall not return to me" (II Sam. 12:23).

In heaven, we will be completely conformed to the image of Christ!

I want to go there, don't you?

* * *

Only Two Destinations

When the astronauts of Apollo 11 astonished the world with their spectacular visit to the moon, they took their spaceship on a very narrow trajectory through space. Only the tiniest margin for deviation was permitted, and flight corrections were made periodically throughout the historic voyage.

Now suppose the NASA control center in Houston had received word from Apollo 11 that the astronauts were off course and Houston had replied, "Oh, that's all right. There are a number of roads leading to the moon!" They never would have come back!

People today don't like the word "narrow," but Jesus said that there are two roads to the future, with two destinations—heaven and hell, and that the way to hell and destruction is broad, but the way to heaven is narrow, and "few there be that find it."

Which road are *you* on—the broad road which leads to destruction, or the narrow road which leads to eternal life?

BILLY GRAHAM

* * *

Toes Within the Gates

Captain Edward Rickenbacker, an ace aviator in World War I, had a close brush with death when his plane crashed in a swamp near Atlanta, Georgia. He was critically injured. For days his life hovered close to death. Later, in speaking of the ordeal, he said, "Seven times my toes were within the gates of death! But I had no fear—only ineffable joy as scenes of indescribable glory and beauty beyond description came into view!"

Long ago Paul was "caught up to the third heaven . . . and heard unspeakable words" (II Cor. 12:2b, 4a).

As Dwight L. Moody's life ebbed away, he exclaimed, "I see heaven opening! God is calling! I must go!"

Told by RALPH M. SMITH

* * *

"What If It Were Today?"

High on a hillside in Jerusalem lives eighty-three-year-old Hans Kroch, a retired Israeli business man from Leipzig. He is building a model of the eternal city, an exact replica of Jerusalem as it was in 66 B.C. With a scale of one quarter inch to one foot, it sprawls over six hundred square yards. The model will cost approximately $1 million by the time it is finished.

God's children around the world are looking for a descending "holy city, new Jerusalem . . . from God out of heaven" (Rev. 21:2); when "sorrow and mourning shall flee away" (Isa. 51:11b); when our war-sundered, sin-sodden world "shall be filled with the knowledge of the glory of the Lord, as the waters cover the sea" (Hab. 2:14): "For here we have no continuing city, but we seek one to come" (Heb. 13:14).

* * *

No More Tears

A pastor sat at the bedside of a member of his church who said, "Pastor, I know I am going to die, but I have no fear. As I pass through the valley, the One who has been with me in life will be with me, and I will eternally be with Him in glory."

As the dying man thus spoke, tears came to his eyes. Tenderly the pastor took his handkerchief and wiped away the tears.

Said the grateful man, "Pastor, the next time tears are wiped from my eyes, God Himself will do it!"

Did he not speak scripturally? He surely did. The Bible says, "And God shall wipe away all tears from their eyes; and there shall be no more death, neither sorrow, nor crying, neither shall there be any more pain . . . These words are true and faithful" (Rev. 21:4, 5).

Told by RALPH M. SMITH

* * *

Attired in His Best

In a group of ministers, a dear friend of mine related an occurrence which deeply touched me and others, too. He said, "It is with difficulty that I relate an incident which is etched indelibly upon the scroll of memory. My father, a minister, was hospitalized when he became critically ill. On visiting him one day, I found him immaculately dressed in his best suit.

" 'Why, Dad!' I said. 'What does this mean? You are ill. Put on your pajamas and get back in bed.'

"Dad said, 'Son, I'm going home! I'm going to my heavenly home!'

"The thought was dominant in his mind. He wanted to appear in the presence of his Lord attired in his best.

"A short while thereafter Dad did go to his eternal home to be forever with his Lord. He was ready to appear before Him acceptably and rejoicingly because he was 'dressed in His righteousness alone, faultless to stand before the throne!'"

Told by RALPH M. SMITH

* * *

"Suppose He Isn't in Heaven?"

Said Dr. Carl F. H. Henry, "In one of my last street meetings, during my college years, a heckler kept shouting, 'Where did Cain get his wife?'

"When I could ignore the disturber no longer, I replied, 'When I get to heaven, I'll ask him!'

"'Suppose he isn't in heaven?' parried the disrupter.

"I retorted, 'Then you can ask him!'"

* * *

"It's Wonderful"

"Ever since surgery had revealed that my mother had an inoperable malignancy," said Julia Tinkey, "I had spent a part of each day at her side in a hospital. This night I had to be with her. All her life Mother had been such an active person, teaching school, running the farm, raising five children, and cheerfully taking on tasks at church. As I sat at her bedside, I prayed that mother would not go with drugs numbing her mind and that she be allowed to go to God in dignity and peace.

"As I sat prayerfully with her, she stirred and said, 'Julia, are you there?'

"I assured her that I was. Her eyes opened and she said, 'The doctor told me. And, Julia, it's all right. I am in God's care and it's wonderful!'

"As she talked, she seemed to be bathed in effulgent light! As I gazed intently at her, the mysterious radiance seemed to envelope me too. She was smiling, and I smiled back at her. I felt that Mother was seeing a world beyond the physical world, and that I was almost there with her. I asked, 'Do you mean, Mother, that you see God?' She replied, 'Yes, Julia, face to face! It's so wonderful!' I asked, 'What's so wonderful? Tell me!'

"She replied, 'Millions and millions of people! There's light, light everywhere!'

"These were her last words. Her eyes closed, but the smile did not fade."

Wondrous and indescribable glory awaits God's children when they come to life's setting sun: "At evening time it shall be light" (Zech. 14:7b). Paul earnestly desired "to depart and be with Christ; which is far better" (Phil. 1:23).

Adapted from Guideposts

HELL

Son, Remember

Shakespeare wrote, "To be alone with my conscience is hell enough for me."

A philosopher said, "Hell is at the end of a misspent life."

Milton said, "Which way is hell? Myself is hell."

In hell, memory is acutely and accusingly alive: "Son, remember that thou in thy lifetime receivedst thy good things, and likewise Lazarus evil things: but now he is comforted and thou art tormented" (Luke 16:25).

The Bible says, "The wicked shall be turned into hell, and all the nations that forget God" (Ps. 9:17).

Living in Hell

Kathleen Spiller, 26, was one of two women charged in the disappearance of $492,000 from the Penticton, B.C., branch of the Royal Bank of Canada. For nearly three years, she had taken money from the bank. During that time, she spent thousands of dollars on cars, clothes, jewelry and her home. An aching conscience finally led her to confess the embezzlement. She said, "I could not go on living in hell!"

Adapted from The Prairie Overcomer

Agonizing Concern

Sometime ago, a plane carrying twenty-four Tennessee sportsmen to a hunting expedition in British Honduras, crashed in a heavy fog and burned at New Orleans International Airport. Sixteen perished!

A survivor commented, "It was an agonizing thing to watch that plane burn and know your friends were in it!"

O that all of God's children had an agonizing concern for Christ rejectors who are in the darksome, downward way whose terminus is hell: "And in hell he lifted up his eyes . . . for I am tormented in this flame" (Luke 16:23, 24b).

Unrestrained

Some years ago, in commenting upon the causes of diminishing church attendance in England and the relaxation of moral standards, *The London Times* editorialized: "Among the causes, there can be little doubt that one of the chief has been the disappearance of the belief in eternal punishment. Rightly or wrongly, men are not afraid of God as they used to be, and have cast off restraints which fear imposed."

HOLY SPIRIT

Later May Be Too Late

The ancients conceived of opportunity as a fleet-footed runner, with a forelock on his head. The back of his head was bald. The runner could be seized by the forelock when he was passing by. Having passed, he was gone forever.

How freighted with eternal consequences is the moment when we feel the wooing of the Holy Spirit, saying, "Give me thine heart." Later may be too late to respond to His plea. Long ago God warningly said, "My Spirit shall not always strive with man" (Gen. 6:3a).

* * *

A Sure Tranquilizer

In response to a delegation of complaining citizens, an airport manager said, "There will soon be more powerful, even noisier engines, plus a sonic boom. We're in for trouble, all of us!"

Complained John Milton three centuries ago, "A barbarous noise environs us." What would he say today?

Amidst the clack and clatter of multitudinous noises, how difficult it is for God's children to become sufficiently quiescent before God to hear the "still small voice" of the indwelling Holy Spirit.

We become spiritually depleted when we fail to obey the tranquilizing directive: "Be still and know that I am God" (Ps. 46:10).

The Slow Agent of Death

As reported in *The Edmonton Journal,* a New York City otologist said, "Aborigines living in the stillness of isolated African villages can easily hear each other talking in low conversational tones at great distances. But civilized humans have lost that capacity because millions of microscopic hair cells which transmit sound from ear to brain have been destroyed by an incessant flood of noise, and noise is the slow agent of death!"

How tragic it is that so many of God's children have lapsed into a heedless, unhearing condition of which the Saviour warned: "For this people's heart is waxed gross, and their ears are dull of hearing" (Matt. 13:15).

For God's children to hear the still, small voice of the indwelling Holy Spirit, they must become quiescent and unhurried before Him: "Be still, and know that I am God" (Ps. 46:10a).

* * *

Unimaginable Odds

Religious tedium may come to those who face glittering altars listening to unimpassioned discourses by uninspired prophets, while they contemplate how to turn a thousand dollars into ten thousand; but not to those whose symbol is a cross and who wrestle against principali-

97

ties and powers in the arena of the world, witnessing to the best hope of earth. *Ennui* is not for men who "turned the world upside down" through the dynamism of the Spirit who struck fire to the young church and marched it against unimaginable odds to victory!

LON WOODRUM

* * *

Use This Stammering Tongue

In one of Dwight L. Moody's services in London, several members of the nobility were present. One prominent member of the royal family sat in the royal box.

As Moody read the Scripture lesson, he came to the verse, "And many lepers were in Israel in the time of *Eliseus* the prophet" (Luke 4:27). To his embarrassment, he had difficulty in pronouncing Eliseus. Bravely he made three attempts to pronounce the word, but without success.

Closing his Bible, Moody looked upward and pleaded, "O God, use this stammering tongue to preach Christ crucified to these people!"

God answered his plea. Torrents of eloquence poured from his lips. The Holy Spirit's convicting and converting power melted the audience. All of those present knew the answer to the ancient question: "Where is the Lord God of Elijah?" (II Kings 2:14).

* * *

Orthodoxy Functioning

It takes Holy Spirit unction to make orthodoxy function! Is there anything more dead than dead orthodoxy? "Thou hast a name that thou livest and art dead" (Rev. 3:1b).

HOME

A Merchant Prince Testifies

J. C. Penney said, "The highest duty of parents is to build Christian homes where children can grow spiritually strong, and to teach the Bible in season and out of season. I never apologize for better Christian homes, because my entire experience tells me that the dealings between men in business, government and social relationships are influenced for good or ill by home background."

Long ago God gave this directive to parents: "And the words, which I command thee this day, shall be in thine heart; and thou shalt teach them diligently unto thy children, and shalt talk of them when thou sittest in thine house" (Deut. 6:6, 7a).

* * *

Family Prayer

Dr. Donald Lind, a nuclear physicist and astronaut, said, "Science may tell you how electrons bounce off protons, but it doesn't tell you how to handle juvenile delinquency, divorce and war. Most of that, I think, is going to come through common sense and revealed religion. And I think we should start in the home. We have family prayer every morning and evening. Once a week we have 'family night' when my wife and I teach and discuss the principles of the Gospels. The children not only get some instruction, but they know we are believers, too."

Moody Monthly

* * *

A Sure Wrecker

Some years ago, in one of my pastorates, a man whose soul was riven with sorrow, came into my study. "What's the trouble?" I asked.

Between sobs, he said, "As you know, I have a fine and faithful wife, and very dear children. It will be most difficult for me to tell you what occurred at a convention I recently attended in another city. At the convention, liquor flowed freely. Though I seldom imbibe any alcoholic beverages, my associates insisted that I have just one nip. I did. Then, I had another, and another, and another! "The next morning, when I awakened,

there was a strange woman in my room! My wife has learned of what happened, and she is now suing me for a divorce!"

After relating the horrendous story, the man succumbed to uncontrollable grief.

Watch the beginning of sin! Satan is subtle. He doesn't ask anyone to plunge precipitously into sin. He lures his victims on a step at the time, until he brings them to the point of no return—"taken captive by him at his will" (II Tim. 2:26b).

Told by RALPH M. SMITH

* * *

A Flower in Her Hair

A smart woman can keep springtime in her husband's eyes by keeping a fresh flower in her hair. The husband can keep springtime in her heart by supplying the flower!

* * *

Say That Again, Roger!

"Mommy, I wish the one who stole my tricycle would bring it back and then he would live with us," said Roger.

"But, my boy, why do you want a thief to live with us?"

Roger replied, "Mommy, if he lived with us, he would go to church and be saved, and then he wouldn't be a thief anymore."

* * *

When Family Life Deteriorates

Dr. Paul Popenoe, founder of the American Institute of Family Relations, said, "No society has ever survived after the family life deteriorated!"

* * *

Married on the Rock

If ever a marriage was started on the rocks, it was that of Robert Homer Berdan and his bride, Frances Frei, who were married in a ceremony on top of the Rock of Gibraltar, in St. Michael's Cave.

Berdan said later, "We chose the site because we wanted to found our marriage on a rock."

How wise are newlyweds who found their marriage on the enduring Rock of Ages, the Saviour. Of Him the Bible says, "For other foundation can no man lay than is laid, which is Jesus Christ" (I Cor. 3:11).

* * *

"I Missed Out"

Conrad S. Jensen, retired deputy inspector of the New York Police Department, said, "I've missed out on life. At least that is what many of my associates have said, and it's true in a way. I've missed out on a lot of things.

"First of all, I missed coming from a broken home. I missed having an alcoholic for a father or an unfaithful woman for a mother. I missed growing up as a juvenile delinquent. I missed being a 'regular guy' or 'one of the boys' and getting into trouble with them. I missed being a drunk, a dope addict or a degenerate.

"By the grace of God, I missed an unhappy marriage leading to divorce. I missed the heartbreak of having our two children bring disgrace and shame to our home.

"I missed the misery, during over a quarter of a century in police work in New York City, of being tainted and destroyed by the corruption that confronts every policeman in America.

"Ours was a Christian home with emphasis placed on Christian living. Throughout my school days, and then in the business world for a time, I tried to live my convictions as a child of God. Surrounded by those who found pleasure in worldly pursuits, my Christian stand seemed to be out of place and often caused them to remark that I was missing out on a lot of things, and thank God for it!"

* * *

"For God's Sake, Help!"

A scientist at White Sands, New Mexico, was describing to Dr. Louis Evans the calculations which are made to send a rocket to the moon. Suddenly he stopped and pleaded, "Dr. Evans, you're a man of God, aren't you? Then for God's sake help me! My wife is leaving me tomorrow morning!"

99

Scientifically the man was a success. Domestically he was a failure.

What a day is this to enter understandingly and feelingly into the heartaches and heartbreaks of sorrowing ones and bring them to the Mender of broken things—the Saviour! He gives "beauty for ashes, the oil of joy for mourning, the garment of praise for the spirit of heaviness" (Isa. 61:3).

* * *

One Out of Three

Said Billy Graham, "Latest statistics show that whereas one out of three marriages in America ends in divorce, only one out of 500 occurs in homes where there is regular prayer and Bible study!"

* * *

Beauty of Character

An ancient Chinese proverb teaches: "If there is righteousness in the heart, there is beauty in the character. If there is beauty in the character, there will be harmony in the home. If there is harmony in the home, there will be order in the nation. If there is order in the nation, there will be peace in the world."

* * *

Disappointed and Lonely

As I sat in the university Student Union I engaged Janet, an intelligent student, in conversation. She was eager to communicate how she felt on the inside. I wanted to understand what was happening in her life with God, so I listened.

"Since I have been here, I have tried to evaluate what the essence of the Christian faith is as I've experienced it. Frankly, when I look back on my home and my church, I don't think of a loving group of people, full of concern for each other. I don't think of reality in knowing God. I just think of people going through the ritual, all wearing masks. Our family went to church and talked about God and truth, but I knew enough of what was going on in some families to know that there were brokenhearted people, people disappointed with life, and lonely people in those pews. But nobody ever talked about that level of life. We talked about God and doctrinal truth—great thoughts that weren't anywhere on the level where people were living.

"My mother didn't tell my father how lonely she felt, how she wished he would talk with her. She just kept busy, pretending it didn't matter. We never talked or prayed about this. Nothing was ever on the level of the real *you*. We were always acting out some kind of unreal, victorious superexistence!"

When I listen to young people like Janet spell out their disillusionment, I want to print huge signs and put them on the front lawns of every church.

WANTED: THOROUGHLY CHRISTIAN HOMES

We don't need better church programs, additional youth pastors, more catechisms, and more conferences on youth needs. *We need better Christian homes.*

GLADYS M. HUNT
in *Christian Teacher*

* * *

A Blooper

A husband sat before the television looking intently at a hotly contested football game.

Coming beside him, his wife said dejectedly, "Honey. I believe you love football better than you love me."

Continuing to look fixedly at the game, he absent-mindedly replied, "Honey, I do love you more than I love *baseball*!"

Our love for our wife or husband or children is sublimated and glorified, and our love for the wholesome things of life takes its rightful place in our lives when our love for God is preeminent.

"Thou shalt love the Lord thy God with all thy heart . . . soul, and with all thy mind" (Matt. 22:37).

RALPH M. SMITH

100

Woman's Place

Woman was made of a rib
Out of the side of Adam,
Not out of his feet to be trampled upon,
But out of his side to be equal with him,
Under his arm to be protected,
And near his heart to be loved.

MATTHEW HENRY

* * *

"Daddy, You Still Have Us!"

A wealthy man had spent much money, time and effort in collecting curios from distant lands. One night a disastrous fire burned to the ground his palatial home with its valuable, irreplaceable contents.

As the man and his family helplessly huddled nearby, he lamented, "I have lost everything! I have lost everything!"

His little four-year-old boy said, "No! No! Daddy, you still have us!"

Too many of us fail to recognize the value of those who are near and dear to us, while we flatter and give prime attention to those who mean little or nothing to us.

Told by RALPH M. SMITH

* * *

Steps to a Happy Marriage

1. Have your own home, no matter how humble; 2. Share the day's activities with each other and also your hopes for the future; 3. Meet each other at least halfway when discouragements arise. Quarrels are not a matter of *who's* right, but *what's* right; 4. Involve each other in family finances—in spending and saving; 5. Be together in whatever discipline and punishments you use in rearing children; 6. Remember that small acts of appreciation can be the most effective way to demonstrate love and respect for each other; 7. Worship as a family—at home and in church.

Eternity

* * *

When We Fail To Listen

Said John M. Drescher in *Meditations for the Newly Married,* "Communication can be called the core of any successful marriage. When partners fail to listen to each other there is deep trouble ahead Love can survive large problems in the open better than small ones buried and smoldering within."

* * *

Submitting Wives

Said Dr. James M. Boice, speaker on a nationwide broadcast and consulting editor of *Eternity,* "When my wife and I were married, the officiating minister spoke briefly from the verse, 'Wives, submit yourselves unto your own husbands, as unto the Lord' (Eph. 5:22). Afterwards a woman told us that she had never heard those things before. We asked, 'What things?' She replied, 'About a wife submitting to her husband,' and added, 'When I go home I'm going to tear that page out of my Bible!'

"When Paul said wives are to submit themselves to their husbands, he used a verb what means 'to set, determine, or place' and a preposition that means "under.' Thus the words refer to a type of obedience that is supporting—like a foundation supporting a house, or like a member of the White House cabinet supporting the President of the United States. The wife is to have this supporting obedience to her husband. This is not a demeaning position."

How mutilated would be our Bibles if commands we do not wish to obey were torn out! The Book would resemble a plucked chicken.

* * *

Banging Shutters

"Living with a grumbler is like living in a room with the window shutters banging in the wind," said H. E. Lucock. "Grumbling does two things, each fatal to the spiritual life: It shuts out thanksgiving, and dries the spirit of service to our fellowman."

"Do all things without murmurings and disputings" (Phil. 2:14).

101

HUMAN RELATIONS

Don't Marry Her!

A man became greatly interested in a woman whom he wanted to marry. He asked John Wesley's opinion of her.

"Don't marry her under any circumstances," advised Wesley.

"Why not?" the man asked in surprise. "She is a member of your church in good standing, isn't she?"

Wesley replied, "That is right."

"Then why shouldn't I marry her? Can you give me one good reason why I shouldn't?"

Wesley replied, "Brother, the Lord can live with a great many people you and I can't."

The New Immorality?

A panel of psychiatrists and psychologists was discussing the so-called new morality which permits premarital and extramarital sexual relations. A rural minister in the audience asked one sitting near him, "Are they talking about fornication and adultery?"

The ancient command, "Thou shalt not commit adultery," is as binding today as it was when first thundered from the rocky crags of Mount Sinai. Those who go counter to God's adamant, immutable law break not the law but themselves.

"For ever, O Lord, thy word is settled in heaven" (Ps. 119:89).

RALPH M. SMITH

HUMAN RELATIONS

From Kitty Hawk to Venus

Said Dr. Orley R. Herron to the Wheaton College student body, "We have advanced in this century from Kitty Hawk to Venus, but cannot reconcile our black neighbor with our white. We have developed the most devastating arsenal in the history of mankind, but cannot annihilate the ghetto. Our scientists have conquered disease; but hatred and passion control many men of ill will, and millions die each year and have not accepted God's provision for redemption. We must not face-rate society but try to heal it. That healing must be accomplished by Christ in your lives."

* * *

Raucous Discord

Said William Willoughby, "We are rich in goods, but ragged in spirit; reaching with magnificent precision for the moon, but falling into raucous discord on earth."

* * *

Sympathy for Whites

Said a black enthusiast, "I feel sorry for anyone who is not a black in this century."

Hope for All Men

In his acceptance speech at the Republican convention in 1956, General Dwight Eisenhower said, "We must have the vision, and the deep religious faith in our Creator's destiny for us, and believe that in our time there can emerge with God's help good will and good hope for all men."

* * *

"I Have a Dream"

Said Martin Luther King, "I have a dream that someday my four children will be judged not by the color of their skin, but by their character."

"Man looketh on the outward appearance, but the Lord looketh on the heart" (I Sam. 16:7b).

* * *

Outside and Inside

In presenting a white visiting minister to his congregation, a Negro pastor said, "On the outside, he's white. On the inside, he is as black as we are."

In God's sight racial colors blend into one. All men are equal before Him: "God

is no respecter of persons: but in every nation he that feareth him, and worketh righteousness, is accepted with him" (Acts 10:34, 35).

* * *

Where Christianity Took Root

Dr. George Sweeting, president of the Moody Bible Institute, Chicago, said, "The apostles concentrated their efforts in the throbbing cities of their day. Some of the Epistles are evidenced of the importance of the cities after which they were named. The City of Ephesus was notorious for its moral looseness. Corinth seethed with vice. Rome was riddled with perversions, court plots, and murders. Yet those were the centers where Christianity took root and flowered."

Oh, that more of us were weeping over our sin-sodden, crime-ridden cities as did the Saviour: "And when he was come near, he beheld the city, and wept over it" (Luke 19:41).

* * *

A New Heart

In *The London Observer*, Arnold Toynbee wrote, "What mankind needs is a new way of life with new aims, new ideals, and a new order of priorities."

The Bible affirms that a new way of life results from a new heart and a new nature which God imparts through the miracle of regeneration: "A new heart also will I give you, and a new spirit will I put within you: and I will take away the stony heart out of your flesh" (Ezek. 36:26). Only transformed individuals can transform our sin-sodden society.

* * *

A Practical Suggestion

In commenting upon the racial street demonstrations, black pastor Henry Mitchell of the North Star Missionary Baptist Church in Chicago, said, "The marchers don't represent the mass of the Negro people. I propose that marchers march to the West Side slums with rakes, brooms, and grass seed to spruce up the area."

Lost Canyons of Cities

Said Monsignor Francis J. Lally, editor of the *Boston Pilot*, "The world is wounded seriously in many ways. Favored nations have everything they want, while one-half of the children in underdeveloped countries die before they are fifteen, and one-half in Latin America die before they are four. Most American cities detour us around the problem. As we speed along the expressways, we never see the poor sections—the lost canyons of the cities, or the blighted fields of Appalachia."

* * *

Man's Inhumanity

Many and sharp the numerous ills,
 Interwoven in our frame;
More poignant still we make ourselves,
 Regret, remorse and shame;
And man's heaven-erected face,
 The smiles of love adorn;
Man's inhumanity to man,
 Makes countless thousands mourn.

ROBERT BURNS

* * *

Redeemed Ones in Society

Said Dr. Hudson T. Armerding, "The most comprehensive legislation and the most massive financial aid will not solve today's problems unless first society has in it men and women of principle and integrity. Those who are overcome by alienation, meaninglessness, and despair cannot purposefully contribute to the solution of the world's ills. The transforming power of the Gospel speaks directly to these fundamental needs. Redeemed individuals in society are the salt of the earth and the light of the world."

* * *

Highest Social Stratum

Said Rev. Tom Skinner, a black evangelist, "I'm a son of God. I do not have to fight for dignity, because I belong to the royal family of God. I've been purchased by the blood of Christ, which puts me in the best family stock in the world. I do not have to fight for economic equal-

ity, because I'm a joint heir with Jesus Christ. That makes me rich! I do not have to struggle for social equality, because I am seated together with Jesus Christ in heavenly places. This puts me in the highest social stratum."

* * *

We Haven't Come to Burn

Dr. J. H. Jackson, pastor of Chicago's large Olivet Baptist Church and president of the National Baptist Convention, said in the opening session of the convention in Atlanta, "We have not come to disturb the ordinary business of Atlanta. We have not come to burn your buildings. We have not come to shed any tears. We have come to tell America there is no hope outside of Jesus Christ!"

Chicago Daily American

* * *

White Race Atrocities

Through the centuries, rivers of blood have flowed because of man's inhumanity to man. The following blood-chilling incidents were given in *Time*, May 3, 1968:

"Like the North American Indian before him, the Brazilian Indian has had no worse enemy than the white man and the white man's ways. Early Portuguese colonizers and their descendants enslaved natives by the thousands, butchered whole tribes as a warning to others, ruthlessly flogged, tortured or starved any Indian worker who stepped out of line. In their massacres, the officials and speculators displayed a grisly relish and inventiveness. In the Bahia state, the government claims, white men purposely killed off two tribes of Pataxo Indians ten years ago with inoculations of smallpox virus in order to get their land. In Mato Grosso five years ago, a gift of sugar laced with arsenic wiped out the Tapaiuna Indians. In Parana, where land prices are high, the Guarani tribe has fallen from 5,000 members to 300 in the past ten years."

The desperately wicked heart of unregenerated man is capable of committing the most fiendish and atrocious crimes against mankind.

Black Race Atrocities

The white race is not the only perpetrator of horrible crimes and inhumanities. The civilized world looked aghast upon Nigeria's strangulation war against tiny Biafra. Commented *Time*, Aug. 23, '68: "Eight million Biafras are starving to death. Gradually the image of Biafra's human agony has unsettled the conscience of the world. The image is of Ibo infants and children with anguished, vacant eyes, distended bellies, shriveled chests and matchstick limbs crippled from edema. In the border town of Ikot Ekpene, the emaciated bodies of a brother and sister lay side by side in a rough cradle. Their eyes had been pecked out by vultures still circling overhead, waiting to attack a line of wasted bodies in a ditch outside of town."

* * *

When a Prodigal Was Rehabilitated

Some tell us that the church has concentrated too long on the *vertical* man-to-God relationship and is now beginning to catch up on the *horizontal* man-to-man relationship. So today the watchwords are relevance and involvement. We are getting more excited over Lazarus in his poverty than over Dives on his way to hell. Some are for putting the robe on the prodigal son while he is still feeding swine, killing the fatted calf for a generation still feeding on husks. They seem to have forgotten that the prodigal was rehabilitated *after* he returned to the Father."

VANCE HAVNER

* * *

Where Poverty Exists

Commented *The Sentinel Star* in Coburg, Canada, "A country is surely going to the dogs when politicians declaim the low income people as poor people. Poor people are those who have money in the bank and poverty in the head, who never experience the happiness of fashioning something with their hands. Bound by selfishness, they can never be rich in sharing. Poverty exists in the mind. No one is poor who has eyes to see and ears to hear."

Spiritual Progress

Said A. J. Toynbee, renowned historian, "The spiritual progress of individuals in this life will in fact bring with it much more social progress than could be attained in any other way."

* * *

Sowbelly and Beans

In asking Congress for money owed his Indian tribe in Oregon, Roy McIntyre, known as Chief Yellow Streak in the Snow, said, "The red man continues to live on beans and sowbelly. Once people said the black men were the dirtiest and the red men the meanest creatures alive. Now it's just the opposite. The Indians are the dirtiest and the black men the meanest. How can we Indians ever get together like the black men and fight for our just rights?"

* * *

If We Survive

Said Franklin D. Roosevelt, "If civilization is to survive, we must cultivate the science of human relationship—the ability of all peoples, of all kinds, to live together in the same world at peace."

"The Lord make you to . . . abound in love one toward another, and toward all men" (I Thess. 3:12).

* * *

When Color Distinctions Vanish

A weary teacher entered her home after a hectic day at school. She sank wearily in a chair and fell asleep. As she slept, she dreamed that the Master would soon visit her class. Hastily she began to arrange her pupils for His visit, putting the white children in the two front rows and the Mexican and black children behind them.

Then she thought, "This isn't right!" Distressed, she decided to rearrange them.

At that moment, the Master entered! In His presence, all color distinctions vanished!

The teacher awakened with a changed attitude toward her pupils of different colors and races. She thereafter had unfeigned love for all of them!

"Go Away"

In a newspaper, there was a brief essay written by a sixth-grade Israeli boy in Jerusalem.

One day the Israeli saw coming toward him a small Arab boy with dirty feet and tattered clothes. Holding out a package of chewing gum, the boy pleaded, "Buy this! Inly ten *agorot!*"

The Israeli walked faster, but the little Arab trotted after him. Then the Israeli shouted, "Go away! Leave me alone!"

Sad-faced, the little Arab boy walked away. Then the Israeli lad became sad. He thought, "Why did I act so cruelly?" Tears came to his eyes. He tried to find the small Arab boy, but the boy had vanished in the midst of the people.

Throughout the day, the Israeli boy was troubled in his heart. He could not forget the piteous plea, "Buy this! Only ten *agorot!*"

How like that Jewish lad are many of God's children—unresponsive to the piteous pleas of bothered, burdened ones about them. God's Word says, "As we have . . . opportunity, let us do good unto all men, especially unto them who are of the household of faith" (Gal. 6:10).

* * *

Wilderness of Human Want

Said H. E. Lucock, "The ancient barriers of race, clan, color and class, with their fearful taboos, high walls of exclusion, had no meaning for Jesus. The whole course of social betterment has been following in His footsteps through the wilderness of human want and need. He is still far ahead in the unconquered wastes of life."

A characteristic of a Christlike Christian is unfeigned love for all mankind.

* * *

Twisters Or Bullies

Said C. S. Lewis, "As long as men are twisters or bullies they will find some new way of carrying on the old game under the new system. Without good men, you cannot have a good society."

INFLUENCE

The Decisive Seat of Evil

Said George Kennan, former U. S. ambassador to Russia, "The decisive seat of evil in this world is not in the social and political institutions, but simply in the weakness and imperfections of the human being, including myself and the student militant at the gate."

Resident in the "deceitful . . . and desperately wicked" heart of man are "evil thoughts, adulteries, fornications, murders" (Mark 7:21).

* * *

The Only Catalyst

Hatred is always present in the "desperately wicked" heart of man. There is no country in the world where large populations of two different races live in harmony. The Irish hate the English; the British hate the Jamaicans in their midst; the Swedes hate Norwegians. Most Europeans hate Russians, and Russians hate and distrust most foreigners. Frenchmen hate Germans, and vice versa. Arabs have an implacable hatred for Jews, and Jews hate Arabs. Malaysians and Indonesians hate Chinese and communistic Chinese hate and distrust everybody. Most tribes in Africa hate one another. Pakistanis hate Indians and vice versa, *ad infinitum!*

In America, some white people hate black people, and some black people hate white people.

The only catalyst for changing racial hatred and ill will is God's love for all mankind in our hearts. Christ commands His followers, "Love one another, as I have loved you, that ye also love one another" (John 13:34).

* * *

Pigmentocracy

Said Bill Pannell, "When you are judged by your color before you can open your mouth, the republic has become a pigmentocracy."

INFLUENCE

A Living Force

"A good name," said Henry Ward Beecher, "awakens among those who hear it honoring thoughts, lively emotions of pleasure, respect, gratitude, confidence and even love and enthusiasm. It is not a dry, leafless thing with faded remembrance of beauty. It is a living energetic force. In short, a good name is the impression which your real life has produced on the heart and the imagination of those who have known you."

The Bible says, "A good name is rather to be chosen than great riches, and loving favor rather than silver and gold" (Prov. 22:1).

* * *

Verbal Dynamite

The words and writings of Erasmus led to the *Renaissance.*

The words and writings of Nikolai Lenin, Karl Marx and Friedrich Engels, led to *revolution.*

The imperishable Word of God leads to *regeneration:* "Being born again . . . by the word of God, which liveth and abideth forever" (I Pet. 1:23).

We cannot overestimate the far-reaching influence of a good book, nor the mind-warping influence of a bad one!

* * *

Who Should Be Blamed?

Self-censuringly a teacher said, "We professors have lost our religion. We do not know what people should live by. Conditions in the world demonstrate the condition of the individuals in it. Most people have been trained by teachers. We, the teachers, are most to blame for our world. We have failed."

German Chancellor Bismarck affirmed, "What you want the state to be like tomorrow, you must introduce in the schools today."

Who can overestimate the character-molding influence of a Christ-like, Bible-believing teacher?

Crookedness

There was a crooked man,
Who had a crooked smile,
Who made a crooked fortune.
In a very crooked style.

He lived a crooked life,
As crooked people do,
And wondered how it turned out
His sons were crooked, too.

AUTHOR UNKNOWN

* * *

Persona Non Gratis

In Kenya, Africa, hippies are considered unwanted corrupters of African youth. They are called apostles of drugs, pornography, and loose sexual morals, and, worst of all, parasites living on others.

The *Uganda Argus* has called for a limitation of all tourist travel by hippies "so that they do not have the opportunity to inflict their repugnant appearance and way of life on African youths."

Many young people are disillusioned with the status quo. It is our privilege to try to enter concernedly into their lives, bring them to the Saviour and turn them to the pathway of ennobling service for God and man.

* * *

A Better World

Said Phillips Brooks, "No man or woman of the humblest sort can be really strong, gentle, pure and good without the world being better for it."

* * *

This Is Living-stone!

When David Livingstone's body was brought to England for burial, a poem written in his honor was printed in *Punch.* One verse of the poem said:

He needs no epitaph to guard his name,
Which men will prize while worthy
work is known,
He lived and died for good, be that his
fame,
Let marble crumble—this is Living-
stone!

Christ is building His church not with stone, steel and mortar, but with living stones—redeemed boys and girls, men and women: "Ye also as lively (living) stones, are built up a spiritual house" (I Pet. 2:5a).

* * *

A Sense of Him

For me 'twas not the truth you brought,
To you so clear, to me so dim,
But when you came you brought
A sense of Him.
And through your eyes He beckoned me,
And through your heart His love was
shed,
Till I lost sight of you and saw
The Christ instead.

AUTHOR UNKNOWN

JESUS

"I Freely Give"

Spectator said, "Pure water is the best of gifts that man to man can bring."

Pure water is getting increasingly difficult to find. The Danish government has begun marketing pure ice from Greenland's ancient glaciers and icebergs, samples of which were recently displayed in Washington, D. C., at the opening of a Smithsonian exhibition called "Greenland Arctic Denmark." Greenland's ice is probably the last source of unpolluted water.

Long ago the Saviour brought living water to slake man's spiritual thirst. To spiritually parched souls, He said: "If any man thirst, let him come unto me, and drink. He that believeth on me . . . out of his (innermost being) shall flow rivers of living water" (John 7:37, 38); "If thou knewest the gift of God . . . thou wouldest have asked of him, and he would have given thee living water" (4:10).

JESUS

I heard the voice of Jesus say,
"Behold, I freely give,
The living water; thirsty one,
Stoop down, and drink, and live!"

HORATIUS BONAR

* * *

"Nothing Shall Detract"

When Leonardo de Vinci was forty-three years old, the Duke Ludovinco of Milan asked him to paint the dramatic scene of Jesus' last supper with His disciples.

Working slowly and giving meticulous care to details, he spent three years on the assignment. He grouped the disciples in threes, two groups on either side of the central figure of Christ. Christ's arms were outstretched. In His right hand, He held a cup, painted beautifully with marvellous realism.

When the masterpiece was finished, the artist said to a friend, "Observe it and give me your honest opinion of it."

"It's wonderful!" exclaimed the friend. "The cup is so real I cannot divert my eyes from it!"

Immediately Leonardo took a brush and drew it across the sparkling cup! He exclaimed as he did so, "Nothing shall detract from the figure of Christ!"

For God's children to live radiantly and victoriously, they must say, 'That in all things he (Christ) might have the pre-eminence" (Col. 1:18b).

* * *

"What Think Ye of Christ?"

H. G. Wells said, "Christ is the most unique Person of history. No man can write a history of the human race without giving the foremost place to the penniless teacher of Nazareth."

Dr. Arnold Toynbee, famed historian, said, "As we stand and gaze with our eyes fixed upon the farther shore of history, a simple figure arises from the flood and straightway fills the whole horizon. There stands the Saviour!"

An Exact Replica

According to an advertisement in Wellings Mint, Limited, the renowned statue *The Winged Victory* was in 67 fragments when it was discovered. An ancient 329 B.C. coin, bearing the image of the masterpiece, showed the experts exactly how to put together the fragments of the statue.

The first man, Adam, was made in the image of God:: "And God said, Let us make man in our image, after our likeness" (Gen. 1:26a). When Adam fell, the divine image was marred—shattered to bits.

An exact replica, or reproduction, of the image of God was shown in the sinless Son of God. He was "the brightness of his (God's) glory, and the express image of (God's) person" (Heb. 1:3).

Jesus said, "He that hath seen me hath seen the Father" (John 14:9b).

* * *

Flawless

W. E. Sangster said, "By unanimous testimony, Jesus was a good man. Yet He had no sense of guilt. He prayed, 'Father, forgive them' (Luke 23:34). Never did He pray, 'Father, forgive Me.' His standing challenge to all was this: 'Which of you convinceth me of sin?' (John 8:46). Nobody took up the challenge."

Only of Christ can it be said: "Who knew no sin" (II Cor. 5:21); "Without sin" (Heb. 4:15b); "Who did no sin" (I Pet. 2:22).

* * *

Heart to Heart

Said Henry Drummond, "Ten minutes spent in Christ's presence, even two minutes if it be face to face and heart to heart, will make the whole life different."

Observing the boldness of Peter and John in the long ago, some "marvelled; and . . . took knowledge of them, that they had been with Jesus" (Acts 4:13).

* * *

All He Could Talk About

After World War II, Martin Niemöller visited America. In his appraisal of Niemoeller, a news reporter wrote with mild

disgust: "Think of it! Here is a man who spent three years in solitary confinement. When he comes out, all he can talk about is Jesus Christ!"

Paul said, "For we preach not ourselves, but Christ Jesus the Lord" (II Cor. 4:5a).

* * *

No Choice

Some years ago a conversation ensued between Dr. Howard Lowry, the late president of Wooster College and Dr. Radhakrishnan, a Hindu philosopher who became president of India.

Said Dr. Lowry, "I am sometimes embarrassed by the Christian claim of the uniqueness of Jesus Christ. To say to India, where there are only 10 million out of 400 million who are Christians, 'Jesus Christ is the light of the world,' isn't that arrogance? Isn't that a subtle way of exalting ourselves, as if to say, 'We only have the light?'"

Dr. Radhakrishnan replied, "Yes, but the Christian has no choice. That is what your Scriptures say. You cannot say less. You are saved from arrogance when you say it in the spirit of Jesus Christ!"

* * *

A Living Reality

J. Edgar Hoover said, "For me Jesus is a living reality. He is truly man's hope for joy and salvation. No matter what problems confront me, I know that I can count on our Redeemer for strength and courage."

What is Christ to you?

* * *

The Ubiquitous Christ

Richard Bancroft, famed historian said, "I find the name of Jesus Christ printed on nearly every page of modern history."

* * *

An Illustrious Master

A minister introduced Hudson Taylor, founder of the China Inland Mission, as an illustrious guest.

After standing silently for a moment before beginning his message, Taylor said, "I am a little servant of an illustrious Master!"

* * *

What Manner of Man Is He?

What manner of Man is He—this Christ,
 Who stilled the waves of the sea?
This question was asked by men of old
 In that ship on Galilee.
I know what manner of Man was He,
 For once in my troubled soul,
A storm was raging—I would have sunk,
 Had he not taken control!

What manner of Man is He—this Christ,
 Who heals all manner of ills?
Who makes great promises to His own,
 And all He says, He fulfills.
I know what manner of Man is He,
 For by Him I have been healed
Of sin's strong hold, and now I'm free,
 Himself to me He has revealed!

What manner of Man is He—this Christ,
 Who said He'd return some day?
To gather His own unto Himself,
 The faithful who watch and pray.
I know what manner of Man is He,
 I'm looking for Him to come,
I'm longing to meet Him in the air,
 I want Him to take me home!

ELIZABETH KIEKE
(a blind poet)

* * *

"Thou Remainest"

Said Bertrand Russell, famed philosopher and iconoclast, "In this strange and insecure world where no one knows whether he will be alive tomorrow, and where ancient states vanish like morning mists, it is not easy for those who, in youth, were accustomed to ancient solidities to believe that what they are now experiencing is a reality and not a transient nightmare. Very little remains of institutions and ways of life that when I was a child appeared as indestructible as granite!"

"Change and decay in all around (we) see," but Jesus Christ is "the same yesterday, and today, and for ever" (Heb. 13:8). Of Him the imperishable Word of God says, "Thou remainest" (Heb. 1:11a).

JESUS

The Fountainhead of Vitality

Said Dr. John R. Mott in *International Review of Missions*, "It is proved that the more open-minded, thorough and honest we were in dealing with those non-Christian faiths, and the more just and generous we were, the higher Christ loomed in His absolute uniqueness, sufficiency and supremacy—as One different from the rest, strong among the weak, erect among the fallen, believing among the faithless, clean among the defiled, living among the dead—the fountainhead of vitality, the world's Redeemer and Lord of all!"

* * *

A Universal Possession

Said Mohandas K. Gandhi, "I believe that Jesus belongs not solely to Christianity, but to the entire world!"

Gandhi was eminently right! Jesus' love is all-pervasive. His gospel is race-inclusive. His vicarious death was for all mankind! Jesus "by the grace of God (tasted) death for every man" (Heb. 2:9b).

Said John Wesley, "Take back my interest in thy blood unless it flowed for the whole human race!"

* * *

One In Him

In Christ now meet both East and West,
 In Him meet South and North,
All Christly souls are one in Him,
 Throughout the whole wide earth.

JOHN OXENHAM

* * *

The Greatest Penologist

Samuel J. Barrows, an American criminologist, said, "We speak of Howard, Livingstone, Beccaris, and others as great penologists who have profoundly influenced modern life. But the principles enunciated and the methods introduced by Jesus seem to me to stamp Him as the greatest penologist of any age. He has needed to wait, however, nearly twenty centuries to find his principles and methods recognized in modern law and penology."

Fully Revealed

W. Russell Maltby affirmed, "Life will work only one way, and that is God's way. God's way has been revealed fully and finally in Jesus Christ, that inexorable realist from Galilee. The sooner we learn this and take it to heart, the better will life be."

Pleadingly God says to morally and spiritually sick mankind, "Stand ye in the ways, and see, and ask for the old paths . . . and walk therein, and ye shall find the rest for your souls" (Jer. 6:16).

* * *

Lord over All

Some years ago, Dr. Henrietta Mears visited the Taj Mahal in India. The famed structure is noted for its unusual acoustical qualities. Standing in the center of the white marble mausoleum, the guide said loudly, "There is no God but Allah, and Mohammed is his prophet!"

His voice reverberated through all the chambers and corridors of the tomb.

Dr. Mears asked, "May I say something, too?"

The guide courteously replied, "Certainly."

In a clear, distinct voice, Dr. Mears said, "Jesus Christ, Son of God, is Lord over all!"

Her voice, too, reverberated from wall to wall and through the corridors of the minareted shrine, saying, "Lord over all . . . over all . . . over all . . . over all!"

* * *

Not Seeking Answers

Said a dissolute, discouraged college youth who had come to the end of himself, "I'm not seeking answers anymore. I'm seeking Jesus Christ!"

"And ye shall seek me, and find me, when ye shall search for me with all your heart" (Jer. 29:13).

* * *

"He Careth for You"

When you've met some disappointment,
 And you're tempted to feel blue,

When your plans have all been side-
tracked,
Or some friend has proved untrue;
When you're toiling and you're struggling
At the bottom of the stairs,
It will seem a bit like heaven,
Just to *know* that Jesus cares!

Ah, this life is not all sunshine,
Some days darkest clouds disclose,
There's a cross for every joybell,
And a thorn for every rose!
But the cross is not so grievous,
Nor the thorn the rosebud wears,
And the clouds have silver linings,
When we *know* that Jesus cares!

AUTHOR UNKNOWN

* * *

"He Is Despised"

So great and virulent was Thomas
Paine's hatred of Christ and the Chris-
tian religion that he was loath to give
Jesus even the unconscious homage in-
volved in using a calendar which dates
all events from His birth.

Christian Herald

* * *

Severed from Its Root

Said D. Elton Trueblood, "We live in
a 'cut flower' civilization which may be
radiant, fragrant and lovely now, but will
soon wither and die because it has been
severed from its root."

The source of the Christian's spiritual
life is Christ: "I am the vine, ye are the
branches" (John 15:5a). When we fail
to abide momentarily in Him, we become
barren and joyless: "Israel is an empty
vine, he bringeth forth fruit unto him-
self" (Hos. 10:1a).

* * *

No Way Out

"Give me a room as high up as pos-
sible," said 84-year-old Odie R. Seagraves,
one of the last oil pioneers of Texas, to a
hotel clerk in Dallas.

From his eighth-floor room, Seagraves
leaped to his death below!

Commented James A. Clark, oil his-
torian, "Seagraves once controlled oil and

gas properties valued at $10 billion. His
career was a constant up-and-down—from
rags to millions and back again!"

Seagraves left a suicide note in his
hotel room in which he said, "There is no
way out!"

There *is* a way out for anyone who will
accept it. Long ago the all-sufficient, ever-
present Saviour said, "I am the way"
(John 14:6). His way is an increasingly
luminous way. It "shineth more and more
unto the perfect day" (Prov. 4:18).

* * *

"Thou Remainest"

All the Christian symbols in the
Mosque of St. Sophia have been covered
by an overlay of Moslem symbols. As a
Christian American tourist gazed up at
the vast dome, he saw that the figure of
Christ was coming back through the
superimposed paint. He exclaimed, "He
is coming back! You blot Him out, but
He comes back again! The future belongs
to Him!"

"He must reign, till he hath put all
enemies under his feet" (I Cor. 15:25).

* * *

The Express Image of the Father

Thousands of tourists visit the Sistine
Chapel in the Vatican Palace in Rome to
see the frescoes by Michelangelo. As they
look at his great swirling frescoes on the
vaulted ceiling, their necks begin to throb
with pain.

Recently American TV viewers had a
closer and more relaxed look at the great
artist's creation in a color movie shot in
many cases from only a few feet away—
the closest filming of the masterpiece ever
made before.

Commented *Time,* "Masterpieces often
remain hidden in plain sight, but none
more so than the Sistine ceiling, perhaps
the greatest painting ever made. It is ex-
posed to view, and yet cannot be seen in
detail. It gleams a long way overhead,
sixty-eight feet at its apex, and it is enor-
mous—5,599 square feet. The huge blue
vault of air beneath it obscures all but
the main features."

111

For centuries many wondered what God is like. Then, "when the fulness of the time was come," He was revealed in the Person of His Son, who was "the brightness of his (the Father's) glory, and the express image of his person" (Heb. 1:3). All who beheld the Son could see the Father's glory, grandeur, and greatness. In the Saviour, we have a close-up, detailed portrait of the Father: "For in him dwelleth all the fulness of the Godhead bodily" (Col. 2:9).

'Twas for Me

Why was He silent when a word
 Would slay His accusers all?
Why does He meekly bear their taunts
 When angels await His call?

He was made sin—my sin He bore
 Upon the accursed tree,
And sin hath no defense to make,
 His silence was for me!

AUTHOR UNKNOWN

JEWS

Indestructible

There are approximately three billion people on the earth. Twelve million, or less than one-half of one percent, are classified as Jews.

The great pagan nations of Biblical times—the Assyrians, the Babylonians, the Persians, the Phoenicians, the Philistines—have all vanished from the earth, but the Jews remain!

The Bible says, "Thus saith the Lord, which giveth the sun for a light by day, and the ordinances of the moon and of the stars for a light by night. . . . If those ordinances depart from before me . . . then the seed of Israel also shall cease from being a nation before me for ever" (Jer. 31:35, 36).

* * *

Rabbis Disagree

In addressing the 82nd annual meeting of the Central Conference of American Rabbis, the rabbinical arm of Reformed Judaism, Rabbi Randall M. Falk urged that Jews reexamine the role of Jesus. "The figure of Jesus as a teacher of the Judaic ethical tradition may be a real bond between Christians and Jews," he said.

Rabbi Balfour Brickner, director of American Reform Judaism's Commission on Interfaith Activities, disagreed and said, "It is not the Christian Christ which Jews must discover, but the Jewish Jesus that Christians must become more aware of."

What a wondrous time it will be when penitent Jews look in faith "upon (Him) whom they have pierced, and shall mourn for him . . . and shall be in bitterness for him" (Zech. 12:10).

* * *

Slow to Learn

Gideon Hausner, a former Israeli attorney general and a member of the Knesset, Israel's parliament, said in 1971, "Russia's 3.5 million Jews are now being held as hostages in order to force a Soviet solution of the Middle East crisis. Not being allowed to leave for Israel, these Jews stand in danger of being destroyed by not being allowed to live as Jews. Already they are restricted as far as worship is concerned. The Jews are not allowed to teach the history of their own people, and they are being hounded from their jobs as being 'unreliable' servants of a foreign power. A study of the anti-Semitic pamphlets being circulated in Russia reveals that even the Nazis could learn a trick or two from them!"

How slow are "the rulers of the darkness of this world" (Eph. 6:12) to learn that God's curse is upon those who persecute and seek to exterminate the Jews, His specially chosen people! Long ago God said to Abraham, "And I will make of thee a great nation, and I will bless thee . . . and thou shalt be a blessing: And I will bless them that bless thee, and curse him that curseth thee: and in thee shall all the families of the earth be blessed" (Gen. 12: 2, 3).

Send the Messiah

Following the service of circumcision for Orthodox Jews, the following prayer is said:

"May the all-merciful God, regardful of the merit of them that are akin by the blood of circumcision, send us His Mashiach [Messiah], walking in His integrity, to give good tidings and consolation to the people that are scattered and dispersed among the peoples. May the All-merciful send us the righteous priest who remains withdrawn in concealment, until a throne bright as the sun and radiant as the diamond shall be prepared for him, the prophet who covered his face with his mantle, and wrapped himself therein, with whom is God's covenant of life and of peace."

May the time not be distant when Israel will penitently "look upon [the Messiah] whom they have pierced, and . . . mourn for him . . . and . . . be in bitterness for him" (Zech. 12:10).

Paul, in speaking of Israel's present blindness toward Christ, said, "But their minds were blinded: for until this day remaineth the same vail untaken away in the reading of the old testament; which vail is done away in Christ. When it [the heart] shall turn to the Lord, the vail shall be taken away" (II Cor. 3:14, 16).

* * *

Genes and Jews

Commenting upon Jewish achievement, C. P. Snow, a British scientist and novelist, said, "Is there something in the Jewish gene pool which produces talent on quite a different scale from, say the Anglo-Saxon gene pool? I am prepared to believe that it may be so. Take any test of achievement you like—science, mathematics, literature, music, public life. The Jewish performance has been not only disproportionate, but almost ridiculously disproportionate. The Jewish record of achievement is mainly of this last generation, although it can stretch back to the early 19th century when, for the first time, the Jews had any chance to compete with Gentiles over a wider range of human action."

JOY

Majors and Minors

An article in *Look* said, "Our economic commitment to fun is staggering. The fun market stands close to $150 billion, and it is confidently forecast that it will reach $250 billion by 1975. To note this is to agree with Billy Graham that there's a 'single mad pursuit of fun,' but it is not to agree (with him) that 'moral decadence' is here. After all, Americans see fun as divine."

How unwise we are when we major on fleeting, illusory pleasures and minor on abiding, satisfying pleasures!

"In thy presence is fullness of joy; at thy right hand there are pleasures for evermore" (Ps. 16:11b).

Glum and Grouchy or—

As an English nobleman mingled with guests at his country estate, he met an attractive but not strikingly beautiful woman. After they exchanged greetings, he said to her, "Would you come and let my roses see you?"

Later a friend asked, "Why were you so interested in that lady?"

He replied, "She was charming."

The friend asked, "But what makes her charming?"

He replied, "She made life seem more joyful and worthwhile."

Shouldn't this be the fixed purpose of each one of God's children?

How repellent is a glum, grouchy Christian!

JOY

Nursing Miseries

As a businessman sat at a table in a railroad dining car, a husband and his wife entered and asked, "May we sit with you at your table?"

"Certainly," the businessman replied.

When the meal was served, the wife grumblingly found fault with each item placed before her. It was either too hot or too cold; too overdone or underdone.

Sensing the husband's embarrassment, the friendly businessman asked, "What is your business?"

"I'm a manufacturer," he replied, adding, "My wife is a manufacturer, too."

"That's interesting! And what does she manufacture?" the man queried.

The husband quipped, "She manufactures misery for herself and for everybody else!"

Some people seem to find great pleasure in nursing their miseries. They aren't happy unless they are miserable.

We owe it to ourselves and others to be contagiously cheerful.

To each one of God's children is given the command: "Be of good cheer" (John 16:33b).

Told by RALPH M. SMITH

* * *

"I'm Lonely As Hell"

Confessed a top pop singer in a recent TV interview: "Mister, I'm not happy. I'm lonely as hell!"

How great and enduring is the joy of God's children as they daily live for the Saviour and are sustained by His never-failing promise: "In thy presence is fulness of joy; at thy right hand there are pleasures for evermore" (Ps. 16:11b).

* * *

Capable of Loving God

One of God's children, who had very little of this world's goods, said, "I rejoice in being exactly what I am—a creature capable of loving God. I look for a while out of my window and gaze at the moon and the stars, the work of God's almighty hand. I think of the grandeur of the universe and think myself one of the happiest beings in it!"

Hollowness Within

Herbert Butterfield wrote, "It is a phenomenon by no means rare to meet with comparatively unlettered people who seem to have struck profound spiritual depths, while there are many highly educated people who are seemingly performing clever antics with their minds to cover the gaping hollowness that lies within."

A prayer of Jesus is pertinent: "I thank thee, O Father, Lord of heaven and earth, because thou hast hid these things from the wise and prudent, and hast revealed them unto babes" (Matt. 11:25).

* * *

God's Telephone Number

Dr. Norman Vincent Peale asked a victim of crippling infantile paralysis, "How is it that you are always cheerful, radiate sunshine, and flash a smile to others?"

"It's because I have God's telephone number," replied the girl.

"That's interesting," said Dr. Peale. "Tell me about it."

The polio victim said, "It is Jeremiah 33:3."

"Why, that's a Bible verse," said the minister.

"That's right, and it says, 'Call unto me, and I will answer thee, and shew thee great and mighty things, which thou knowest not.' "

The Jeremiah number is never too busy to receive your call. Anyone, anywhere, anytime may dial it and get an instant response!

ALICE MARIE KNIGHT

* * *

Joy Is Elusive

On a murky Monday morning in Chicago, the sky was leaden. The rain descended in a dismal drizzle outside as a minister entered the Psychopathic Court to appear on behalf of a mental patient.

The functionaries and political hangers-on in the court greeted each other gloomily.

How different it was with the minister. His heart was filled with joy as he spoke comfortingly to a number of burdened, bothered people whose loved ones were to

114

be committed to a mental institution, commending them to the Mender of broken things. Jesus came long ago to "give beauty for ashes, the oil of joy for mourning, the garment of praise for the spirit of heaviness" (Isa. 61:3).

If we go out in *quest* of joy, it will elude us. If we go out to *impart* joy, we will find it.

"And the seventy returned again with joy, saying, Lord, even the devils are subject unto us through thy name" (Luke 10:17).

* * *

Glum, Grumpy, and Grouchy

Emmett Kelly, Jr., the famous clown who is called the "Crown Prince of Pantomime," never smiles. He elicits laughter without saying a word. His sad face, big red nose and huge shoes are enough to create smiles.

It is an open secret that behind his unsmiling mask, Kelly laughs harder than the people laughing at his antics. Said he, "Laughter is one of God's greatest gifts to the world. It is really the answer to most of our problems. There is never enough laughter. Maybe, the infinite Being—God—is using me to help start smiles around the world. I believe in America with all my hidden heart. Here, we are free to smile. Here, our Maker makes room for laughter!"

Often there is too much gloom and defeatism among God's children. Glum, grumpy, grouchy people are repellent. We need more joyous, radiant Christians.

"Rejoice in the Lord always: and again I say, Rejoice" (Phil. 4:4).

* * *

Evils Punctured

Said H. S. Coffin, "The Creator made man capable of laughter, and some of the most threatening evils can be punctured with satire."

* * *

A Saving Grace

In *Jolly Earthquake,* Dr. Russell Conwell wrote of the saving grace of a sense of humor—"thinking in fun while we feel in earnest."

Where Found

Where is joy found? *In wealth?* No. Jay Gould, a multimillionaire said remorsely when dying, "I suppose I am the wretchedest wretch that ever lived."

In sinful pleasure? No. Like Solomon, Lord Byron could say, "And whatsoever mine eyes desired I kept not from them. I withheld not my heart from any joy" (Eccl. 2:10). On his 33rd birthday, Lord Byron sadly lamented,

On life's road so grim and dirty,
I have dragged to three and thirty,
What have these years brought to
 me?
Nothing but thirty-three.

In worldly fame? No. Lord Beaconsfield enjoyed worldly fame, yet he wrote, "Youth is a mistake; manhood a struggle; old age a regret!"

How quickly does a Who's Who become a Who Was! How ephemeral is earthly glory: "For all flesh is as grass, and all the glory of man as the flower of grass" (I Pet. 1:24a).

Where then may abiding joy be found? In Christ alone: "Whoso trusteth in the Lord, happy is he" (Prov. 16:20); "Your heart shall rejoice, and your joy no man taketh from you" (John 16:22).

* * *

Thee Alone I Seek

Desiring a closer fellowship with God, George Matheson said, "Whether You come in sunshine or in rain, I would take You into my heart joyfully. You are Yourself more than sunshine. You are Yourself compensation for the rain. It is You and not your gifts I crave!"

Once earthly joy I craved,
 Sought peace and rest;
Now Thee alone I seek:
 Give what is best.
 ELIZABETH P. PRENTISS

* * *

The Rebound

Those who bring sunshine into the lives of others cannot keep it from themselves!

If we go out to *search* for joy, it will elude us. If we go forth to *impart* joy, we will find it.

* * *

Sitting On Thorns

Said Jeremy Taylor, "He who has so many causes for joy and so great is very much given over to sorrow and peevishness, and chooses to sit down on his little handful of thorns."

Though Jesus was "a man of sorrows, and acquainted with grief" (Isa. 53:3a), the Saviour was the most joyous person who ever lived: "But unto the Son he saith . . . Thou hast loved righteousness and hated iniquity; therefore God, even thy God, hath anointed thee with the oil of gladness *above* thy fellows" (Heb. 1:8, 9).

* * *

"God Is Not Burning Up"

As a Christian Vietnamese stood by his burning home, with the flames lighting up his face, he praised God.

One asked, "How can you praise your God when everything in your home is burning to the ground?"

He replied, "But my God is not burning up!"

In the midst of a world aflame, God lives. He is still "within the shadows, keeping watch above His own!"

We are finite, but God is infinite: "And all the inhabitants of the earth are reputed as nothing: and he (God) doeth according to his will . . . and none can stay his hand, or say unto him, What doest thou?" (Dan. 4:35).

* * *

Gifts I Ask of Thee

These are the gifts I ask of Thee, Spirit Divine:
Strength for the daily task, courage to face the road,
Good cheer to help me bear the traveler's load,
And, for the hours of rest that come between,
An inward joy of all things heard and seen.

HENRY VAN DYKE

* * *

The Joy You Give

Somehow, not only for Christmas
But all the long year through,
The joy that you give to others
Is the joy that comes back to you;
And the more you spend in blessing
The poor and lonely and sad,
The more of your heart's possessing
Returns to make you glad!

JOHN GREENLEAF WHITTIER

JUDGMENT

Tokens of the New Morality

In *Chicago Today,* Harriet Van Horne editorialized, "In Central Park, New York, they're now chaining trees and shrubs to the earth. The idea is to outwit thieves who dig by night.

"The tokens of the new morality are at every hand. Nearly 200,000 school windows in New York City are smashed every year. A Manhattan hotel lost $500,000 worth of spoons, finger bowls, ash trays and such items during its first six months in business. And pilferage in stores—from news dealers to department stores—now runs to $1 billion a year!

"If some day soon the Lord smites us with plague and pestilence, let no man say we didn't have it coming."

* * *

World at Rope's End

Shortly before his death, H. G. Wells wrote, "This world is at the end of its rope. The end of everything we call life is close at hand!" The gloomy pronouncements of non-Christians about cataclysmic judgments in store for the sin-sodden, Christ-rejecting world are often Scripturally accurate.

"But the day of the Lord shall come

116

as a thief in the night; in the which the heavens shall pass away with a great noise, and the elements shall melt with fervent heat, the earth also and the works therein shall be burned up" (II Pet. 3:10).

* * *

Then It Happened!

In November, 1970, a tragic fire occurred in a dance hall in the town of Saint-Laurent-du-Pont, France. The hall was packed with hundreds of young people and adults. A young man inadvertently dropped a lighted match on a foam cushion. Then it happened! A flash fire occurred in which 145 of the dancers perished!

In commenting upon the tragic incident, *Newsweek* said, "There was no fire alarm system or telephone, and, during its invariably packed weekend rock dances, its unmarked emergency exits were always padlocked or latched from the inside to prevent gatecrashing."

Myriads today are heedless of the fact that God's fiery judgment will inevitably fall upon all who spurn His offer of mercy and forgiveness. The Bible says, "When the Lord Jesus Christ shall be revealed from heaven with his mighty angels, in flaming fire taking vengence on them that know not God, and they that obey not the gospel" (II Thess. 1:7, 8).

* * *

Waiting! Waiting! Waiting!

On death row in San Quentin Prison, eighty-three condemned men were waiting for the day of their execution.

How revealing are the thoughts they expressed! One said, "I don't look out of the window much. It bothers me to look outside and see fluffy clouds."

A twenty-seven-year-old former salesman described what it is like to go through an execution-or-reprieve existence. He said, "I think the people who do the hardest time are those who constantly think of being locked up and not being free. You try to think of the free world."

Fifty-year-old Thomas Vardum described the deadly routine thus: "After a while it becomes monotonous here—a big ball of boredom. It doesn't mean anything. There have been a couple of men who couldn't make it. They cracked up under the pressure. It gets on your nerves at times. It's very close. It's a strange world cut off from everything."

There is an analogy between those judged and condemned men and those who reject God's gracious offer of mercy and forgiveness through His Son: "He that believeth not is condemned (judged) already, because he hath not believed in the name of the only begotten Son of God" (John 3:18).

* * *

"Damnation, Sir"

James Boswell, the biographer of Samuel Johnson, recorded a conversation Johnson had with Sir Joshua Reynolds about his fear of death.

"What are you afraid of?" asked Reynolds.

"Damnation, sir," replied Johnson, "damnation!"

Realistically the Bible speaks of what awaits all who pass out of this world unforgiven and unprepared to meet God: "For if we sin wilfully after that we have received the knowledge of the truth, there remaineth no more sacrifice for sins, but a certain fearful looking for of judgment and fiery indignation, which shall devour the adversaries" (Heb. 10:26, 27).

* * *

Drastic Methods

During World War II, an interesting item appeared in newspapers throughout England. It said:

The tail feathers of Lady Strickland's prize peacock are growing in again following the blast of a nearby bomb. Lady Strickland, who is very deaf, was blown off her feet by the same blast. When she stood, she calmly remarked, 'At last I've heard something!' "

Good often comes out of seeming disaster. God often has to speak to His unheeding, unhearing children by drastic methods.

G. F. ALLEE

Impending Apocalypse

In popular thinking, the word *apocalypse* is synonymous with doomsday. It means, however, a revelation, an unveiling, a disclosure. To students of God's Word, the word means the Book of Revelation, which is a disclosure of things to come.

Recently *Newsweek* commented, "Never before have the makers of movies been so absorbed with the details of impending apocalypse. Never before have the merchandisers of movies been so high on the commercial potential of extinction!"

* * *

The Day of the Lord

Early one February morning in 1970, the little town of Val d'Isere in France became the scene of disaster and death. The town is a ski resort. Towering above the picturesque town is the 7,000-foot-high mountain Le Dome. The peace of Val d'Isere was suddenly shattered when Le Dome dumped some 100,000 cubic yards of snow on a three-story youth hostel!

In reporting the horrendous avalanche, *Newsweek* said, "Traveling at a speed of 120 miles per hour, the avalanche hit with such tremendous force that in minutes 42 people lay dead! Most of them were buried in a frozen tomb of snow!"

How terrifying for unsaved Christ-rejectors will be the sudden coming of the day of the Lord: "A day of darkness and gloominess, a day of clouds and of thick darkness" (Joel 2:2); a day in which impenitent ones will plead, not to the One whose mercy and forgiveness they have spurned, but to "the mountains and rocks, (saying) Fall on us, and hide us from the face of him that sitteth on the throne. . . . For the great day of his wrath is come; and who shall be able to stand?" (Rev. 6:16, 17).

KINDNESS

The Fruits

Kind hearts are the gardens;
Kind thoughts are the roots;
Kind words are the flowers;
Kind deeds are the fruits.

AUTHOR UNKNOWN

* * *

Getting Even

The only persons we should resolve to get even with are those who have shown us kindness.

* * *

"Neighbor, Let Me Help You."

"They helped every one his neighbor; and every one said to his brother, Be of good cheer" (Isa. 41:6).

Dear Neighbor: Today my hands are strong, so let me help you. Tomorrow they may be weak, or old, or sick and you will have to lighten my load. But today my hands are strong, so let me share your burden. For why do we exist, if we cannot care for our fellowman, walk in his path, know his sorrows? Neighbor, today my hands are strong. Let me help you!

GLORIA M. WHITE

* * *

Heart Hunger

Dr. J. R. Miller said, "All human hearts hunger for tenderness. Harshness pains us. Ungentleness touches our sensitive spirits as frost touches the flowers. It stunts the growth of all lovely things. Gentleness is like a genial summer to our life. We are always right when we show gentleness."

David said, "Thy (God's) gentleness hath made me great" (Ps. 18:35b).

* * *

Love Never Fails! Try It!

Years ago in India, Captain Shaw of the Salvation Army visited a leper colony. There he saw three of the lepers shackled. Why? They were desperate criminals. Said Captain Shaw, "Remove those

shackles. No one will be shackled in this colony."

"But these men are dangerous incorrigibles," warned a guard.

Said Captain Shaw with finality, "Remove those shackles."

Shortly thereafter, Captain Shaw had to go elsewhere for three weeks, leaving behind his wife and children. Upon his return, he saw the three allegedly desperate men near the entrance of his home.

"What are you doing here?" he fearfully asked.

They replied, "We heard that you would be away from your family for three weeks. We took our place near your home to see that no harm would befall your wife and children."

The lives of the criminals had been changed by the love and kindness shown them when others distrusted and degraded them.

When all else fails, try love: "Love never faileth."

* * *

A Mark of Greatness

One day an unusual incident occurred on a crowded London-bound train. A tall youth, sitting in a comfortable first-class compartment, left his seat and elbowed his way to a forward coach. There he spoke kindly to a work-weary woman whom he saw standing and swaying with the motion of the train.

"Go and take my seat," he said.

"I'm not allowed to go where you sat," she replied. "I have only a third-class ticket."

Insistently, the young man said, "You take my first-class ticket, and I'll take yours and find a seat in a coach."

Tickets were exchanged and the young man disappeared.

Who was that courteous, considerate youth? He was Prince Charles, heir to the British throne.

This incident brings to mind another exchange, infinitely more astounding. The everexistent Son of God exchanged heaven's light and bliss for earth's night, sorrow and suffering, He "made himself of no reputation, and took upon himself the form of a servant" to bring those receiving Him to God.

Told by GERALD HAWTHORNE

* * *

Warmest Regards!

The editor of one religious journal has a disarming answer to scurrilous personal letters. He responds in his own handwriting and says, "Thank you for your letter. If you knew me as I know myself, you would condemn me much more! Warmest regards!"

Bravo!

LAWLESSNESS

A Little Stealing Is O.K.

If the theories of Lawrence R. Zeitlen, professor of industrial psychology, were accepted by managers of retail businesses, employees would be allowed to steal a little. Stealing, he claims, makes dull jobs interesting. It lifts employee morale and may be cheaper than using elaborate security precautions and increasing pay.

There is no doubt that the problem of stealing by employees has reached staggering proportions. About $4 billion is stolen annually in merchandise and cash from retail establishments. Zeitlen estimates that 75 per cent of all employees in retail establishments steal to some degree, taking three times as much as shoplifters.

Zeitlen's proposal goes counter to God's changeless commandment: "Thou shalt not steal" (Exod. 20:15), and Paul's directive, "Let him that stole steal no more" (Eph. 4:28a).

Adapted from *The Prairie Overcomer*

LAWLESSNESS

Individual Responsibility

Editorialized *Jewish Life:* "We live in an age in which the intellectual climate favors and even encourages irresponsibility in human behavior. The great and most heinous of crimes are justified as being a result of historical circumstances. The tremendous rise in the number of murders and homicides all over the world is attributed not to the decline in the morality of the individual, but rather to the inequalities and injustices of society.

"Society is only as good as the people. Our opinion leaders—be they preachers, politicians, or publishers—should issue regular reminders that individuals are responsible for what they do. Men are accountable for their actions, no matter what their environment."

"So then every one of us shall give account of himself to God" (Rom. 14:12).

* * *

God's Absolutes

God's laws are absolutes. They are as changeless as God Himself: "But the word of the Lord endureth for ever" (I Pet. 1:25a).

One of God's absolutes is, "Thou shalt not commit adultery" (Exod. 20:14).

When men break God's absolutes, they break themselves: "For whatsoever a man soweth, that shall he also reap" (Gal. 6:7).

* * *

No Guard Rail

On a recent Sunday in Covington, Georgia, eleven persons were killed when the car of a hot rodder, allegedly traveling 180 miles per hour, went out of control, crashed into an embankment, catapulted over a fence and plowed into the crowd of spectators!

An official of the American Hot Rod Association said, "We strictly abhor what happened out there. The conditions under which the people were racing were totally 100 percent unsafe. Had there been a guard rail on this track we would not have had these fatalities!"

Along life's perilous pathway, God in goodness has placed a guard rail—*The Ten Commandments*. Morally they are as binding as when first proclaimed amid Sinai's rocky crags. When man hurls himself against God's adamant, immutable law, he breaks not the commandments but himself: "The word of the Lord endureth for ever" (I Pet. 1:25a).

* * *

Exit Policeman

Said Ann Landers—columnist, author, and lecturer—"When you take liquor, you remove the 'policeman.' That's the most dangerous effect of drink. Under the influence of liquor you will say and do things you would never say or do ordinarily. You are not yourself. It's like saying that a store is a safe place because they have taken away the policeman who was on the lookout for pickpockets and shoplifters. Actually, inhibition is a very good thing. People need inhibitions and good judgment if they are to act like human beings. This is what makes men different from the beast."

* * *

A Glaring Miscarriage of Justice

Some years ago Richard Speck allegedly murdered eight student nurses in Chicago in cold-blooded deliberations. He was tried and sentenced to death. Acknowledging his guilt, the Supreme Court of the United States later ruled that the death sentence was illegally passed upon him because there was no one on the jury opposed to a death penalty! Therefore the imposition of the death penalty was illegal.

How can sanity be restored to the courts if appeals continue to result in judgments favorable to criminals tried and convicted at great expense and trouble?

The Bible says, "Because sentence against an evil work is not executed speedily . . . the heart of the sons of men is fully set in them to do evil" (Eccl. 8:11).

Adapted from
The Presbyterian Journal

America's Number One Enemy

After imbibing five rum drinks and several glasses of beer, Leopoldo Morales, Jr. murdered the wife of a Fort Bliss soldier, her husband, and two other individuals. He was so inebriated that he did not remember the crime.

Morales was sentenced to die. The Texas Court of Criminal Appeals let the death sentence of the lower court stand, decreeing, "The death penalty is not cruel and unusual punishment for a crime that the condemned man does not ever remember committing."

Rivers of tears have flown because of deranging, dehumanizing and depraving alcoholic liquor, America's number one enemy.

Increasing numbers of youths are becoming enmeshed in its merciless, enfeebling power and led in many instances to drug addiction.

* * *

Determined To Destroy

John Newton Mitchell, Attorney General of the United States, said in addressing the Virginia Bar Association, "Never in our history has this country been confronted with so many revolutionary elements determined to destroy by force the government and the society for which it stands. Organized crime completely controls some cities in this country, and exercises some degree of control in most of the large cities."

* * *

"Be Subject . . ."

A business man parked his car in a zone reserved for loading and unloading.

Before he left his car, he wrote a note and placed it under the windshield wiper. It read, "Dear Policeman, I have circled this block for twenty minutes, trying to find a parking place, but without success. I have a very important appointment. If I don't park here, I will lose my job!"

When the businesman returned to his car he found a parking violation ticket and a note which read, "Dear Sir, I have been circling this block for twenty years. I have a very important position, and if I don't give you this ticket, I'll lose my job. 'Lead us not into temptation!' "

"Let every soul be subject to the higher powers" (Rom. 13:1a).

* * *

The Moral Crisis

Dr. Will Herberg, a distinguished philosopher, said, "The moral crisis of our time consists primarily not in widespread violation of accepted moral standards themselves. The very notion of morality or a moral code seems to be losing its meaning for increasing numbers of men and women in our society. To violate moral standards while at the same time acknowledging their authority is one thing. To lose all sense of the moral claim, to repudiate all moral authority and every moral standard is something far more serious."

When anyone becomes a law unto himself, and believes that individual feeling is the standard of right or wrong, moral and spiritual darkness ensues: "Every man (does) that which (is) right in his own eyes" (Judges 21:25).

* * *

A Constant Diet of Violence

Said the report of the U.S. Commission on Violence, "It is reasonable to conclude that a constant diet of violent behavior on television has an adverse effect on human character and attitudes. It encourages violent forms of behavior and fosters moral and social values about violence in daily life which are unacceptable in a civilized society."

Sing a song of TV for little ones,
Four-and-twenty jailbirds packing
Tommy guns,
When the scene is over, blood is
ankle deep,
Wasn't that a pretty dish to send the
kids to sleep!

AUTHOR UNKNOWN

121

LAWLESSNESS

Malicious Action Is Insanity

In addressing some 15,000 black messengers to the National Baptist Convention, Dr. Joseph H. Jackson, the president, said of the arsonists and lawless segment of our society, "If necessary, allow them to run their affairs in a walled city or separate community. Our society must be protected from their malicious actions which are forms of insanity caused by mob rule and drugs. We must support law and order, for there are no problems in American life that cannot be solved through commitment to the highest laws of our land and in obedience to the American philosophy and way of life."

Christianity Today

* * *

The Basic Source of Crime

In a recent report to the nation on *Causes and Prevention of Violence,* Dr. Milton S. Eisenhower said, "The correlation is not one of race with crime, but of poverty with crime."

Attorney General John N. Mitchell sharply disagreed with the equating of crime with poverty. He said, "No doubt some of our social evils contribute to crime, but we shouldn't accept poverty as an excuse for the commission of a crime. This could lead to the point where a person could be exonerated for a crime on the grounds of poverty."

Heinous crimes are perpetrated by both the poor and the rich. If poverty is a major cause of crime, then Abraham Lincoln could have been the Stokley Carmichel of his day!

Christ, the greatest of teachers, traced crime to its basic source—the "desperately wicked" heart of men: "For from within, out of the heart of men, proceed . . . adulteries . . . murders, thefts . . . lasciviousness" (Mark 7:21, 22).

* * *

Learn To Read and Riot

Said Dr. Orley R. Herron in Wheaton College chapel, "A total of 200 student riots were reported in 1968, which may have indicated a certain amount of truth in a sign I saw on the road. It read, 'Go to college to learn to read and riot!' "

* * *

Equal Protection

Said J. Edgar Hoover, "We must bring the matter of crime and the criminal back into balance with the safety and welfare of the public. Those who abide by the law should have equal protection with those who break the law. In dealing with crime, expediency is a short cut to disaster."

* * *

Condoned Treason

The Black Manifesto, drafted by James Forman and adopted as a policy statement by the National Black Economic Development Conference which met in Detroit, contained these statements: "We call for the total disruption of selected church-sponsored agencies operating anywhere in the United States and the world.

"To win our demands, we will have to declare war on the white Christian churches and synagogues and this means we may have to fight the total government structure in this country!"

Christian Herald

* * *

They Ignored the Stench

On observing a rock concert in June, 1970, at a sport stadium in Orlando, Florida, Patrick Boyhan, who taught mathematics at Meadowbrook Junior High School, said, "It was appalling, disgusting, ghastly, distressing, frightful! Marijuana was bought and smoked without any effort to hide it. I listened to boys and girls use the dirtiest of barracks' language. Boys and girls were asked to take off their clothes. Never before in my life have I seen such an outward expression of violence, revolution, subversion. Sheriff's deputies who were in attendance looked like statues, while all the lawbreaking was going on in front of them. They just ignored the stench."

How long will God let our nation go unjudged and unpunished?

122

Others Have Rights Too

Eric Severeid said, "The use of force to express conviction is intolerable. When a person deliberately defies a court order, then he ought to go to jail. Laws and ordinances can be changed, but they cannot be rewritten in the streets where other citizens also have rights."

LIGHT—DARKNESS

"Take My Hand, Precious Lord"

During the darkest days of World War II, King George VI said in a New Year's message, "I said to the man who stood at the gate of the New Year, 'Give me a light that I may tread safely into the unknown.' But he answered, 'Put your hand into the hand of God. That will be better than a light, and safer than a known way!'"

* * *

In God's Hand

Helen Keller said on her sixtieth birthday, "If the blind put their hand in God's hand, they find the way more surely than those who see physically but have no spiritual sight."

Jesus said, "I am the light of the world: he that followeth me shall not walk in darkness, but shall have the light of life" (John 8:12b).

* * *

Through Whom the Light Shines

As little Gail sat with her mother in the sanctuary on the Lord's Day, she looked with enchantment at the figures in the beautiful stained glass windows, vivified and glorified by the light which filtered through them.

She whispered, "Mommy, who are those people?"

Mommy replied, "They are saints, darling."

As they walked from church, Gail said, "Mommy, now I know who saints are."

"That's fine, dear," replied mother. "Who are they?"

"They are people the light shines through!"

Redeemed boys and girls, men and women are living saints through whom "the light of the glorious gospel of Christ" shines.

ALICE M. KNIGHT

The Loneliness of Humanity

How gloomy and bereft of light is the fatalistic creedal statement given in *A Preface to Morals* by Walter Lippmann:

"We see, surrounding the narrow raft illumined by the flickering light of human comradeship, the dark ocean on whose rolling waves we toss for a brief hour. From the great night without, a chill blast breaks in upon our refuge. All the loneliness of humanity amid hostile forces is concentrated upon the individual soul, which must struggle alone, with what courage it can command, against the whole weight of a universe that cares nothing for its hopes and fears."

Why do men grope in spiritual darkness, and condemn Jesus, "the light of the world"? The Bible says: "Men loved darkness rather than light, because their deeds were evil" (John 3:19b).

* * *

Destined to Extinction

How dismal and dreary is the future to those who do not believe in God and the revelation He has given in His eternal Word. His prophetic Word is "a light that shineth in a dark place, until the day dawn" (II Pet. 1:19).

Said Bertrand Russell, "Man is the product of causes. His origin, his growth, his hopes and fears, his loves and his beliefs, are but the outcome of accidental collocations of atoms. No heroism, no intensity of thought and feeling, can preserve an individual life beyond the grave. All the labors of all the ages, all the devotion, all the inspiration, and all the noonday brightness of human genius are destined to extinction in the fast death of the solar system. The whole temple of man's achievement must inevitably be buried beneath the debris of a universe in ruins. All these things are beyond dispute, so nearly certain that no philosophy which rejects them can hope to stand!"

LOST

Wanted: More Light

"Pray for me, pastor, that I'll get more light," requested a man who had fallen into sinful worldly ways.

The pastor replied, "No, I'll not pray for more light for you, but I will pray that you will walk in the light which God has already given to you."

* * *

Blind Staggers

A unique experiment occurred recently at the University of Alberta. Twenty chickens were exposed to TV 24 hours a day for two and a half months, after which they got blind staggers and wanderd about in a daze. Mrs. Jean Luber, a professor of zoology at the university, found that the chickens, when exposed to continued televiewing, developed glaucoma, a hardening of the eyeball which often results in blindness.

Many people suffer from spiritual blindness. The Bible speaks thus of them: "The god of this world hath blinded the minds of them that believe not" (II Cor. 4:4a).

* * *

Darkness Everywhere

Lamented Nehru as Gandhi died from an assassin's bullets, "O God! O God! The light has gone out of our lives and there is darkness everywhere!"

Though Jesus, "the Sun of righteousness" has come, myriads still "dwell in the land of the shadow of death" (Cf. Mal. 4:2a; Isa. 9:2b).

Fog-enshrouded Souls

For centuries Londoners have cursed and boasted about their famous fog. Charles Dickens wrote about the leaden skies filled with black soot that resembled "snowflakes gone into mourning for the death of the sun!"

Years later T. S. Elliot spoke of "the yellow fog that rubs its back upon the windowpanes."

The peasoupers shrouded the malevolent doings of London villains from Jack the Ripper to Mr. Hyde.

Because of a recent enactment of Parliament, prohibiting the burning of soft coal, the suffocating, smoke-laden, brown or yellow stuff that formerly enshrouded the city with discomforting regularity and sometimes with lethal results, has all but vanished. About eighty percent of London is actually free from fog.

Sin-shackled, fog-enshrouded souls grope in the miasmic lowlands of hopelessness and, enervating dread, their "hearts failing them for fear, and for looking after those things which are coming on the earth" (Luke 21:26).

God's trustful, obedient children bask in the glow and warmth of the ever-present "Sun of righteousness" and the "Light of the world" (Cf. Mal. 4:2a; John 8:12).

Long ago two disciples exclaimed, "Did not our heart burn within us, while he talked with us by the way, and while he opened to us the Scriptures?" (Luke 24:32).

LOST

Ultimate Obliteration

In his autobiography, ninety-seven-year-old Bertrand Russell retrospectively viewed life as having little meaning for him, and prospectively viewed the future as overshadowed by the spectre of ultimate obliteration. Gloomily he wrote, "What else is there to make life tolerable? We stand on the shore of an ocean, crying in the night and the emptiness. Sometimes a voice answers out of the darkness. But it is the voice of one drowning, and in a moment the silence returns. The world seems to me quite dreadful. The unhappiness of many people is very great. I often wonder how they will endure it. To know people well is to know their tragedy. It is usually the central thing about which their lives are built. I suppose that if they did not live most of the time in the things of the moment, they would not be able to go on!"

How filled with despair is the heart-rending lament of a soul without God!

124

The Other Side of the Coin

As a guide conducted Charles H. Spurgeon through an art gallery, they came to the painting of a man with a benign, benevolent face. "My!" exclaimed Spurgeon. "Tenderness and graciousness beam from that face! How Christlike!'

"Come with me," said the guide, "and I will show you the reverse side of the picture."

Spurgeon stood aghast as he looked at the other side and saw the fiendish, malevolent face of one more bestial than manlike.

The purpose of the artist was obvious. He had depicted the depths of depravity and degeneracy to which one may descend who spurns the mercy of God and casts off all restraints.

Told by RALPH M. SMITH

* * *

"Get Out While There Is Still Time!"

September 7, 1900, had been a hot, sultry day in Galveston, Texas. Dr. Isaac M. Cline, the local forecaster of the Galveston Weather Bureau, stood on the roof of the Levy Building at sunset studying the ominous thick stratocumulus clouds, which were a brick-dust hue. He felt that impending disaster lay ahead for the island city!

At 4 A.M. Isaac was awakened by his brother Joseph. "Look," he exclaimed as he led his brother to a window. Several inches of water covered the yard. The Gulf was creeping beneath his home which was on higher ground. He awakened his wife and said, "We may be in for a bad storm! Move quickly! I'd like to stay here with you, but I must warn the sleeping people. I'll be back as soon as possible!"

Isaac discovered the tide was already four and one-half feet above normal. "'This is something I have never known," he said, glancing at the rolling clouds and increasing high waves.

Isaac quickly harnessed his horse to a two-wheeled cart. With his coattails flying in the howling wind, he began to drive furiously along the beach, shouting warning to residents and tourists: "Leave now! Get out while there is still time! This storm is different. You must move to higher ground. Believe me *this one is different!*"

Some heeded Isaac's warning and fled. Others refused to move. They said, "We've seen overflows before. We are not going to let a little water scare us!" Despair knotted Isaac's throat as he watched people rocking undisturbed in swings on wide porches.

Ever urging his horse on to faster pace, he continued to warn the people before the impending catastrophe overwhelmed the city.

As darkness enveloped the horrendous scene that evening, Isaac was horrified by what he saw: innumerable horses and human bodies floating in the swirling water! Hundreds of houses had collapsed as though they had been built of matchsticks!

"The warning of Dr. Isaac M. Cline," commented the New York *Evening Sun,* "saved thousands of lives. Six to eight thousand more probably would have been saved if they had heeded the warning: 'Leave now! Get out while it is still time! Believe me, *this storm is different!'*"

How like those heedless ones are the myriads today who ignore the warnings of the Bible concerning a coming judgment when evildoers and Christ rejectors "shall be punished with everlasting destruction from the presence of the Lord, and from the glory of his power" (II Thess. 1:9). This is *certain:* "God . . . hath appointed a day, in the which he will judge the world in righteousness by that man whom he hath ordained; whereof he hath given assurance unto all men, in that he hath raised him from the dead" (Acts 17:30, 31).

Adapted from *Austin* (Texas) *American-statesman*

* * *

A Living Dead Man

The epitaph of Charles Starkins is written in legalese and filed in the records of the New York State Correctional Service Department.

He breathes, he works every day, but he's a dead man so far as the State of

LOST

New York is concerned. His death came one morning in 1953 with the rap of a judge's gavel, sentencing him to life in prison for the murder of his father.

Under a 171-year-old state law, known as Civil Death, Starkins' marriage was dissolved, his children no longer had a father and there was no court to which he could take his case. Seven years after Starkins walked through the front gates at Sing Sing Prison, he was told his children had been adopted. The State Legislature is now considering a proposal to repeal the civil death law.

Lamented Starkins, "When you're sent to prison you still have your feelings. Your love and concern for your family just don't stop. You're still a human being."

In February, 1970, Starkins was paroled, but he had lost track of his family.

All who spurn God's mercy, so freely offered in Christ, are "dead in trespasses and sins" (Eph. 2:1). They are alienated from spiritual life until they are quickened into life through the Saviour who said long ago, "I am come that they might have life, and that they might have it more abundantly" (John 10:10b).

* * *

Mom, Where Were You Lost?

A mother took her four-year-old son to a village fair. Before they entered the crowd, she said, "My boy, hold my hand, and don't let go."

As they walked along, the balloons, clowns and merry-go-round captivated his attention. He let go of his mother's hand and was quickly lost in the crowd.

Mother was frantic! She notified the fair policemen, and after diligent search, the boy was found.

Innocently, he asked his mother, "Mom, where were you lost?"

How slow unsaved ones are to acknowledge that *they* are lost and that *they* are the objects of the Saviour's quest: "For the Son of man is come to seek and to save that which was lost" (Luke 19:10).

ALICE MARIE KNIGHT

Why He Became An Outcast

Some years ago a man who was on trial for his life revealed, "My father always said I was no good. Mother said I would never amount to anything. The schoolteacher said that I was worthless. Even my home town people said I would become a criminal. And I always wondered why. I was just like other boys, only a bit more independent. The only creature that ever seemed to believe in me was my dog. My dog died, and I became an outcast."

Give a boy a bad name, and he'll live up to his reputation.

Told by HARRY A. IRONSIDE

* * *

How Ironic!

Two men and a youth—Arnold Dobson, Harold Most, and his son Harold Jr.—recently perished in the blazing summer heat of the Death Valley area. Sheriff deputies found their bodies seven, fourteen and seventeen miles from an abandoned car. "They were kind of strung out like a black line. The heat turned them black," said Deputy Red Landergran.

In leaving their stranded car to seek help, the three had tragically headed in the wrong direction, going toward a ranch house they had passed thirty miles back. Just a mile in the other direction was a grove of willows and a spring!

The shores of time are strewn with those who went in the wrong direction, taking the way of spiritual darkness and death: "There is a way which seemeth right unto a man, but the end thereof are the ways of death" (Prov. 14:12).

* * *

Neurosis of Emptiness

Dr. Carl Jung, the famous psychiatrist, said, "Those psychiatrists who are not superficial have come to the conclusion that the vast neurotic miseries of the world could be termed a neurosis of emptiness. Men cut themselves off from the root of their being—from God—and their life turns empty, inane, meaningless, without purpose. When God goes out, value goes, and life turns dead on our hands!"

Long ago one pleaded, "O wretched man that I am! who shall deliver me from the body of this death?" (Rom. 7:24).

* * *

Shades of Enoch Arden

A man was taken as a prisoner of war when the Russians marched into Germany in 1945. For some time he corresponded with his wife. Then her letters were returned to her. Not hearing from her husband, she presumed that he was dead. After several years, she remarried.

Twenty years later, the "dead" husband gained his freedom and returned home. After much heart searching, the wife annulled her second marriage and remarried her first husband.

Few separations have such a dramatic ending.

The most tragic and irreparable separation will occur when the unsaved hear the fateful words, "Depart from me, ye cursed, into everlasting fire, prepared for the devil and his angels" (Matt. 25:41b).

* * *

Sincere Seekers

Said H. G. Wells, "Until a man 'has found God, he begins at no beginning; he works to no end."

God does not elude the sincere, penitent seeker: "And ye shall seek me, and find me, when ye shall search for me with all your heart" (Jer. 29:13).

* * *

Payday Someday

A tribe in Africa elects a new king every seven years. The serving king has unlimited power even over life and death. He is honored and surfeited with every possession and luxury known to savage life. There is only one catch: At the end of his seven-year reign he is killed!

Every member of the tribe knows about the long-standing custom, but there are always applicants for the job of king. In exchange for seven years of power and luxury, the men are willing to sacrifice the remainder of life's expectations.

Someone may say, "Oh, well, what does it matter? They are only ignorant savages." Yet, in our modern, enlightened civilization men of intelligence and rare leadership ability are making a similar choice between possession of things now and bankruptcy hereafter.

Jesus said, "For what shall it profit a man, if he shall gain the whole world, and lose his own soul?" (Mark 8:36).

TODD W. ALLEN

* * *

A Hurricane Party

In 1969, about a dozen revellers were gathered for an exciting "hurricane party" in the posh Richelieu apartments in the town of Pass Christian, Mississippi, near the beach.

Police Chief Jerry Peralta came to urge the revellers to flee for safety. "The winds are now whipping at sixty miles an hour and the ocean is creeping over the sea wall," he warned. They refused to leave. When he took the names of the next in kin, they laughed raucously.

Some two hours later it happened! All the lights went out in Pass Christian! A three-story-high wave smashed over the sea wall! The Richelieu apartments were crushed to bits by the rushing waters and ferocious winds of Hurricane Camille!

The bodies of twenty-three persons were found in the rubble, including the revellers who a few hours before had failed to heed the warning of their would-be savior!

How like those revellers are many today who refuse to heed the warning to flee for refuge to the Saviour: "Surely in the floods of great waters they shall not come nigh unto him" (Ps. 32:6).

* * *

"To Us Belongeth Confusion of Face"
(Dan. 9:8a)

Sometimes homing pigeons become confused. An estimated 20,000 of the birds failed to return to their lofts after they were set free by a British racing federation. Valued at $600,000, the loss was described as the worst disaster in the history of homing pigeon racing.

127

LOVE FOR OTHERS

"One can only assume," said a spokesman for the race, "that the birds flew into a fog belt, turned around and went the other way. They could now be either in Scotland or on the continent."

Like those confused homing pigeons, myriads of people today have lost their way in the fog of doubt and distrust. Morally and spiritually confused, they have lost the true and tried norms of decency and respectability.

Long ago God gave this command: "Stand ye in the ways, and see, and ask for the old paths, where is the good way, and walk therein" (Jer. 6:16).

It's Easy to Get Lost

Dr. Donald H. Morgan has observed, "On a marker at Bok Tower in Lake Wales, Florida, occur these thought-provoking words, 'I have come here to find myself.'

"How easy it is to get lost in our morally and spiritually confused world. Men are daily inventing new ways to get lost."

The anguished cry of some is, "I have gone astray like a lost sheep; seek thy servant" (Ps. 119:176), but many are too proud to confess their lostness and need of the Saviour. They are like the Indian who was lost in a forest and seeking his wigwam. A woodsman saw him and asked, "Are you lost?" He replied, "No, no, I'm not lost. Wigwam lost."

LOVE FOR OTHERS

Institutions Without Soul

Lincoln's Gettysburg address consisted of only 272 words, requiring only two and a half minutes to deliver.

Edward Everett, the speaker who preceded Lincoln with a two-hour oration, wrote him the next day: "I should be glad if I could flatter myself that I came as near to the central idea of the occasion in two hours as you did in two minutes."

The major emphasis of Lincoln's address was *people:* "Government of the *people,* by the *people,* and for the *people.*"

When religious institutions lose their concern for the needs of people, they become soulless—distorted caricatures of what they ought to be. Only one biblical word is needed to describe them: Ichabod, which means *inglorious.*

* * *

The Motive for Existence

Some years ago, in a lecture at Columbia University, the agnostic Bertrand Russell said, "The root of the matter is an old-fashioned thing, a thing so simple I am almost ashamed to mention it for fear of the derisive smile of my critics. The thing is Christian love or compassion.

If you possess this love, you have a motive for existence, a guide in action, a reason for courage, an imperative necessity for intellectual honesty."

When everything else fails, "charity (love) never faileth" (I Cor. 13:8a). Try it!

* * *

Look, How They Love!

The Christian theologian Tertullian wrote in the first century after Christ, "It is our care for the helpless, our practicing of lovingkindness, that brands us in the eyes of our opponents. 'Look,' they say, 'how they love one another. Look how they are prepared to die for one another!' "

Tradition tells us that the aged apostle John, in bidding farewell to his congregation, admonished them to love one another.

"But, we want something new," they said. "Give us a new commandment."

John replied, "Brethren, I write no new commandment unto you, but an old commandment which ye had from the beginning . . . that we should love one another" (1 John 2:7; 3:11).

If Somebody Cared . . .

A forlorn, discouraged exconvict walked up to a total stranger on a busy street and asked, "Would you mind thinking about me for an hour or two? If I knew there was someone, somewhere who cared enough to think about me, it would enable me to find myself again and face life anew!"

* * *

The Best and Worst

Christian love is at its best when practiced on your neighbor at his worst.

* * *

"I Hold It True"

Sadder than losing a loved one is never having had a loved one to lose.

I hold it true, whate'er befall,
I feel it, when I sorrow most;
'Tis better to have loved and lost,
Than never to have loved at all.

In Memoriam
ALFRED, LORD TENNYSON

* * *

Healing Rays

The tiniest dewdrop hanging from a blade of grass in the morning is big enough to reflect the sunshine and the blue of the sky.

The obscurest life, aglow with the love of God and man, can reflect the healing rays of the Sun of Righteousness and the Light of the world.

* * *

Love With Skin On

Said a disillusioned youth to a minister, "I am sick and tired of hearing about God's love for me. I want to see love with skin on it!"

The youth wanted to see love exemplified in deeds.

Long ago the apostle John wrote: "Let us not love in word, neither in tongue; but in deed and in truth" (I John 3:18).

Said Henry Ward Beecher, "We never know how much one loves till we know how much he is willing to endure and suffer for us. Suffering for another measures love."

"I Sought My Brother"

No one could tell me where my soul might be,
I sought for God; He seemed to elude me,
I sought my brother out and found all three.

AUTHOR UNKNOWN

Long ago Cain asked, "Am I my brother's keeper?" (Gen. 4:9). There is but one answer to the ancient question. We *are* our brother's keeper: "For none of us liveth to himself, and no man dieth to himself" (Rom. 14:7).

* * *

The Never-Failing Ingredient

Some time ago the importance of love was highlighted in a dramatic experiment performed in an orphanage by some social scientists.

Babies in the orphanage were divided into two groups. Both groups received all the routine care provided by the nurses and matrons. They were fed on schedule, given proper medical attention, and had their diapers changed regularly.

But one group was given personal, loving care above the routine duties. The babies in Group One were held and cuddled as they were fed, changed, and put to sleep. The babies in Group Two had their basic physical needs met but were shown no love at all. They had nothing more than routine care.

It did not take long in the experiment for marked differences to develop. All the youngsters in Group One thrived. They developed bright, sunny personalities. But some of the babies in Group Two developed signs of serious emotional maladjustment. Their physical condition suffered too.

Love does "make the world go 'round." Love is vitally important.

Eternity

* * *

A City of Sinners

Preparatory to beginning a meeting in a large city, famed evangelist Billy Sunday wrote a letter to the mayor in which he asked for the names of individuals he

129

knew who had spiritual problems and needed help and prayer.

How surprised the evangelist was when he received from the mayor a city directory!

Everywhere there are burdened, bothered ones "standin' in the need of prayer." Many are inwardly yearning for the Christlike touch of love and understanding.

The Sure Cure

Said Dr. Karl Menninger, world-famed psychiatrist, "Love cures people, both the ones who give it and the ones who receive it!"

"Love never faileth" (I Cor. 13:8a). Try it!

LOVE, GOD'S

Who First Loved Us

Saviour, teach me day by day,
Love's sweet lesson to obey;
Sweeter lesson cannot be
Loving Him who first loved me.

With a childlike heart of love,
At Thy bidding may I move;
Prompt to serve and follow Thee,
Loving Him who first loved me.

Teach me all Thy steps to trace,
Strong to follow in Thy grace;
Learning how to love from Thee;
Loving Him who first loved me.

Love in loving finds employ,
In obedience all her joy;
Ever new that joy will be
Loving Him who first loved me.

Thus may I rejoice to show
That I feel the love I owe;
Singing, till Thy face I see,
Of His love who first loved me.

JANE E. LEESON

* * *

"God So Loved the World"

But why? What could You find lovable in this gaggle of genocides who treat their brothers as animals, their animals as things?

And Your own Son! You knew how we would treat Him—and He was willing! What, *what* did You see in us?

F. MAGUIRE

Jesus' Boundless Love

Jesus, Thy boundless love to me
No thought can reach, no tongue declare;
O knit my thankful heart to Thee,
And reign without a rival there!

O let Thy love my soul inflame,
And to this service sweetly bind,
Transfuse it through my inmost frame,
And mold me wholly to thy mind!

PAUL GERHARDT
Trans. John Wesley

* * *

Sowing Precious Seed

A gnarled, stooped, old Chinese woman, supporting herself with a cane, related this touching story to Mrs. E. Weller of the China Inland Mission:

"Twenty years ago, in this very place, a foreign young woman, who couldn't speak many of our words, taught me the first two lines of 'Jesus Loves Me.' My daughter and I say these lines every night. We worship Jesus and pray to Him about everything. We've had no idols in our homes since that young woman taught me those lines."

Mrs. Weller sat beside the old woman and told her more about Jesus, the wonderful Saviour.

In telling the incident later, Mrs. Weller said, "That old woman probably has long since seen her Saviour face to face and has greeted the unknown young lady who told her about Jesus' love."

130

"In the morning sow thy seed, and in the evening withhold not thine hand: for thou knowest not whether shall prosper, either this or that, or whether they both shall be alike good" (Eccl. 11:6).

* * *

If the Bible Were Destroyed

Said Dr. Ralph M. Smith, "One of my minister friends has made more than 600 outlines of John 3:16 whose central truth is the immeasurable, unfathomable love of God for all mankind.

"Henry Morehouse began to preach when he was sixteen years old. He died in his early manhood. Every time he stood to preach, he gave as his text: 'For God so loved the world, that he gave his only begotten Son, that whosoever believeth in him should not perish, but have everlasting life' (John 3:16).

"If all the Bible were destroyed except John 3:16, anyone anywhere could be saved by believing this oft-quoted and cherished verse!"

* * *

A Personalized Love

Said Augustine, "God loves us every one as though there were but one of us to love!"

* * *

How Comprehended?

The love of God cannot be comprehended as only a noun. It must have the dynamic, propelling power of a verb: "Having loved his own which were in the world, he loved them unto the end (to the uttermost)" (John 13:1b).

"Love Found A Way"

Helen Keller became blind and deaf when nineteen months old. Her mother lamented, "If I said it once, I said it a thousand times: 'Helen, if only there were some way for me to let you know how much I really love you!'"

God found a way to show His great love for us: "But God . . . for his great love wherewith he loved us . . . hath quickened us together with Christ" (Eph. 2:4, 5).

O the love that drew salvation's plan!
O the grace that brought it down to man!
O the mighty gulf that God did span
 At Calvary!

WM. R. NEWELL

* * *

Our Best Today

Often the best way to make things go is to take the "I" out of *live* and put in an "O."

There's so much to believe in and love in life that it's impossible ever to run out. All you have to do is look up and around.

First and foremost, there's belief in and love for your Creator—God. God is love and all love starts with Him and in Him. The love of God opens the way to all other loves: love for your helpmate, your children and your children's children . . . love for your neighbor as yourself . . . love for your community and for America . . . love for freedom and fair play, and love for all people everywhere regardless of color or creed or status.

Love is all of God's master plan to create His heaven in your heart!

Adapted from
Austin American-Statesman

131

MISSIONS

"His Way Is Perfect"

When searching for David Livingstone, Henry M. Stanley had a most unusual reception from King Mutesa in Uganda. The queen had a strange dream about the white man's God and His Son Jesus Christ shortly before Stanley's arrival. She related her dream after the arrival of Stanley at the royal house.

The king and queen pleaded with Stanley to send a letter to England and ask for a missionary teacher to be sent to them. He wrote the letter and sent it out by a young Frenchman who was leaving Stanley's party.

The bearer of the letter was murdered. Several months later his body was found by some British soldiers. Searching through his clothing, they found Stanley's letter in one of his boots. They sent it to England, where it was featured in the *Daily Telegraph*.

Great interest was aroused. When the Church Missionary Society appealed for missionary volunteers to go to King Mutesa's land, seven young men responded!

Often we do not understand why God allows certain things to occur: "What I do thou knowest not now; but thou shalt know hereafter" (John 13:7). This is certain: "As for God, his way is perfect" (Ps. 18:30a).

* * *

How Long Must They Wait?

In June 1971 the Tasadays, a Filipino tribe which had been isolated from other people for hundreds of years, was discovered. The tribe was living in a rain forest 3,000 feet up Tasaday Mountain— a place ribboned by rivers and never known to shelter man. A helicopter flying there went from the space age to the Stone Age in 30 minutes!

The Tasadays had never known the taste of salt or sugar, rice or corn. Their language has no word for sea. Their heaven is no higher than the top of a tree. Their basic tools are made of stone. When the American anthropologist, Dr. Robert E. Fox, reached the Tasadays, they were fearful. However, their fear soon gave way to warmth and friendliness.

In different places around the world live many tribes and people groping in darkness—spiritually lost because they have never had a crumb of the Bread of Life. They are without God and without hope.

How slow Christians are to share with them the emancipating Gospel of the grace of God!

* * *

Send Me

The secretary of a foreign missionary board preached on missions in a large church. Realistically he depicted the all-encompassing darkness which enshrouds the souls of sin-shackled multitudes who have never heard of Jesus the Saviour.

At the conclusion of the message, he asked for volunteers for the mission field. Some of the youths responded.

Years later, the secretary returned to the same church, preached again on missions and called for volunteers. Again some young people responded. Among them were several who had previously volunteered for the mission field.

The secretary said, "Some years ago some of you said, 'Here am I,' but you apparently failed to add, 'Send me!' "

* * *

The Wail of Perishing Ones

Years ago, in a meeting of the Reformed Presbyterian Church of Scotland, a plea was made for missionaries to join one who had already gone to the South Seas.

John G. Paton, a young student, seemed to hear God's voice saying, "Since none better qualified can be got, rise and offer yourself!"

Years later, in referring to God's call, he said, "I not only heard God's voice, but I heard also the wail of the perishing ones in the South Seas!"

132

"Ride for Thy Life"

The word "posthaste" came into usage during the reign of Henry VIII of England. Relays of horses were stationed in principal towns in England. When a letter was stamped "posthaste," it meant "ride for thy life!" If a carrier were caught delaying en route, he was hanged!

Letters of the sixteenth century often bore a drawing of a letter carrier suspended from the gallows! Beneath the drawing occurred the words: "Haste! Posthaste! Haste for thy life!"

How slow many of God's children have been to obey the Saviour's directive: "Go ye into all the world, and preach the gospel to every creature" (Mark 16:15). "The king's business required haste" (I Sam. 21:8b).

Complacently Rejoicing

As Hudson Taylor, founder of the China Inland Mission, stood to preach before a great audience in Bristol, England, he experienced great spiritual agony. Later, he said, "I was unable to bear the sight of a congregation of a thousand or more Christians, complacently rejoicing in their own salvation, while millions are perishing for lack of knowledge—lost!"

How unlike the Savior are God's children when they have no solicitous concern for perishing souls. As Christ looked upon the shepherdless multitudes, He was "moved with compassion on them" (Matt. 9:36).

MOTHER

I Was So Cross to the Children

"God, I was so cross to the children today! Forgive me. I was discouraged and tired, and I took it out on them. Forgive my bad temper, my impatience, and most of all, my yelling. I am so ashamed as I think of it. I want to kneel down by each of their beds, wake them and ask them to forgive me. But I can't. They wouldn't understand. I must go on living with the memory of this awful day, my unjust tirades. Hours later, I can still see the fear in their eyes as they scurried around, trying to appease me, thinking my anger and maniacal raving was their fault.

"O God, the pathetic helplessness of children! Their innocence before the awful monster—the enraged adult. How forgiving they are—hugging me so fervently at bedtime, kissing me good night. All I can do is straighten a cover, touch a small head burrowed in a pillow and hope with all my heart that they will forgive me.

"Lord, in failing these little ones whom You have put in my keeping, I am failing You. Please let Your infinite patience and goodness replenish me for tomorrow!"

MARJORIE HOLMES
I've Got to Talk to Somebody, God
© 1969, used by permission of
Doubleday & Co., Inc.

Across the Years

A picture memory brings to me:
I look across the years and see
Myself beside my mother's knee.
I feel her gentle hand restrain
My selfish moods, and know again
A child's blind sense of wrong and pain.
But wiser now, a man gray grown,
My childhood's needs are better known.
My mother's chastening love I own.

JOHN GREENLEAF WHITTIER

* * *

The Name of Mother

The noblest thoughts my soul can claim,
The holiest words my tongue can frame,
Unworthy are to frame the name
 More sacred than all other.
An infant when her love first came,
A man, I find it just the same:
Reverently I breathe her name—
 The blessed name of Mother.

L. A. FETTER

* * *

God's Representative

William Thackeray wrote in *Vanity Fair,* "Mother is the name for God in the lips and hearts of little children."

A Jewish proverb notes, "God could

not be everywhere, so He made mothers."
And a Spanish proverb declares, "An ounce of mother is worth a ton of priest."

The Talmud states, "Who is best taught? He who has first learned from his mother."

NATURE

"How Manifold Are Thy Works!"

How remarkable are the facts about thunder, storms and lightning given in an editorial of *The Austin (Texas) American Statesman*:

Still only half understood, the thunderstorms that fill summer skies with jagged light and rolling sound are among nature's most fascinating phenomena.

They generate electricity and spread fertilizer. Thunderstorms—44,000 a day—crash down on every continent but Antarctica.

An average thunderstorm releases fifty times the energy of the first atomic bomb. Yet it begins as a column of gently rising air—warm, moist, walled by a chimney of cooler air, and topped by a cottony cumulus cloud.

This thunderstorm "cell" of rising warmth, if conditions are just right, gains power as it lifts. Air expands and cools. It begins wringing out its load of water vapor. Droplets form and grow heavier. The cloud boils higher and darker. A "cumulus gone wild" becomes a thunderhead. The greatest violence occurs 15,000 to 25,000 feet in the air.

How this crackling dynamo works is scarcely understood, two hundred years after Ben Franklin's time. But scientists say that lightning, flashing between earth and clouds, continuously recharges nature's electrical system.

Lightning, in addition, combines nitrogen and oxygen in the air into priceless fertilizer for the soil. Rain washes it down. An estimated 100 million tons of usable plant food is thus produced each year, far more than all the fertilizer man makes!

In contemplation of God's wondrous works, we exclaim, "O Lord, how manifold are thy works! in wisdom hast thou made them all: the earth is full of thy riches" (Ps. 104:24).

* * *

All Equal Before Fish

Herbert Hoover said, "To go fishing is the chance to wash one's soul with pure air, with the rush of the brook, or with the shimmer of the sun on blue water. It brings meekness and inspiration from the decency of nature, charity toward tacklemakers, patience with fish, a mockery of profits and egos, a quieting of hate, a rejoicing that you do not have to decide a darned thing until next week. And it is discipline in the equality of men—for all men are equal before fish."

* * *

Compassion for Flowers

The English poet, William Wordsworth, was a devoted lover of nature. He would sit for hours looking at the daisies or daffodils. " 'Tis my faith," he said, "that every flower enjoys the air it breathes."

It is said that Wordsworth never plucked a bud or even pressed the stem of a flower with his fingers. He was the founder of the Society for the Prevention of Cruelty to Flowers.

The Bible tells us about the miracles of God. The seed catalogue shows some of them.

* * *

Evidence of God Everywhere

Sam P. Jones said, "We see God all around us: the mountains are God's thoughts upheaved; the rivers are God's

thoughts in motion; the oceans are God's thoughts imbedded; the dewdrops are God's thoughts in pearls!"

Long ago, as the psalmist looked at the star-studded sky, he exclaimed, "The heavens declare the glory of God; and the firmament sheweth his handiwork" (Ps. 19:1).

* * *

Defenseless Against Ourselves

Almost daily we hear and read ominous warnings about the lessening chances of mankind's survival on earth.

"Man has lost the capacity to foresee and to forestall. He will end by destroying the earth," said Albert Schweitzer.

"The human race's prospects of survival were considerably better when we were defenseless against tigers, than they are today when we have become defenseless against ourselves," declared Arnold Toynbee.

"Our approach to nature is to beat it into submission. We would stand a better chance of survival if we accommodated ourselves to this planet, and viewed it appreciatively instead of dictatorially and skeptically," wrote E. B. White.

The Book of Revelation also speaks warningly: "And the third angel sounded, and there fell a great star . . . upon a third part of the rivers and upon the fountain of waters; and the name of the star is Wormwood; and the third part of the waters became wormwood, and men died of the water because it had been poisoned" (Rev. 8:10-11).

Though "the whole creation groaneth and travaileth in pain" (Rom. 8:22b), God's children should always "look for new heavens and a new earth, wherein dwelleth righteousness" (II Pet. 3:13).

* * *

"Marvelous Are Thy Works!"

Wrote Natalie Barber, "When I was a student at the University of Vermont, I was convinced that the universe ran according to scientific rules and that the idea of a loving God was a myth.

"In embryology lab we were studying the growth of the chick. Each day our instructor opened one of the twenty-one fertilized eggs in the incubator and carefully removed the living embryo so we could observe the progress of its growth.

" 'The heart won't start beating,' our instructor explained, 'until other parts of the circulatory system are ready—about the forty-fourth hour.'

"When I returned to study the tiny heart of a forty-four-hour chick, the heart had grown. Then it began contracting spasmodically in tiny, fitful tremors. As I watched, the tremors grew stronger, more regular. The heart was beating, pushing blood through the tiny embryo in a movement that would nourish the chick throughout its life.

"I was spellbound by what I had seen take place before my eyes! I thought of the perfect timing. Then at that moment, a new life began for me. I felt the guiding hand of God upon His universe. This was no scientific machine I had been observing. This was a living act performed by the Creator who cared."

"Marvellous are thy works; and that my soul knoweth right well" (Ps. 139: 14b).

* * *

Indian Summer

The poignant hush and the blue haze of Indian summer when the cornstalks stand like sentinels guarding the yellow pumpkins upon the ground; the graceful lines of a startled deer as it stands poised to run when I invade its private sanctuary; millions of stars dotting the canopy of heaven on a night when frost nips the air; wisps of smoke curling from chimneys and the contented happy sounds of living coming from the home I pass as I walk down the street in the twilight; autumn leaves casting a cloak of many colors over the hillsides; a tawny squirrel peering at me from the crotch of a tree, his bushy tail waving like a warning flag to tell me he has staked his claim to this tree where he has hidden his store of food for winter—for all this, and much more, oh, God, give us eyes to see, and ears to hear! One lifetime is not long enough in which to drink in all this loveliness!

Home Life

NATURE

Look at a Rose and Thank God

As Stanley Baldwin conversed with a friend, he looked at a lovely bowl of roses and exclaimed, "Plunge your face in those roses and thank God!"

* * *

Doubts Go

Said Tertullian, "If I give you a rose, you won't doubt God."

* * *

Three Days to See

Said Helen Keller in her splendid essay *Three Days to See,* "I who am blind can give one hint to those who see: Use your eyes as if tomorrow you would be stricken blind. Make the most of every sense. Glory in all the facets of pleasure and beauty which the world reveals to you through the several means of contact which nature provided."

* * *

The Heavens Declare

Said astronaut Major Wm. Anders, "The more I see of God's universe the deeper is my belief in God!"

The psalmist said, "The heavens declare the glory of God; and the firmament sheweth his handiwork" (Ps. 19:1).

* * *

Everything Beautiful

Many tourists who go to Ireland visit the Holy Trinity Church in Glengariff. The church has some beautiful stained-glass windows. After a casual glance at them, the visitors go to a clear-glass window through which they see a most wondrous view—a lake of deepest blue, studded with rhododendron-carpeted islets, fringed by range after range of purple hills. When the sightseers step back slightly from the window, the scene seems to be actually in the glass itself!

How appropriate is the inscription beneath the window: "The heavens declare the glory of God and the firmament sheweth his handiwork" (Ps. 19:1).

Of God's creation, the Bible says, "He (God) hath made every thing beautiful in his time" (Eccl. 3:11).

Told by KENNETH HARVEY, Belfast

* * *

Glorious Moments

During college, I found many of my boyhood ideas about the world, based on the Bible, shaken by new learning. I felt betrayed. I had accepted certain things as true. Now apparently there were different truths. Why would God allow such a thing to happen?

One Friday in early fall, as I drove to class, this feeling seemed to climax. I steered my car automatically, arguing in my mind with my teachers and then with God.

I crested a hill, and suddenly before me lay a wooded valley with every leaf of every tree ablaze with glorious color, running the spectrum from yellow to deep wine.

I had to stop! Recalling my textbook, I said to myself, "This color results as the leaves surrender their vital factors to the tree, giving it a reserve for winter—an undeniable scientific fact."

But then another fact from another Book came to me: *He that loses his life shall find it.*

And all at once I knew the conflict had been only in me. There were not different truths—only different roads to the same reality. In this case, an old religious truth had been clothed for me in bright new colors—we and the leaves are never more beautiful than when we surrender our life to the Creator!

C. EUGENE FOLSOM

* * *

God's Nearness

When God created man, He placed him in a beautiful garden: "And the Lord God planted a garden eastward in Eden; and there he put the man whom he had formed" (Gen. 2:8).

In another garden—Gethsemane—the Saviour agonized in prayer and emerged victorious over spiritual anguish and sorrow: "O my Father, if it be possible, let this cup pass from me; nevertheless not as I will, but as thou wilt" (Matt. 26:39).

"If I Were the Creator"

Upon the completion of his first year in college, a youth returned to his country home to spend the summer vacation.

His studies in the college had given him some sophisticated ideas about creation and the seemingly wrong arrangement of things in general.

Out walking with his dad one day, he saw a huge pumpkin growing on a small vine. Then, looking up, he observed a small acorn on a large oak tree.

"Dad," said he, "if I were the Creator, I would have put the acorn on the fragile vine, and the pumpkin on the mammoth oak."

Just then the acorn fell and hit his head!

"Well, my boy, I imagine you are glad now that the Creator put the pumpkin where it is," said his father.

"As for God his way is perfect" (Ps. 18:30a); "Oh that men would praise the Lord for his goodness, and for his wonderful works to the children of men" (107:31).

Told by RALPH M. SMITH

* * *

Too Busy

Some are so busy doing God's work that they have no time left to observe His handiwork: "The whole earth is full of His glory" (Isa. 6:3b).

OBEDIENCE—DISOBEDIENCE

A Voice from the Skies

"Timothy Adams, go home!" boomed a thunderous voice from the heavens.

Six-year-old Timothy Adams on the ground below had been loitering en route home from kindergarten until the voice startled him. It was now 5 P.M., and much later than the time Timothy usually arrived at home. Ninety minutes after the pupils were dismissed from school, his mother, Mrs. Paul Adams, had called the police, seeking help.

Shortly thereafter, police officers William Dycus and James Threece saw Timothy from their helicopter and told him to go home. Fifteen minutes later, the mother reported the safe arrival of her son.

As Timothy ran into the house, wide-eyed with excitement, he said, "Oh, Mommy, a big voice from the sky told me to come home!"

Mother did nothing to clear up for her son the origin of the voice from the sky.

Myriads on earth will continue in their spiritual lostness if they fail to hear and obey the pleading voice of God, "O earth, earth, earth, hear the word of the Lord" (Jer. 22:29).

ALICE M. KNIGHT

Weary of Empty Life

A woman who had grown weary of her empty, worldly life, said to Dr. G. Campbell Morgan, "I am going to give myself to Christ and follow Him. I have counted the cost. I may possibly have to do some things which are distasteful to me and which mean sacrifice and suffering. But I will do them, so help me, God."

"That's right," commented Dr. Morgan. Then he commended her for her noble resolve.

Later the woman, with face beaming joy and contentment, said to Dr. Morgan, "Do you recall what I said to you sometime ago about following Christ, no matter what it entailed?"

"Yes," said Dr. Morgan.

"Everything has been so different from what I thought," she joyfully exclaimed. "I began to follow Christ with fear and trepidation, foolishly thinking that He would require me to do distasteful things contrary to my nature and wishes. But now I do what pleases me every day. The Lord has made me pleased with the things that please Him."

137

OBEDIENCE—DISOBEDIENCE

No Call to Stay

A friend asked Dr. Donald Carr of Persia, "How did you receive the call to serve the Lord as a missionary in Persia?"

Dr. Carr replied, "I had no call to stay at home, but I had the command to 'Go ... into all the world, and preach the gospel to every creature'" (Mark 16:15).

* * *

Don't Stoop

Said Spurgeon, "If God calls you to be His worker, don't stoop to become a king."

* * *

Scat!

A farmer made six holes in his door as exits for his six cats.

A friend asked, "Why do you make six holes in the door? One hole would have been enough."

The farmer replied with emphasis, "When I say 'scat,' I mean scat!"

When the Lord says, "Except ye repent, ye shall all likewise perish" (Luke 13:5b), He means exactly what He says.

* * *

Nothing So Momentous

Said F. M. Meek, "Nothing is more momentous in a man's life or a nation's existence than the call to leave an inadequate present and go to God's promised and uncertain future."

* * *

In and Out

Said Dr. Alan Redpath, "The Christian life is not an up-and-down life, but an in-and-out life: in for orders, out for obedience; in for worship, out for witnessing; in for surrender, out for service."

* * *

Blind But Obedient

Richard Vonderhaar, a blind fifteen-year-old boy safely flew and landed a single-engine Cessna plane at Lunken Airport, Cincinnati, Ohio. How did he do it? By his explicit obedience to the verbal directives of instructor-pilot General Dowers.

In commenting upon the successful feat, General Dowers said, "It was amazing the way that kid grasped instruction!"

Long ago, wilfull Saul lost his kingdom by disobedience to God and made shipwreck of his life. Remorsefully he lamented: "I have played the fool, and have erred exceedingly" (I Sam. 26:21b). Saul ended his life ignobly: He "took a sword, and fell upon it" (31:4b).

Adapted from *Prairie Overcomer*

* * *

The Highway to Renewal

In addressing the Canadian Congress on Evangelism, Dr. F. D. Coggan, Anglican archbishop of York, said: "I had rather, ten thousand times rather, incur the divine rebuke for error in method, or even in doctrine, in a task done in obedience to His command, than I would hear Him say, 'I told you to go and you never went!'

"When we obey the command and unitedly go out on evangelistic work, I believe we shall find that it will be with us as with the lepers: 'As they went, they were cleansed!' As we go, we shall find renewal."

* * *

We Know Better

A salesman did his best to persuade an elderly, weather-beaten farmer to buy a set of books on scientific farming, but without success.

"No, I don't want those books," the old man replied.

"But, sir," said the salesman, "if you had these books you could be twice the farmer you are!"

"Son," drawled the farmer, "I don't farm half as good as I know how now!"

Most of us know better than we do. It is better not to know than to know and not do: "For it had been better for them not to have known the way of righteousness, than, after they have known it, to turn from the holy commandment delivered unto them" (II Pet. 2:21).

Crossroads

"When I stood at the crossroads in my early years to choose a career," said Dr. J. H. Jowett, "I decided for the law. But when I was about to begin, an old Sunday school teacher of mine met me. He asked me what I was going to do with myself. I told him I was going into law. He quiet-

ly said, 'I always hoped and prayed you would go into the ministry.'

"Those were momentous words. They threw all my life into confusion. I went exploring down another road, and I met the great Companion, Christ. In submission I obeyed His call to follow Him. At the end of thirty-five years, I have never regretted my choice!"

OLD AGE

No Nothing

Dr. D. H. Truhitte, an octogenarian, shows friends a small card about retirement, which says: "No business, No enemies, No money, No phone, No worries, No nothing, but I live in America!"

How fortunate!

* * *

Good as Dead

Ernest T. Campbell said, "When a man's life expectancy expires, he is as good as dead."

Long ago the psalmist lamented: "Why art thou cast down, O my soul? And why art thou disquieted in me? Hope thou in God: for I shall yet praise him for the help of his countenance" (Ps. 42:5).

* * *

"I Am Tired"

Mrs. Jaromira Kaspar, shortly after celebrating her ninety-eighth birthday in Texas, was asked by a news correspondent, "Would you like to live another ninety-eight years?"

She replied, "No. This has been a good life, but I am tired."

"There remaineth . . . a rest to the people of God" (Heb. 4:9).

* * *

The Devil's Crowning Work

Lord, Thou knowest better than I know that I am growing old.

Keep me from getting talkative, and thinking I must say something on every subject, on every occasion.

Release me from craving to try to straighten out everybody's affairs.

Keep my mind free from the recital of endless details—give me wings to get to the point.

I ask for grace enough to listen to the tales of others' pains. Help me to endure them with patience. But seal my lips to my own aches and pains—they are increasing and my love of rehearing them is becoming sweeter as the years go by.

Teach me the wondrous lesson that occasionally it is possible that I may be mistaken.

Keep me reasonably sweet. Some are hard to live with, but a sour old woman is one of the crowning works of the devil.

Make me thoughtful but not moody, helpful but not bossy.

Eternity

* * *

When I Am Gone

As a neighbor observed a feeble old man planting an apple tree, he asked, "Why are you planting an apple tree? You will probably not live until it is old enough to bear fruit."

The octogenarian calmly replied as he continued his task, "The world will not be at an end when I am gone!"

* * *

Not Wholly a Matter of Ripe Cheeks

On his seventy-fifth birthday, General Douglas MacArthur said, "Youth is not entirely a time of life—it is a state of mind. It is not wholly a matter of ripe cheeks, red lips, or supple knees. It is a temper of the will, a quality of the imagination, a vigor of the emotions. I promise to keep on living as though I expected to live forever!"

OLD AGE

Life's Rainbow

I sat beneath a great old tree
One sunny, childhood day
And dreamily fished in the little brook
That crossed the meadow gay:
A lowering cloud came o'er the sky
And hid the sun from view;
Then, lo, a gorgeous rainbow came,
Its beauty shining through.

Those halcyon days have passed away;
No longer am I a child;
The clouds of life hang low, and oft
Tears come instead of smiles.
But through the mists of doubts and fears,
If I but lift my eyes,
A lovely bow of HOPE will shine
Across life's cloudy skies.

STELLA PATTERSON

* * *

Opportunity

Age is opportunity, no less
Than youth itself, though in another
 dress.
And as the evening twilight fades away
The sky is filled with stars invisible by
 day.

HENRY WADSWORTH LONGFELLOW

* * *

Why Not Keep On?

How challenging it is to so-called old-sters to know that many people have done their finest work after becoming octogenarians!

On his eighty-fourth birthday, Dr. Robert G. Lee, pastor emeritus of the First Baptist Church, Memphis, Tennessee, said, "A friend asked me, 'Are you going to keep on preaching?' I said, 'Why not? I am physically able, mentally sound, spiritually desirous and in love with Jesus. Why not keep on preaching as I have done for sixty-two years?'"

Titian, master of Venetian painting, produced some of his most wonderful canvases after eighty, painting his famous "Battle of Lepanto" at ninety-eight.

Tennyson was eighty-three when he composed *Crossing the Bar.*

When eighty-three, George Bancroft was writing deathless history.

John Wesley preached with undiminished eloquence at eighty-eight.

Edison was still inventing at ninety.

Grandma Moses began painting when seventy-eight.

J. C. Penney, a Christian merchant prince, worked strenuously at his business at ninety-five.

When eighty-three, Gladstone, for the fourth time, became Prime Minister of Great Britain.

How sustaining and comforting is God's sure promise to His children: "And even to your old age I am he . . . I will carry you . . . and will deliver you" (Isa. 46:4).

* * *

"It Is Hard to Grow Old Alone"

Many years ago, H. P. Danks wrote a song which brought fame and fortune to him: *Silver Threads Among the Gold.*

When he wrote the song, Danks and his wife were deeply devoted to each other. They were very poor, and their poverty seemed to draw them closer together. He expressed his love and devotion to her in these words:

> "Darling, I am growing old,
> Silver threads among the gold;
> But, my darling, you will be,
> Always young and fair to me."

Fame and fortune brought discord and unhappiness. Danks and his wife separated and their home was broken up. Years later, Danks was found dead, kneeling beside his bed in a cheap boarding house in Philadelphia. On the bed lay an old copy of his famous song—*Silver Threads Among the Gold.* Across it, he had scrawled the pathetic, forlorn words, "It is hard to grow old alone!"

* * *

Renewing Power of Love

"For, lo, the winter is past, the rain is over and gone; the flowers appear on the earth; the time of the singing of birds is come, and the voice of the turtle is heard in our land" (Song of Sol. 2:11, 12).

Spring still makes spring in the mind
 When sixty years are told,

Love makes anew this throbbing heart
And we are never old!

Over the winter glaciers
I see the summer glow,
And through the wind-piled snowdrift,
The warm rosebuds below.

RALPH WALDO EMERSON

* * *

As Young As Your Faith

Said Samuel Ullman, "Youth is not a time of life—it is a state of mind. Nobody grows old by merely living a number of years. People grow old by deserting their ideals. You are as young as your faith, as old as your doubts; as young as your self-confidence, as old as your fear; as young as your hope, as old as your despair. In the central place of your heart there is a wireless station. So long as it receives messages of beauty, hope, cheer, grandeur, courage and power from God and man, so long are you young."

* * *

An Inborn Desire

Nearly three hundred years ago, Jonathan Swift said, "Every man desires to live long, but no man wants to be old."

Oliver Wendell Holmes said, "To be seventy years young is something far more cheerful than to be forty years old."

God has given these wondrous promises to His people: "With long life will I satisfy him, and shew him my salvation" (Ps. 91:16); "And even to your old age I am he; and even to hoar hairs will I carry you: I have made, and I will bear; even I will carry, and will deliver you" (Isa. 46:4).

Grow old along with me,
The best is yet to be!

BROWNING

* * *

Keep Going

As the years pass, keep mentally vigorous. The brain, like the muscles of the body, needs activity to keep fit. The more it's used, the more efficient it remains.

Sir Winston Churchill mobilized the entire British Empire during World War II when he was sixty-six.

Frank Lloyd Wright, the famous architect, designed New York City's imposing Guggenheim Museum when he was in his 80's and 90's.

When in his eighty-first year, Tennyson wrote *Crossing the Bar*, a poem whose fear-allaying, hope-imparting message will endure as long as time lasts.

Keep going, and old age will find it hard to catch up with you!

* * *

A Young Old Man

Said Dr. Theodor Reik, Viennese psychoanalyst, "At eighty-one, I think of myself as a young old man. I still have students and patients, and I am writing books. Older persons should not isolate themselves from society. They should cultivate a sense of humor and curb worry which makes them look ten or even twenty years older."

* * *

Hope for the Aging

Said Dr. Steven Lunger of Duke Medical Center, "We have to get rid of the superstition that aging is something inevitable and beyond the power of modern scientific research. We pay a terrible price for this delusion, which has no logical basis anymore."

Whether we die in the morning of life or in the late afternoon of life, what matters most is how we have lived—gloriously or ingloriously, nobly or ignobly, selfishly or unselfishly, for Christ or against Christ.

* * *

Last Turn the Best

Said Henry Van Dyke, "I shall grow old, but never lose life's zest, because the road's last turn will be the best!"

"But the path of the just is as the shining light, that shineth more and more unto the perfect day" (Prov. 4:18).

141

PARENTAL RESPONSIBILITY

Intellectual Disenchantment

Said Mrs. Billy Graham, mother of five children, and also a grandmother, "I think our teenagers today are the most intelligent, most gifted, most informed crop of young people that the United States—and perhaps the world—has ever seen. They have reacted in 'intellectual disenchantment' with the emptiness of society as they see it, with the hypocrisy of their elders."

* * *

Baby's Skies

Would you know the baby's skies?
Baby's skies are Mother's eyes.
Mother's eyes and smile together.
Make the baby's present weather.

Mother, keep your eyes from tears,
Keep your heart from foolish fears,
Keep your lips from dull complaining
Lest the baby think 'tis raining.

M. C. BARTLETT

* * *

Bitter Streams

Said John Locke, English philosopher, "Parents wonder why the streams are bitter when they themselves have poisoned the fountain!"

"Our fathers have sinned, and are not; and we have borne their iniquities" (Lam. 5:7).

* * *

Crookedness

There was a crooked man,
Who had a crooked smile,
Who made a crooked fortune,
In a very crooked style.

He lived a crooked life,
As crooked people do,

And wondered how it turned out,
That his sons were crooked too.

AUTHOR UNKNOWN

* * *

What Children Want

A well-dressed couple confronted a salesgirl in a toy shop with a request for toys that would keep their children entertained. "My husband and I are both employed," explained the mother, "and the children are alone a great deal."

The salesgirl showed them a variety of games and play equipment, but to each there was some objection. "It seems to me," the mother finally said impatiently, "that if you knew what we are really looking for, you could find it among these toys."

The salesgirl hesitated, and then said quietly, "I'm sorry, madam, I think that what you are really looking for, and what your children want, is a mother and father. And we don't sell them here!"

MARION LEACH JACOBSEN,
in *Moody Monthly*

* * *

Criminally Liable

Madison Heights, a suburb of Detroit with a population of 34,000, recently enacted an ordinance which stipulates: "Parents of a child under seventeen who violates a city or state law can be held criminally liable for a $500 fine and ninety days in jail."

Where there is parental failure to obey the command, "Train up the child in the way he should go," and to go that way themselves, youths may make shipwreck of life!

There are no substitutes for Christian homes and parental example.

PEACE

The Journey Is Too Great

Come ye yourselves apart and rest a
 while,
Weary you are of the press and throng;
Wipe from your brow the sweat and dust
 of toil,
And in My quiet strength again be
 strong.

Come ye aside from all the world holds
 dear,
For converse which the world has never
 known;
Alone with Me and with My Father here,
With Me and with My Father, not
 alone.

Come, tell Me all that ye have said and
 done,
Your victories and failures, hopes and
 fears;
I know how hardly souls are wooed and
 won,
My choicest wreaths are always won
 with tears.

Come ye and rest! The journey is too
 great,
And ye will faint beside the way and
 sink;
The bread of life is here for you to eat,
And here for you the wine of love to
 drink.

Then, fresh from converse with your Lord,
 return,
And work till daylight softens into even;
The brief hours are not lost in which ye
 learn,
More of your Master and His rest in
 heaven.

BISHOP BICKERSTETH

* * *

A Prayer of Saint Francis of Assisi

Lord, make me an instrument of Your
peace! Where there is hatred, let me sow
love. Where there is injury, pardon.
Where there is doubt, faith. Where there
is despair, hope. Where there is darkness,
light. Where there is sadness, joy.

O Divine Master, grant that I may not
so much seek to be consoled as to console;
to be understood, as to understand; to be
loved as to love; for it is in giving that we
receive. It is in pardoning that we receive
pardon. It is in dying that we are born to
eternal life.

* * *

"Over the Rainbow"

In the famed motion picture, "The
Wizard of Oz," young Judy Garland sang
and popularized a song which deeply
touched the hearts of millions who greatly
admired her: "Over the Rainbow."

The song expresses a longing to escape
to some faraway place where problems
"melt away like lemon drops." It tells of
a distant shangri-la where blue birds fly
over the rainbow, and asks, "Why, oh
why, can't I?"

Did Judy ever find what the heart
yearns for—rest and spiritual satisfaction?
Seemingly not. *She later took her own
life!*

The soul has an innate spiritual yearn-
ing for God: "As the hart panteth after
the water brooks, so panteth my soul
after thee, O God. My soul thirsteth for
God, for the living God" (Ps. 42:1, 2).

Many endeavor to satisfy this inward
thirst by chasing elusive phantoms and
tantalizing mirages over barren deserts
of emptiness and futility, hoping to es-
cape to utopian bliss and tranquility.
They say, "O that I had the wings like a
dove! for then would I fly away, and be
at rest" (Ps. 55:6).

Where may enduring spiritual rest and
satisfaction be found? Only in the Saviour
who says to all weary, bothered ones:
"Come unto me, all ye that labor and are
heavy laden, and I will give you rest"
(Matt. 11:28).

*O, that the world might hear Him
 speak,
The word of comfort that men seek;
To all the lowly, and unto the meek,
Jesus whispers peace.*

Told by GORDON GRAHAM

143

PERSEVERANCE

A Desperate Need

Said Dr. John Whitnah, branch chief in the division of biology and medicine of the Atomic Energy Commission: "It seems to me that we need very desperately to keep Jesus Christ in the center of our thinking. Christ can bring peace not only to individuals who are groping for the right way in their own lives but also to those who are involved in human relations, whether in communities or in the world. We cannot afford to continue the trend toward moving God and Jesus Christ out of our national affairs."

Long ago God lamented over His wayward children, saying, "O that thou hadst hearkened to my commandments! then had thy peace been as a river, and thy righteousness as the waves of the sea" (Isa. 48:18).

* * *

God Alone Suffices

Saint Theresa of Avila said, "Let nothing disturb thee. Let nothing affright thee. All things are passing. God never changes. Patience gains all things. Who has God wants nothing. God alone suffices."

It's Hypocritical

Said Senator Mark O. Hatfield, "It is hypocritical for a Christian to claim he has the peace of God in his heart if he remain oblivious to the violence and destruction in the world."

* * *

A Must

In a letter to J. Hudson Taylor, a friend said, "I am worried and distressed, while you are always calm. Do tell me what makes the difference."

The great missionary replied, "The peace you speak of is in my case more than a delightful privilege. It is a necessity. I could not possibly get through the work I have to do without the peace of God, 'which passeth all understanding,' and misunderstanding, too. It keeps my heart and mind in blessedness."

In His last will and testament, the Saviour bequeathed His peace to God's children: "Peace I leave with you, my peace I give unto you: not as the world giveth, give I unto you. Let not your heart be troubled, neither let it be afraid" (John 14:27).

PERSEVERANCE

Carry On!

Robert Louis Stevenson was a victim of tuberculosis. His affliction, however, did not weaken his literary ambition.

Stevenson wrote with his right hand. When he could no longer use his right hand, he learned to write with his left hand. When his left hand failed, he dictated his literary works. When speech failed, he dictated a novel in the deaf-and-dumb alphabet—dactylology.

Stevenson's handicaps never quenched his inward joy. He wrote,

> The world is so full of a number of things,
> I am sure we should all be as happy as kings!

How much mankind owes to its handicapped ones, who courageously and perseveringly use their infirmities as step-pingstones to heights of great glory and achievements!

* * *

Difficulties

Henry Van Dyke said, "No doubt a world in which matter never got out of place and became dirt, in which iron had no flaws and wood no cracks, in which gardens had no weeds, and food grew already cooked, in which clothes never wore out and washing was as easy as the soapmakers' advertisements describe it, in which rules had no exceptions and things never went wrong, would be a much easier place to live in. But for purposes of training and development it would be worth nothing at all.

"It is resistance that puts us on our mettle; it is the conquest of reluctant stuff that educates the worker. I wish you enough difficulties to keep you well and make you strong and skillful!"

144

Carry On

"In trying times, too many people stop trying."

* * *

The Shoulders of Others

A group of mountain climbers were asked why they persisted so doggedly in trying to reach an almost inaccessible summit. They replied, "Because of the creed of the mountaineer: 'Men climb mountains on the shoulders of others.' Someday some men, unhampered by having to explore and reject the impossible ways where we and others have tried and failed, will move more directly on the possible way which has emerged out of many failures and partial success and will stand on the top. When they do it, it will in some measure be our victory, too; for men climb mountains on the shoulders of others!"

The Bible says of God's redeemed ones, "Ye are . . . the household of God; And are built upon the foundation of the apostles and prophets, Jesus Christ himself being the chief corner stone; In whom all the building fitly framed together groweth unto a holy temple in the Lord" (Eph. 2:19-21).

* * *

Stick-to-itiveness

After failing in many experiments, Thomas Edison said to a discouraged coworker: "Shucks! We haven't failed. We now know one thousand things that won't work. So we are that much closer to finding out what will work."

POWER

The Powerhouse of Methodism

Said Warren W. Wiersbe, "One of the most moving experiences of my life came when I stepped from John Wesley's bedroom in his London home into the little adjacent prayer room. Outside the house was the traffic noise of City Road, but inside that prayer chamber was the holy hush of God. Its only furnishings were a walnut table which held a Greek New Testament and a candlestick, a small stool and a chair. When he was in London, Wesley entered the room early each morning to read God's Word and pray.

"The guide in Wesley's home told me, 'This little room was the powerhouse of Methodism!' "

* * *

Wait!

Florence Nightingale spoke thus of life: "Life is a hard fight, a struggle, a wrestling with the principle of evil, hand-to-hand, foot-to-foot. Every inch of the way must be disputed. The night is given us to take breath, to pray, to drink deeply at the fountain of power. The day is given us to use the strength which has been given us, to go forth to work with it till evening."

How powerless we are to "run with patience the race that is set before us" unless we are endued with power from on high.

* * *

"Great Is Our GOD"

In telling of the wonders of the universe, *Newsweek* said, "A galaxy is a fantastically large archipelago of millions upon millions of stars, along with enormous quantities of gasses and dust. There are tens of billions of galaxies adrift in the vast ocean of the universe, most of them grouped in clusters!"

Our heavenly Father made them all: "He made the stars also" (Gen. 1:16); "He telleth the number of the stars; he calleth them all by their names. Great is our God, and of great power: His understanding is infinite" (Ps. 147:4-5).

* * *

Healing Rays

In the Pyrenees, some French scientists have built the world's largest solar furnace. With its complex, it concentrates enough sunlight to create a temperature in excess of 6,000 degrees Fahrenheit.

POWER

Commented *Time,* "Anchored against a reinforced concrete office and laboratory building, the huge concave mirror alone consists of 8,570 individual reflectors. For the furnace to operate efficiently, these small 18-inches-square mirrors must be precisely adjusted so that their light will converge exactly at the parabola's focal point 59 feet in front of the giant reflector. It takes only a minute for the powerful light from the reflector to cut a fiery hole through the ⅜-inch-thick steel plate!"

Oh that more of God's children were so unobstructively adjusted to Jesus, "The Sun of righteousness," that His healing rays would melt the ice jams within us of deadly unconcern and indifference!

* * *

Old-Time Power Is Here!

Emerson opined that Adam and Eve could have electricity in the Garden of Eden. The latent, unused energy was there. While the centuries glided noiselessly by, God waited for someone to discover and harness electricity's mighty power.

God's children often plead, "O Lord, send the old-time power." But God has already sent the old-time power. Too few are sufficiently emptied of self to be "filled with all the fulness of God" (Eph. 3:19b).

* * *

Never Reduced

In August, 1969, an electric generator conked out and reduced by one-fifth the capacity of Consolidated Edison to deliver power to its customers in New York City during the hottest month of the year. A plea was made to reduce electric consumption because there was little reserve.

Power from on high is never reduced for God's children. Each one of them may be "filled with all the fulness of God" (Eph. 3:19b) by presenting themselves in emptiness to God and pleading:

"Hover o'er me, Holy Spirit,
 Bathe my trembling heart and brow;
Fill me with Thy hallowed presence,
 Come, O come and fill me now."

When Tasks Are Too Hard

Eleanor Roosevelt carried the following prayer on a paper in her purse: "May the Heavenly Father, who has set a restlessness in our hearts and made us all seekers after that which we can never fully find, keep us at tasks too hard for us that we may be driven to Him for strength."

Said Browning, "A man's reach should exceed his grasp, or what's a heaven for?"

* * *

Power to the Faint

The Bible does not say that the Lord helps those who help themselves. The Lord helps those who admit their helplessness: "O our God . . . we have no might against this great company that cometh against us; neither know we what to do; but our eyes are upon thee" (II Chron. 20:12).

Help of the helpless,
O abide with me.

He giveth power to the faint; and to them that have no might he increaseth strength" (Isa. 40:29).

* * *

"His Blood Availed"

The power of God to deliver men from the enslavement of sin is clearly set forth in these personally experienced words of Charles Wesley:

He breaks the power of cancelled sin,
 He sets the prisoner free;
His blood can make the foulest clean,
 His blood availed for me!

* * *

Power Readily Available

Little Larry was having difficulty lifting a heavy stone. His father standing nearby asked, "Are you using all your strength?"

Larry replied, "Yes, Dad. I am."

"No, you're not," said the father. "I'm right here waiting, and you haven't asked me to help you."

God's power is readily available to His children when they ask for it: "He giveth power to the faint; and to them that have no might he increaseth strength" (Isa. 40:29a).

146

PRAYER

Terrified To Be Alone

Said C. F. Andrews, an English missionary to the Orient, "Whenever I come back to the West from the East, the first impression I get is that the external life has overcome the life of the Spirit; that men and women are living on the surface, as if they are almost frightened to go deeper with God; almost terrified to be alone with their own spirit and with God in silence. They seem almost to have lost the use of the greatest of all faculties—prayer and communion with God."

"Be still, and know that I am God" (Ps. 46:10).

* * *

Buried Alive

In expressing his belief in prayer, J. Edgar Hoover related the following incident:

"I recall vividly an instance which occurred just before Christmas 1968. A college student, Barbara Jane Mickle, was kidnapped in Decatur, Georgia. Kidnapping is one of the most atrocious of crimes. Every available resource of the FBI was mobilized to locate the young girl. Time was important and clues were few.

"Three days later an anonymous phone call was received by our Atlanta office. In an excited voice the caller gave directions for finding a 'capsule.'

"FBI agents raced to the location given by the anonymous caller. It was a wild area with many vines, scrub bushes and trees. I was informed by telephone of the tip given to our Atlanta office. Along with my associates, I knew we would need help beyond ourselves to find the missing girl.

"Our agents searched frantically. They were alert for any possible clue—a spot of disturbed ground, a broken twig, a scarred piece of bark. As the December day began to grow dark, the agents wondered, 'Was the anonymous call only a cruel hoax?'

"Then there came a shout from an agent deep in the woods! He had found what appeared to be a freshly dug grave! Agents quickly converged on this spot, and could hear a knocking noise from under the ground! They began to dig furiously with shovels and boards, even with bare hands. Soon a wooden box was uncovered. In it was Barbara Mickle, shocked and hungry, but alive! She had been buried in the 'capsule' for some eighty-four hours!

"We at the FBI believe that our prayers made the difference that day."

God's promise is unfailing: "Call unto me, and I will answer thee, and show thee great and mighty things, which thou knowest not" (Jer. 33:3).

Baptist Standard

* * *

And Prayer

As a little girl lay motionless on a hospital bed, the doctor said to her anxious parents, "Everything has been done that we know to do. Now we can only wait!"

The father quietly added these words, "And pray."

Later the fully recovered child was dismissed from the hospital. Then the doctor said, "There'll never be a drug that can take the place of prayer!"

ALICE MARIE KNIGHT

* * *

What to Pray For

Anna Propson said, "I am lame, and at the age of 15 I prayed for a physical miracle to make me walk straight like other people. My prayer was not answered in this way. Instead God gave me a fierce desire to avoid letting my lameness keep me from leading a full, rich, active life, and spending it as far as possible in helping others. This I have done.

"If prayer kept my fragile self from a shattered, embittered life, it can protect you, too, when the journey is rough!"

Prayer changes us!

147

PRAYER

"Call Unto Me ... I Will Answer" (Jer. 33:3).

The largest volcano, which is one of the world's most active, is in Sicily's Mount Etna. In July, 1971, it had its most violent eruption in more than two decades. As rivers of lava poured out of the mountain, the villagers of San Alfio, led by their priest, called upon the patron saints to halt the flow of lava toward their village.

As the people prayed, the priest held a small reliquary which contained tiny pieces of bones, alleged to belong to fourth century martyrs.

Sweating from the radiated heat of the lava 25 yards away, Father Pariai said, "We sinners must promise a better life as we ask the saints to destroy this monster."

What a privilege it is in times of impending disaster to go personally to God the heavenly Father through the one Mediator, the Lord Jesus Christ: "For there is one God, and one mediator between God and men, the man Christ Jesus" (I Tim. 2:5).

God gives this sure promise to His children: "Call unto me, and I will answer thee, and shew thee great and mighty things, which thou knowest not" (Jer. 33:3).

* * *

Pinpointed Prayer

Little Joan Teague prayed every night for her uncle who was in Vietnam. After he was wounded three times, he was sent to Hawaii.

Then Mom observed that Joan had ceased to pray for her uncle. She asked, "Joan, why have you stopped praying for Uncle Buddy?"

Sweetly Joan replied, "Why, Mom, I prayed that he would soon leave Vietnam. God answered my prayers, so there's no need to pray for him anymore."

Definite prayer for definite need brings the definite answer in God's good time: "What wilt thou that I should do unto thee? . . . Lord, that I might receive my sight. . . . And immediately he received his sight, and followed Jesus" (Mark 10:51-52).

ALICE MARIE KNIGHT

God Has Secrets

Antonio Stradivari was the world's greatest violin maker. Commented *Newsweek*, "His instruments are unsurpassed in sweetness and lightness of tone, which grew stronger with the years. It has always been perplexing just why modern violin makers have not been able to produce instruments equal to the old Italian masters of the 17th and 18th centuries. The materials are all on record and available, except the formula for the old varnish, made of oil and gum resin. That not only enriches the tone but it protects the wood and provides a soft luster rather than a shine."

The formula for the varnish which Stradivari used is unknown. It is a secret.

God has His secrets too: "The secret things belong unto the Lord our God" (Deut. 29:29a). In answering the prayers of His children, God sometimes discloses His secrets: "Call unto me, and I will answer thee, and shew thee great and mighty things which thou knowest not" (Jer. 33:3).

* * *

Dr. Simpson's Connection With God

For years, Dr. A. B. Simpson had poor health. When he was only 38 years old, a famous New York physician told him that his days were numbered.

The physician's diagnosis only underscored his physical helplessness. The minister knew that he always preached with great effort. Climbing stairs or even a slight elevation was a suffocating agony of breathlessness.

One day at Old Orchard, Maine, Dr. Simpson attended a unique religious service which sent him back to his Bible to find out for himself about Christ's attitude toward disease. He became convinced that Jesus had always meant healing to be a part of His Gospel—the redemption of man's total being.

Soon after this revelation, Dr. Simpson took a walk. Coming to a pine woods, he sat down on a log to rest. Soon he found himself praying, telling God of his complete helplessness with regard to his physical condition. He then asked Christ to

enter him and to become his physical life for all the needs of his body, until his lifework was done.

"There in the woods, I made a connection with God," he said later. "Every fiber in me was tingling with the sense of God's presence!"

Sometime thereafter, Simpson climbed a mountain 3,000 feet high! "When I reached the top," he related joyfully, "the world of weakness and fear was lying at my feet. From that time I had literally a new heart in my breast!'

The promise is sure: "And this is the confidence that we have in him, that, if we ask any thing according to his will, he heareth us" (I John 5:14).

* * *

God, That's Your Business

In His unerring wisdom God sometimes chooses the furnace of affliction for some of His saints: "Behold, I have refined thee, but not with silver; I have chosen thee in the furnace of affliction" (Isa. 48:10). It is certain, however, that God makes no mistakes.

A missionary had been an invalid for eight years. Constantly she had prayed that God would make her well, so that she might do His work. Finally, worn out with seemingly futile petition, she submissively prayed, "All right. I give up. If You want me to be an invalid, that's Your business. Anyway, I want You even more than I want healing."

The Son of God prayed thus, "O my Father, if it be possible, let this cup pass from me: nevertheless not as I will, but as thou wilt" (Matt. 26:39b).

* * *

Has Never Been Fully Tried

Hudson Taylor said, "The power of prayer has never been fully tried in any church. If we want to see the mighty wonders of divine grace and power, instead of weakness, failure, and disappointment, the whole church must accept God's standing challenge: 'Call unto me and I will answer thee, and show thee great and mighty things which thou knowest not' (Jer. 33:3)."

Parents May

As parents may in deepest love
 Refuse their child's request,
Our loving Father may say no;
 He, too, knows what is best.

AUTHOR UKNOWN

* * *

An Emergency Number—911

The American Telephone and Telegraph Company is establishing a globe-girdling emergency number—911. Anyone, anywhere, anytime may dial 911 and receive help. The call will go to a central switchboard. From there it will go instantly to the service needed: a physician, hospital, Red Cross, the fire or police department.

Heaven has an emergency number which any of God's children anywhere, any time, may dial and get instant help: "And call upon me in the day of trouble; I will deliver thee, and thou shalt glorify me" (Ps. 50:15).

* * *

"If Two of You Shall Agree"

Two young women separated by many miles made a covenant to pray for a relative who seemed hopelessly enslaved by lust. At a designated time each evening, both paused to pray five minutes for this man in need.

After some weeks, one heard a knock at her door late in the evening. It was the one for whom prayer had been made. He was deeply distressed, but marvelously receptive to the good news of forgiveness and release in Jesus Christ!

Some will toss off this kind of thing as mere coincidence. Christians who pray will not argue the point. They simply confess with Archbishop Temple, "When I pray, coincidences happen. When I do not, they don't."

Eternity

* * *

The Sentinel

The morning is the gate of day;
 But ere you enter there,
See that you set to guard it well,
 The sentinel of prayer.

149

PRAYER

So shall God's grace your steps attend;
 But nothing else pass through
Save what can give the countersign.
 The Father's will for you.

When you have reached the end of the
 day,
 Where night and sleep await,
Set there the sentinel again
 To bar the evening's gate.

So shall no fear disturb your rest,
 No danger and no care;
For only peace and pardon pass
 The watchful guard of prayer.

AUTHOR UKNOWN

* * *

Practical Prayer

Hoping to wake up the lethargic law-makers in a session of Indiana's State Senate, L. Ray Sells, a stocky Methodist preacher who works on the poor side of town, prayed, "How are we doing, God? We've made our deals, given our reports, and delivered our great speeches. Did You hear us, God? We're hung up, God. Help us to see beyond the chair ahead of us, beyond this chamber. Help us leap the barriers of our party, and most of all, help us overcome our urge to be medi-ocre. Help us to see the poor and the sick and the hungry who want food. Help us hear those who cry for justice in the land. Help us make life better for all, and not more comfortable for the few. Whip us into shape, God, and hound us until we do what needs to be done. Make our nights restless and our steaks tough, until we care as much for others as we care for our political necks!"

* * *

A Frenzy of Pride

In *Prayer and Modern Man*, J. Ellul said, "Prayer for society puts the latter in its proper place. In spite of all its strength and technical successes, our great society is a poor little commonplace reality. Without persistent prayer this grandiose society will be nothing but a frenzy of pride and suicide."

"Try Asking God"

As Kate Smith and two of her friends sat in a boat drifting some distance from shore, a dense fog suddenly enveloped them. Realizing their danger, Kate said to her companions, "There is a verse in the Bible which says, 'Again I say unto you, That if two of you shall agree on earth as touching anything that they shall ask, it shall be done for them of my Father which is in heaven'" (Matt. 18:19).

They asked God to send help, and pres-ently they discerned an indistinct object approaching them through the fog. It was a boat searching for them.

After this frightful experience, Kate Smith adopted as her life's motto, *Try Asking God!*

God's sure promise has never been re-scinded: "And call upon me in the day of trouble: I will deliver thee, and thou shalt glorify me" (Ps. 50:15).

Told by RALPH M. SMITH

* * *

The Unfailing Therapy

Dr. Alexis Carrell, a renowned physi-cian, said, "Prayer is a force as real as terrestrial gravity. As a physician I have seen men, after other therapy had failed, lifted out of disease and melancholy by the serene, tranquilizing power of prayer."

"Call unto me, and I will answer thee, and shew thee great and mighty things, which thou knowest not" (Jer. 33:3).

* * *

Prayer Is Practical

Frederick Douglas, American abolition-ist, prayed fervently for freedom. He said, "It did not come until I got on my feet and ran away."

William Booth counseled Salvation Army workers thus: "Pray as if every-thing were dependent upon God. Work as if everything were dependent upon you."

Prayer is practical. To pray prevail-ingly, we must be willing to put shoe leather to our prayers. Like faith, prayer and effort are inseparable.

Prayer is work: "Epaphras . . . a serv-ant . . . always laboring fervently for you in prayers" (Col. 4:12).

150

If You Would See His Face

After Albert Thorwaldsen, Danish sculptor, completed his famous statue of Christ, he invited an intimate friend to see it.

The statue showed Christ's arms outstretched and His head bowed between them. After looking silently at it for some moments, the friend said, "But I cannot see His face."

The sculptor replied, "If you want to see His face, you must get on your knees."

The humblest saint can see further on his knees than the most learned philosopher can see from the world's highest eminence.

* * *

Put Feet to Your Prayers

A honky-tonk was a nuisance in the community and an irritant to all law-abiding, right-thinking people.

One day a housewife said to her Negro maid, "Let's pray that something will happen to that notorious place!"

They knelt and prayed.

That night the honky-tonk burned to the ground!

When the maid came to work, her employer greeted her joyfully!

"Our prayers were answered!" she exclaimed.

With a twinkle in her eyes, the maid said cryptically, "I believe in prayer, but I also believe we must put feet to our prayers!"

Though we do not condone any lawless act, we could wish that throughout our land there would be a revival of the iconoclastic spirit which characterized Frances E. Willard and her "hatchet brigade" who through their prayers at the doors of saloons and courageous acts put many of the bars out of business.

* * *

Had for the Asking

'Tis heaven alone that is given away,
'Tis only God may be had for the asking.
—James Russell Lowell

Just a Little Talk

Just a little talk with Jesus,
How it smooths the rugged road,
How it cheers and helps me onward,
When I faint beneath my load!
When my heart is crushed with sorrow,
And my eyes with tears are dim,
There's naught can yield me comfort,
Like a little talk with Him!
Author Uknown

* * *

Hands Held in Prayer

"I know my mommy and daddy love me," said a little girl to her playmate. "Mommy makes me special muffins with green elephants on them. And daddy throws me high in the air and doesn't let me fall."

The little friend said, "I know my mommy and daddy love me because they hold my hand when someone's praying in church and it's like we're praying too. Every one of us holds hands. We all sit side by side and we fill up a whole bench—almost."

O the blessedness of the touch of hands in prayer!
Alice M. Knight

* * *

A Most Practical Force

Editorialized the *Austin American-Statesman*, "Prayer is the most practical force in the world today. It's one way to invest your time that pays off automatically, instantly. Prayer has a strange way of fulfilling its own purpose. When you pray, you automatically acknowledge your belief in God. When you pray for courage and strength, the very fact that you are asking for courage gives you that courage and strength. When you pray for wisdom, you put yourself in contact with the fount of all wisdom—God. You open your mind for answers. Prayer is a two-way 'hot line' to heaven. Even as you pray, God is placing the answer in your heart. Prayer is a personal, community and world concern."

151

How challenging is the sure promise: "What things soever ye desire, when ye pray, believe that ye receive them, and ye shall have them" (Mark 11:24).

* * *

Don't Worry, Mommy

Little eight-year-old Gary and his little sister Cheryl knew that their mother was quite ill and that she would enter a hospital very soon.

Mommy told Gary and Cheryl to go in their room and play and keep very quiet.

The children were so quiet that Mommy peeked into the room. What she saw brought tears to her eyes. Gary and Cheryl were kneeling in prayer and asking God to please make Mommy well.

As Gary left for school next day, he kissed his mother and said, "Don't worry, Mommy. The Lord is going to make you well!"

ALICE M. KNIGHT

* * *

Come Confidingly

It was the custom of a young man in Memphis, Tennessee, to go into his church en route to work, kneel at the altar and simply say, "Hello, Jesus! This is Jim!"

One morning the caretaker of the church said, "I have often observed you and heard what you said."

Jim told him, "Recently I knelt to say, 'Hello Jesus! This is Jim!' and I was sure I heard Jesus say, 'Hello Jim! This is Jesus!'"

O that more of us were on such intimate terms with the Lord that we would come into His presence informally, confidingly and, above all, reverently.

Told by RALPH M. SMITH

* * *

Prayer Changes Us

Said Henry M. Stanley, African explorer, "On all my expeditions, prayer made me stronger morally and mentally than any of my nonpraying companions. Prayer did not blind my eyes, or dull my mind, or close my ears, but on the contrary it gave me confidence. It did more:

it gave me joy and pride in my work. It lifted me hopefully over the 1,500 miles of forest tracks, eager to face the day's perils and fatigues."

* * *

An Impossibility

Said Martin Luther, "To be a Christian without praying is no more possible than to be alive without breathing."

* * *

Here Am I

Both bird and human parents respond to stimuli from their young. Cries and gaping mouths stimulate parent birds to feed their young. The hunger cry of her baby automatically stimulates the human mother's flow of milk.

The cry of God's children moves His heart and hand in their behalf. The promise is sure: "Then shalt thou call, and the Lord shall answer; thou shalt cry, and he shall say, Here I am" (Isa. 58:9).

* * *

A Vow Kept

The husband of a humanly hopeless alcoholic wife was suddenly stricken with what seemed to be a fatal illness. He was rushed to a hospital. Agonizing, the wife waited in the corridor. A doctor emerged and told her that her husband couldn't breathe; that the inside of his throat was swollen shut, and that a tracheotomy was under way.

In desperation she prayed, "Dear Lord, please don't take him from me. I'll do anything if only You will let him live. I will never touch another drop of liquor if You will spare him. You alone know how hard that will be, but with Your help I can do it."

Just then a smiling doctor came from the emergency operating room. He exclaimed, "It's amazing—like a miracle! Until a few minutes ago, we didn't think your husband had a chance. Now we have every reason to believe he's going to make it."

The alcoholic wife kept her vow to God. She said, "How could I fail God who spared my husband, my health, self-respect, and the respect and love of my precious children?"

152

What Discord!

Henry Wadsworth Longfellow said, "What discord we would bring into the universe if our prayers were all answered! Then we would govern the world, and not God. And do you think we would govern it better?"

The promise is sure: "No good thing will he withhold from them that walk uprightly" (Ps. 84:11b).

* * *

God's Willingness

Said Archbishop Trench, "We must not conceive of prayer as overcoming God's reluctance, but as laying hold of His highest willingness."

Thou art coming to a King;
Large petitions with thee bring;
For His grace and power are such.
None can ever ask too much!

JOHN NEWTON

* * *

An Inclusive Prayer

Prayed Dag Hammarskjold, "Give me a pure heart that I may see Thee, an humble heart that I may hear Thee, a heart of love that I may serve Thee, and a heart of faith that I may abide in Thee."

* * *

Prayer Is a Dialogue

Said Bishop Fulton J. Sheen. "Most people commit the same mistake with God that they do with their friends—they do all the talking."

Prayer isn't a monologue. It is a dialogue—our talking to God and God talking to us: "Speak; for thy servant heareth" (I Sam. 3:10b).

A Living Death

"I went in the mine a sinner and came out a Christian," tearfully but gratefully said Eugene H. Martin, of Clintonville, W. Va., as he recounted ten days of horror spent in a black mine. He and six other coal miners returned from what they described as a living death.

Joseph Fitzwater, another of the rescued miners, testified, "We're out by the grace of God. If you believe in Him, nothing is impossible. When the water broke, and flowed in upon us, we asked God for a miracle, and it happened!"

Larry B. Lynch was the first one to be brought up to the surface. Joyously he prayed, "Thank you, God! You have delivered us from this living death!" Before the rescued men were taken to a hospital, he led a brief prayer meeting with the men and their relatives at the entrance of the mine.

God's sure promise has not been rescinded: "And call upon me in the day of trouble: I will deliver thee, and thou shalt glorify me" (Ps. 50:15).

* * *

The Rat Race

Said Dr. Alan Redpath, "I find today that people of every age group, including Christians, are involved in a rat race. They're on a conveyor belt from dawn until night seven days a week. They are too tired to pray and read the Bible. Studies, business, the family and the home—all these things create in one the feeling he is beginning to sink. What did Peter do when he began to sink? He cried, 'Lord, save me!' "

PREACHERS

Futilities

In an editorial in *Decision,* these timely questions were asked:

Do we fiddle around with things that don't mean a straw to God or man, while neglecting the souls of our neighbors?

Do we just talk about people's souls, to the complete disregard of their total being?

Do we burn up God's time in committee meetings that never should have been called in the first place?

Do we encourage people to look past us to our Lord and Savior, the Prince of Glory?

153

PREACHERS

Do we importune them to receive Jesus Christ, who alone can meet every human need?

Do we tell them how to do it?

"Look unto me, and be ye saved, all the ends of the earth: for I am God and there is none else" (Isa. 45:22).

* * *

How To Do It

In presenting an idea to others, put it before them:

Briefly, so they will read it;
Clearly, so they can grasp it;
Illustratively, so they will remember it;
Accurately, so they will be guided by its light.

* * *

"Sic 'em, Tiger!"

"When I was a student in college," said Dr. Ralph M. Smith, "I was invited to preach in a small Negro church. I had never done this before. It was a valuable and memorable experience for me.

"The fervid amens of the black brethren worked me up almost to the point of exhaustion. I paused to mop the sweat from my face. Then I glanced at my sermon notes and said, 'I don't know whether I should say this or not.'

"An aged deacon, who sat near the front, said loudly and fervently, 'Say it, brother! Say it, brother!'

"I knew his cup of joy was brimming over. The loud amens and the sanctioning nods of the head that day were like saying to a dog, 'Sic 'em, Tiger!' I could hardly stop preaching."

At football games, many of us yell like Apache Indians, but when we come to church, we sit like wooden Indians— demure and stolid, with faces like blown-out lamps.

"Enter into his gates with thanksgiving, and into his courts with praise . . . and bless his name" (Ps. 100:4).

Catty Critics

The following letter to Ann Landers and her factual and heartsearching reply should silence many critics:

"Our minister is an embarrassment to the congregation. He is a very fine person and extremely conscientious, but he always looks tacky. His clothes appear to be worn, his shoes look rundown, and his shirt cuffs are frayed. His winter coat looks like something he picked up in a rummage sale. Please don't think I am being catty, but his wife also looks shabby. No one expects a minister's wife to be a fashion plate, but this woman is wearing dresses and hats that are at least eight years old.

"No one wants to tell the minister and his wife to shape up. They are compassionate, lovable people, and his sermons are the best, but we feel that, since they do represent us in the community, they should not go around looking like charity cases. Any suggestions on how to get the message across?—MEMBER."

"DEAR MEMBER: You failed to give the most important detail. How much do you pay your lovable, compassionate, conscientious minister?

"Are you aware that half of the Protestant ministers in this country earn less than $8,000 a year? A chemist with comparable education earns approximately 50 percent more. Plumbers, electricians, and bricklayers often make twice as much as the man they listen to in the pulpit on Sunday.

"This situation is a national disgrace, and I hope you will go back and tell your fellow members that the reason the minister's coat looks like he picked it up at a rummage sale is because he probably did!"

* * *

Wilbur Smith's Call

"I was eighteen years old and living in Chicago. My father was vice president of Moody Bible Institute. I had been brought up in a Christian home and was not an unbeliever, but I had no patience with ministers or the ministry. Then one

morning, the Lord suddenly dealt with me. I wasn't praying. I wasn't weeping for my sins. I was rather perplexed as to what I should do. The Lord suddenly said to me, 'You are to go into the Christian ministry!' I can't explain it. It was overwhelming! It was from the Lord!

"So I went down to the Moody Bible Institute and enrolled as a student. I didn't say anything to anyone. Then I went to see my father. He was in tears! The institute had telephoned him and told him that his eldest son had enrolled as a student. Then I found my mother in tears. She told me that before I was born she had prayed that if her first child was a son, he would go into the ministry. I had never heard this before. I have never questioned my call from God."

* * *

We Would See Jesus

A young minister, who was an honor graduate from a seminary, entered with zest upon his first pastorate. In his initial sermon, he preached a fiery message on social reform. The following Sunday, there was a note on the pulpit which read, "Sir, we would see Jesus!"

Failing to get the plea of the note, he continued to preach on current social matters.

Then one Sunday, he found a second note on the pulpit. It also read, "Sir, we would see Jesus!"

As the young minister went home after the service, the plea was reiterated in his mind: "Sir, we would see Jesus!"

Entering his room, he prayed, "O Lord, You know of my deep concern about the social ills and glaring inequalities which cry for redress."

God seemed to say to him, "I, too, have concern, but injustices will continue until men are changed inwardly. Preach Christ, the One who is able to change the hearts and lives of men through the miracle of regeneration."

The young minister began to preach Christ. Lives were transformed, and God's children were edified and blessed!

Later a third note was placed on the pulpit. It read, "Then were the disciples glad, when they saw the Lord" (John 20:20b).

Told by HARRY A. IRONSIDE

* * *

Gave More Than Asked

After Charles Haddon Spurgeon had won fame as a mighty gospel preacher, his mother said to him, "Charles, I constantly prayed that you would give your life to Christ, never that you would become a Baptist minister."

With a twinkle in his eye, Charles facetiously retorted, "Mother, the Lord answered your prayers according to his usual bounty and gave you more than you asked for!"

* * *

Time To Speak Out

Dr. Karl Menninger, famed psychiatrist, gave this needed advice: "Ministers who are discouraged with their preaching should not turn away from it and confine themselves to counseling individuals, but should preach more loudly. It is time for clergymen to speak out! People must be told to stop destroying themselves. You should be the evocative minority. People are moved by what you say."

Long ago God gave this directive to His servants, "Cry aloud, spare not, lift up thy voice like a trumpet, and show my people their transgressions" (Isa. 58:1a).

* * *

Get Excited

An editorial in *Decision* suggests to laymen, "Get your ministers excited about the Gospel. Burn into them the conviction that God's power is waiting to be released. See to it that each congregation is on tiptoe from Sunday to Sunday, wondering what kind of spiritual feast is going to be set when the Bible is opened and God's Word is proclaimed!"

* * *

Try To Understand

Said Ann Landers, whose daily newspaper column is read by an estimated 54

155

million people, "My advice to the clergy is this: Try to understand how desperately people need love, compassion, understanding, and most of all, someone to talk to. Try to understand, too, that the clergyman occupies a very special place in the lives of a great many people. When clergymen disappoint their parishioners, they tarnish the image of all clergymen."

The Saviour made the heartaches and heartbreaks of others His very own: "Himself took our infirmities, and bare our sicknesses" (Matt. 8:17b). He was sent to "heal the brokenhearted" (Luke 4:18). As He was sent, so are His servants: "As my Father hath sent me, even so send I you" (John 20:21).

* * *

Advice to Young Lawyers and Preachers

"If you're strong on facts and weak on logic, talk facts. If you're strong on logic and weak on facts, talk logic. If you're weak on both, pound the table!"

* * *

Asleep During the Revolution

In *Don't Sleep Through the Revolution,* Dr. Paul S. Rees says: "If you are centrally sound in your message and motive, you can afford to be unorthodox in your methodology. The church is not a *settlement* but a *pilgrimage,* not an *estate* but an *embassy,* not a *mansion* but a *mission*—going out where people are, getting next to them, identifying with them, giving them confidence at some level or other of their legitimate interest."

Are we better than our Master? He mingled with outcasts. Never, however, did He partake of their sins.

* * *

Why Don't You?

Dr. Charles Blair, pastor of Calvary Temple, Denver, Colorado, said, "My first year as a pastor was a floundering experience. The turning point came when I read a book of sermons by Dr. Robert G. Lee, then pastor of Bellevue Baptist Church, Memphis, Tennessee. I went to Memphis to interview Dr. Lee. For a week I trailed him as he made sixty pastoral calls, and I said to him one day, 'Dr. Lee, if I made that many calls, I might have a big church too.' He replied, 'Well, why don't you?'

"Then I wrote to Dr. Louis Evans, pastor of Hollywood Presbyterian Church, and later went to see him. He could spare me only twenty minutes, but they changed the course of my study life. 'Son,' Dr. Evans said, 'for every minute I preach, I study an hour.' When I came back, Denver looked different to me!"

* * *

"Any Word from the Lord?"

As a minister stood to preach, he ineptly said, "Before I begin to speak, I want to say something!"

Today millions of distraught, disillusioned ones are mutely asking the question asked by imperiled King Zedekiah long ago, "Is there any word from the Lord?" Blessed indeed is that minister who unequivocally affirms, "There is!" (Jer. 37:17).

* * *

Dearth of Bible Scholars

Earl D. Radmacher said in *Moody Monthly,* "It is interesting that the Greek word for "scholar," which comes from the word *scholeo,* has the idea of the word "leisureliness.""

"Do we ask ourselves why we don't have Bible scholars today? Maybe it is because we don't let our pastor take time to be leisurely in the Word of God and to let God really speak."

* * *

Gobbledygook Is a Disease

It is sometimes difficult to comprehend what people are saying, and even harder to know what they mean. For example, in Air Force language, here is a description of a very common item:

"Lamp incandescent, 3.2 volt, .16 amperes, miniature bayonet base, T-3½ clear finish bulb, white illumination, 1 tungsten C-2R filler, ridge 7, 1 foot 3 1/16 length, 3,000-hour rated life, burns in any position, federal code 00000, part NR 504520, number 45!"

156

That, believe it or not, is the description of an ordinary flashlight!

Gobbledygook is a disease not simply of government publications, but one which sometimes afflicts ministers and others in religious circles. Suppose you were to see a bulletin board outside a church advertising the sermon for next Sunday as, "The Theological Ramifications of Supralapsarianism," or find yourself seated comfortably in a church pew and open the morning bulletin to find that the sermon topic is to be, "The Soteriological Implications of the Divine Incarnation." Provocative topics? Hardly!

Yet this is one of the things some worshipers encounter.

One thing a preacher must guard against in trying to communicate is shooting over the heads of the people.

We do not need glib gobbledygook from the pulpit. We need men who will touch on the issues where people are and speak to those needs from the Word of God. If God is true and the Bible is true, it is relevant for our age. Let us not make ourselves and our message irrelevant by the way we handle the greatest task in the world—the preaching of a vital message from the living God to a needful world!

MAJOR DAVID P. BYRAM,
Chaplain, U. S. Air Force
In *Baptist Standard*

* * *

Fed Up

The Crusader printed this anonymous letter from a pastor, entitled "Really Fed Up":

I am fed up with complimentary comments at the door with little indication that the message has been received.

I am fed up with being careful not to hurt feelings even though those of my family and myself are rarely considered.

I am fed up with drafty parsonages, inadequate salaries, and car allowances that are less than one-fourth of the actual expense.

I am fed up with fund-raising activities, with Santa Claus in the church, and with 101 activities that belong anywhere but in the church.

I am fed up with people who gloat about the large bank accounts they have for their children's education, while I must go on year after year knowing that if my child goes to college, he'll have to do it on his own.

In short, I'm fed up. I'm fed up enough that—even though I'm approaching middle age—I am seriously considering going into a secular profession. And before I am labeled by the reader as one who is leaving the plow, may I remind him that ministers aren't the only ones who are expected to plow.

* * *

Beginning to Rot

After I had been in the ministry for nine years, a good-intentioned elderly lady said to me, "You are beginning to mellow!"

With a twinge of pleasure and satisfaction, I thanked the lady for her gracious words. Later, in looking up the word "mellow" in a dictionary, I was cut down to size when I saw that the word meant "beginning to rot!"

RALPH M. SMITH

* * *

Dictionaries Needed

In a letter to the editor of *Moody Monthly,* a correspondent said, "I understand that about 75 percent of *Moody Monthly* subscribers are ordinary laymen like myself who do not have theological training. I am not exaggerating when I say that I have to use a dictionary to understand what some of these theologians are trying to say. It is a lot easier to understand the Bible than some of their articles. For instance, what is meant by, 'Evangelism goes by the board, except it is transmogrified into social welfare,' and what is a 'pantheistic perspective?'

"You know, when Churchill turned to America for help, he did not say, 'Supply us with the necessary inputs of relevant equipment and we shall implement the program and accomplish its objectives.' No, he said, 'Give us the goods and we will finish the job!' "

Christ long ago spoke simply and un-

PREACHERS

derstandably. He commanded, "Feed my lambs" (John 21:15b). Put the spiritual food sufficiently low that the little children can reach and understand. Then the older people can get it, too.

* * *

Praying To Become Ill

Dr. J. W. MacGorman, a highly respected professor at Southwestern Baptist Theological Seminary, said, "When I was a student at the University of Texas, Dr. D. H. Truhitte, pastor of the Hyde Park Baptist Church in Austin, asked me to bring the message in the 11 A.M. worship service. The closer the hour came, the more fearful I became. Looking for a quiet place where I could be alone for a while, I found only one place—the janitor's closet. Every other room, including the pastor's study, was occupied. Midst brooms, mops and other cleaning equipment I prayed, not that God's power would be felt in the service but that I would become ill. To run away would be cowardly, but to be carried away in an ambulance would save me from any stigma of shirking my responsibility."

How great is the responsibility of God's messenger! The gospel which he proclaims is "the savour of death unto death, and . . . the savour of life unto life" (II Cor. 2:16).

Before Charles H. Spurgeon entered his pulpit in the Spurgeon Tabernacle in London, he would agonize in prayer alone and plead, "O God, if You don't go with me and undergird me, I cannot go!"

Long ago Paul asked, "And who is sufficient for these things?" (II Cor. 2:16b). No one, without God. Paul answered his question thus: "Our sufficiency is of God" (3:5).

* * *

Loud Preaching—Evil Tempers

In his *Letter to a Young Minister,* John Newton said, "Very loud preaching is a bad habit. People are seldom, if ever, stunned into the love of the truth."

In warning against angry, scolding preaching, he wrote, "If we indulge invective and bitterness in the pulpit, we are but gratifying our own evil tempers, under the pretense of a concern for the cause of God and truth. A preacher of this kind may be compared to the madman in the Proverbs,, who scattereth at random firebrands, arrows and death. Such persons may applaud their own courage, but they forget that 'the wrath of man worketh not the righteousness of God' " (James 1:20).

* * *

Alarmingly Prevalent

More than a century ago, Lyman Beecher, the famous Congregational minister, lamented, "Irreligion has become alarmingly prevalent in all parts of our land. The name of God is blasphemed; the Bible denounced; the Sabbath profaned; and the public worship of God neglected."

* * *

"There Is"

Long ago imperiled, perplexed Zedekiah asked the prophet Jeremiah, "Is there any word from the Lord?" (Jer. 37:17). Instantly the affirmative answer came, "There is!"

O for more authoritative spokesmen who preface their words with the formula: "Thus saith the Lord!'

* * *

All Stops Out

A minister left his sermon notes on the pulpit. The caretaker observed a notation in red, a prompter especially for the minister. It read: "Point very weak. Shout loudly!"

Told by RALPH M. SMITH

* * *

A Layman's Plea

Pleaded Dr. L. Nelson Bell, "O that ministerial sociologists within the church would change and become preachers of the unsearchable riches of God's mercy and grace! O that those who, acutely aware of the evils of poverty and discrimination, try to remedy them by governmental edict and money, would realize that there can be no lasting solution to

158

these or other problems aside from the transforming power of Jesus Christ in the lives of individuals!"

* * *

Not Discouraged

As a Baptist deacon walked home from church one Sunday morning, he met a friend who asked, "Where have you been?"

The deacon replied, "I have been to church, and I am still not discouraged!"

While being realistic about wrong and avoiding Pollyanna optimism, a pastor must remember that distraught, discouraged ones look to God's man for inspiration and spiritual help.

"Comfort ye, comfort ye my people, saith your God" (Isa. 40:1a).

* * *

Finger in Every Pie

On the local church level, there is no greater evidence of weakness and spiritual pride, to say nothing of organizational inefficiency, than to see the pastor running everything—attending, initiating, invocating, benedicting. This creates all kinds of lay-clergy tensions and causes the thinking layman to throw up his hands in despair. The pastor must see that he is not a one-man band. But he is not to be relegated to second fiddle. He is to fulfill the job which the Bible so clearly calls him to fulfill: 'Feed the flock of God . . . taking the oversight thereof, not by constraint, but willingly; not for filthy lucre, but of a ready mind: Neither as being lords over God's heritage, but being ensamples to the flock' (I Pet. 5:2, 3)."

ROBERT L. ROXBURGH
in *Eternity*

* * *

Tragedy in Pulpits

Said Dr. Wilbur M. Smith, "Some years ago, I sat reading in the library of one of the largest Methodist seminaries in America. I observed 200 copies of Guignebert's book on a table to be sold to the new students to study the life of Christ. I thought, if 200 students come to the conviction of the non-supernaturalness of the Lord Jesus, taught in Guignebert's book, what tragic results will appear in the pulpits of our land!"

* * *

He Only Talked

One night as Dwight L. Moody walked to his home at the close of a service, he overheard two people talking. One asked, "Did Moody preach tonight?" The other replied, "No, he didn't preach. *He only talked!*"

Later Moody commented, "If I can only get people to think I am talking with them and not preaching at them, it is dead easy to get their attention."

One who knew Moody well said of his preaching, "It was straight talking, lit with illustrations always to the point, and backed by his great skill in dealing with the *personal problems of individuals.*"

* * *

A Priority List

A physician sternly said to a minister, "You are just too busy. I don't know your schedule or how you spend your time, but something is out of focus. There are some things you will have to eliminate. I suggest that you set up a priority list."

Is it not significant that Jesus said to His *active* disciples, "Come ye yourselves apart into a desert place, and rest a while" (Mark 6:31)?

* * *

"What a Great Saviour!"

Two men heard Charles Spurgeon preach. As they left the service, one exclaimed, "What a great orator is Spurgeon!"

The other man said thoughtfully, "What a great Saviour Spurgeon has!"

* * *

The Devil's Dislike

At the conclusion of a sermon on hell by Dr. George W. Truett, an angry unbeliever said to him, "Sir, I don't like your sermon."

Dr. Truett flashed, "Neither does the devil."

159

PRESENCE, THE LORD'S

Preaching and Practicing

Keenly aware of his failure to practice what he preached, a minister said to his people, "Do as I tell you and not as I do."

Another minister said, "It is easier to teach twenty, than to be one of twenty to follow my own teaching."

Peter admonished, "Feed the flock of God . . . being ensamples to the flock" (I Pet. 5:2, 3).

* * *

Like Little Bo Peep

Said Dr. C. George Fry, "Sheep counting is an agelong remedy for insomnia, but not so with clergymen. It only serves to keep them awake. Not since the depression have ministers had so much cause for sleepless nights as they have today. Like little Bo Peep, they are wondering where all the sheep are!"

* * *

A Womanish Man

In addressing the audience in the Texas Baptist Evangelism Conference, 1969, Dr. Wayne E. Ward said, "I often speak to student bodies in various colleges. What a joy it is to me to look at you and be able to distinguish between the sexes!"

Often the distinction between the sexes is undiscernible today. It is said that a confused minister said to a couple at the conclusion of the wedding ceremony, "One of you please kiss the bride."

How anachronistic today is a womanish man!

* * *

Long Sermons and Empty Pews

Said Dwight L. Moody, "If every minister of the Gospel had the same training as I went through, there would not be such long sermons preached, or so many empty pews. I preached for years in the army and on the streets, and I learned to say what I had to say rapidly and forcibly, backing up my points with apt illustrations, as Christ enforced His sayings with His striking parables. This is the way to keep an audience interested."

An aged minister gave this wise advice to young ministers: "Stand up; speak up; shut up!"

* * *

From the Heart to the Heart

Said an admiring friend of Moody, "He preached *to* the heart *from* the heart."

When we thus preach, we preach relevantly.

PRESENCE, THE LORD'S

Always with the Lord

If you are in Christ in life, you will be with Him in death. If we live, Christ will be with us: "Lo, I am with you alway" (Matt. 28:20). If we die, we will be instantly and eternally with Him: "Having a desire to depart, and to be with Christ, which is far better" (Phil. 1:23); "So shall we ever be with the Lord" (I Thess. 4:17).

RALPH M. SMITH

* * *

Where Have You Been?

Said Wendell P. Loveless, "In their public prayers, many of God's children often preface their petitions: 'O Lord, as we come into Thy presence.'

"The Lord could answer, 'Where have you been? My children are *always* in My presence: "Lo, I am with you alway, even unto the end of the world" (Matt. 28:20b); "My presence shall go with thee, and I will give thee rest" (Exod. 33:14).'"

To me remains nor place nor time;
My country is in every clime;
I can be calm and free from care
On any shore, since God is there.

MADAME GUYON
Trans. WILLIAM COWPER

* * *

God for Us

Napoleon was wrong when he said, "God is on the side of the largest batalions."

160

As Paul stood almost solitarily against the pagan world, he said, "If God be for us, who can be against us?" (Rom. 8:31).

A contemporary of Luther said, "The whole world is against you, Luther." The intrepid reformer replied, "Then it is God and Luther against the whole world!"

God and one constitute a majority!

* * *

A Gentleman's Word

In 1856, David Livingstone faced a grave peril in Africa. He was passing through the wild country of the native chief Mburuma. The chief was hostile and had been seeking to rouse the countryside against the white man's expedition. Reports had come to Livingstone that natives had been seen creeping toward the camp!

Alone in his tent, Livingstone opened his Bible and read the promise on which he had staked his life so often. Then he wrote in his diary:

"January 14, 1856. Evening. Felt much turmoil of spirit in prospect of having all my plans for welfare of this great region knocked on the head by savages tomorrow. But Jesus said, 'All power is given unto me in heaven and in earth. Go ye therefore and teach all nations . . . and, lo, I am with you alway, even unto the end of the world.'

"This is the word of a Gentleman of the most strict and sacred honour, so that's the end of fear. I will not cross furtively tonight as I intended. Nay, verily, I shall take observations for latitude and longitude tonight, though they may be the last. I feel quite calm now, thank God!"

Guideposts

* * *

Hush, For God Is Here

On the door of the church where John Wesley preached his first sermon are the following words: "Enter this door as if the floor within were gold, and every wall of jewels of priceless worth were made; as if the choir, in robes of fire, were singing here; nor shout, nor rush, but hush, for God is here!"

Whenever and wherever any of God's children meet in the Lord's name, He meets with them: "But the Lord is in his holy temple: let all the earth keep silence before him" (Hab. 2:20).

* * *

The Preacher Faded

Ian Maclaren said, "I never realized the existence of unseen world as I did one day in the Free Kirk of Drumtochty. The subject of the minister was Jesus Christ and before he had spoken five minutes I was convinced that Jesus was present. The preacher faded from before me and there rose the figure of the Nazarene!"

How reassuring is the promise: "For where two or three are gathered together in my name, there am I in the midst of them" (Matt. 18:20).

* * *

How Near

Lord of all being, throned afar,
Thy glory flames from sun and star;
Center and soul of every sphere,
Yet to each loving heart, how near!

Grant us Thy truth to make us free,
And kindling hearts that burn for Thee,
Till all Thy living altars claim,
One holy light, one heavenly flame!

OLIVER WENDELL HOLMES

* * *

Closer Than Breathing

Said Tennyson, "Closer is He (Christ) than breathing, nearer than hands and feet!"

"Lo, I am with you alway, even unto the end of the world" (Matt. 28:20b).

* * *

"Are You There, Margie?"

During World War II, a nurse received a letter from her father which said, "Mother is in the hospital awaiting surgery. She wishes that you could be with her."

The nurse thought, "But I am half a world away in a field hospital in France. The casualties are heavy. Our tent overflows with praying, cursing and deadly-

161

quiet men. One of the mortally wounded soldiers reached his hand to me and pleaded, 'Are you there, Margie? Hold my hand!'

"I was not Margie, but the failing vision and clouded mind of the dying soldier caused him to think I was Margie. I did not know the identity of Margie—wife, sister, or sweetheart—but she was obviously greatly loved and important to the soldier.

"As his life ebbed away, he pleaded, 'Are you still there, Margie? Don't go away! Hold my hand!'

"As my hand tightened on his weakening grasp, I said, 'I am here. I'll stay with you—always.'"

When God's children come to the portals of life beyond, death's Conqueror, the Saviour, will be with them: "Yea, though I walk through the valley of the shadow of death, I will fear no evil: for thou art with me" (Ps. 23:4a). They are "graven . . . upon the palms of (His) hands" (Isa. 49:16a). How fear-allaying is the promise: "I the Lord . . . will hold thine hand, and will keep thee" (42:6).

No Separation

During World War II, a young Belgian was parachuted into his country to work with the underground movement against the Germans. He was captured and placed in solitary confinement.

A Belgian pastor, apprehended for spying, occupied an adjoining cell. The two began to tap messages to each other on the stone wall which separated them.

One day the young Belgian tapped "How unbearable it is to be alone with one's self!"

The pastor replied, "It is heaven to be alone with one's Lord!"

On the day the youth was led to his execution, he tapped this message: "I am going out to life eternal through faith in Christ, and I shall be forever with my Lord!"

Nothing can separate God's children from the Lord. If they live, He is with them: "Lo, I am with you alway" (Matt. 28:20). If they die, they instantly go into His presence: "For I am in a strait betwixt two, having a desire to depart, and to be with Christ; which is far better" (Phil. 1:23).

PRIDE—HUMILITY

Washing Dishes for Jesus

In the last years of his life, an elderly man in his seventies worked as a dishwasher in the Life Line Mission on the San Francisco waterfront. Recently he died. He requested that he remain anonymous—a skid-row benefactor.

He bequeathed $150,000 to the mission which shelters destitute men and $128,000 to Messiah College in Pennsylvania—a Brethren in Christ college.

Announcement of the unusual bequest came on Christmas Eve, when a check for $110,000 arrived on the Messiah College campus, with information that $18,000 would come later.

Dr. Ray Hostetter, president of the college, knew the identity of the benefactor but respected his wish to keep his name secret.

President Hostetter said, "He apparently worked for years and saved almost every nickel he earned to invest in the stock market. The money will be used to build a kitchen in the new Eisenhower Student Center on the Grantham campus in honor of the memory of an old man who spent much time in working in the kitchen of a mission—washing dishes."

* * *

Twinkle, Twinkle

A noted astronomer, seated beside an Anglican bishop on an airplane, said to him, "I never had much interest in theology. My religion can be summed up, 'Do unto others as you would have them do unto you.'"

"Well," the bishop responded, "I've had little time for astronomy. My views on

astronomy are summed up in 'Twinkle, twinkle, little star!' "

The Bible says, "Answer not a fool according to his folly, lest thou also be like unto him" (Prov. 26:4).

* * *

Ephemeral Glories

Commented *Time* in its Dec. 13, '71 issue, "Security men almost outnumbered the guests at the Guy de Rothchild chateau outside Paris, and with good reason. A dazzle of diamonds winked and twinkled in all directions—from hair, hands, necks and bosoms.

"Elizabeth Taylor outshone everyone at the costume ball with the 69.4-carat, million-dollar 'Burton Diamond' at her throat, and her black hair caught up in a net studded with 1,000 small diamonds and edged with 25 larger ones. Perhaps to relieve the monotony, her feather spray was held in place by a 20-carat emerald. Estimated total worth of Liz's jewelry: $3,000,000!"

After all ephemeral glories of the world have passed into oblivion, the obscurest of God's children whose consuming passion was the winning of souls, will shine on with undimmed luster and dazzling beauty: "And they that be wise shall shine as the brightness of the firmament; and they that turn many to righteousness as the stars forever and ever" (Dan. 12:3).

* * *

Greatness Manifested

As Dr. John Broadus bade a guest in his home goodnight, he said, "Don't forget to leave your shoes outside your door."

Next morning the guest was delighted to observe that his shoes had been brightly shined.

Each night thereafter he placed his shoes outside his door. Next morning he found them shined.

On the morning of his departure, the guest wanted to thank the one who had rendered the lowly service. Watching through the opened door of his room, he saw Dr. Broadus himself coming with his shoes!

How surprised he was to learn that the great scholar and Christian, Dr. Broadus, was the one who had been performing the lowly, helpful task!

"Even as the Son of man came not to be ministered unto, but to minister" (Matt. 20:28).

* * *

"Look What I Did!"

A man, presenting Dr. Jonathan Goforth to a Chicago audience, spoke glowingly of him as a brilliant speaker and as a missionary who had accomplished great things.

In acknowledging the praiseful words, Dr. Goforth said, "When I listen to such words of adulation, I am reminded of the story of a proud woodpecker which lighted on a tall dead pine tree and began to peck. Just then a bolt of lightning struck the dead tree and splintered it to smithereens!

"The terror-stricken bird flew and lighted on a nearby tree. Regaining its composure, it looked down at the splintered heap and proudly exclaimed, 'Look what I did!' "

* * *

"What a Cock Am I!"

The tale is told of Chanticleer, the rooster who leaped to his perch each morning in the darkness just before the dawn. He crowed lustily, and thereafter the sun came up!

Cried Chanticleer, "What a cock am I! Whenever I crow, the sun obeys my call!"

How like the proud cock was the ancient, arrogant monarch Nebuchadnezzar who arrogated the glory for accomplishments: "Is not this great Babylon, that I have built for the house of the kingdom by the might of my power, and for the honor of my majesty?" (Dan. 4:30).

* * *

Distorted Mirror

Observed Dag Hammarskjold, former secretary-general of the United Nations, "Vanity rears its ridiculous little head and holds up the distorting mirror in front of you for a mere instant, but one

time too many. It is at such times that you invite defeat and betray Him whom you serve. No man can do properly what he is called upon to do in this life unless he can learn to forget his ego and act as an instrument of God."

* * *

Like the Frantic Bird

A woman, deeply burdened by her sins, went into a church to pray. As she prayed, she heard the frantic fluttering of a bird, flying high up in the vaulted ceiling, seeking a way out of the church.

Finally the bird descended and perched on a pew. As it rested there for a moment, the bird saw an open door through which it streaked.

Thought the woman, "How like that frantic bird I have been, seeking vainly a way out of my lostness when all the while the door of God's mercy and forgiveness has been open. My pride and self-righteousness have kept me from descending to the low level of humility to confess my sins and turn penitently to the Saviour for His cleansing blood."

RALPH M. SMITH

* * *

Matters Controversial

"In matters controversial,
My perception's very fine;
I always see both sides of things:
The one that's wrong and *mine*."

AUTHOR UKNOWN

* * *

Hazardous Indulgences

In commenting upon the first landing of U.S. astronauts on the moon and their return to earth, Dr. Owen Chamberlain, Nobel prize-winning physicist, said, "It shows that mankind can be in charge of his own destiny!"

Kenzo Tange, Japanese architect, said of the lunar landing, "It should evoke a new recognition of the greatness and stature of men!"

It is hazardous to indulge in the glori-

fication of man and arrogate to ourselves praise for accomplishments, ignoring the help of God. Proud, arrogant Nebuchadnezzar did this to his own destruction: "Is not this great Babylon, that I have built for the house of the kingdom by the might of my power, and for the honour of my majesty?" (Dan. 4:30). After God reduced him to bestial level, he confessed, "Those that walk in pride he (God) is able to abase" (4:37b).

* * *

Stop Friction!

"Stop friction in your company!" So read a directive circulated by Texaco Canada, Limited.

The directive continued: "At this moment, there are possibly several hundred places within your company where friction is quietly and damagingly at work—gears, pistons, shafts, chains, wire ropes, wheels, bearings, cams and pulleys."

Friction among God's children works disastrously! It is creative of the Spirit-grieving sins of envy, strife and division. Basic in these evils is the deadly sin of pride: "Only by pride cometh contention" (Prov. 13:10a).

* * *

"To God Be the Glory"

An admiring friend said to Dr. Joseph Parker, who for many years was the pastor of the City Temple in London, "Dr. Parker, you are a self-made man."

Instantly Dr. Parker replied, "You lift a great responsibility from the shoulder of the Almighty."

How tall we stand when we kneel and humbly confess with Paul: "But by the grace of God I am what I am" (I Cor. 15:10).

* * *

Never Too Small

You may be too great to be used by God, but never too small.

Said Samuel to disobedient Saul, "When thou wast little in thine own sight, wast thou not made the head of the tribes of Israel?" (I Sam. 15:17a).

The Right People to Pluck

In addressing a student body, a proud businessman said, "I give all the credit for my financial and business success to one thing alone—pluck, pluck, pluck!"

What little impression he had made was dissipated when a student unexpectedly asked, "How can we find the right people to pluck?"

Beware of the deadly, soul-stunting sin of pride!

"A man's pride shall bring him low; but honor shall uphold the humble in spirit" (Prov. 29:23).

* * *

Know-It-Alls

In Texas, it is often facetiously said, "You can tell a Texan every time, but you can't tell him much!"

One asked Thomas Edison, "How did you come to know so much?"

Edison replied, "By letting others know that I didn't know and wanted to know!"

"To God Be the Glory"

In a concert in Chicago, Harry Lauder, Scottish singer and songwriter, sang to an overflowing audience. At the conclusion, the audience stood en masse, and applauded uproariously. After the applause subsided, the audience said in unison, "Thank you! Thank you! Thank you!"

Showing splendid humility, Lauder replied, "Don't thank me! Thank the good God who put the songs in my heart!"

"What hast thou that thou didst not receive?" (I Cor. 4:7).

* * *

Not Little Enough

So few of us are little enough to be used of God: "When thou wast little in thine own sight, wast thou not made head of the tribes of Israel?" (I Sam. 15:17).

REPENTANCE

Harden Not Your Heart

It was raining hard at 5:30 A.M. on Saturday, when Deputy Sheriff Doty of the Logan County Sheriff's Department got a call to ride up Buffalo Creek Hollow in West Virginia and warn the people.

The twenty-mile long hollow, one of many deadend valleys creasing the mountain sides of Appalachia, drains Buffalo Creek from the headwaters atop Buffalo and Spring Mountains.

The Buffalo mine supervisor told Doty that three days of rainfall, plus the melting of an 18-inch accumulation of snow, had dangerously raised the level of a lake dammed up behind a 200-foot-high slag heap in a side hollow across from the mine. After viewing the high water, he feared that the slag-pile dam might give away at any moment!

Entering the twenty-mile hollow, Doty began to blow his siren. "There is imminent danger of the slag pile giving away! Flee for safety while you can," he warned.

More than 4,000 people lived in the fifteen settlements along the creek. They had heard similar warnings before, and now they refused to worry about the slag pile. They told Doty, "No! The company is always saying it's gonna bust!"

Less than three hours later, the 400-foot-wide wall of slag burst open "like a bomb had hit it," sending a wall of water down the mountain side and bringing death and destruction to the people in the hollow!

More than one hundred perished! Five hundred families were left homeless. The hollow was a tangle of broken mobile homes, half-buried refrigerators, roof tops and mud. Some communities like Parde, Lorado, Robinette, and Crites vanished entirely!

Myriads of people today continue in the downward way to destruction, heedless of the warnings of God's Word: "He, that being often reproved hardeneth his neck, shall suddenly be destroyed, and that without remedy" (Prov. 29:1).

REPENTANCE

Deathbed Repentance

True, heart-changing repentance for sin is never too late, but seldom is late repentance true.

True repentance recognizes the fact that all sin is primarily against God: "Against thee, thee only, have I sinned, and done this evil in thy sight" (Ps. 51:4a).

* * *

The Prayer Breakfast

The Presidential prayer breakfasts in Washington are attended by many influential people. They are held in the huge ballroom of the most prestigious hotel in the nation's capital.

In opening the program of a recent breakfast, Congressman H. Quie of Minnesota said, "We have not arrived! We are a gathering of sinners!"

In the closing prayer, Senator Harold Hughes of Iowa, a redeemed alcoholic, said, "Jesus stretches His hand out to you. Take it! Let him into your life!"

In the long ago, God said to His ancient people, "All day long I have stretched forth my hands unto a disobedient and gainsaying people" (Rom. 10:21).

Though many in our nation have forgotten and forsaken God, in mercy "his hand is stretched out still" (Isa. 5:25b).

* * *

God's Hot Line

Dr. Carl F. H. Henry gave this urgent warning: Recently a nationwide emergency alert — issued in error — caused many American radio and television stations to stop normal broadcasting. One program director thought the NORAD bulletin signalled another December 7— Pearl Harbor all over again!

Actually, Jesus Christ put the whole world on an emergency alert long ago by His resurrection. Indeed a greater than NORAD—the American national warning system — has spoken. In the past God has winked at man's ignorance "but now commandeth all men every where to repent: because he hath appointed a day, in the which he will judge the world in righteousness by that man whom he hath ordained . . . in that he hath raised him from the dead" (Acts 17:30, 31).

"Except ye repent, ye shall all . . . perish" (Luke 13:3). Repent or perish! Which will it be?

* * *

Mea Culpa

A Japanese said, "We Japanese can work until we drop, but we cannot say, 'We are sorry.' "

It is often difficult to say penitently, "*Mea culpa*—my fault, my blame. I am sorry."

* * *

We Disagree

Sometime ago the *Ladies Home Journal* reported a survey of what 1,000 women had to say about the church under the attention-arresting caption, "You Can't Find God in the Church Anymore."

We disagree with the caption. God may be found *anywhere*, if we penitently turn from sin to the Saviour, pleading, "God be merciful to me a sinner" (Luke 18:13b).

God's promise is unfailing: "And ye shall seek me, and find me, when ye shall search for me with all your heart" (Jer. 29:13).

* * *

Remorse Isn't Repentance

In his memoirs, *Inside the Third Reich*, Albert Speer, Hitler's minister of armaments and war production, remorsefully acknowledges his part in the horrible atrocities of that dark era: "I myself determined the degree of my isolation, the extremity of my evasions, the extent of my ignorance of horrors. I ought to have known about them. I did not investigate, for I did not want to know what was happening. I was inescapably contaminated morally, because from fear of discovering something which might have turned me from my course, I closed my eyes. I still feel responsible for Auschwitz in a wholly personal sense!"

There is a difference between remorse and repentance. Judas, filled with remorse, "departed, and went and hanged himself" (Matt. 27:5). Peter, deeply re-

pentant, "remembered the word of Jesus ... Before the cock crow, thou shalt deny me thrice. And he went out and wept bitterly" (26:75).

Genuine repentance is never too late, but seldom is late repentance genuine.

RESURRECTION

Easter Breaks!

Easter day breaks!
Christ rises! Mercy every way is
 infinite!
Earth breaks up; time drops away;
In flows heaven with its new day
Of endless life!

ROBERT BROWNING

* * *

What He Cannot Lose

Said Jim Elliot, the Wycliffe Bible Translator who was martyred by Ecuador's Auca Indians, "He who gives what he cannot keep to gain what he cannot lose is no fool!"

"And I give unto them eternal life; and they shall never perish" (John 10:28a).

* * *

A $250,000 Reward

James Kidd of Arizona willed his estate worth $250,000 to anyone who could prove scientifically that the soul survives the body after death.

God's trustful children do not need any scientific proof of the soul's survival after death. Scriptural affirmation is enough: "Then shall the dust return to the earth as it was: but the spirit shall return to God who gave it" (Eccl. 12:7).

* * *

Useless Tears

Mary Magdalene wept because the tomb was empty: "But Mary stood without at the sepulchre weeping" (John 20:11a). Well might she have wept if the tomb had not been empty!

"And if Christ be not raised, your faith is vain; ye are yet in your sins. ... If in this life only we have hope in Christ, we are of all men most miserable" (I Cor. 15:17, 19).

* * *

"A Living Hope"

Said Louis Pasteur: "There are two men in each one of us: the scientist, who desires to attain knowledge of nature through observation, experiment and reasoning; and the man of feeling who mourns his dead children and who cannot prove he shall see them again but believes that he will and lives in that hope. The two domains are distinct, and woe to him who tries to let them trespass upon each other."

* * *

Shakespeare's Bones

Shakespeare's body was interred in the chancel of the Episcopal church in Stratford-on-Avon. The inscription on his tomb says, "Good friend, for Jesus' sake, forbear to dig the dust enclosed here. Blest be the man that spares these stones, and curst be he that moves my bones."

Long ago Jesus said, "Marvel not at this: for the hour is coming, in the which all that are in the graves shall hear his voice, and shall come forth: they that have done good, unto the resurrection of life; and they that have done evil, unto the resurrection of damnation" (John 5:28, 29).

REVIVAL

A Short Time

Some time ago, *The (London) Daily Mail* warned, "We (the nations) have only a short time to make our peace with each other or to make our peace with God!"

Many of God's children, believing that the cup of man's iniquity is now brimming and that only a worldwide, heaven-sent revival can avert impending judgment are earnestly pleading, "O Lord, revive thy work in the midst of the years . . . in wrath remember mercy" (Hab. 3:2b).

* * *

Fishing in a Bathtub

Said James McReynolds, "In most pulpits the Sunday sermon, no matter how evangelistic, speaks to only the 'faithful few' while the people today meet in places other than churches—on beaches, at athletic events, at parent-teacher associations, in taverns, at musical festivals, community functions, and vacation areas."

Fishing for souls in many churches is like fishing for fish in a bathtub. They aren't there.

If we would reach the unsaved, unchurched multitudes, we must emulate the example of our Saviour, who mingled with the shepherdless ones in the marketplaces, highways, and byways. We must enter feelingly and understandingly into their heartaches and heartbreaks. We must never, however, partake of their sins.

* * *

Perishing with Spiritual Drought

Dr. Lyman Beecher earnestly pleaded, "O Lord, we must have revival! It must rain faster, or we will perish with spiritual drought!"

O, that more of God's children were pleading today, "O Lord, revive thy work . . . in the midst of the years make known; in wrath remember mercy" (Hab. 3:2).

> Revive! Revive!
> And give refreshing showers;
> The glory shall be all Thine own;
> The blessing shall be ours.

ALFRED MIDLANE

Confusion of Face

The presiding officer of a service club was badly mixed up when introducing a guest speaker. He said, "Our distinguished speaker today is from Oklahoma. He is a ranchman, and he has made a million dollars!"

Responding, the guest speaker said, "I am not from Oklahoma. I am from Texas. I am not a ranchman. I am an oilman. And I haven't *made* a million dollars. I *lost* a million dollars."

How illustrative of the jumbled thinking of many today in our morally and spiritually confused world who "call evil good, and good evil; that put darkness for light, and light for darkness" (Isa. 5:20).

What would happen if even an appreciable number of God's children in our nation would penitently confess that "to us belongeth confusion of face . . . we have sinned against thee (God)" (Dan. 9:8), and would turn brokenheartedly from sin to God?

Told by LANDRUM LEAVELL

* * *

"O Lord, Revive Thy Work"

Genuine revival is always preceded by prayer and ultimates in confession and forsaking of sin.

Long ago God gave this recipe for a spiritual revival: "If my people . . . shall humble themselves, and pray, and seek my face, and turn from their wicked ways; then will I hear from heaven, and will forgive their sin, and will heal their land" (II Chron. 7:14).

God gave recently a spiritual awakening to many at Southwestern Baptist Theological Seminary, Fort Worth, Texas. A group of students and faculty members had been praying for such a revival for more than two years.

For several days the special meetings ran from two to nine hours. Confessions of cheating among students and reconciliations between professors, their families, and ministers' families occurred.

"O Lord, revive thy work in the midst of the years . . . in wrath remember mercy" (Hab. 3:2).

168

"In Wrath Remember Mercy"

Said Billy Graham, "The urgency and need for a mighty moving of the Spirit of God in our nation and across the world is impressed upon us in every newscast. Our daily papers compel us to realize that we are at a crossroad, and that our choice is either Christ or chaos!"

* * *

Only One Hope

Said Vance Havner, "Only repentance and revival can revitalize our churches. Until that happens, we will have one group compassing sea and land to make more proselytes of the kind already too numerous, and the other group promoting a truncated social program under religious auspices.

"What is urgently needed might happen if some of our august conventions could forget the order of business long enough to attend to what is really our most important business just now and try God's formula: 'If my people . . . shall humble themselves . . . pray . . . seek my face, and turn from their wicked ways; then will I hear from heaven, and will forgive their sin, and will heal their land' (II Chron. 7:14). We quote that verse often, but somehow we don't get around to doing what it says."

RICHES

$15 Billion Awaits Claimants

Many men have daydreamed of discovering a source of fabulous wealth on their ranch—a rich mine or a gusher. Some daydream of discovering a treasure-trove, buried in the earth in the cellar.

Affirmed the *Austin (Tex.) American Statesman:*

"But not many Americans have been able to realize such dreams. Many *may* do so. A huge fortune is lying unclaimed in this country, waiting to be tapped by the right people. The fortune, according to *Wall Street Journal,* amounts to $15 billion. It's not in buried gold or back yard oil wells, but in abandoned stock and bond holdings, accumulated dividends, bank accounts, legacies, and insurance proceeds.

"Some of the fantastic accumulation of wealth has been building up for generations. As a result, in certain cases the abandoned wealth is valuable enough to make its owner an instant millionaire!

"For example, there are stocks and bonds registered in the name of one Mary Griffin that are now worth more than a million dollars. All that is known of Mrs. Griffin is that she lived in New York City 30 years ago, and all she or her heirs have to do to collect the bonanza, is to show up and prove they are the rightful owners or inheritors.

"If anybody ever produces Texas Pacific Land Trust Certificate Number 390—the largest single missing security in the United States—he or she can turn it in to the Republic National Bank of Dallas, Texas, for a cool $2 million!"

Limitless and inexhaustible spiritual riches are available to all of God's children: "No good thing will he withhold from them that walk uprightly" (Ps. 84:11b).

"My Father is rich in houses and
　　lands,
　He holdeth the wealth of the
　　world in His hand!"

* * *

$100,000 Refused

During the Civil War, raiders swept through southwest Missouri. They seized a slave mother and her baby boy on Carver's Diamond Grove farm. The boy was destined to become a great American and a mighty benefactor to his race and mankind. Mr. Carver got the boy back in exchange for a racehorse, but the mother was never found!

Mr. Carver named the boy George Washington Carver. Though never strong physically, the boy worked his way through high school and Iowa State Col-

lege of Agriculture, and was graduated with a M.S. degree in agriculture in 1896.

In 1896, on the invitation of Booker T. Washington, founder of Tuskegee Institute in Alabama, Carver became the head of the department of agriculture at the Institute. For forty-seven years, he unselfishly and totally dedicated himself to the task of educating Negro youths for service for God and mankind. His salary throughout the years was $29 a week. He refused to receive more, saying that he had enough for his small needs.

It was said that Thomas A. Edison once offered Carver $100,000 yearly as a starting salary if he would join his staff. Carver refused the fabulous offer because he wanted to continue to mold the characters and lives of the Negro students in Tuskegee Institute.

Long before George Washington Carver's praiseworthy sacrifice of material gain, it was recorded of another great benefactor and selfless one, Moses, who "when he was come to years, refused to be called the son of Pharaoh's daughter; choosing rather to suffer affliction with the people of God, than to enjoy the pleasures of sin for a season; esteeming the reproach of Christ greater riches than the treasures in Egypt" (Heb. 11:24-26).

* * *

Penny Wise, Pound Foolish

Mary MacMahon, an aged widow, lived in Hollywood, Florida. When she died, officers found a fortune stashed away in her home. Detective James Hampton reported, "I've never counted as much money before, and possibly I never will again."

The officers found stacks of stocks in a closet and much cash stored in cardboard boxes on the floor and shelves everywhere. The bills ranged from ones to hundreds and the find totalled $242,283.87.

Said Detective Hampton, "The queer thing about the situation was a safe in the home which was cemented to the floor. In the safe was approximately $150

in pennies. One of the pennies was carefully wrapped in paper which bore the notation, 'Found shopping on Van Buren Street.'"

Was not that eccentric widow who safeguarded so carefully the pennies, without similar concern for the $242,283.87, "penny wise and pound foolish?"

How like her are those who barter imperishable spiritual riches for mere trifles. Esau did that: "For one morsel of meat (he) sold his birthright . . . afterward, when he would have inherited the blessing, he was rejected: for he found no place of repentance, though he sought it carefully with tears" (Heb. 12:16, 17).

* * *

Abiding Riches

One has said, "You are richer today than you were yesterday if you have laughed often, given something, forgiven even more, made a new friend, or made steppingstones of stumbling blocks; if you have thought more in terms of 'thyself' than of 'myself,' or if you have managed to be cheerful even if you were weary. You are richer tonight than you were this morning—if you have taken time to trace the handiwork of God in the commonplace things of life, or if you have learned to count out the things that really do not count, or if you have been a little blinder to the faults of a friend or foe. You are richer if a little child has smiled at you, and a stray dog has licked your hand, or if you have looked for the best in others, and have given others the best in you."

* * *

"Rich Toward God"

Henry Ward Beecher said, "No man can tell whether he is rich or poor by turning to his ledger. It is the heart that makes a man rich. He is rich according to what he *is,* not according to what he *has.*"

Jesus said, "A man's life consisteth not in the abundance of the things which he possesseth" (Luke 12:15b).

Enduring Spiritual Riches ✔

As a missionary sat in a railway station in China, he suddenly detected that his briefcase was gone!

He became greatly distressed and wept as he thought of its contents: irreplaceable mementos; identification cards which are difficult to replace; his sermon notes, and what he valued above all else—his well-marked Bible and hymnal.

Moments later, his sorrow gave place to joy! He thought, "I still have enduring spiritual riches: 'Blessed . . . with all spiritual riches . . . in Christ' (Eph. 1:3b). I have also His Word and His song in my heart: 'Thy word have I hid in my heart' (Ps. 119:11a), 'Singing and making melody in your heart to the Lord' (Eph. 5:19b)."

Long ago, as Paul sat in a cold and cheerless Roman prison, he triumphed over his outward circumstances. Though he didn't have a cloak to cover his shivering body, he had Christ and joyously wrote, "I have all, and abound: I am full" (Phil. 4:18a).

Told by Landrum Leavell

* * *

Gate Receipts ✔

When Phineas T. Barnum, the famed circus showman, died in his eighty-second year, his last words were a question about the big show's gate receipts in Madison Square Garden. Then he was gone!

How worthless are the material things in death: "For we brought nothing into this world, and it is certain we can carry nothing out" (I Tim. 6:7).

* * *

Glaring Inequalities

A news item in 1971 stated that Queen Elizabeth's household expenses were running into the red at the rate of $240,000 a year. Prime Minister Edward Heath appointed a parliamentary committee to look into the royal finances. The committee was expected to recommend that the Queen's pay be raised substantially, if not doubled.

Here are the itemized expenditures:

Prince Philip received $96,000 a year. The oldest son, Prince Charles, received $240,000 which began when he reached the age of 21. His sister, Princess Anne, received $14,400 a year which was scheduled to be increased when she marries to $36,000 a year. The Queen Mother received $168,000 a year. Princess Margaret, the Queen's sister, received $36,000 a year.

Few know the exact size of the Queen's fortune, though $140 million would be close to the mark, the news dispatch affirmed.

In this world, a wide gulf exists between the haves and the have-nots. Glaring inequalities exist everywhere, and will remain until the great equalizer, death, levels the haves and the have-nots. No one can bribe the grim reaper, howsoever earnestly they plead.

Years ago, as Queen Elizabeth I died, she pleaded, "All my possessions for one inch of time!"

How wise we are in obeying the divine directive, "If riches increase, set not your heart upon them" (Ps. 62:10b).

* * *

The Best Things

The best things are nearest: breath in your nostrils, light in your eyes, flowers at your feet, duties at your hand, the path of right just before you. Then do not grasp at the stars, but do life's plain, common work as it comes, certain that daily duties and daily bread are the sweetest things of life.

Robert Louis Stevenson

* * *

Dollars in Trust for God

Said Oliver Wendell Holmes, "Put not your trust in money, but put your money in trust."

How wise for time and eternity are those who hold their dollars in trust for God!

* * *

An Insatiable Evil

Said Ben Franklin, "Money never made a man happy yet, nor will it. There

is nothing in its nature to produce happiness. The more a man has, the more he wants. Instead of its filling a vacuum, it makes one. If it satisfies one want, it doubles and trebles that want another way."

"Trust (not) in uncertain riches, but in the living God, who giveth us richly all things to enjoy" (I Tim. 6:17).

* * *

Unappropriated Riches ✓

On a wintry day at twilight, a ragged man entered a little music shop on a side street in London. Under his arm was an old violin.

"I'm starving," said he to Mr. Betts, the owner of the shop. "Do please buy this old violin so I can get something to eat."

Mr. Betts offered him a guinea, worth about five dollars at that time. The man gratefully received it and then shuffled out into the frigid night.

When Mr. Betts drew a bow across the strings of the old violin, it produced a rich, mellow tone! How astonished he was! Lighting a candle, he peered intently into the inside of the instrument. There he observed the magic name—Antonio Stradivari—and the date, 1704! He knew instantly that this was the famous Stradivarius that had been missing for a hundred years. The attics of Europe had been diligently searched for this missing violin, but in vain.

Subsequently the famous violin changed hands several times and brought as much as $100,000.

For years, the penniless man didn't know the value of what he possessed. He lived in poverty, on the edge of starvation.

How like that penniless pauper are many of God's children. They are "heirs of God, and joint-heirs with Christ" (Rom. 8:17a), and are "blessed with all spiritual blessings in heavenly places in Christ" (Eph. 1:3b). But they are spiritually impoverished through their failure to appropriate the eternal riches which God has provided for them: "Come . . . take the water of life freely" (Rev. 22:17).

Full and Empty Cups

A Scottish proverb says, "It is more difficult to carry a full cup than an empty one."

How tragic it is that so many miss God's best because of prosperity. The Bible says of Uzziah, "When he was strong, his heart was lifted up to his destruction" (II Chron. 26:16).

Warningly God said to His ancient people, "And when thy . . . silver and thy gold is multiplied . . . Then thine heart be lifted up, and thou forget the Lord thy God" (Deut. 8:13, 14).

"If riches increase, set not your heart upon them" (Ps. 62:10b).

* * *

No Time to Live

A man who had been successful in business proposed this honest epitaph for his tombstone: "Born 1878, a human being; Died 1954, a wholesale grocer."

Asked by a friend, "Would you care to comment on the unusual epitaph?"

"Certainly not," he replied. "I have been so busy selling groceries and amassing riches that I have pushed practically everything else out of my life. I have been successful but so busy making a living, I never had time to live."

* * *

A Noble Decision

When he was fifty-three years old, John D. Rockefeller succumbed to illness. During that sickness he resolved that he would devote the rest of his life, not to multiplying the many millions he had already acquired, but to using his fabulous wealth to alleviate suffering and promote the welfare of mankind everywhere.

How wise we are to hold our dollars in trust for God!

* * *

What You Make of Gold

Dug from the mountainside, washed from the glen,
Servant am I or the master of men.
Steal me, I curse you; earn me, I bless you;

172

Grasp me and hoard me, a fiend shall
 possess you;
Live for me, die for me, covet me, take me,
Angel or devil, I am what you make me.

ANONYMOUS

* * *

Only Three Philosophies

Long ago the Saviour said, "A man's
life consisteth not in the abundance of the
things which he possesseth" (Luke
12:15b).

In the ultimate analysis, there are only
three philosophies about earthly posses-
sions:

First, what's yours is mine, and I'll get
it, even by murder: "And Ahab spake
unto Naboth, saying, Give me thy vine-
yard" (I Kings 21:2); "Then they sent to
Jezebel, saying, Naboth is stoned, and is
dead" (vs. 14).

Second, what's mine is mine, and I'll
keep it: "I will pull down my barns, and
build greater; and there will I bestow all
my fruits and my goods" (Luke 12:18).
Many can all they get and get all they
can.

Third, what's mine is God's, and I will
share it with the needy and have-nots:
"Neither was there among them any that
lacked . . . distribution was made unto
every man according as he had need"
(Acts 4:34, 35).

How wise we are when we hold our
possessions in trust for God!

RALPH M. SMITH

"Uncertain Riches" ✓

In a recent downward plunge of the
stock market, Henry Ross Perot, the bil-
lionaire president of Electronic Data Sys-
tems Corporation, lost some $600 million!

Asked how he felt in losing around $100
million a day for over a week, Perot re-
plied, "I really have no feeling about it at
all. It has a dramatic impact, I know, and
I certainly have a deep concern for my
stockholders. My cash holdings are very
strong, and my company is very strong.
I have more than enough to be comfort-
able on."

How uncertain are earthly riches: They
"certainly make themselves wings; they
fly away as an eagle toward heaven"
(Prov. 23:5b).

How abiding are heavenly riches: There
"thieves do not break through nor steal"
(Matt. 6:20b).

In death we leave all material riches:
"For we brought nothing into this world,
and it is certain we can carry nothing
out" (I Tim. 6:7).

* * *

Riches Contemned

Contemning wealth and comfort, the
Greek philosopher Diogenes slept in a
tub.

One day Alexander the Great visited
Diogenes and asked, "Can I do anything
for you?"

Diogenes replied, "Yes! Get out of my
light!"

SALVATION

De-slumming the Slummer

Said Dr. Carl F. Winters, educator and
criminologist, "America must take the
slum out of the people rather than the
people out of the slums in order to reduce
crime over the nation."

Only inwardly changed individuals,
transformed by God's grace, can change
a sin-sodden society.

A Nauseous Feeling

A university student said to Billy Gra-
ham, "Whenever I hear the word *God,* I
feel physically ill. How do you explain
it?"

Graham said, "Suppose that my stomach
is upset, and you bring me a sizzling-hot,
juicy steak. It may be cooked just as I
like it. Yet the sight of it would give me
a nauseous feeling.

173

SALVATION

"The Bible teaches that when people are rebelling against God, they cannot bear to think about Him. They have no spiritual relish for Him. Only when God heals their sin-sick souls can they have relish for Him. Then they exclaim with the psalmist: 'As the hart panteth after the water brooks, so panteth my soul after thee, O God. My soul thirsteth for thee' (Ps. 42:1, 2a). Only God can bring spiritual healing to our mind and soul."

* * *

The Doldrums

In the olden days when ocean vessels were driven by wind and sail, nothing was more feared by seamen than to be caught in the doldrums—those parts of the ocean near the equator where calms or baffling winds prevail.

Once a vessel sailing to South America was caught in the doldrums. For days the becalmed vessel was like "a painted ship in a painted sea!" The ship's supply of fresh water dwindled until none was left.

At last, wind came and the vessel sailed on its journey. Soon another ship was seen approaching, and the famishing sailors cried, "Water! Water! Give us water!"

The reply came, "Let down your buckets!"

Following the directive, the thirst-craved sailors drew up buckets filled with fresh water from the mighty Amazon River which continues to flow for many miles into the ocean off the coast of Brazil.

There was great rejoicing as the sailors slaked their thirst!

The Saviour waits to satisfy the spiritual thirst of all sin-seared, famishing souls: "If any man thirst, let him come unto me, and drink" (John 7:37b).

Why die of spiritual thirst when the living water may be had for the asking?

I heard the voice of Jesus say,
 "Behold, I freely give
The living water; thirsty one,
 Stoop down, and drink, and live."
HORATIUS BONAR

Breathing Corpses

How lifelike are the wax figures of well-known persons displayed in the wax museums! Some are figures of notorius desperadoes. How accurately their facial features are portrayed! To enhance the lifelikeness, a mechanical device is sometimes concealed on the chest of a figure to simulate breathing and give the illusion of life.

How like those wax figures are the spiritually dead, merely professing Christians! The Bible depicts them thus: "Thou hast a name that thou livest, and art dead" (Rev. 3:1).

* * *

Unchanged

An inscription on a 6,000-year-old Egyptian tomb reads, "We live in a decaying age. Young people no longer respect their parents. They inhabit taverns and have no self-control."

Through the centuries, human nature has remained unchanged. It is "corrupt according to the deceitful lusts" (Eph. 4:22b).

Through the miracle of regeneration, sinful ones become new creatures with a new nature: "If any man be in Christ, he is a new creature" (II Cor. 5:17).

* * *

"Water! Water!"

A combat crew had to ditch their bomber in the vast loneliness of the South Pacific Ocean. Although most of them drowned, five climbed aboard a rubber raft. For twelve days they drifted with no sign of rescuers. The sun scorched and burned their skin. As their rations were exhausted, their flesh shrank until they were little more than living skeletons. Their lips cracked and their tongues became thickly swollen.

Two of the men went mad and leaped overboard. Another died quietly, and they rolled his body into the sea. Two were left. When a rescue vessel found the raft, only one was alive. He cried when he told of the death of his last companion.

"The night before you found us," he said, "it rained and the raft caught a pail

174

of fresh water. I tried to give some to my buddy. It would have saved his life; but his mind was wandering, and he had the idea that I was trying to give him sea water to poison him and finish him off. He wouldn't drink! I was too weak to force him!"

The rescued airman beat his pillow in frustration and said, "If only he had drunk the water I offered him, he could have lived!"

The Saviour offers the water of life to all who will receive it: "If any man thirst, let him come unto me, and drink" (John 7:37); "I will give unto him that is athirst of the fountain of water of life freely" (Rev. 21:6b).

A. D. DENNISON, JR.

* * *

A Christian in Small Things

A servant girl applied for membership in a church. The pastor asked, "Is there any evidence you can give me to indicate you have had a change of heart?"

The girl replied, "Since I trusted Jesus as my Saviour, I don't hide the dirt under the rugs when I sweep."

Said the pastor, "That's enough! We will receive you into our fellowship!"

If we are Christians in small things, we are not small Christians.

ALICE M. KNIGHT

* * *

Creeds Can't Save

Abraham Lincoln said, "I doubt the possibility of settling the religion of Jesus Christ into molds of man-made creeds and dogmas. It was a spirit of life that the Saviour laid stress on and taught. I cannot without reservations assent to long and complicated creeds and catechisms. If a church would ask simply for assent to the Saviour's statement of the substance of the law: 'Thou shalt love the Lord thy God with all thy heart, and with all thy soul, and with all thy mind and thy neighbour as thyself,' I would gladly unite with that church."

No creed, howsoever complex or simple, can give us eternal life or take us to heaven. We enter the kingdom of God by

way of the new, spiritual birth: "Except a man be born again, he cannot see the kingdom of God" (John 3:3). Unfeigned love for God and man is a concomitant condition *following* our spiritual birth through faith in Christ.

* * *

A Civilized Monster

Some young people today have accepted the view that man is naturally good, humane, decent, just and honorable, but corrupt and wicked institutions have transformed the noble savage into a civilized monster. They believe that destroying the corrupt institutions will cause man's native goodness to flower.

How totally at variance this theory is with the history of man and the Bible's depiction of him in his lostness and desperately wicked state.

Clarence Darrow, the famed criminal lawyer, said, "You can make nothing of man but man—selfish, mean, tyrannical, aggressive. That's what man is and a lot more. It is useless to try to change him!"

Darrow's characterization of man—apart from the transforming, character-changing grace of God—is true. But when the deceitful and desperately wicked heart of man is changed by God, man becomes a new creature in Christ.

* * *

Tragic Waste of Life

A minister visited a senior college student who lived in a ramshackle, dismally dirty house, hoping to win him to Christ. The yard was littered with debris—a shambles. The student's hair was long and unkempt.

The minister said, "I have come to talk to you about God and your need of the Saviour."

"I don't believe in God or the Saviour or the Bible," said the youth.

The minister thought, "How tragic! What a waste of life!"

Before leaving, the minister said, "You will graduate from the university in a short while. Would you mind giving me an answer to this question: What do you intend to do with your life?"

SALVATION

Half seriously, the disheveled youth replied, "I'm going to be an ecologist. I'm going to clean up the environment."

The minister mused: "What inconsistency! How can he talk about cleaning up the environment while he himself lives in filth and is in desperate need of inward, spiritual cleansing, and bodily cleansing?"

All mankind needs spiritual cleansing from sin's defilement: "The blood of Jesus Christ . . . cleanseth us from all sin" (I John 1:7b).

Told by RALPH M. SMITH

* * *

Genetic Manipulation

Some scientists believe that genetic manipulation holds promise for both the improvement and the destruction of human civilization. By controlling genes which largely determine the physical and mental characteristics of a person, the scientists hope they can create a perfect man.

In addressing a scientific audience, Prof. Harold P. Green of George Washington University said, "A society which is concerned about its future must necessarily face up to the implications of genetic manipulation and make conscious decisions as to the types of social control to be imposed upon the technology and its practitioners."

To control the physical and mental characteristics of man is not enough to make a perfect man. Man's "deceitful and desperately wicked" heart must be changed. A full-orbed man must have a change of heart, a spiritual birth through the miracle of regeneration. No genetic manipulation, however beneficial it may be mentally and physically, can produce the spiritual birth needed by both the moral and the immoral man. The Saviour said to a moral, cultured and religious man, "Ye must be born again."

* * *

How He Felt

After Martin Luther passed from spiritual death into spiritual life in Christ, he exclaimed, "I felt as though I had been born again and had gone through open gates into Paradise itself!"

From Above

Nicolas Guiliana of Le Touquet, France, wandered off the shore into the Bay of LaCanche at low tide, unaware of the down-dragging quicksand just ahead. He sank into the quicksand up to his chest.

Dozens of people watched helplessly as he sank, and Guiliana thought all was over for him. Suddenly he heard the roar of a helicopter and a voice shouting, "Grab onto the skids!"

Guiliana grabbed the skids and was carried safely to shore, 200 yards away.

Guiliana's deliverance from physical death came from above. Our deliverance from spiritual death also comes from above. David said, "I waited . . . for the Lord . . . he heard my cry. He brought me up . . . out of . . . the miry clay" (Ps. 40:1-2).

* * *

God Accepted His Challenge

Said Horace Bushnell, as he struggled with his doubts, "What is the use of trying to get further knowledge, so long as I do not cheerfully yield to what I already know?" Then he fervently prayed, "O God, I believe there is an eternal difference between right and wrong. I give myself to the right and refrain from the wrong. I believe You exist. If You hear my cry and will reveal Yourself to me, I pledge myself to do Your will—fully, freely and forever!"

God accepted Bushnell's challenge and his doubts vanished.

"O taste and see that the Lord is good: blessed is the man that trusteth in him" (Ps. 34:8).

* * *

Kittens and Breadbox

During a friendly conversation with a stranger, a minister asked, "Are you a Christian?"

The man replied, "Yes."

"What are your reasons for believing that you are a Christian?" asked the minister.

"I was born in America. America is a Christian nation, isn't it?"

"Yes, America is called a Christian nation," the minister replied.

"And I was brought up in a Christian home and church," the man continued.

Thoughtfully the minister replied, "These things are good and have their place, but they can no more make you a Christian than a cat's having her kittens in a breadbox can make them biscuits!"

The minister explained that one becomes a Christian by turning penitently from sin to the Saviour and pleading, "God be merciful to me a sinner."

Told by RALPH M. SMITH

* * *

Parachuting Cats

Said a staff writer in the *Austin American-Statesman,* "Things got so bad a few years ago, they had to parachute cats into Borneo. The whole problem started with malaria. Health officers had the area sprayed with DDT to kill the mosquitoes.

"The insecticide also poisoned and partially paralyzed flies which fell easy prey to lizards which then became diseased from the DDT in the flies. The lizards, usually able to escape the cats, were being killed off by the cats; and the cats, in turn, died from the DDT in the lizards.

"With the cats gone, rats from the bushes invaded the villages, creating further problems of disease and death."

Sin-shackled man is prone to experiment with different alleged expedients to eradicate the inborn evils of his heart, but to no avail.

Long ago the Saviour, in speaking of the worthlessness of self-reformation, said, "When the unclean spirit is gone out of a man, he walketh through dry places, seeking rest, and findeth none. Then he saith, I will return into my house . . . and taketh himself seven other spirits more wicked than himself . . . and the last state of that man is worse than the first" (Matt. 12:43-45).

What unregenerate man needs to do is to acknowledge his lostness and penitently plead, "God be merciful to me a sinner" (Luke 18:13b).

* * *

Fifty Yards Short

A headline in *The Cleveland Press* said, "Charleston Air Crash Believed Fatal to 30!"

In dense fog, the ill-fated plane landed fifty yards short of the runway, crashed, and burst into flames!

The word "short" is descriptive of humankind's failure to measure up to God's standard: "For all have sinned and come short of the glory of God" (Rom. 3:23). How tragic would be our fate but for the fact that "The Lord's hand is not shortened, that it cannot save" (Isa. 59:1).

* * *

A Sine Qua Non

Water is absolutely essential to every form of life. Every living cell of both plants and animals depends on water.

We have about five quarts of blood in the blood vessels of our body. Water makes up about three quarts of the blood fluid.

Of every ten pounds of our weight, about seven pounds is water.

Without water to drink, we would die in a short time.

We will die of spiritual thirst if we refuse to slake our thirst with living water, which Jesus freely gives: "If any man thirst, let him come unto me, and drink" (John 7:37); "I will give unto him that is athirst of the fountain of the water of life freely" (Rev. 21:6).

SECOND COMING OF CHRIST

The Outlook and the Uplook

How bright are the uplook and future for God's children who cherish "that blessed hope, and the glorious appearing of the great God and our Saviour Jesus Christ" (Titus 2:13)!

How dark and dismal are the outlook and future for those who fail to reckon with God and His gloom-dispelling, hope-kindling prophetic Word!

Professor John Holt of Yale recently said: "Nobody seriously believes that we are likely to solve, or are even moving toward a solution of, any of the most urgent problems of our times—war, the proliferation of atomic, chemical, and bacteriological weapons, overpopulation, poverty, the destruction of the earth's natural resources, the degradation of man's physical and biological environment, the fossilization and depersonalization of his political and economic institutions, his increasing alienation, boredom, and anger! We do not think any more that we can really make the world a fit and happy and beautiful place for people to live. We scarcely think that we can keep it a place where people can live at all!"

Jesus said, "And when these things begin to come to pass, then look up, and lift up your heads; for your redemption draweth nigh" (Luke 21:28).

As God's children scan world horizons through the telescope of the "sure word of prophecy," they are constrained to exclaim, "The coming of the Lord draweth nigh" (Jas. 5:8b).

* * *

Bringing the King Back

On September 4, 1970, France celebrated the 100th anniversary of the founding of the Third Republic. There was one segment of the population, however, which did not join in the celebration—the Royalists, who aspired to restore the monarchy to France. The *Aspects de la France* carried an editorial which read, "One hundred years of the Republic and one hundred years of calamity. Today more than ever before, every thinking patriot, every intelligent (person) can only want to put an end of the long interregnum, where the king's absence has been so cruelly felt!"

Myriads of God's children today long for the return and righteous reign of Jesus, as "King of kings, and Lord of lords" (Rev. 19:16b). The response of many to His sure promise, "Surely I come quickly" (Rev. 22:20b) is, "Even so, come, Lord Jesus!"

* * *

"Which Way Can We Turn?"

In his last speech in Parliament as Prime Minister, Sir Winston Churchill gloomily and dejectedly said, "Which way can we turn to save our lives and the future of the world? It does not matter so much to old people. They are going soon anyway. But I find it poignant to look at youth in all its activity and ardor, and, most of all, to watch little children playing their many games, and wonder what would lie before them if God wearied of mankind."

In a world filled with dread and gloom, this fear-allaying directive comes to God's children with clarity, "And when these things begin to come to pass, then look up . . . for your redemption draweth nigh" (Luke 21:28b).

"The coming of the Lord draweth nigh!"

* * *

The Uptaker

Alexander Maclaren affirmed, "The apostolic church thought more about the second coming of Jesus Christ than about death or about heaven. The early Christians were looking not for a cleft in the ground called a grave, but for a cleavage in the sky called Glory. They were watching not for the undertaker, but for the Uptaker."

Perhaps sooner than we think, "the Lord himself shall descend from heaven" (I Thess. 4:16a).

178

SECOND COMING OF CHRIST

"One Taken . . . the Other Left"

In the U. S. Army, no American soldier is ever knowingly left on the battlefield, whether wounded or dead. Soldiers often risk their lives to take their fallen comrades back to their base.

One day, as Pfc. Ed Bable, age 19, from Beaver Falls, Pa., and some of his comrades in Viet Nam were pushing through the jungle, they entered a trap set by the Viet Cong. A vicious crossfire caught them. Several of them fell, mortally wounded. Bable escaped and made his way back to safety, but he didn't stay long. Struggling through the muck, he returned to the scene of the ambushment. Quickly he lifted two of his fallen comrades to their feet. Supporting one with each arm, he brought them back to the American zone.

At the second coming of Christ, His church composed of all born-again believers, will be raptured, "Caught up . . . to meet the Lord in the air" (I Thess. 4:17). The unsaved ones will be left behind. In speaking of this event, Jesus said, "But as in the days of Noah were, so shall also the coming of the Son of man be. . . . Then shall two be in the field; the one shall be taken, and the other left. Two women shall be grinding at the mill; the one shall be taken, and the other left. Watch . . . for ye know not what hour your Lord doth come" (Matt. 24:37, 40-42).

If Christ came today, would you be with the saved, raptured ones? Or would you be left behind? What you do with Christ *now* could determine where you will be hereafter.

* * *

Caught Up Together with Them

Many throughout the nation and around the world lamented the passing of Anna Eleanor Roosevelt. In honoring her memory, they spoke of her as *the first lady of the world* and extolled her for her espousal of the cause of the downtrodden.

An interesting cartoon appeared in the newspapers. It showed a tombstone on which were the words:

FRANKLIN DELANO ROOSEVELT
1882 - 1945

ANNA ELEANOR ROOSEVELT
1884 - 1962

Above the tombstone was a smiling, shadowy picture of Mrs. Roosevelt's face. The title of the cartoon was *Reunited.*

God's children on earth are temporarily separated from their loved ones who have died in the Lord. Paul spoke of the "whole family (of God) in heaven and earth" (Eph. 3:15).

When Christ comes again, they will be reunited: "For the Lord . . . shall descend . . . then we which are alive and remain shall be caught up together *with them* . . . to meet the Lord in the air" (I Thess. 4:16, 17).

How enduring are the blessings of those who become God's children through faith in Christ!

* * *

"Please Don't Come to Earth, Dear Jesus!"

During World War II when Berlin and other cities were aflame and being reduced to rubble, little Johannes Sommer, son of a Methodist minister who lived in Uchtenhagen, near Berlin, prayed sweetly, innocently and earnestly, "Dear Jesus, please don't come to earth. There is war on the earth!'

The priceless truth which little Johannes didn't understand was that when Jesus comes to earth again to reign in righteousness, there will be globe-girdling, all-pervasive peace: "And he shall judge among many people . . . and they shall beat their swords into plowshares, and their spears into pruninghooks: nation shall not lift up a sword against nation, neither shall they learn war any more" (Mic. 4:3).

When Isaiah envisioned that glorious day, he exclaimed, "The whole earth is at rest, and is quiet: they break forth into singing" (Isa. 14:7).

Told by GERTRUD WASSERZUG

179

SELF-CONTROL

Incurable Stupidity

Said Pitirim Sorokin in *The Crisis of Our Age,* "The history of human progress is a history of incurable stupidity. In the course of human history, several thousand revolutions have been launched with a view to establishing paradise on earth. Practically none of them has ever achieved its purpose."

When Christ, "The Prince of Peace," ushers in His righteous reign and banishes war, sin, sickness and sorrow, the earthly paradise envisioned by the ancient prophets will be a reality: "The whole earth is at rest, and is quiet: they break forth into singing" (Isa. 14:7). Then, "They shall obtain joy and gladness, and sorrow and sighing shall flee away" (35:10b).

The soulful plea of myriads of God's children in response to the sure promise is, "Surely I come quickly. . . . Even so, come, Lord Jesus" (Rev. 22:20).

SELF-CONTROL

It Spun Crazily

A Northwest Airlines Electra frantically radioed to the control tower, "No control!" The plane spun crazily from the sky seconds after takeoff, struck a railroad embankment, and exploded! All thirty-seven passengers aboard, including a mother and four children, perished!

The shores of time are strewn with moral and physical derelicts who went down in defeat and despair because of *no control.* With many, there was a time when they boasted, "I know where to draw the line!" But they didn't.

Satan is too wise to ask anyone to plunge precipitously into sin. He lures his victims on a step at the time, until he brings them to the point of no return—"taken captive by him at his will" (II Tim. 2:26b). He does not ask a young man to become an alcoholic, but a man of *distinction.* How quickly a man of *distinction*—a tippler—becomes a man of *extinction!*

* * *

Temperance

Temperance is the moderating of one's desires in obedience to reason.

CICERO

* * *

Digging One's Grave with a Spoon

A recent factual report by the Metropolitan Life Insurance Company shows that the male who is 20 percent overweight has a 45 percent greater chance of developing heart disease and a 53 percent greater chance of having cerebral hemorrhages, and is 13 percent more susceptible to contracting diabetes than one of average weight.

The longer the waistline the shorter the lifeline!

* * *

How to Kill a Husband

Want to kill your husband and get away with it? Don't bother with cyanide, blunt instruments, or revolvers! Just feed him a steady diet of rich pastries and heavy starches until he is at least 15 to 25 percent overweight!

MRS. DALE CARNEGIE
in *How to Help
Your Husband Get Ahead*

* * *

Pig-like People

How pig-like are some people! Pigs eat excessively. Many people thoughtlessly eat excessively and drink alcoholic beverages. Then they become subjects to heart disease, stomach trouble, kidney and liver disease, and perhaps alcoholism.

Pigs never look up unless they are on their back. God has to put some people on their back so they will look up and call upon Him for mercy and forgiveness, and mend their ways.

* * *

Controlled by God

O Thou, who hast at Thy command
The hearts of all men in Thy hand,
Our wayward, erring hearts incline
To have no other will but Thine.

Our wishes, our desires, control;
Mold every purpose of the soul;
O'er all may we victorious prove
That stands between us and Thy love.

Thrice blest will all our blessings be,
When we can look through them to Thee;
When each glad heart its tribute pays
Of love and gratitude and praise.

JANE COTTERILL

SELFISHNESS—UNSELFISHNESS

Facing Death with an Audience

Two brothers spent four frightful hours clinging to their overturned boat, trying to get help from amused spectators on the shore.

Dave Pront and his brother Jim were fishing in Pittock Dam when their boat overturned.

After their rescue by the fire department, Dave said in an interview, "We got fed up seeing the people on the shore just watching us through their binoculars and waving at us while we were screaming for help. A boat went by, but the guy just smiled and waved at us. We never saw him again. If it hadn't been for my brother who kept holding onto me, I would not be here to relate the ordeal. It sure makes you wonder about people!"

It certainly does!

Is there a more enfeebling and reprehensible evil among God's children today than the sin of do-nothingism?

God's curse is upon this spiritually-dwarfing sin: "Curse ye Meroz . . . curse ye bitterly the inhabitants thereof; because they came not to help of the Lord . . . against the mighty" (Judges 5:23).

* * *

Paid for Doing Nothing

"Why do you wish to join the Indian army?" a youth was asked. He replied, "In the Indian army, they pay you a lot for doing little. When you are advanced further, they pay you more for doing less. When you retire, they pay you quite a lot for doing nothing."

* * *

Worse Than Death

On July 29, 1958, Dag Hammarskjold, the Secretary General of the United Nations, wrote these words in his diary: "The only value of a life is its content for *others.* Apart from any value it may have for others, my life is worse than death. How incredibly great is what I have been given!"

* * *

None an Island

John Donne, an English clergyman, said, "No man is an island to himself. Every man is a part of the main (the whole)."

The Bible says, "For none of us liveth to himself" (Rom. 14:7a).

* * *

It Can't Be Done

Nazir Chaundry operates a store which straddles the boundary line of two sections of a city. One section is "wet" and the other section is "dry." If he sells alcoholic beverages in the "dry" section of the store, he will lose his license.

Some Christians try to live as Chaundry operates his store. In one section of their life they try to live for God, especially on the Lord's Day. In the other section, they live selfishly and for the perishing things of the world.

How slow they are to learn that they cannot serve two masters: "For either (they) will hate the one, and love the other; or else (they) will hold to the one, and despise the other" (Matt. 6:24b).

* * *

Beautified

Said J. C. Penney, a merchant prince, "Our lives are made useful and beautiful, not by what we selfishly receive from others and consume, but by what we unselfishly surrender."

* * *

Invest Yourself

Said Astronaut Walt Cunningham, "Between the time you arrive on the earth

181

and the time you depart, there are many ways of living. The worst way is to exist as a miser spends his money—clinging to life and paying it out in dribbles. The way to live is to spend your life generously, invest yourself in it. It's not how long you live, but how you spend your life."

Radiant and triumphant are those who can say, "For me to live is Christ!"

* * *

I, Myself and Me

I gave a little party this afternoon at three,
'Twas very small, three guests in all: *I, myself* and *me:*
Myself ate up all the sandwiches, while *I* drank the tea;
And it was *I* who ate the pie and passed the cake to *me.*

AUTHOR UNKNOWN

* * *

We Care

Recently a minister entered a restaurant where each of the waitresses wore a saucer-like button with the words: WE CARE.

As the minister ate his dinner, he tried to get the attention of the waitress who kept zooming past him, but without success. Finally he blocked her way. She seemed displeased to render the requested service.

Then the minister thought, "The attitude of that waitress belies the words on the button: WE CARE."

How incongruous it is for us to say, "We care" and fail to enter feelingly into the sorrows and sufferings of others. No generation of Christians ever lived in a needier world. Great will be our accountability to God, if we say we care and show by our unresponsiveness that we are too selfishly occupied with ourselves to have genuine concern for others.

Many are waiting a kind, loving word,
Help somebody today;
Thou hast a message O let it be heard,
Help somebody today.

SERVICE

Never-Ceasing Motion

Tripping hither, tripping thither,
Nobody knows the why or whither!
If you ask the special function
Of our never-ceasing motion,
We reply without compunction
That we haven't any notion.

W. S. GILBERT
From *Iolanthe*

* * *

What Did You Do About It?

In Hong Kong, Dr. Vernon Richardson observed a little Chinese girl sitting with her face pressed against the glass window of a bakery. Exhausted and hungry, she had fallen asleep outside the window behind which were stacked large loaves of bread.

"What an excellent picture that touching scene will make!" exclaimed Dr. Richardson, and he quickly snapped it.

When he returned to his home in Baltimore, the bakery scene with the hungry little girl was shown in his church with his other pictures. His comment on the bakery scene was interrupted by one who said, "Tell us what you did about it."

"About what?" asked the pastor.

"The little hungry girl against the window."

After a heartsearching moment, Dr. Richardson replied, "I did nothing about it. How remiss I was! I could have entered the bakery and bought the little girl more bread than she had ever had to eat before."

Most of us know how to do much better than we do. The extent of our accountability to God is commensurate with our knowledge of human need and the extent of our ability to relieve the need: "To him that knoweth to do good, and doeth it not, to him it is sin" (Jas. 4:17).

Adapted from
Adult Bible Study Quarterly, SBC

There's No Lost Good

The poet Robert Browning said, "There never shall be one lost good. All we have willed or hoped or dreamed of good shall exist."

Jesus said, "And whosoever shall give to drink unto one of these little ones a cup of cold water . . . verily I say unto you, he shall in no wise lose his reward" (Matt. 10:42).

* * *

Unwise to Envy Others

In Africa, so the story goes, a native had a prize flock of hens. Dutifully, each hen daily laid a sizable egg. The natives who were not so successful with their flocks eyed their neighbor with envy.

How proud was the rooster of the flock! Ascending to his perch, he would flap his wings vigorously, crow lustily, and look with admiration upon his harem of hens.

One day, the rooster walked through a hole in the enclosure and chanced to find an ostrich egg! He stared incredulously at the enormous egg.

Hurriedly returning to his flock, the rooster exclaimed, "Come, girls! See what others are doing! You must see it to believe it!"

It is unwise for us to look with envy upon what others are doing and to compare our talents and accomplishments with theirs.

The Bible warns us against this, saying: "For we dare not . . . compare ourselves with some that commend themselves: but they measuring themselves by themselves, and comparing themselves among themselves are not wise" (II Cor. 10:12).

Told by J. EVERETT KILBURN

* * *

Still Needed

Charlotte Edwards pleaded, "There was a time in my life, Lord, when I was needed. There was so much to do. I had no chance, nor time, to think of myself. Somebody, or something, demanded my constant attention.

"It's different now that the children are grown. The physical discomforts which I was too busy to do anything but ignore now speak out to me. Past emotional hurts walk into my memory. My thoughts seem to revolve in a very small circle indeed.

"Today, Lord, will You help me lift my mind from the grooves of self? Will you help me direct my thoughts toward those around me again? There must be people who need me.

"Lord, help me to make my days count. Help me to move outward again."

* * *

Glorifying Crime

In the *Baptist Standard,* J. W. Lassater said, "At times I feel that both myself and my son are doomed to failure because we do not have a background of crime or drug addiction, nor are we converts from some spurious religion.

"Recently I was asked to use a certain man in my church. I asked why. The reply was, 'Because he was once a member of the Clyde Barrow gang!'

"We rejoice in the mightiness of God to save men from a life of crime and degradation. But it is high time that we cease glorifying crime and playing it up to the point that our young people are made to feel such a background makes one a 'super servant' of Christ and is a prerequisite to Christian service."

* * *

What I Can Do

Edward Hale, former chaplain of the U.S. Senate, said, "I am only one, but I am one. I can't do everything, but I can do something. What I can do, I ought to do, and what I ought to do, by the grace of God, I shall do!"

The Bible says, "Whatsoever thy hand findeth to do, do it with thy might; for there is no work . . . in the grave, whither thou goest" (Eccl. 9:10).

* * *

Living Wonderfully

Said Dr. Harvey Cushing of Boston to Spencer Tracy and his wife, "Your son John is afflicted with deafness. There is nothing I can do for him. But I want to tell you that you are blessed among par-

183

ents. In helping John, you can lead a wonderfully interesting life!"

We, too, can live a wonderfully interesting life if we will lovingly help and sacrificially serve others in the name of the One who "came not to be ministered unto, but to minister, and to give his life a ransom for many" (Matt. 20:28).

* * *

Serving with a Selfish Motive

"We moved into a new neighborhood," said a man in a Christian conference on the West Coast. "The guy across the street couldn't have been nicer. He spent hours helping me move furniture and paint. His wife sent food over.

"I've got a great neighbor, I thought, *maybe a friend, even.*

"Then one night he told me he'd like to go over my insurance program. He was an insurance agent.

"When I said no and told him that my insurance was with a man who had handled it for some years, he dropped me! I never saw him after that except when we'd pass on the street."

How hypocritical and unworthy we are when we serve Christ or show kindness to others for personal, selfish gain!

The only motive for rewarding service or helpfulness to others is indicated in these words: "For the love of Christ constraineth us" (II Cor. 5:14a).

JOSEPH T. BAYLY
In *Eternity*

* * *

The Easy Yoke

Said Henry Drummond, "What is a yoke for? Is it a burden to the animal which wears it? No. It is just the opposite. It makes its burden light. If attached to an oxen in any other way than by a yoke, a plough or cart would be a galling, intolerable burden. Drawn by means of a yoke, the burden is comparatively light."

Jesus said, "For my yoke is easy, and my burden is light" (Matt. 11:30).

The Sharpened Axe

As Dr. Chalmers of Edinburgh contemplated sending his son to college, a friend said to him, "Don't do it. The times are too urgent. Send him to the fields which are white unto harvest."

Dr. Chalmers said, "Who accomplishes the most—the man who goes into the forest with a dull axe and works all day, or the man who stays home long enough to sharpen his axe and then spends the rest of the day chopping trees?"

* * *

Lord of Pots and Pans

One of God's faithful mothers prayed, "Lord of all pots and pans and things, make me a saint by getting meals and washing dishes. Warm all the kitchen with Your love. Forgive me all my worrying. Accept this service that I do, as unto Thee!"

"And whatsoever ye do in word or deed, do all in the name of the Lord Jesus, giving thanks to God and the Father by him" (Col. 3:17).

* * *

In Lowly Paths

O Master, let me walk with Thee
In lowly paths of service free;
Tell me thy secret, help me bear
The strain of toil, the fret of care.

Help me the slow of heart to move
By some clear, winning word of love;
Teach me the wayward feet to stay,
And guide them in the heavenward way.

Teach me Thy patience, still with Thee
In closer, dearer company,
In work that keeps faith sweet and strong,
In trust that triumphs over wrong.

In hope that sends a shining ray
Far down the future's broadening way,
In peace that only Thou canst give—
With Thee, O Master, let me live.

WASHINGTON GLADDEN

* * *

Wearing Out or Rusting Out?

A recent report concerning the retired ship *S. S. United States* avers, "In the

cold James River, tied to a dock at the Newport News Shipbuilding Dry-Dock, the mighty ship rests and keeps on resting. The superliner stills holds the speed record of crossing the Atlantic in 3 days, 10 hours and 40 minutes. But it isn't going anywhere now! The $79,400,000 ship was put into service seventeen and a half years ago and had more million-dollar voyages in 1969 than in any other previous season."

How like that retired ship are God's children who are at ease in God's spiritual Zion, rusting out when they could be wearing out in God's all-glorious service. To the listless, unconcerned ones, God gives this command: "Awake thou that sleepest . . . and Christ shall give thee light" (Eph. 5:14).

* * *

Saints in Shoe Leather

It is high time for churches to begin putting *fewer* saints in stained glass windows and *more* saints in shoe leather.

"They that were scattered . . . went every where preaching the word" (Acts 8:4).

* * *

Moody Was Right

"I had rather put ten men to work than do the work of ten men," said evangelist Dwight L. Moody.

* * *

Useful

Cotton Mather said that the pagans mistakenly identified the early Christians as "Christians." Perhaps the reason was because the Greek word *chrestos* meant "useful." Christians were considered "the useful ones." They followed the example of Christ, "who went about doing good, and healing all that were oppressed of the devil" (Acts 10:38b).

Do-nothingism in our sorrowing, suffering world is most reprehensible: "To him that knoweth to do good, and doeth it not, to him it is sin" (Jas. 4:17).

"To God Be the Glory!"

Said Lillian Dickson, a missionary to Formosa, "You can usually do anything in this world that you want to do and that needs doing, if you don't care who gets the credit for it."

* * *

The Best Portion

Said Browning, "The best portion of a good man's life (is) his little, nameless, unremembered acts of kindness and of love."

* * *

Regardless of Feeling

Said Charles Kingsley, "Our love for God does not depend upon the emotion of the moment. If you fancy you do not love Him enough, above all when tempted to look inward, go immediately and minister to others. Visit the sick or perform some act of self-sacrifice, regardless of how dull or indisposed you may feel while doing it. The fact that you are doing it, proves your spiritual part is on God's side, however tired the flesh may be."

"And let us not be weary in well doing: for in due season we shall reap, if we faint not" (Gal. 6:9).

* * *

Soul Nourishment

Said Albert Schweitzer, "The interior joy we feel when we have done a good deed, when we feel we have been needed somewhere and have lent a helping hand, is the nourishment the soul requires."

Help me in all the work I do,
To ever be sincere and true,
And know that all I'd do for you,
Must needs be done for others.

CHARLES D. MEIGS

* * *

Divinely Called

Said J. C. Penney, "You and I may not have been called to serve Christ and humanity in a foreign land, but let there be no doubt about our having been called. Each one of us—the missionary, the min-

ister, and the layman—has the same priceless gift to lay upon the altar of service: *a life*. That is of primary importance. Where the life shall be used is of secondary importance. Where there is a willingness to pay the price, God will surely find a place for you."

* * *

Turn Up Something

Some discouraged students said to Dwight L. Moody, "Nothing turns up." Quipped practical Moody, "Go out and turn something up!"

Said Sir Philip Sidney, English soldier and poet, "Either I will find a way, or I will make one."

Said Dante, "He who sees a need and waits to be asked for help is as unkind as if he had refused it."

Prayed Peter Marshall in the U.S. Senate, "O God, reach down and change the gears within us that we may go forward with Thee."

Said Cardinal Newman, "Fear not that thy life shall come to an end, but rather fear that it shall never have a beginning."

Said Robert Browning, "Get thy tools ready! God will find the work!"

* * *

You're the Answer

Many seek to find the answer to the problem. Few seek to *be* the answer to the problem. Some say, "Here am I," but fail to say, "Send me" (Isa. 6:8).

S E X

Morbid Suspicion

Dr. Norman Vincent Peale told of a major league pitcher who was so jealous of his wife that he could think of nothing else. He would go to the phone in the clubhouse between innings and call home to make sure that she was there and was not out indulging in an extramarital affair. The obsession was ruining him as an outstanding athlete.

Dr. Peale's consulting psychiatrists at the clinic determined that the man's consuming obsession was due to premarital sex relations himself, followed by a sense of guilt and self-condemnation that built up into morbid suspicions of the married partner.

Some ruin their chance for lifelong marital happiness by disobeying the changeless command, "Thou shalt not commit adultery" (Exod. 20:14). Some sacrifice the permanent on the altar of the temporary.

* * *

Character-Forming Music

Eternity magazine commented, "Plato insisted that in his ideal Republic only certain kinds of music would be played, because music had such a character-forming influence on youth. Do you think music shapes character? Absolutely! Plato was right.

"That is why it is so important that the lyrics and texts of our songs be worthwhile. If hard rock music sings about drugs and permissive morality and violence, it becomes unhealthy, and our culture reaps the consequences morally. Some of the lyrics of modern songs are utterly degrading. They can cause a change in moral attitude."

John Philip Sousa said, "I care not who writes my country's laws if I may write its music."

* * *

Cementing Nuptial Union

In their book *Toward Christian Marriage*, W. M. Capper and H. M. Williams say, "There are some Christian thinkers who regard the first union in marriage as cementing a lifelong mystical unity, which is accompanied by mental, emotional and physical changes which can never—at least to the full—be repeated. The one partner discovers the other in a reciprocal act of self-giving, and the inmost consciousness of each awakens to the fact that the life of each has been fused in that of the other. There will be other pleasurable and deeper emotional experiences,

but it is at this point that the marriage is really consummated."

In speaking of two individuals becoming one in the marital relationship, Jesus said, "And they twain shall be one flesh: so then they are no more twain, but one flesh" (Mark 10:8).

* * *

Marriage Here To Stay

Sociologist Dr. Carlfred B. Broderick said, "Sexual decay has gone about as far as it will go. Over the next few years, the wheel of human relations could do a reverse turnabout to puritanism. Despite all those young couples living together in unblessed bliss, more people were married in the United States in 1970 than in any year since 1946. Marriage is here to stay."

* * *

A Sacred Gift

Brother Antoninus, a Dominican monk, said, "Mankind has entered a sexually obsessive age. You can't stop it. My work is to make sex divine and holy."

God has already made the sexual relationship between husband and wife holy: "Marriage is honorable in all, and the bed undefiled: but whoremongers and adulterers God will judge" (Heb. 13:4). The command, "Thou shalt not commit adultery" (Exod. 20:14) is as binding today as when first proclaimed from Mount Sinai.

* * *

Sex Detached from Love

"The danger is not that the exploitation of sex may arouse lust but that it could produce impotence," said Norman Cousins in *Saturday Review*. "By detaching sex from love and annihilating privacy, sex is robbed of its delight. What is even worse, an infallible formula has been found for making sex boring. People who insist on seeing everything run the risk of feeling nothing."

* * *

What a Psychiatrist Sees

Is premarital sex right or wrong? Even if some are trying it, does that make it right?

God created sex. When used in the right way, it can bring joy, satisfaction and fulfillment in all of life. When indulged in outside of the marital relationship, it brings heartache, frustration, and ruin.

In a lecture at Hardin-Simmons University on October 14, 1965, Dr. Armond Nicoli, a Harvard University therapist, declared:

"This is what a psychiatrist sees: Unwanted pregnancies, ill-advised marriages, abortions followed by severe depressions and haunting repetitive nightmares, disillusionment, frustration, despondency, suicide. It is for this reason that psychiatrists are concerned about what is happening. It is for this reason that many of them are aware that something is wrong somewhere. This new sexual freedom is not what people are led to believe. . . . It certainly does not lead to prolonged ecstatic pleasure. There is no evidence that it leads to greater freedom and openness and more meaningful relationships between the sexes. Quite the opposite. And there is certainly very little evidence that it leads to exhilarating relief from stifling inhibitions. When you focus down on what this new freedom really entails, one can't help but be impressed that it doesn't appear to be much fun. . . . Somehow there has been a great deal of deception going on. Somehow a lot of people have been deluded. It may be that these new standards are not quite in our best interest."

* * *

A Time Bomb

Pleasure is the aim of premarital sex. However, the indulgence may prove to be a time bomb, eventually destroying marital happiness. If mates indulge in sex before marriage, how can either one be sure that the extramarital indulgence will not be continued after marriage? The unethical background could produce abnormal jealousy and morbid suspicion after marriage.

Dr. Norman Vincent Peale tells of a typical case. Here is his initial interview with an almost obsessed husband:

"I asked him what grounds he had for

his jealousy. At first he denied that he was jealous. Then, when I refused to accept this, he tried to laugh it off. His wife was very attractive, he said. He knew that most men were potential wolves. He just wanted to make sure that there was no trouble.

" 'It seems to me,' I said, 'that you don't have much faith in your wife. Why not?'

"He scowled and stared at the floor.

" 'Tell me something,' I said. 'Am I right that you two were lovers before you were married?'

"He looked up defiantly and said, 'What if we were? We got married, didn't we?'

" 'Yes,' I said, 'but you thought your conduct was wrong, even at the time. And now, right now, something in your subconscious mind is whispering to you that, if you wife was willing to break the moral code with you, she might easily do it with somebody else. Isn't that the case?'

"I have seldom seen a man grow so angry. 'No!' he shouted. 'Why do you say that?'

" 'Because I have run into this situation before,' I said.

"My visitor stared at me for ten long seconds. Then he took a deep breath.

'Maybe you've got something there! I'll think about it.' "

God's standard—God's Law—does not change. The command, "Thou shalt not commit adultery," is just as binding today as when first thundered in the long ago from Mount Sinai's rocky crags.

* * *

Of Plague Proportions

"Austin and the nation are in the midst of an epidemic of nearly plague proportions! No scare tactic—just fact," Joe Pair, state supervisor of the Texas Health Department's VD program, recently said.

In commenting on the problem, Dr. William Miller, public health physician of the Austin-Travis County Health Department, affirmed, "Venereal disease is now the nation's number one communicable disease! Texas holds the dubious honor of leading the nation in the number of reported infectious syphilis cases per capita. And gonorrhea is completely out of hand. There is little or no hope for gonorrhea control!"

Long ago God gave an immutable law which says, "Be not deceived . . . whatsoever a man soweth, that shall he also reap . . . he that soweth to his flesh shall of the flesh reap corruption" (Gal. 6:7-8).

SIN

Immutable—Changeless

Said C. W. Brown in *The Cap and the Gown*, "Two and two make four. Never by any ill chance only three and a half; never by any amount of coaxing or stretching four and a half, but always everywhere just four, no more. It is an absolute statement of fact. It always has been so and always will be.

"There is no shuffling or chance in the moral world. Impulses lead to choice; choices become habits; habits harden speedily into character; and character determines destiny!"

Just as sure as two and two make four is the operation of God's immutable, changeless moral law: "For they have

sown the wind, and they shall reap the whirlwind;" "He that soweth to his flesh shall of the flesh reap corruption" (Hos. 8:7; Gal. 6:8).

* * *

Seeing Life in Retrospect

When Lord Byron lay dying in a dismal, dark room at the age of thirty-six, his self-indulgent life seemed to flash in retrospect. Remorsefully, he said,

My life is in the yellow leaf,
 The fruits and flowers of life are gone;
The worm, the canker, and the grief
 Are mine alone.

The fire that on my bosom preys
Is loaned of some volcanic isle;
No torch is lighted at its blaze,
A funeral pyre.

How different it was with Adoniram Judson when he came to life's setting sun. He joyously exclaimed, "I go with the gladness of a schoolboy bounding away from school! I am so free in Christ!"

* * *

Extirpated

Henry Thoreau said, "There are a thousand hacking at the branches of evil to one who is striking at the root."

Jesus said, "And now also the axe is laid unto the root of the trees" (Matt. 3:10).

Sin is resident in the deceitful and desperately wicked heart of man. Through the miracle of regeneration, the roots of sin are extirpated, and a new nature is planted within by God. That gives victory over sin: "Sin shall not have dominion over you" (Rom. 6:14).

* * *

Grumpy and Grouchy

A grumpy, mean-tempered husband habitually found fault with his wife, who was a patient, Christlike Christian.

One morning as he sat sullen and silent at the breakfast table, his wife gently asked, "How do you want your eggs cooked?"

He grumped, "One fried and one scrambled."

When she placed the eggs before him, his face became livid with rage!

The wife asked, "What's wrong?"

He snarled, "You fried the wrong egg!"

What havoc is wrought in homes and churches by an irascible, surly churl—the devil's masterpiece.

The Bible differentiates between the sins of the flesh and sins of the spirit, or disposition: "Let us cleanse ourselves from all filthiness of the *flesh* and *spirit*" (II Cor. 7:1b).

How aptly does the pouting elder brother of the prodigal son illustrate the personality-warping, soul-shriveling sins of the spirit, or disposition. He refused to enter into the joyous festivities commemorating the return and restoration of the penitent prodigal. Sulking he said, "Lo, these many years do I serve thee, neither transgressed I at any time thy commandment: yet thou never gavest me a kid, that I might make merry with my friends" (Luke 15:29).

Think of that! Wanting a kid upon which to feast his friends, when a lamb chop would have been more than enough for his friends. He had none: "A man that hath friends must show himself friendly" (Prov. 18:24).

When will we cease giving the elder brother a clean bill of health, while roundly condemning the prodigal son?

Told by LANDRUM LEAVELL

* * *

Python in a Pit

The Calgary Herald published the following frightful story.

A giant python swallowed three men at the bottom of a ninety-foot oil exploration well at Murar Megang, South Sumatra. When the leader of the team, Mr. Luskito, failed to emerge from the well after two hours, a second man, Mr. Rusli, was lowered to investigate. When he failed to return, a third man, Mr. Amin, went down but did not reappear.

A fourth man armed with dynamite was lowered into the well. The snake immediately reared up at him. Realizing that his mates had been swallowed, the man signalled to be pulled up. Then he dropped the dynamite into the well, killing the python!

The three victims were found dead in the snake's stomach!

Long ago, David spoke of the horrible pit from which he was lifted when he cried to God for deliverance: "I waited patiently for the Lord, and he . . . heard my cry. He brought me up also out of an horrible pit, out of the miry clay" (Ps. 40:1-2).

189

SIN

Like Weeds

Sins, like weeds, seem to get started where nothing else is growing.

* * *

What God Did

Sir Oliver Lodge said, "Men of culture no longer bother about their sins."

Thank God that long ago He was bothered about the sins of mankind and did something about it! He sent the Saviour "to be the propitiation for our sins" (I John 4:10b).

* * *

Caught in His Own Trap

A Texas storekeeper got tired of thieves breaking into his store, so he rigged up a 12-gauge shotgun to shoot anybody who entered after hours. One morning he came to work, forgot to disengage the trap, opened the door, and shot himself. As he stumbled to the counter where he died, he gasped, "I have shot myself!"

Sin ends up killing the one who practices sinning: "His own iniquity shall take the wicked himself, and he shall be holden with the cords of his own sins" (Prov. 5:22).

Sin pays wages—death: "For the wages of sin is death; but the gift of God is eternal life through Jesus Christ our Lord" (Rom. 6:23).

At Calvary

* * *

Men and Wolves

A fifteen-year-old boy fell from a bridge rail into the lair of some wolves in the San Diego Zoo. The wolves attacked him. He suffered a twelve-inch slash on the back of his skull and many puncture wounds from their fangs.

The boy's screams attracted two passers-by who vaulted a three-foot wall and jumped down a six-foot enbankment into the wolf enclosure. "The wolves didn't attack us, but every time the boy got to his feet, they rushed him again," said the two men who beat off the wolves and rescued the boy.

It was the nature of the wolves to attack the boy, and it is the nature of unregenerated mankind to lie, kill, steal, and commit adultery. The Bible says that the unchanged heart of man is "deceitful above all things, and desperately wicked" (Jer. 17:9).

The Bible warningly says, "But if ye bite and devour one another, take heed that ye be not consumed one of another" (Gal. 5:15).

* * *

Sin Pays Wages—Death

Said Jacquin Sanders in *Newsweek* Feature Service, "The least heartening comeback story of the year is the return of venereal disease as a major health problem. VD is now the nation's most common communicable disease, except for the common cold. Conservative estimates put the number of Americans who contracted VD in 1969 at more than 1.5 million—up 15 percent. Vast numbers of victims do not report that they have the disease and very often do not know it. San Francisco health authorities estimate that one in every five teenagers will be infected before leaving high school!"

Said Dr. William Brown, chief of the venereal program at the National Communicable Disease Center in Atlanta, "Gonorrhea is now out of control. Under present conditions there seems absolutely no room for optimism."

Failure to reckon with God's immutable laws brings tragic consequences: "Be not deceived . . . he that soweth to his flesh shall of the flesh reap corruption" (Gal. 6:8).

* * *

Vice Is a Monster

Vice is a monster of so frightful mien,
As to be hated needs but to be seen;
Yet seen too oft, familiar with her face,
We first endure, then pity, then embrace.

ALEXANDER POPE

* * *

Potential Cancer Victims

A renowned American scientist recently described to the Associated Press the development of a revolutionary cancer theory and declared it might point the

way for ultimate control of mankind's most fearful malady. His theory is this: A potential viral trigger or "spark" for cancer is inborn in all human beings but is never triggered in most people.

Dr. Robert J. Huebner, internationally know virologist of the National Cancer Institute, explained the theory thus: "The actual seeds for cancer, in the form of genetic ingredients for a certain type of virus, are present in all of us, from the time we're conceived, but most people are kept from malignantly flowering, thanks to other genetic forces. When cancer does occur, it's the result of previously suppressed mechanism being switched on by defective genes present in some people, or by such environmental factors as radiation or certain chemicals. In some people, the concept holds that the very process of aging may provide the switch-on action.

"The theory is supported by tests that revealed potential cancer seed mechanism in mice, chickens, and cats."

The deadly spiritual virus of sin is inborn in every human being: "Behold I was shapen in iniquity; and in sin did my mother conceive me" (Ps. 51:5); "The wicked are estranged from the womb: they go astray as soon as they be born" (Ps. 58:3).

There is an unfailing cure for the virus of sin: "The blood of Jesus Christ his Son cleanseth us from all sin" (I John 1:7).

* * *

Transmissible

Recently a rabid mongrel terrier took refuge in a wooded area in England. The British government decreed the slaughter of all wildlife in the 3,000-acre area, to prevent the rabies from obtaining a foothold among the wildlife of England.

Cledwyn Hughes, Minister of Agriculture, said, "We are dealing with a grim, dangerous, and deadly disease—rabies—and I am determined that it shall not get a foothold in this country."

Rabies, also called hydrophobia, is usually fatal. It attacks the brain and central nervous system and is readily transmitted to man by the bite of an affected animal.

Sin is also a death-bringing malady which is transmitted by its victims to others: "The iniquity of the fathers (is visited) upon the children" (Exod. 20:5); "As by one man sin entered into the world, and death by sin; and so death passed upon all men" (Rom. 5:12).

* * *

One Chromosome Too Many!

Daniel Hugon, a Frenchman, was adjudged guilty of murder. He was given only a seven-year sentence because of an extenuating circumstance: he had one chromosome too many!

During the trial, exhaustive and involved testimony was given by researchers and professors on whether an extra Y chromosome makes men "born killers."

The experts attested that it did not but agreed that its presence precipitated troubles of comportment and honor.

The jurors concluded that a man thus unbalanced from birth should not be severely punished for his crime.

Sin in the "desperately wicked" heart of man is the basic cause of crime: "For from within, out of the heart of men, proceed evil thoughts, adulteries, fornications, murders" (Mark 7:21).

* * *

Epidemic Proportions

Said Commissioner Edward O'Rourke of the Health Department, New York City, "Venereal disease has reached epidemic proportions in New York City."

Said Robert Ingersoll, lawyer and agnostic, "I believe in the law of the harvest: men reap as they sow."

* * *

A Neutral Gray Life

In commenting upon the verse, "Though your sins be as scarlet, they shall be as white as snow" (Isa. 1:18a), William Temple said, "My sins are not scarlet; they are gray!"

Many who are not guilty of the baser sins—fornication, adultery, drunkenness—live a neutral gray life, a life devoid of radiance and exuberance.

Whether our sins are *gray* or *scarlet*,

191

we can triumph over them, being "more than conquerors through him that loved us" (Rom. 8:37).

How abhorrent to God are the *gray* sins, such as, *spiritual pride*: "God, I thank thee, that I am not as other men are" (Luke 18:11); *negative goodness*: "Lo, these many years do I serve thee, neither transgressed I at any time thy commandment" (15:29); and *selfishness*: "I will pull down my barns, and build greater; and there will I bestow all my fruits and my goods" (12:18).

* * *

Distorted

A guide in Trinity College showed Charles H. Spurgeon a bust of Byron. As Spurgeon gazed at it, he exclaimed, "What an angelic face! What nobility it reflects!"

"Step this way," said the guide, and he showed Spurgeon the other side of the bust. Spurgeon was horrified as he looked upon the distorted, dissipated face which so realistically portrayed Byron when living immorally, in reckless disregard for the norms of society.

Within each one of us is inherent potential for both good and evil. Transformed by God's grace, we may reach the highest pinnacle of achievement for God and man. Going into ways of sin, we may descend to the lowest depths of depravity and degeneracy.

Told by RALPH M. SMITH

SMALL THINGS

"I'm for Tiny Things"

Said William James, renowned philosopher and psychologist, "I'm done with big successes. I am for those tiny, invisible, molecular forces that work from individual to individual, creeping through the crannies of the world like soft rootlets and, given time, rending the hardest monuments of men's pride."

* * *

When God Is in It

If you cannot do great things, do small things in a great way.

The Bible asks an ever-pertinent question, "For who hath despised the day of small things?" (Zech. 4:10a).

Ever remember, "When God is in it, little is much!"

* * *

When God Makes

When God makes a lovely thing,
The dearest and completest,
He makes it little, don't you see,
For little things are sweetest:
Little flowers, little birds,
Little diamonds, little pearls,
But the dearest thing in all the earth,
Are His little boys and girls.

AUTHOR UNKNOWN

Only a Bird

Some years ago a transatlantic jet airliner circled over Boston airport, ready to land. The plane didn't make it! While scores of horrified persons watched, the huge plane went out of control and slammed into the ground. More than one hundred people died in that flaming crash!

Detectives examined every bit of wreckage in an effort to reconstruct the tragedy. At last they announced their findings. The crash had been caused by a bird, probably a sea gull. It had been sucked into the jet engine, causing the craft to go out of control.

What havoc small things can work! Beware of so-called little sins: "Take . . . the foxes, the little foxes, that spoil the vines . . . our . . . tender grapes" (Song of Sol. 2:15).

Adapted from *Upward*

* * *

Growing Up

When you're small, you believe in the big. When you're big, you believe in the small.

"That which is highly esteemed among men is abomination in the sight of God" (Luke 16:15).

192

"How Great Is God Almighty"

All things bright and beautiful,
 All creatures great and small,
All things wise and wonderful,
 The Lord God made them all.

Each little flower that opens,
 Each little bird that sings,
He made their glowing colors,
 He made their tiny wings.

The purple-headed mountain,
 The river running by,
The sunset, and the morning
 That brightens up the sky.

The cold wind in the winter,
 The pleasant summer sun,
The ripe fruits in the garden,
 He made them every one.

The tall trees in the greenwood,
 The meadows where we play,
The rushes by the water,
 We gather every day.

He gave us eyes to see them,
 And lips that we might tell
How great is God Almighty,
 Who has made all things well.

CECIL FRANCES ALEXANDER

SORROW—SUFFERING

God's Appointments

Said Henry Ward Beecher, "I look back upon a life whose miscarriages were my gains. My best successes have been seeming disappointments. I would have been damaged, perhaps ruined, had I gained what I vehemently strove for. Sorrows that I shunned and joys that I sought changed places. Pain became pleasure and grief became gladness!"

When God's children have full-orbed knowledge in glory, they will know that life's seeming disappointments were in reality God's appointments: "Then shall I know even as also I am known" (I Cor. 13:12b).

"Thou hast enlarged me when I was in distress" (Ps. 4:1).

* * *

A Blessing in Retrospect

Wallace Johnson, builder of numerous Holiday Inn motels and convalescent hospitals, said, "When I was forty years old, I worked in a sawmill. One morning the boss told me, 'You're fired!' Depressed and discouraged, I felt like the world had caved in on me. It was during the depression, and my wife and I greatly needed the small wages I had been earning.

"When I went home, I told my wife what had happened. She asked, 'What are you going to do now?'

"I replied, 'I'm going to mortgage our little home, and go into the building business.'

"My first venture was the construction of two small buildings. Within five years, I was a multimillionaire!

"Today, if I could locate the man who fired me, I would sincerely thank him for what he did. At the time it happened, I didn't understand why I was fired. Later, I saw that it was God's unerring and wondrous plan to get me into the way of His choosing!"

Told by RALPH M. SMITH

Deep in unfathomable mines,
 Of never-failing skill;
He treasures up His bright designs,
 And works His sovereign will.

WILLIAM COWPER

* * *

Ready to Heal

This hope-bringing message was displayed on a church bulletin board: "God will mend a broken heart if you will give Him the pieces!"

The Saviour came to "heal the brokenhearted" (Luke 4:18).

He is ready to respond to those with fragmented hearts and frustrated lives when they turn penitently to Him: "The Lord is nigh unto them that are of a broken heart; and saveth such as be of a contrite spirit" (Ps. 34:18).

SORROW—SUFFERING

Silent Sharing

The mother of Jane's little playmate died. The next morning Jane told her mother how sorry she was for her little friend.

Mother, too, was grieved. She asked, "Jane, what did you say to your playmate?"

Jane replied, "Mommy, I didn't say anything. I just sat beside her and put my arms around her while we both wept."

Often what we *do* speaks more comfortingly to sorrowing ones than what we say.

Told by O. J. Chastain

* * *

"Grin and Bear It!"

A pastor asked those present in a midweek prayer meeting to stand and quote their favorite Bible verse.

An elderly woman, who had only a little knowledge of the Bible, stood and stoically said, "My favorite verse is, 'Grin and bear it!'"

There is no such Bible verse, but when the "fiery trial" assails God's children, they may submissively "rejoice, and be exceeding glad: for great is (their) reward in heaven" (Matt. 5:12a).

Long ago the psalmist trustfully said, "When my heart is overwhelmed . . . lead me to the rock that is higher than I" (Ps. 61:2b).

Ralph M. Smith

* * *

Beauty Remains

The French artist Renoir was so pain-wracked with rheumatism that every stroke of his brush brought perspiration to his anguished face. Being unable to stand, he sat in a chair.

Despite his suffering, Renoir painted enduring masterpieces of great beauty. One day a friend asked, "Why do you continue to torture yourself?"

Renoir replied, "The pain passes, but the beauty remains!"

A Sine Qua Non

Pathos and heart-appeal were lacking in the singing of a young lady who had studied voice with one of the country's greatest teachers for years. Said he one day to her, "I have taught you all I know. You lack only what I cannot give you."

"What's that?" asked the young lady.

Earnestly the instructor said, "Something will have to come into your life that will bring sorrow and suffering. Only then can you sing with depth of feeling and understanding."

Told by Richard DeHaan

* * *

Good Out of Disaster

Some years ago, in the western cape region of South Africa, the ground heaved and split wide open. Terror gripped the natives. Houses were demolished! Many lives were lost!

Some asked, "Can any good come out of a calamity with such widespread loss?"

Good did come. After the devastating earthquake, springs gushed up overnight. Old boreholes sprang to life and long dried-up river beds became rushing watercourses. Widespread parched areas became verdant with grasses.

God, in goodness and mercy, sometimes allows seeming disaster to befall His children that they may learn the sufficiency of His sustaining grace. Like a potter, he reshapes marred, broken vessels into vessels of beauty and enduring grandeur.

* * *

An Impersonal World

A heart-rending story was reported by the press, telling of a young father who shot himself in a tavern telephone booth. James Lee had called a Chicago newspaper and told a reporter he had sent the paper a manila envelope containing the story of his suicide.

The reporter frantically traced the call, but it was too late! When the police arrived, the young man was slumped in the booth with a bullet through his head.

· In one of his pockets, they found a

194

child's crayon drawing, much faded and worn. On it was written, "Please leave this in my coat pocket. I want to have it buried with me." The drawing was signed in childish print by his little blonde daughter, Shirley, who had perished in a fire just five months before.

Lee had been so grief-stricken that he asked total strangers to attend his daughter's funeral so she would have a nice service. He said there was no family to attend because Shirley's mother had been dead since the child was two years old.

The grieving father could not stand the loneliness or the loss, so he took his life.

Jesus, "the man of sorrows," wants us to come to Him with our heartaches and heartbreaks. He is always "touched with the feeling of our infirmities," and He will help us.

I must tell Jesus all of my trials,
I cannot bear these burdens alone,
In my distress He kindly will help me,
He ever loves and cares for His own.

E. A. HOFFMAN

"Casting all your care upon him; for he careth for you" (I Pet. 5:7).

Told by CHARLES R. HEMBREE

* * *

Mental Illness Leads

The National Institute of Mental Health recently reported that more hospital beds are filled for reasons of mental illness than all other illnesses combined. One out of 12 persons will be institutionalized sometime during his life because of mental ill health.

* * *

"Whom the Lord Loveth"

One day a minister visited a friend who was passing through the deep, dark waters of sorrow and suffering. He found the friend in his garden, clearing the grape vines of superfluous leaves and undergrowth.

"What are you doing?" the minister asked.

The friend replied, "Because of abundant rains of late, the vines are overgrown with branches and leaves. That prevents the sun from reaching and ripening the grapes and bringing them to luscious maturity. I am pruning part of them away."

Thoughtfully the minister replied, "Even so does our loving heavenly Father prune off superfluous foliage from His children. Sometimes He takes away temporal blessings and earthly comforts that they may bring forth the life-enriching fruit of the Spirit: 'love, joy, peace, longsuffering, gentleness, goodness, faith, meekness, temperance' (Gal. 5:22, 23). He does this in love — never hastily or capriciously: 'He doth not afflict willingly' (Lam. 3:33); 'Whom the lord loveth he chasteneth' (Heb. 12:6)."

* * *

The Deadly Sleep of Indifference

Two mountain climbers almost perished on the Cairngorm Hills in Scotland. With bleeding fingers they dug themselves out of a frigid hut in which they had been sheltered, and staggered silently through breast-deep snow. They advanced two miles in three hours.

Then one said hoarsely and thickly, "I'm sleepy! I'm done! I can go no further!"

His companion said, "If you do, you'll sleep the sleep of death!"

In spite of the warning, the man buckled and slumped in the snow.

Reasoned his companion, "There is only one thing I can do." Then he did it. He struck him on the face with his iron-shod boot. The blow produced the desired effect. It roused the freezing man, so near to death's door. The two staggered on and finally reached the warmth of the nearest cottage.

Sometimes God in mercy has to deal drastically with His children to rouse them from the deadly sleep of neglect and indifference, but He does this only in love because He desires His best for them: "For whom the Lord loveth he chasteneth" (Heb. 12:6a).

195

Made for Conflict

In a letter to a friend, Robert Louis Stevenson wrote, "For fourteen years I have not had a day of real health. I have wakened sick and gone to bed weary. I have done my work unflinchingly. I have written in bed and out of bed, when torn by coughing and when my head swam for weariness. The battle goes on. Ill or well is a trifle, so long as it goes on. I was made for conflict. The powers that be have willed my battlefield shall be this dingy, inglorious one of the bed and the medicine bottle!"

How blessed are those who, without murmur, accept whatever God in His all-knowing wisdom permits and submissively say, "Christ shall be magnified in my body, whether it be by life, or by death" (Phil. 1:20b).

* * *

Broken Pieces

God will mend your broken life if you will give Him the pieces: "And the vessel that he made was marred in the hand of the potter . . . so he made again another vessel, as seemed good to the potter to make it" (Jer. 18:4).

* * *

Resplendent Heights

We can't appreciate, in full,
The mountain tops—unless
God lifts us to such altitudes
From valleys of distress.

We can't appreciate, in full,
His cool, refreshing breeze,
Unless we've sweltered through the heat
Of bleak adversities.

We can't appreciate, in full,
His dawn of rosy hue,
Unless we've felt the darkest hour
Before the sun breaks through.

We can't appreciate, in full,
His warm, embracing rays
Unless they've followed frigid blasts
Of bleak and wintry days.

We can't appreciate, in full,
The rainbows He's provided,
Unless we've battled through a flood
Before the waves subsided.

We can't appreciate, in full,
His wondrous healing mission,
Unless affliction's made us need
The healing-balm Physician.

We can't appreciate, in full,
His mighty sacrifice,
Unless we've shared His sufferings
En route to Paradise.

We can't appreciate, in full,
His love which none can sever!
Until we're safe within His arms
To share His bliss—forever!

FLORRIE ESTELLE HUDSON
a blind poet

* * *

"Out of the Depths . . . I Cried"

Years ago a young Baptist minister and one of his close friends were out hunting. As the minister crawled under a barbed wire fence, his gun accidentally went off. The discharge struck the leg of the friend who bled to death before he got to a hospital.

The young minister was so overwhelmed with sorrow that his church gave him a leave of absence. Seeking to allay his grief, he visited his mother in North Carolina but to no avail.

Finally returning home, he said to his wife, "I am going into my room to pray, and I will stay there until I find relief. I will not be available to callers. Don't let anyone come in."

For three days the young minister confined himself. When he finally emerged, the sorrow which had overwhelmed him was gone! His face shone with radiance! He had met personally with Christ, the One who gives "beauty for ashes, the oil of joy for mourning, the garment of praise for the spirit of heaviness" (Isa. 61:3b).

This experiential meeting with Christ was an epochal event in the life of Dr. George W. Truett, who was the young minister. On the following Sunday, he stood in his pulpit, in the First Baptist Church, Dallas, Texas, a new man—changed by an in-depth acquaintance with Christ.

Told by RALPH M. SMITH

SOUL-WINNING

One Thing Lacking

Dr. George Sweeting, president of the Moody Bible Institute, recalled, "A woman once said to me, 'I have been a Christian for twenty years. I am not aware, however, of having led anyone to the Lord. I have memorized Scripture verses and know how to meet the objections of the unconverted. But I have brought no one to a decision for Christ. Why hasn't God been using me?'

"Wanting to help the distressed woman, I said, 'Have you ever wept over unsaved ones, and yearningly prayed for them? You have not failed for lack of knowledge but for lack of love. When one has genuine love for people, she will weep over them and yearn for their conversion.'

"Going to her room, she began to pray earnestly for her unsaved sister. Then she went to her. She enfolded her in her arms and weepingly said, 'More than anything in this world, I want you to become a Christian!'

"That night in church the sister responded to the plea of God's servant to publicly confess Christ and ask for His mercy and forgiveness."

O that more of us were weeping with Christ over lost souls!

* * *

Try Tears

A discouraged Salvationist said to William Booth, founder of the Salvation Army, "My work is at a standstill. Souls are not being saved. I have tried everything I know to try. Nothing seems to work."

Booth said, "Try tears!"

Too few Christians can say with Paul, "I have great heaviness and continual sorrow in my heart . . . for my brethren" (Rom. 9:2-3).

* * *

Solicitious Concern

A critically ill girl was visited by her pastor. She said, "Soon I will go to heaven to be forever with Jesus."

Then a look of sadness pervaded her face, as she added, "My dad doesn't know Jesus as His Saviour. At my funeral, I want you to talk right to his heart and do your best to make him know that we will be separated forever if he doesn't ask Jesus to come into his life and change it!"

O that more Christians were solicitously and sleeplessly concerned for perishing ones and were agonizing in prayer for their salvation!

Long ago Paul said, "I say the truth in Christ . . . that I have great heaviness and continual sorrow in my heart. For I could wish myself were accursed from Christ for my brethren, my kinsmen according to the flesh" (Rom. 9:1-3).

Told by RALPH M. SMITH

* * *

No Warning

"Holiday joy turned to tragedy Christmas Day for families faced with the grim task of identifying the bodies of twenty relatives killed in an airliner crash that injured twenty-seven others," reported an AP dispatch.

A survivor of the tragedy said, "We had no warning of the impending danger. It seemed as if we were headed for the runway in a normal way. Then it happened!"

Each Christian is under obligation to lovingly warn and plead with unsaved ones to "flee from the wrath to come" (Matt. 3:7) lest they go out into a lost hereafter. Great will be our accountability to God if we fail to do this: "When I say unto the wicked, Thou shalt surely die; and thou givest him not warning . . . to save his life; the same wicked man shall die in his iniquity; but his blood will I require at thine hand" (Ezek. 3:18).

* * *

Within a Yard of Hell

C. T. Studd, pioneer missionary, said, "Some people want to live within the sound of the church bell. I want to run a rescue mission within a yard of hell!"

197

SOUL-WINNING

"We've Won!"

A husband and wife, who were football enthusiasts, sat watching a professional football game on TV. As they looked, they sipped cokes and munched on cookies, peanuts, and fruitcake.

Suddenly their favorite team intercepted the ball and scored a touchdown which won the game.

The wife leaped to her feet and screamed piercingly, "We've won! We've won! We've won!" Then she grabbed a copper cowbell from the side table and shook it vigorously as she shouted, "We've won!"

The husband sat silent. After the din subsided, he blurted: *"We* haven't done anything but add another two pounds to our human blubber and lengthen our waistline!"

It is good to be enthusiastic about things that are character building. The Bible says, "But it is good to be zealously affected always in a good thing" (Gal. 4:18a).

More of God's children should be as zealously concerned about winning souls for Christ as they are about winning a football game and should weep with Christ over sin-shackled souls: "And when he was come near, he beheld the city, and wept over it" (Luke 19:41).

* * *

Evangelize or Fossilize

Proselytism is not evangelism. It is an arrogant and often unscrupulous attempt to win converts to one's own particular brand of religion. If members of one church set out to recruit members from other churches by offering all kinds of inducements on the assumption that only in their church can anyone be saved, that is proselytism. Jesus roundly condemned this: "Woe unto you, scribes and Pharisees, hypocrites! for ye compass sea and land to make one proselyte, and when he is made, ye make him twofold more the child of hell than yourselves" (Matt. 23:15).

When a European beckoned Paul in a vision and said, "Come over into Macedonia, and help us" (Acts 16:9), it never occurred to Paul to say, "Why should I? They have their own religion."

To the early Christians to evangelize was part of what it meant to be a Christian. They had an irresistible urge to make Christ known and bring others to Him. Why should they bottle up what meant to them more than anything else? When the authorities in Jerusalem commanded the early disciples not to speak or teach in the name of Jesus, their reply was, "We cannot but speak the things which we have seen and heard" (Acts 4:20).

"Ye that make mention of the Lord, keep not silence" (Isa. 62:6b).

Adapted from DAVID H. C. REED
in *Christianity Today*

* * *

No Place Out of Bounds

In *Listen to the World,* Gordon Winch said, "In the future, less and less evangelism will be done at the church building. It will be rather a crusade in which to participate. No place is out of bounds for him who is mastered by the living Christ.

"A half-drunk woman had repeatedly observed a minister come and sit among the drinkers. She finally said to him, 'I know why you are here. You are here to represent Jesus!' "

To reach the unreached, unchurched, and unsaved multitudes, Christians must emulate the example of the Saviour, who mixed with the multitudes and ate with publicans and sinners but never partook of their sins.

* * *

"Good Heavens! He's Lost!"

In a meeting in which many of England's nobility were present, George Whitefield vividly depicted the sinner as a blind beggar, holding a staff, and being led by a dog on a leash.

He told how the blind beggar groped unguided until he came to the edge of a high cliff. He accidentally dropped his staff and leaned over to reach for it!

A listener in the audience, who could

stand the suspense no longer, cried, "Good heavens! He's lost! Whitefield, save him!"

Unsaved lost ones are teetering on the edge of eternity, with only a heartbeat between them and death.

Have we become so cold and callous that we do not "weep o'er the erring ones" and try to rescue them from the dark, downward way of sin and despair?

Soon will the season of rescue be o'er,
Soon will they drift to eternity's
* shore;*
Haste then, my brother, no time for
* delay,*
But throw out the Life-Line and save
* them today!*

 EDWARD S. UFFORD

* * *

When the Saints Go Marching Out

I sometimes think the church resembles nothing more than a holy huddle. Those who are on the field seem to spend most of their time in the huddle. Some seem to have forgotten the plays and the aim of the game. Some like the coziness and safety of the huddle. Did you ever hear of anybody getting hurt in a huddle? Some have been knocked down so often that the spirit seems to have been knocked out of them. So we spend most of our time planning strategy, analyzing the enemy, and sometimes criticizing our own team members.

Christians might well adopt a new theme song: "When the Saints Go Marching Out."

 LEIGHTON FORD

* * *

No Substitute for Tears

Spurgeon said, "If there were no sowing in tears, there would be no reaping in joy!"

The Bible says, "He that goeth forth and weepeth, bearing precious seed, shall doubtless come again with rejoicing, bringing his sheaves with him" (Ps. 126:6).

"Then Go to Hell!"

During an invitation to unsaved ones to confess Christ, a retarded boy who dearly loved his Lord approached a self-righteous Christ-rejector and asked, "Do you want to go to heaven?"

Angrily the man replied, "No!'

The abashed boy blurted out, "Then go to hell!"

The inept words of the retarded boy awakened the slumbering soul of the unsaved man. He began to think, "I do not want to go out into a lost hereafter." Weeping, he went forward, sought and found the Saviour.

 Told by LEN G. BROUGHTON

* * *

Where the Fish Are

Authentic fishers of men do not fish in a nice stained-glass aquarium to which have been invited prospective fish to be caught by the big fisherman properly attired, but rather they fish where the fish are—in the fast-flowing streams and muddy pools of life.

 ROBERT ROXBURGH

* * *

Try Tears

In the 1966 Berlin Conference on Evangelism, Evangelist Fernando Vangioni related this story:

"At the close of a meeting in a Spanish church in New York City, inquirers were shunted to a back room for instruction. A young woman in the group demurred, feeling trapped by the procedure. She said to me, 'You can't do anything for me. I am no good. I don't want to hear any more preaching.'

"I countered, 'Let me just pray for you. Then you may go if you wish.'

"As I prayed, my heart so melted in tenderness for the discouraged, disillusioned girl that my voice broke and tears ran down my face.

"As I dried the tears from my eyes, I said, 'I've prayed. You may go now.'

"The young woman, deeply moved, said, 'I will stay. You have wept for me! Now you may talk to me!' "

199

SOUL-WINNING

How to Clean Up Corruption

Shortly after a young pastor began his ministry in a small city, one of the members of the church said to him, "Pastor, I have been designated by the official board of our church to talk to you about the corruption in our city. Our mayor is a corrupt, conniving politician. The chief of police is in league with the underworld. Many of us doubt the integrity of our councilmen. We want you to preach against the corruption of our city."

The pastor replied, "Give me a little time to think about what I ought to do, and I'll take the appropriate steps."

Weeks passed and the young pastor spoke no condemning words concerning the alleged corruption of the city officials. In time, he made an appointment to meet with the mayor.

The mayor received him graciously. Then the pastor said, "Mr. Mayor, I want to take just a few minutes of your valuable time. I congratulate you upon the confidence the people of our city have reposed in you by electing you to your position of responsibility. I also want to tell you that there is a much higher honor awaiting you if you will become a servant of Jesus Christ, the Saviour."

The pastor left and a week passed. Then one day his phone rang. The mayor said, "Sir, I must see you. It is important. I want to talk to you about becoming a Christian!"

Within two weeks after the pastor's visit with the mayor, a wondrous thing occurred in his church: the mayor, the chief of police, the chief of the fire department, and five councilmen walked down the aisle and confessed their faith in Jesus Christ! Inwardly transformed men began zealously to clean up the city, all because a young pastor personally presented Christ to a corrupt official.

RALPH M. SMITH

Only One Suit

A newspaper account of the death of a socially prominent woman in France stated that she was "the best dressed woman in Europe." Her wardrobe contained one thousand dresses. What could be more frustrating than to have to decide each day and evening which one of a thousand dresses should be worn!

When William Booth died, he had only one suit and a red cap. But he had to his credit thousands of transformed lives, and he had won the enduring soul-winner's "crown of rejoicing" (cf. I Thess. 2:19).

Told by RALPH M. SMITH

* * *

Burdened Hearts

In replying to the question, "What is needed to help the individual church member become effective as a soul-winner?" Dr. Lee Roberson, pastor of the Highland Park Baptist Church, Chattanooga, Tennessee, replied, "Leadership. I would like to say that Christians need training, but this is not true. Some Christians are well trained, but still they do nothing. The best soul-winners in most churches are untrained and uneducated, yet they have burdened, burning hearts. Therefore, I would have to say that evangelism in the local church must begin with the pastor. The pastor must be used of God to inspire others to win souls."

* * *

Until . . .

Said Dr. Roland Q. Levell, "Evangelism is incomplete until the evangelized becomes an evangelist."

To each one of God's children comes the command, "Go . . . and tell . . . how great things the Lord hath done for thee, and hath had compassion on thee" (Mark 5:19).

TEMPTATION

Deadly Unconcern

In Jakarta, Indonesia, as a ten-year-old boy lay asleep in a rice field, he was swallowed alive by a thirty-foot snake. The reptile was unable to move because the boy's legs protruded from its mouth. After the snake was killed, the boy was pulled out—too late! He was dead!

Many today are sleeping the sleep of deadly neglect and unconcern while the enemy of souls, Satan, works disastrously: "Be sober, be vigilant!" (I Pet. 5:8).

* * *

Don't Argue But Quote

In your encounters with Satan, the enemy of souls, don't argue but quote. That's what Jesus did: "It is written, That man shall not live by bread alone, but by every word of God" (Luke 4:4).

"The sword of the Spirit, which is the word of God" is the believer's defensive weapon.

* * *

Guards Down

No one expected that Fire Base Mary Ann in Vietnam would be hit by the enemy. This was especially true of the men of the 1st Batallion, 46th Infantry, who manned it. Yet the base *was* hit and more than forty GI's perished!

In speaking of the tragic incident, an officer commented, "There were so many holes in the perimeter wire around the base that the GI's seldom bothered to use the gates. They walked right through the wire to go to the water hole. Many of the claymore mines did not work because their electric wires were corroded. Their guards against the enemy were down."

Many of God's children go down in defeat because of failure to keep their guards up. They live in ease and indifference, while the enemy Satan never takes a vacation. He is ever alert and aggressive. Warningly the Bible says, "Be sober, be vigilant; because your adversary the devil, as a roaring lion, walketh about seeking whom he may devour" (I Pet. 5:8). He is never more subtle than when he approaches as "an angel of light" (II Cor. 11:14b), shod in velvet slippers.

* * *

"It Might Have Been Me"

Years ago Dr. John Kelman was a prominent, trustworthy citizen of Edinburgh. He was tempted, fell disgracefully low in sin, and was imprisoned. The whole city was aghast at the scandal!

As Dr. Alexander Whyte came into the vestry of St. Georges West on the next Sunday morning, the church bells were ringing. He said to one who sat near him, "Do you hear those bells? Our imprisoned brother in his prison cell hears them too! *Man, it might have been me!*"

Warningly the Bible says, "Wherefore let him that thinketh he standeth take heed lest he fall" (I Cor. 10:12).

* * *

Parental Prayer

A young man serving in one of the world's trouble spots was asked, "How is it possible for you to stick it out in such a situation? Aren't the temptations terrific?"

"Yes," he replied, "the temptations are tremendous. But I can still hear the prayers of my father and mother as I left home. They pleaded that God would keep me from wrong and help me to be faithful to Him. I know they are continuing to pray fervently for me as I serve here."

Told by JOHN M. DRESCHER

* * *

The Great Narcotic

Said the famed psychiatrist Dr. Smiley Blanton, "Rationalizing is the great narcotic that people use to anesthetize their consciences to justify yielding to temptation. An embezzler tells himself he is just 'borrowing' the money and will surely put it back. An unfaithful husband assures himself that what his wife does not know will not hurt her. In a thousand daily temptations from padding the expense account to exceeding a speed limit, the rationalizer's attitude is 'Everybody is doing it. Why shouldn't I?'"

201

TESTIMONY

A Way to Escape

A little boy straddled a fence beneath an apple tree, looking up longingly.

A farmer, seeing him, came running and said, "Trying to steal my apples, are you?"

Trembling with fright, the boy said, "No sir! I'm trying *not* to."

"God is faithful, who will . . . make a way to escape, that ye may be able to bear it" (I Cor. 10:13b).

ALICE M. KNIGHT

* * *

Going Steady

Said Lloyd Shearer, in *Parade*, "It is impossible to encourage teen-agers to go steady in today's dating environment— automobiles, drive-ins, beach parties—and not to encourage sexual involvement simultaneously. Total abstinence is simply not operational under those circumstances. Going steady breeds sexual experimentation. To encourage one is to encourage the other. Mothers who 'trust' their daughters and are so convinced that 'My daughter wouldn't think of anything like that,' are in many cases denying the ways of nature and deluding themselves."

* * *

Devil at Keyhole

Said Billy Sunday, "Temptation is the devil looking through the keyhole. Yielding is opening the door and inviting him in."

TESTIMONY

Football Stars Ascribe Glory to the Lord

Out of the crucible of defeat and disappointment often emerge character-moulding, life-changing resolves. We see in clarity the ephemeral, short-lived nature of earthly glories.

The undefeated Arkansas Razorbacks ran proudly onto the gridiron to begin the nationwide televised championship game of 1970 in Fayetteville, Arkansas. There the Razorbacks confronted the undefeated Texas Longhorns and lost the coveted championship title.

How thrilling are the testimonies given later by four men on the defeated team!

Testified linebacker Cliff Powell: I stand before you on a side I'm fortunate enough not to be a part of very often— the loser's side. But this is only in the game of football. In life, which is for bigger marbles, I'm always on the winning side, coached and inspired by the Lord. Yet I can look back when I was a loser in life, too. I thought I was a Christian, but it was only because I followed my own rules in life that I felt classified as a Christian.

My life was centered around being "in" with the gang and football. I felt that, if I was a success in football and gained praise for it that, I'd be on top of the world. Last year I was fortunate to make all-Southwest Conference. I praise the Lord for this, not for my glory but because through it I learned that such prominence does not automatically bring a person lasting happiness. Philippians 3:7-8 really hit me here: "But what things were gain to me, those I counted loss for Christ. . . . I count all things but loss for the excellency of the knowledge of Christ Jesus my Lord . . . and do count them but dung, that I may win Christ." I realized I had to turn my life completely over to the Lord, not just part-time as I had tried. God just doesn't "do His thing" in our lives on a part-time basis.

Since inviting Christ into my life last year, I've experienced meaning through knowing Him personally. Even though I have never been really unhappy, I feel now as if I existed for twenty years and have lived one year! I wouldn't trade this past year for any of those other twenty years!

Testified quarterback Bill Montgomery: All my life I had gone to church and claimed Christ, but that was the extent of my religious experience. As I grew older, with little experience of God, He began to fade from my mind. I wanted to beat Texas in the worst way, but that's not the

biggest thing that has happened to me this year.

As the Razorbacks got off to an undefeated season in 1969, I should have been the happiest person on the team; but something was missing, and for some reason I wasn't happy. Then over a time span of a few weeks I began to really think about the things I had heard all my life but never paid much attention to. I was driven to think about God's love and the many promises Jesus made for finding a more abundant life. After talking to my pastor and some of my Christian brothers in our weekly Bible study, I realized that the missing link in my life was the Saviour, Jesus Christ.

It sounds unbelievable to say that my whole life has changed course, but it has! I am still too much of the sinner I used to be, but for the first time in my life Jesus Christ is by my side lending me a helping hand and showing me the way to a richer, happier life!

Testified tailback Bill Burnett: I got a lot out of Sunday school when I was small; but as I grew older, I sort of "put God in His place," and His place was in church for one hour on Sunday morning. I became interested in many things other than God and Jesus Christ, and I only looked to them when I needed help.

When I came to college, I was like most freshmen—looking for a wild time. I studied and made good grades, and I really never got as wild as I planned because I didn't seem to find the fun I'd expected. I didn't get into trouble or anything like that, but Jesus Christ was definitely not directing my life. I wandered around for about two and a half years with no real purpose in life. I really wasn't happy. I finally realized that I needed something more than I or any other person could provide, but I didn't realize at first exactly what it was.

I became interested in the Bible study groups we were having in the dorm with team chaplain J. D. McCarty. After just one session, I knew it was Jesus Christ that I needed, and I asked Him to direct my life because it was plain to see I wasn't doing too well by myself. I've got a long way to go, but at least now I'm an infant in the spiritual world instead of never having been born again!

You see, the game of life is the most important game of all, the "big game" to win. If I had won the game with Texas, then we would have been SWC and national champions. This was a very important goal for our team, but it is only temporary while the game of life is *eternal.*

Testified defense end Gordon McNulty: You can imagine how low we were at the end of the Texas game. I was in the dressing room feeling sorry for myself and shedding a few tears when a teammate brought me to my senses by saying, "Remember, 'not my will, but thy will be done!' " This helped me to remember that I still had the most important thing in my life—Jesus Christ!

It wasn't so very long ago that losing a ball game of this importance would have sent me plunging to the depths of depression, and I wouldn't have been able to get my head up for weeks. You see, I had made football and success in it my god. I thought that, if there was a God, He was too big and too busy to be interested in me; and therefore I was indifferent to Him. I didn't dream I could know Him in a personal way. This gave my life a shaky foundation. I was up-and-down, mostly down.

Then through a teammate and my local church, I realized that what I was experiencing was my separation from God. I needed Jesus Christ. I asked Him to be my Lord and Saviour. This hasn't made any sinless, dull do-gooder out of me. I simply have a peace and strength I never experienced before. I know I have a Friend who will guide me in my daily life and reach down and help me up when I stumble.

Not long ago the craze seemed to be that "God is dead" for some people. I just talked to my God this morning. I thanked Him for this great life He has given me through His Son Jesus Christ!

TESTIMONY

Modern Man and the Supernatural

Dr. John McIntyre, a physicist, said, "A myth abroad in our time goes something like this: Back in the past, before man understood the world around him, he explained the unknown in terms of supernatural events. But now, *modern man* has outgrown the need for the supernatural. As science has more and more explained the physical world in natural terms, the need for the supernatural has disappeared.

"Until a few years ago my feelings about Christianity were vaguely in accord with the myth. But then I had opportunity to study the Bible in a serious way. I found to my astonishment that a scientific training was not a hindrance but rather an asset to understanding the Bible and believing what it said. Such a study of the Bible led me to realize that the message of the Bible deals with man's rebelling against God and God's method of reconciliation with man effectuated by Christ's atoning death on the cross. It was this feature of the Christian gospel, coupled with the knowledge of my wickedness in God's sight and my need for a Redeemer, that convinced me of the truth of the Christian message: only through Jesus Christ are men reconciled to God.

"I strongly urge you, therefore, to weigh the claims of Jesus Christ. This can be done, for example, by reading the gospel of John, which was written that 'you may believe that Jesus is the Christ, the Son of God, and that believing you may have life through his name' (John 20:31)."

Adapted from *His*

* * *

"I Believe in God"

Dr. Ralph T. Overman, director of the Bi-State Regional Medical Program, St. Louis, testified, "I believe in God. I believe He is a personal being with attributes that make Him as real and experienceable as any human being with whom I have come in contact. It is this faith in Him that gives ultimate meaning to my life. I must also demonstrate that the dynamic of my drive comes from the only real source of values and meaning—my relationship with God through Jesus Christ."

* * *

Jerome Hines Testified:

"Until I was thirty, I had no direct experience that would convince me God was a personal being. I thought of God as a vague cosmic force, incapable of doing miracles and definitely not interested in doing anything for individuals. Later, I discovered to my complete satisfaction as a scientifically trained person, that there is a real God. In fact, I am bold to say that I know Him *personally!* I want to tell everybody that Jesus Christ is not just a great Teacher, that Christianity is not merely a philosophy to live by, nor a religion to choose. Christianity is receiving into one's heart and life the Lord Jesus Christ, who died for our sins. My whole philosophy of life has changed. All I have is no longer mine. It belongs to Jesus Christ!

"Something wonderful has happened to me! It is so marvellous, such a thrilling experience, *it's too good to keep to myself!* Everyone can have this exciting privilege of knowing Christ. You'll never be the same again. It's not only for time; it's for eternity!"

* * *

"My Whole Life Was a Lie"

John B. Dobson, M.D., gave this hope-kindling, personal testimony:

"Apparently, I had everything—an excellent education, a medical degree, and certification in pediatrics. After fifteen years of successful practice in St. Catherine, Ontario, I had a $100,000 home. I had a beautiful wife and children. I was head of the pediatric department in one hospital and assistant head in another. But I was miserable. Life was a farce, a rat race, an endless chain of unconnected happenings. I tried to counter the feeling of hopelessness and despondency with alcohol and drugs. Getting them and using them was all too easy for me. I saw what a fraud I was and reflected that my whole life was a lie.

"In the spring of 1969, my wife and I took a trip to the island of Barbados. One Sunday morning, we saw little black children going to church. Out of curiosity, we decided to join in their worship. I had never been in such a poor, run-down church. I don't remember the pastor's sermon, but he spoke as if he knew Jesus Christ. There was joy in the faces of the worshipers. I began to realize that it was the spirit of Christ that made them different.

"That evening, for the first time in my adult life, I knelt and prayed. I prayed that God, if there was one, would give me what these people had that money could not buy. I asked God for the missing ingredient in my life. I realized that my unbelief and disobedience made me a sinner. I asked God for forgiveness and received Jesus as my Saviour. I was set free! My whole life was changed! Since trusting Jesus, I feel alive for the first time. Christ has given me new wisdom to meet life's problems and decisions. He has given me new strength, freedom from alcohol and drugs. For the first time, I feel clean and free, full of hope and optimism!"

Adapted from *The Christian Reader*

THOUGHT

A Molding Factor

Said Ralph Waldo Emerson, "A man is what he thinks about all the day long."
Said Marcus Aurelius, "A man's life is what his thoughts make it."
Said Norman Vincent Peale, "Change your thoughts and you change your world: 'For as he thinketh in his heart, so is he' (Prov. 23:7a)."

* * *

Forced By Science

Lord Kelvin, an English physicist, said, "If you think strongly enough, you will be forced by science to believe in God."
Only a fool says, "There is no God" (Ps. 14:1a).

* * *

If I Knew You

If I knew you and you knew me,
If both of us could clearly see,
And with an inner sight divine,
The meaning of your heart and mine,
I'm sure that we would differ less,
And clasp our hands in friendliness,
Our thoughts would pleasantly agree,
If I knew you and you knew me.

AUTHOR UNKNOWN

Two Classes

Failures are divided into two classes: those who thought and never did, and those who did and never thought."

* * *

When TV Is Broken

Said a housewife to a friend, "I got to thinking yesterday. You know how it is when the TV is broken!"
Said an Old Testament prodigal, "I thought on my ways, and turned my feet unto thy testimonies" (Ps. 119:59).

* * *

No Action

Every time a man puts a new idea across, he faces a dozen men who thought of it before he did, but they only thought of it.

* * *

Hell Shamed

Said Robert Louis Stevenson, "We all have thoughts and desires that shame hell!"

* * *

Reflect

Said Charles Dickens, "Reflect upon your present blessings, of which every man has many; not on your past misfortunes, of which all men have some."

205

"Here Lies the Mind of John Doe"

On a tombstone shown in an advertisement were the following thought-arresting words: "Here lies the mind of John Doe who at thirty stopped thinking. Some people die at thirty but aren't buried until they're seventy. You have got to think.

Wake up to the fact that learning is a joyous, lifelong affair."

How enriched are our lives when we obey the Scriptural directive: "Whatsoever things are true . . . honest . . . just . . . pure . . . lovely . . . of good report . . . think on these things" (Phil. 4:8).

TIME

The Thing that Pleaseth Thee

Dear Master, for this new year,
 Just one request I bring:
I do not pray for happiness,
 Or any earthly thing.

I do not ask to understand
 The way Thou leadest me,
But this I ask, teach me to do,
 The thing that pleaseth Thee.

I want to hear Thy guiding voice,
 To walk with Thee each day,
Dear Master, make me swift to hear
 And ready to obey.

And thus the year I now begin,
 A happy year will be,
If I am seeking just to do
 The thing that pleaseth Thee.

 FRANCES RIDLEY HAVERGAL

* * *

No Need to Hurry

Said Warren Wiersbe, in *Moody Monthly*, "Perhaps the greatest enemy a man faces is the idea that he has plenty of time—no need to hurry to see the doctor. When he finally makes that visit, he discovers that the situation is critical, perhaps fatal! He has waited too long.

"One of America's wealthiest men died without a will. He had planned to call his attorney after the Christmas holidays, but He met his Maker first."

Warningly the Bible says, "Boast not thyself of tomorrow; for thou knowest not what a day may bring forth" (Prov. 27:1).

"What Is Your Life?"

In defining life, Shakespeare said, "Life is a walking shadow, a poor player that struts and frets his hour upon the stage, and then is heard no more." He also defined life as "a tale told by an idiot, full of sound and fury and signifying nothing!"

James said of life, "It is even a vapor, that appeareth for a little time, and then vanisheth away" (Jas. 4:14b).

Ernest Hemingway said, "Life is just a dirty trick, a short journey from nothingness to nothingness. There is no remedy for anything in life. Man's destiny in the universe is like a colony of ants on a burning log!"

On his thirty-third birthday, Lord Byron forlornly said:

"On life's road so grim and dirty,
I have dragged to three and thirty;
What have these years brought to me?
Nothing but thirty-three."

How challenging is life for a dedicated Christian. Radiantly the Christian exclaims: "For to me to live is Christ" (Phil. 1:21).

Life is fragile! Handle it with prayer!

"So teach us to number our days, that we may apply our hearts unto wisdom" (Ps. 90:12).

* * *

Traveling Time Gone

On the door of a grandfather clock in Chester Cathedral in England occur these words: "When as a child I laughed and

wept, time crept. When as a youth I dreamed and talked, time walked. When I became a full-grown man, time ran. And later, as I older grew, time flew. Soon I shall find while traveling, time gone. Will Christ have saved my soul by then?"

How wise we are to obey the Bible's directive: "Remember now thy Creator in the days of thy youth, while the evil days come not, nor the years draw nigh, when thou shalt say, I have no pleasure in them" (Ecc. 12:1).

* * *

Only a Minute

I have only just a minute—
Only sixty seconds in it,
Have to take it, can't refuse it,
But it's up to me to use it.
I must suffer if I lose it,
Give account if I abuse it,
Just a tiny little minute,
But eternity is in it.

AUTHOR UNKNOWN

* * *

Patience

A Japanese proverb says, "With time and patience, the mulberry leaf becomes silk."

God is never in a hurry: "For a thousand years in thy sight are but as yesterday when it is past, and as a watch in the night" (Ps. 90:4).

Spiritual renewal comes to us when we wait patiently before the Lord: "But they that wait upon the Lord shall renew their strength" (Isa. 40:31a).

* * *

Time Is Running Out

After his flight to the moon in February, 1971, Astronaut Edgar D. Mitchell thoughtfully said, "It is so incredibly impressive when you look back at our planet from out there in space and you realize so forcibly that it's a closed system—that we don't have any unlimited resources; that there's only so much air and so much water. You know how important it is that we start learning to use our resources properly, as we've been prone to avoid doing.

"I was plenty busy during the Apollo 14 mission, but I tried to reflect on the earth and its future. I gained a sense of urgency, a feeling that time was running out for us. We must find new energy sources that won't pollute, like nuclear power now."

Students of God's Word believe that the time for our sin-sodden, morally corrupt world to repent is running out: "My Spirit shall not always strive with man" (Gen. 6:3a); "He will not . . . keep his anger for ever" (Ps. 103:9). Repent or perish!

How great are God's patience and longsuffering "to us-ward, not willing that any should perish, but that all should come to repentance" (II Pet. 3:9b).

* * *

Tomb and Womb

Yesterday is in the tomb. Tomorrow is in the womb!

The future goes forward on the feet of little children. It is ours to nurture and train the little ones in the right way and go that way ourselves.

* * *

The Present Is Yours

Said Grenville Kleiser, "There are many fine things which you mean to do someday, under what you think will be more favorable circumstances. But the only time that is surely yours is the present. Hence, this is the time to speak the word of appreciation and sympathy, to do the generous deed, to forgive the fault of a thoughtless friend, to sacrifice self a little more for others. . . . Today you can make your life significant and worthwhile. The present is yours, yours to do with as you will."

"Go to now, ye that say, Today or to morrow . . . ye know not what shall be on the morrow" (Jas. 4:13, 14).

* * *

An Enterprising Undertaker

An enterprising mortician in Atlanta, Georgia, planned to have windows built as an extension of his funeral home, each to

show a body in its casket. The display would face a driveway at the side of the funeral home for the convenience of those wishing to take a hurried, farewell look upon a decedent with minimal trouble and expenditure of time.

Said the mortician, "So many people want to come by and see the remains of a relative or friend, but they just don't have the time. This way, they can drive by and just keep on going. The deceased will be lying in a lighted window, sort of tilted to the front. Another thing, the people won't have to dress up to view the remains."

Ours is a hurry, worry, bury age. We are getting nowhere fast. The words of the mortician, "They just don't have the time" aptly describe the multitudes who are so engrossed with the perishing things of this world that they take no time to ponder the question, "Where will I spend the endless hereafter?" and do not prepare for life to come.

TITHING

Full Treasure Rooms

To His children God says, "My child, I still have windows in heaven. They are yet in service. The bolts slide as easily as of old. The hinges have not grown rusty. I would rather fling them open and pour forth copious blessings than to keep them shut and hold back blessings. The treasure rooms are still bursting with gifts. The locks on the windows are not on My side. They are on your side. Prove Me now. Fulfill the conditions on your side. Give me a chance."

God's command and promises have not been rescinded: "Bring ye all the tithes into the storehouse . . . and prove me now herewith, saith the Lord of hosts, if I will not open you the windows of heaven, and pour you out a blessing, that there shall not be room enough to receive it" (Mal. 3:10).

* * *

"God, If You Will Let Me Make Money"

Some of the large corporations in the United States had their beginnings and growth through the faithful tithing, and giving beyond the tithe, of their founders.

Henry P. Crowell, "The Autocrat of the Breakfast Table," contracted tuberculosis when a boy and couldn't go to school. After hearing a sermon by Dwight L. Moody, young Crowell prayed, "I can't be a preacher, but I can be a good businessman. God, if You will let me make money, I will use it in Your service."

Under the doctor's advice Crowell worked outdoors for seven years and regained his health. He then bought the little run-down Quaker Mill at Ravenna, Ohio. Within ten years Quaker Oats was a household word to millions. Crowell also operated the huge Perfection Stove Company.

For more than forty years Henry P. Crowell faithfully gave 60 to 70 percent of his income to God's causes.

Moody Monthly

* * *

"What Will Happen If I Don't?"

In a church in Miami, Florida, a distinguished grayhaired gentleman related a thrilling boyhood experience. He said, "With joyful heart, I showed an envelope to my mother. It contained my first week's wages—$13.20. Mother said, 'Son, it would be fine if you would give to God's work a tenth of your first week's earnings.' After serious thought, I asked, 'Why, Mother, do you mean that I should give $1.32?' Mother replied, 'Yes, son, that's what I mean. The Bible teaches it.'

"I asked, 'Mother, what would happen if I didn't do it?' Mother replied, 'Son, you'll miss one of the most satisfying experiences of a Christian—inward joy! If you do obey God's command, 'Bring ye all the tithes into the storehouse . . . saith the Lord of host' (Mal. 3:10), you can

lift your head higher as you enter God's house. When a soul is saved you will have the ineffable joy of knowing you had a part in saving 'a soul from death' (Jas. 5:20).

With a smile wreathing his face, the elderly man exclaimed, "How happy I am that I followed my mother's advice!"

Told by RALPH M. SMITH

TONGUE

Very Little Keys

God is pleased when His children have thankful hearts—thankful for everything, thankful for anything: "In every thing give thanks: for this is the will of God in Christ Jesus concerning you" (I Thess. 5:18).

It is good to be expressively thankful: "And one of them . . . turned back . . . giving him thanks" (Luke 17:15, 16).

It is not good to be unexpressively thankful: "Were there not ten cleansed, but where are the nine? There are not found that returned to give glory to God" (Luke 17:17, 18).

Cicero said, "A thankful heart is not only the greatest, but the parent of all other virtues."

Hearts, like doors, will open with ease,
To very, very little keys;
And don't forget that two of these
are:
"I thank you" and "If you please!"

AUTHOR UNKNOWN

* * *

Altar Too Short

After Bud Robinson had preached a searching sermon on the evils of an uncontrolled, unsanctified tongue, a notorious gossiper went forward and said, "Brother Robinson, I want to lay my tongue on the altar!'

Robinson said, "Woman, the altar is only sixteen feet long. However, put as much of your tongue on it as you can!"

Is anything deadlier or more destructive than the tongue? James said, "It is an unruly evil, full of deadly poison" (Jas. 3:8).

* * *

Allow for the Wind

Said Hugh Allen, in the *News Sentinel* (Knoxville, Tenn.), "When you deliver a political speech, it's like shooting at a target—you must allow for the wind."

* * *

Fifteen Insults Permitted

The following sign was posted in the office of Mayor Travis LaRue, Austin, Texas: "Due to the large quantity of business transacted by the city council, we most respectfully request that anyone wishing to insult the council, please limit himself to fifteen minutes or to fifteen insults, whichever is shorter."

* * *

Words

Commented *Moody Monthly,* "The creation of the world is told in the Bible in 632 words; the Ten Commandments in 297 words; the Declaration of Independence in 300 words. Lincoln's famous Gettysburg Address was given in 266 words. A recent governmental order, to reduce the price of cabbage, was told in 279,999 words!"

Spirituality and glibness of tongue seldom blend in the same individual: "In the multitude of words there wanteth not sin" (Prov. 10:19).

* * *

Bury That Talent

With a look of satisfaction on her face, a woman said to John Wesley, "My talent is to speak my mind!"

Gravely Wesley said, "Woman, God wouldn't care a bit if you buried that talent!"

TRUST

When we give people a piece of our mind, we have no peace of mind left!

Entreated James, "Let every man be swift to hear, slow to speak, slow to wrath" (Jas. 1:19).

* * *

Hammer on the Desk

Speaking to students at the University of Michigan, Sir Eric Ashby said, "Few students can effectively articulate ideas through words. This advice was given to a beginning lawyer: 'If the facts are strong, hammer on the facts. If the law is strong, hammer on the law.'

"In ignorance one novice asked, 'What if neither the facts nor the law is strong?'

"In that case," the counselor advised, "hammer on the desk."

* * *

What Havoc?

A doctor in Sheffield, England, put a decimal point in the wrong place and a two-week-old infant died of a drug dose ten times too strong!

A Sheffield city coroner, Herbert Pillings, ruled the death of the infant was an accident after Dr. Kenneth Allen admitted making an arithmetical error in calculating a dose of the drug Digokin.

What havoc seemingly small things can work! A careless, cruel, caustic word can whelm a soul in sorrow and even cause death: "There is that speaketh like the piercings of a sword" (Prov. 12:18); "Death and life are in the power of the tongue" (18:21a).

* * *

Self-Praise

Said Sir Francis Bacon, English philosopher, "The less people speak of their greatness the more we think of it."

The Bible says, "Let another man praise thee, and not thine own mouth" (Prov. 27:2).

TRUST

Dispirited and Dejected

One day a Christian businessman in New York City entered the office of Dr. Norman Vincent Peale. He was so dispirited and emotionally disturbed that it was difficult for him to speak.

Kindly, Dr. Peale asked, "What's the trouble, my friend?"

He replied, "My business has so preoccupied my time that I am on the verge of a nervous breakdown. The daily routine has so gotten on my nerves that I am fearful of a crackup. I have consulted with my physician and he said that if I don't get help, I'll succumb to one of three things, or maybe all of them: stomach ulcers, high blood pressure or heart failure. He suggested that I seek your help."

Dr. Peale knew that the distraught man needed a continual, abiding trust in his heavenly Father.

Opening his Bible, he read some verses which emphasize the precious Father-son relationship that Christians have with God:

"But as many as received him, to them gave he power to become the sons of God" (John 1:12).

"For as many as are led by the Spirit of God, they are the sons of God . . . and joint-heirs with Christ' (Rom. 8:14, 17a).

"Like as a father pitieth his children, so the Lord pitieth them that fear him. For he knoweth our frame; he remembereth that we are dust" (Ps. 103:13, 14).

Why should Christians succumb to "the spirit of heaviness" (Isa. 61:3) and become discouraged?

Told by RALPH M. SMITH

* * *

Sitting Loose

An elderly lady was asked the secret of her serenity and spiritual poise. She replied, "I have learned how to sit loose."

Too much tension can work havoc with machinery. It can also be disastrous for the human machine—the body. Tense nerves may snap.

Too few of God's children have experienced the tranquilizing, stabilizing power of the sure promise: "In quietness and in confidence shall be thy strength" (Isa. 30:15).

Quiescent trust in the provident care of God works wonders!

In God's Hand

"How can we know what will happen? I may never see you again," said a young man to his soldier brother who was leaving for Vietnam.

Replied the soldier, "None of us knows what the future holds, but we know the One who holds the future—Christ. He has all power in heaven and earth. We are both in God's hand: you are here at home and I in a faraway country. Let us put our trust in the Lord, and not worry about tomorrow."

"I will trust and not be afraid" (Isa. 12:2a).

* * *

Fortified

Albert Casteel, a home missionary to Montana and Puerto Rico, fought cancer for a year. He believed that death could be his greatest victory—his finest hour: "O grave, where is thy victory?" (I Cor. 15:55b); "Having a desire to depart and to be with Christ; which is far better" (Phil. 1:23b).

Said he, "Many have written asking about my attitude toward life, since, at the age of 42, I have a devoted wife and four lovely children, and my year-long illness has been diagnosed as incurable cancer. I am not angry with anyone, and least of all God who is a personal, ever-present, sustaining heavenly Father. This knowledge of God fortifies me to accept the grim prospect with an attitude of profound trust in Him!"

Adapted from *Baptist Standard*

* * *

Taste and See

There are four basic taste sensations to which we react: sweet, sour, salty and bitter.

There is another taste sensation whose delight myriads have experienced since time began: "O taste and see that the Lord is good: blessed is the man that trusteth in him" (Ps. 34:8).

TRUTH—UNTRUTH

Singing Lies

How displeasing to God it is to sing:

O for a thousand tongues to sing
My great Redeemer's praise,
The glories of my God and King,
The triumphs of His grace,

and fail to use the one tongue we do have to "tell . . . how great things the Lord hath done for (us), and hath had compassion on (us)" (Mark 5:19).

How empty are the words:

Take my silver and my gold,
Not a mite would I withhold,

when we cling to riches God has entrusted to our keeping and fail to use them for His glory in giving His Gospel to all mankind.

Let us not forget that God "desirest truth in the inward parts" (Ps. 51:6a).

Linked to the Truth

Abraham Lincoln was once faced with a situation in which concealment of a certain truth would have won many votes for him. He courageously said, "If it should be decreed that I should go down because of this speech, let me go down linked to the truth!"

* * *

They Are Slaves

James Russell Lowell said, "They are slaves who fear to speak for the fallen and the weak. Who speaks the truth stabs falsehood to the heart."

* * *

Half-Truth

The trouble with half-truth is that many are inclined to believe the wrong half.

TRUTH—UNTRUTH

The Worst of Famines

Said Dr. Carl F. H. Henry, "Nothing is more fundamentally important for the world and for the church in the twentieth century than a recovery of truth. Truth-famine is the ultimate and worst of all famines. Unless modern culture recovers the truth often—human truth and truth of God—civilization is doomed to oblivion and the spirit of man to nihilism."

The One who is the Truth said, "And ye shall know the truth, and the truth shall make you free" (John 8:32).

* * *

Truth Triumphant

John Milton said, "Though all the winds of doctrine were let loose to play upon the earth, so Truth be in the field, we do injury by prohibiting to misdoubt her strength. Let her and falsehood grapple! Who ever knew Truth put to the worse in a free and open encounter?"

Truth crushed to earth shall rise again,
The eternal years of God are hers;
But error, wounded, writhes in pain,
And dies among her worshipers.

Jesus said, "And ye shall know the truth, and the truth shall make you free" (John 8:32).

* * *

Nothing Concealed

The word *sincere* comes from the two Latin words *sine* and *cere* which mean "without wax," or "nothing concealed."

In ancient Rome, furniture was often made with inferior wood. Cracks were filled in with wax and painted over. Then the furniture was sold as perfect, but when it was used, its inferior quality was soon revealed.

How searching is this verse: "The Lord . . . will bring to light the hidden things of darkness, and will make manifest the counsels of the hearts" (I Cor. 4:5).

* * *

Right Is Right

Said William Penn, "Right is right, even if everyone is against it, and wrong is wrong, even if everyone is for it."

* * *

Out of Control

A man in the field of finance said with great emotion, "Our country is headed toward the rocks. We seem doomed for sure. My business looks hopeless."

"Why?" I asked. "Surely with the high interest rate and the increasing economy you should not have such a dark outlook."

"The trouble is not with business," the man replied. "It is with people. It seems as though people have thrown away all self-control and they no longer care about honoring their word."

ROBERT F. DAVID,
in *The Presbyterian Journal*

* * *

Unqualified Integrity

In addressing the cadets of the U.S. Air Force Academy, a general said, "The professional officer must be a man of many qualities, but assuredly possessing one basic quality mandatory of any officer in the military service: unqualified integrity. Integrity when once compromised is gone forever and is not replaceable. It is the mark of a professional officer."

God requires unqualified integrity and scrupulous honesty of His children: "Thou desirest truth in the inward parts" (Ps. 51:6a); "Provide things honest in the sight of all men" (Rom. 12:17b).

VICTORY

Keep Guards Up

"Something terrible has happened! Can you come right over?" said a distressed voice over the phone to Dr. C. S. Lovett.

When he went to the home, the parents told him that their teenage son had been jailed for possessing marijuana and attacking a young girl. Their consternation was evident and their grief pathetic.

"We don't understand this," they said. "We led him to Jesus, and we have taken him to Sunday school all these years."

Dr. Lovett's heart went out to them. As he sought to help and comfort them, he asked, "Did you ever teach your boy about Satan—how Satan works and how to resist him?"

The parents thoughtfully acknowledged that they had failed to do this. Then Dr. Lovett said kindly but firmly, "Perhaps that is why this has happened."

How essential it is for God's children to know that Satan subtly entices them to sin when their guard is down. They will fall in the time of temptation if they fail to look to the Lord and use "the sword of the Spirit, which is the word of God" (Eph. 6:17a).

The Bible says, "And they overcame him (Satan) by the blood of the Lamb, and by the word of their testimony; and they loved not their lives unto the death" (Rev. 12:11).

* * *

Don't Live Soft

Bear Bryant, coach of the University of Alabama football team, said, "You can't live soft all week and play tough on Saturday."

Long ago Paul said, "Exercise thyself . . . unto godliness" (I Tim. 4:7b).

Then, when the testings and trials come, we can be victorious—"more than conquerors through him that loved us" (Rom. 8:37b).

* * *

The Greatest Waste

Ben Herbster said, "The greatest waste in the world is seen in the difference between what we are and what we could be."

Christ Reigning Supremely

Said Dr. Stanley Jones, "Victory is the life of Christ reigning triumphantly in every portion of our being and in every one of our relationships."

* * *

A Sixth Sense

Richard Armour gives these timely words: "More and more I am convinced that humor is a sixth sense, as important to our enjoyment of life—even to our survival—as any of the five physical senses. And if there is any place it comes in handy, it is in the home. Ours, anyhow.

"Time and again the sense of humor has come to our rescue when something has set our nerves on edge, made us annoyed or angry, and caused us to escalate from barbed remarks to shouting and door slamming. It has restored calm and sanity, salved bruised egos, and made us wonder what all the ruckus was about."

* * *

Implanting Alien Organs

Commented *The London Observer*, "An entirely new aspect of the young science of heart transplantation is beginning to engage the attention of Professor Chris Barnard's team of doctors at Groote Schuur Hospital in Cape Town. It is the psychology of implanting an alien organ into a man's body and expecting him to live for the rest of his life with the threat of rejection hanging over him like a sword of Damocles. Some doctors feel that it may be necessary for prospective recipients to be examined by psychologists to see whether they are psychologically suitable for organ implantation. Dr. Philip Blaiberg apparently underwent some kind of psychological depression during a critical phase of illness. He is said to have snapped at the mention of Professor Barnard's name."

Today craven fear holds in its vise-like grip myriads who don't have Christ: "Men's hearts failing them for fear, and

213

for looking after those things which are coming on the earth" (Luke 21:26).

God's children are recipients of a new heart, changed by grace divine. They are not exempted from trials and tribulations, but they can triumph over them by God's enabling power: "More than conquerors through him that loved (them)" (Rom. 8:37).

Retrieving Mistakes

Said F. W. Robertson in *Moody Monthly,* "Life is a series of mistakes, and he is not the best Christian who makes the fewest false steps. He is the best who wins the most splendid victories by the retrieval of mistakes."

VISION

Manifest in Devious Ways

Said a Hindu to a missionary, "Why are you so anxious to see God with your eyes closed? See Him with your eyes open, as you look at the poor, the starved, the illiterate, and the afflicted."

God manifests Himself to His children in diverse ways.

* * *

Jeremiads

Through the centuries, each generation has experienced dangerous and disastrous times.

In 1857, *Harper's Weekly* said: "It is a gloomy moment in history. Not for many years has there been so much apprehension. Never has the future seemed so incalculable. In France the political cauldron seethes. Russia hangs like a cloud on the horizon. All the resources of the British Empire are sorely tried. Of our own troubles in the United States, no man can see the end."

When the outlook is dark, try the uplook.

As Stephen was being stoned, he "looked up steadfastly into heaven, and saw the glory of God, and Jesus standing on the right hand of God" (Acts 7:55).

* * *

"The Express Image of the Father"

The German sculptor Dannecker wrought on a statue of Christ for eight years.

Calling a little child into his studio, Dannecker asked, "Who is that?"

The child answered, "A great man!"

The sculptor was disappointed.

He asked a second child who gazed intently at the statue, "Who is that?"

The child answered softly, "It is the One who said, 'Suffer little children, and forbid them not, to come unto me'" (Matt. 19:14).

Some see in Christ only a good man. Others see in Him "The brightness of his (God's) glory, and the express image of his person" (Heb. 1:3a), and submissively exclaim, "My Lord and my God" (John 20:28b).

* * *

The Fool's Eye

Said John Burroughs, "The lure of the distant and the difficult is deceptive. The great opportunity is where you are."

"The eyes of a fool are in the ends of the earth" (Prov. 17:24b).

* * *

He Liberated Lincoln

Gutzon Borglum carved the head of Lincoln from a block of marble which had been in his studio for years. The bust is now in the Capitol Building at Washington.

A charwoman who daily came into Borglum's studio paid scant attention to the block of marble. One morning, as she dusted it, she observed to her astonishment the unmistakable lineaments of Lincoln in the stone.

She hastened to ask Borglum's secretary, "Is that Abraham Lincoln?"

"Yes," was the reply.

"How did the sculptor know Abraham Lincoln was in that stone?" she asked.

"Vision," was the secretary's reply.

May God give us the vision to see po-

tential saints in humanly hopeless ones when they have been transformed by grace divine!

* * *

The Best Is Yet To Be

A friend asked Thorwaldsen, the famous Dutch sculptor, "Which is your greatest statue?" He replied, "The next one!"

Backward and Forward Look

Said Sir Winston Churchill, "The farther you look back, the longer you look forward."

Our hats off to the past—our coats off to the future.

WAR

Mountains of Human Skulls

Ten million people were killed in World War I. Five percent of them were civilians. Fifty million were killed in World War II and forty-eight percent of them were civilians. Nine million were killed in the Korean War and eighty-four percent of them were civilians. It is not known how many have been killed in the Vietnam War, but it is estimated that ninety percent of the dead are civilians!

What a pyramid of skulls their fleshless heads would make!

May the coming of Jesus, "The Prince of Peace," not be distant: "He maketh wars to cease unto the end of the earth" (Ps. 46:9a).

* * *

"God, How I Love It!"

Looking out over blood-drenched battlefields, littered with mangled bodies, General George Patton said of war, "God, how I love it!" War, however, is depraving and dehumanizing. Myriads in our war-sundered world yearn for peace.

* * *

Totally Insensate

In February, 1951, forty-three American prisoners of war huddled together in a foul, cold hut in the mountains of North Korea. Outside it was thirty degrees below zero.

Two of the emaciated and half-starved men were suffering from severe cases of diarrhea. A depraved, dehumanized American corporal leaped to his feet, grabbed the helpless sufferers and thrust them outside! No prisoner raised a pro-

testing voice! Mercifully the ejected ones died within a few minutes.

Had the indescribable horrors and suffering the prisoners had seen and experienced made them insensate to the sorrow and suffering of defenseless ones? Only God knows.

The heartless corporal was later convicted of manslaughter and is now serving a sentence of life imprisonment.

The worst in man surfaces during the strain and stresses of war.

* * *

An Enemy of Liberty

Said George Washington, "Overgrown military establishments are, under any form of government, inauspicious to liberty and are to be regarded as particularly hostile to republican liberty."

* * *

Our Last Chance

At the close of World War II, General Douglas MacArthur said, "We have had our last chance. If we will not devise some great and more equitable system, Armageddon will be at our door. The problem basically is theological and involves a spiritual recrudescence and improvement of human character that will synchronize with our almost matchless advances in science, art, literature, and with all material and cultural developments of the past 2000 years. It must be the spirit if we are to save the flesh!"

God's method of *improving human character* is to change man's sinful nature and give him a new heart. Until the human heart is changed, there will be in-

WAR

ward and outward strife: "For from within, out of the heart of men, proceed . . . adulteries, fornications, murders, thefts, covetousness" (Mark 7:21, 22).

* * *

Dreaming Up New Wars

Senator George McGovern said, "I am tired of old men dreaming up new wars for young men to die in."

How few wars there would be if those who declare war were the *first ones* to be sent to the field of battle!

* * *

Brutalized

Lt. Gen. Omar Nelson Bradley said, "For every man whom war has inspired with sacrifice, courage and love, there are many more whom it has degraded with brutality, callousness and greed."

* * *

Jaw or War

Sir Winston Churchill said, "It is better to jaw, jaw, than to war, war."

* * *

Civilian Killing in War

In *The Asheville Citizens Times,* Malcolm MacLear wrote, "In war unfeeling brutality reaches a saturation point. In such a situation degrees of brutality toward civilians have not been determined in percentage points. What percentage would be given an act that destroyed 60,000 civilians in a second as in Nagasaki? Ninety percent, or only ten percent because the killing was not done eyeball to eyeball?

"Or what percentage in the destruction of Dresden, when many planes destroyed 200,000 civilians in about ten hours?

"Is the percentage of brutality to be determined by the proximity of the involved civilians? As far as the wounded or dead civilians are concerned in the above examples, it makes no difference now, but it does make a difference to present-day soldiers if their acts are to be judged by a proximity percentage factor.

"Mass killing of civilians from a distance or mass killing of civilians on the spot—is there a difference percentage wise?"

* * *

Like Abolishing the Fire Department

The Billings (Montana) Times commented, "Abolishing the ROTC because you don't like war is like abolishing the fire department because you don't like fires."

* * *

The Risk of Universal Death!

Some time ago, the heads of various nations throughout the world received a document prepared by several renowned scientists, who were recipients of Nobel awards. The document was a solemn warning of civilization's destruction unless the nations settle their differences in ways other than by resorting to war.

The document read, "Here, then, is the problem which we present to you—stark and dreadful and inescapable: shall we put an end to the human race or shall mankind renounce war? We appeal, as human beings to human beings, remember your humanity, and forget the rest. If you can do so, the way lies open to a new paradise. If you cannot, there lies before you the risk of universal death!"

For centuries, myriads around the world have yearned for peace. God's children cherish the promise of the coming of Jesus Christ, the Prince of Peace, and His righteous reign. He will "judge among many people, and rebuke strong nations afar off." Then "they shall beat their swords into plowshares, and their spears into pruninghooks." Then "nation shall not lift up a sword against nation, neither shall they learn war any more" (Mic. 4:3).

* * *

Our Survival at Stake

Just before Sir Winston Churchill retired, he said, "Patience and perseverance are now required and must never be grudged when the survival of men is at stake. Even if we have to go through decades of bickering and vain parlance,

216

that would be preferable to the unmanageable horrors which are the alternative."

* * *

Unfit for Eden

Under the caption "What Makes Man Unfit for Eden?" the *Austin American-Statesman* editorialized: "In Paris, intelligent men dispute over the shape of a conference table while soldiers and peasants continue to die in Vietnam.

"In Nigeria, little children continue to starve while their fathers wage a bitter and bloody war over who is to rule them.

"In the Middle East, Arab and Jew continue to kill each other in a quarrel over the same land that was watered with the blood of Crusader and Turk, Jew and Roman, Persian and Babylonian centuries before.

"In America and Russia, billions continue to be expended to maintain the means whereby each country may slaughter hundreds of millions of each other's population.

"Throughout the world, disputations between individuals and between nations, hatred, strife, prejudice and fear ravage the human heart worse than any virus ravages the body!"

May the globe girdling era of tranquility, envisioned by the ancient prophet, come soon: "The whole earth is at rest, and is quiet: they break forth into singing" (Isa. 14:7).

* * *

Hamburger Hill

After a tragic loss of many lives, brave U.S. Marines in Vietnam took "Hamburger Hill." Shortly thereafter it was abandoned by U.S. forces.

Then a U.S. general said that he was ready to retake the blood-drenched hill, even if it cost the lives of a division—at least 5,000 men!

* * *

90 Million Killed Since Century Began

At the twenty-first session of the International Congress of the Red Cross, Sept. 6, 1969, it was reported that more than 90 million people had been killed in wars since the twentieth century began; 2 trillion dollars reportedly had been spent on armaments; 130 conflicts on 5 continents had been waged.

Said Jose Barroso of Mexico, Red Cross League chairman, "If we continue on this road of violence, our century will figure in history as the most humiliating in the existence of the human race!"

Myriads of God's children around the world yearn for the soon return of "The Prince of Peace," the Saviour, and His righteous reign. Their response to His promise, "Surely I come quickly," is, "Even so, come, Lord Jesus" (Rev. 22:20).

* * *

History's Lesson Unheeded

Said Lord Byron, "History teaches us nothing except that history teaches us nothing."

Will the nations ever learn that war is futile, that the conqueror and the vanquished are both losers, that all suffer irreparable loss?

WILL OF GOD

The Raven Express

In a TV interview, Bob Causey, a great basketball star, was confronted with this observation: "Bob, many of your fans are asking why don't you look at your teammate when you pass the ball to him."

Bob flashed back, "Well, I never pass to where my teammate is. I pass to *where he ought to be!*"

If we are not where God wants us to be, we may thwart His plan for our lives.

Elijah would have missed connection with the Raven Express if he had not been at the divinely designated brook Cherith: "I have commanded the ravens to feed thee *there*" (I Kings 17:4b).

WITNESSING

Nothing Else

At a meeting of the Fellowship of Christian Athletes, Bobby Richardson, former New York Yankee second baseman, offered a prayer that is a classic in brevity and poignancy: "Dear God, Your will, nothing more, nothing less, nothing else. Amen."

Biblical Recorder

* * *

If It Agrees with Mine

A neighbor lady offered to take care of a little girl while her mother was in a hospital for some two weeks. Before entering the hospital, the mother wrote out a list of food which her girl liked. Then she told the child, "My dear, eat what our kind neighbor prepares for you and thank her."

The little girl thought for a moment and then said, "I'll eat what she gives me, if she gives me what I like."

How like that little girl are many of God's children. They say, "I'll do your will, dear Lord, if it agrees with mine!"

ALICE M. KNIGHT

* * *

A Tragic Mistake

David Howard said, "We have the tragically mistaken idea that in following God's will, the choice is between doing what we want to do and being happy, and doing what God wants us to do and being miserable. Somehow we have gotten the idea that God is a kind of celestial Scrooge who leans over the battlement of heaven trying to find people who are enjoying themselves and who calls down, 'Cut it out!'"

Only in doing God's will is there unalloyed joy: "I delight to do thy will, O my God: yea, thy law is within my heart" (Ps. 40:8a).

* * *

No Questions Asked

A Sunday school class of teenagers was discussing the verse, "Thy will be done in earth, as it is in heaven" (Matt. 6:10).

The teacher asked, "How do you think the angels do the will of God in heaven?"

One replied, "They do it immediately." Another said, "They do it diligently, and with all their hearts." A third one replied, "They do it without asking any questions!" All of these answers were right.

Each one of us should say, "I delight to do thy will, O my God" (Ps. 40:8).

ALICE M. KNIGHT

* * *

Fortified

Said William James, psychologist and philosopher, "Whoever says, 'God's will be done,' is fortified against every weakness. The whole historic array of martyrs and missionaries prove the tranquilmindedness, under naturally agitating or distressing circumstances, which self-surrender brings."

WITNESSING

Say So

"Ah, Mr. Spurgeon," joyously said an old woman to the famous preacher, "if Jesus Christ saves me, He shall never hear the last of this!"

God's directive is plain: "Let the redeemed of the Lord say so" (Ps. 107:2).

* * *

Keep Experience Up-to-date

There was an old man who never tired of relating a wonderful religious experience he had years previously. He wrote it down and called it "My Blessed Experience." When visitors came to see him, he would often read it to them.

One night when a friend called, he whispered to his wife, "Go upstairs and bring me *My Blessed Experience*."

When she opened the dresser drawer, she gasped in dismay. Returning to her husband, she sorrowfully said, "The mice have destroyed your 'Blessed Experience.'"

It is *good* to cherish and recount blessed experiences which we had years ago. It is

better to keep our blessed experiences up-to-date, daily living so radiantly and victoriously that we will have much to relate about the increasing preciousness of Christ and continual triumphs over self, sin and Satan.

* * *

"Go, Tell"

Said Billy Graham, "Sherwood Eddy interviewed twenty-five young Communists in Moscow one day and asked each one how many hours he gave to the party each day. Not one of them gave less than three hours daily in extolling the alleged virtues of Communism. Some of them gave as much as nine hours each day, witnessing for their beliefs.

"Commented Eddy, 'Can it be that Karl Marx has more witnesses in this generation than Jesus Christ?'"

Thank God for millions of His children who obey in sustained manner the command, "Go . . . tell . . . how great things the Lord hath done for thee, and hath had compassion on thee" (Mark 5:19b).

* * *

An Unashamed Workman

Said Wallace E. Johnson, President of Holiday Inns and one of America's most successful builders: "I always keep on a card in my billfold the following verses and refer to them frequently: 'Ask, and it shall be given you; seek, and ye shall find; knock, and it shall be opened unto you: for every one that asketh receiveth; and he that seeketh findeth; and to him that knocketh, it shall be opened' (Matt. 7:7-8).

"These verses are among God's greatest promises. Yet they are a little one-sided. They indicate a philosophy of receiving but not of giving. One day as my wife, Alma, and I were seeking God's guidance for a personal problem, I came across the following verse which has since been a daily reminder to me of what my responsibility as a businessman is to God: 'Study to shew thyself approved unto God, a workman that needeth not to be ashamed, rightly dividing the word of truth' (II Tim. 2:15).

"Since then I have measured my actions against the phrase: 'A workman that needeth not to be ashamed.'

"Like other Christians who at times grope for the truth, I go off the track and get so involved with problems of loans, unions and balance sheets that I forget the Lord. Sometimes Alma wakes me up or occasionally the Lord will get through to me, and then I face up to the demands of the verse: 'Study to shew thyself approved unto God.'"

How different everything is with God's children when they have God's approving smile upon them! They should have but one fear—the fear of incurring God's disapproval.

* * *

"That's Dead Easy!"

A newly converted Communist entered the study of Dr. Roy O. McClain, a former pastor of the First Baptist Church, Atlanta, Georgia, and said, "As you know, I have renounced communism. I am ignorant as to the Christian way of life, and I want to know what is required of me as a Christian."

Dr. McClain gladly stipulated the following things that the new convert should do in order to grow in grace and Christlikeness. "You should read your Bible daily and pray. You should make much of Christian fellowship and regularly attend the services of the church. You should faithfully witness for Christ, telling others about your newly found joy in Him. And you should give at least a tenth of your income to God's work."

The man instantly replied, "These things will be dead easy for me to do!"

Astonished, Dr. McClain asked, "Easy?"

"Yes, that's exactly right! You see, when I was a Communist, I spent three hours daily extolling the alleged virtues of communism. I gave one-half of my income to propagate communism around the world. And I spent most of my weekends and vacations converting others to communism!"

Dr. McClain thought, "Now I know why one-third of the world's people are under the sway of darksome, soul-enslaving, personality-dwarfing communism!"

WORK

"Keep Not Silence"

A Christian engineer said, "I always found it easy to justify my lack of results in witnessing to my fellow workers on an industrial railroad. I didn't associate with them, but they knew where I stood as a Christian. I didn't drink, smoke or swear, so getting my reputation as being 'religious' was easy. One night, however, one of the men of my crew said to me, 'If you have the answers to our spiritual needs, why don't you share them with the rest of us guys? Or don't you care about us?'

"His question struck home. I confessed, 'You are right! If I were really concerned about you guys like I pretend, I wouldn't let any opportunity pass to show my concern. What an inadequate representative of Christ I've been!' "

The Scriptural directive is crystal clear: "Ye that make mention of the Lord, keep not silence" (Isa. 62:6b).

* * *

Where Responsibility Ends

Said Dr. W. A. Criswell, "God does not hold us responsible for the response of people. He holds us responsible to witness to them."

If God's children fail "to warn .the wicked . . . to save his life; the same wicked man shall die in his iniquity; but his blood will I require at thine hand" (Ezek. 3:18).

The lost rich man in anguish knew that faithful witnessing to his brothers on the way to hell might turn their downward steps away from doom and destruction. He pleaded, "Send him [Lazarus] to my father's house: for I have five brethren; that he may testify unto them, lest they also come into this place of torment" (Luke 16:27-28).

* * *

Only a Little Girl

Only a little girl was converted in a revival meeting. How happy she was! The next day she started on an errand, known only to her and God.

Timidly she knocked at the door of a neighbor. A well-dressed man greeted her cordially. He asked, "Why are you so dressed up?"

She replied, "I am dressed up because I want people to ask me why I'm dressed up. I want to tell them that yesterday I gave my heart to Jesus."

Next she went to Jim the blacksmith. She told him of her new-found joy in Jesus! Jim said, "I will be in church Sunday." He kept his promise. Later he was joyously converted.

In time a spiritual awakening came to the church because the little girl immediately after her conversion obeyed the command, "Let the redeemed of the Lord say so" (Ps. 107:2).

RALPH M. SMITH

WORK

Castles in the Air

Henry David Thoreau, the famed naturalist, said, "If you have built castles in the air, your work need not be lost. That is where they should be. Now put the foundation under them."

The Bible says, "For other foundation can no man lay than that is laid, which is Jesus Christ" (I Cor. 3:11).

Daily Duties

The best things are the nearest: breath in your nostrils, light in your eyes, flowers at your feet, duties at your hand, and the path of God before you.

Then do not grasp at the stars, but do life's plain, common work as it comes, certain that daily duties and daily bread are the sweetest things of life.

"Wisdom is before him that hath understanding; but the eyes of a fool are in the ends of the earth" (Prov. 17:24).

Lie Down and See

The spiritual giant Dr. Len G. Broughton, in commenting upon the verse, "Stand still, and see the salvation of the Lord" (Exod. 14:13), said, "There are many lazy Christians who would be better pleased if the verse read, 'Lie down and see the salvation of the Lord.' "

* * *

A Worthless Day

Master, I was so busy today doing what I thought of as work for You that I did not see the child who needed comfort, the old man looking for encouragement, the young mother needing a helping hand. I did not see the opportunities You placed in my day for being a friend, for helping one find his way out of despair. Forgive my busyness that made me blind to need, my energy that could not stop to love. Destroy the pride that made me think *my* efforts so worthwhile that I did not need to pray. This was a worthless day. Father, forgive.

"As we have therefore opportunity, let us do good unto all men, especially unto them who are of the household of faith" (Gal. 6:10).

* * *

Going Strong at Eighty-six

It is said that John Wesley traveled two hundred and fifty thousand miles, mostly on horseback and in a buggy, over primitive roads. He preached more than forty thousand sermons, wrote twenty-five massive volumes on a variety of subjects, and mastered a working knowledge of ten languages. As Wesley grew older, he reported regretfully that he had to stay in bed as late as 5:30 A.M. At the age of eighty-six, he limited himself to preaching two sermons a day.

* * *

A Working Definition of Hell

Said Bernard Shaw, "A perpetual holiday is a good working definition of hell!"

Said Dr. Edwin Zabriskie, renowned neurologist, "Retirement can be the severest shock that the human organism can sustain!"

"Whatsoever thy hand findeth to do, do it with thy might" (Eccl. 9:10).

* * *

Work Zealously

Emerson said, "Nothing great was ever accomplished without enthusiasm."

Hegel propounded the same truth. He said, "We affirm absolutely that nothing great in the world has ever been accomplished without passion."

In the Bible, Paul says, "It is good to be zealously affected always in a good thing" (Gal. 4:18a).

"Whatsoever thy hand findeth to do, do it with thy might" (Eccl. 9:10a).

* * *

Spend and Be Spent

Go, labor on; spend and be spent,
Thy joy to do the Father's will!
It is the way the Master went;
Should not the servant tread it still?

Go, labor on; 'tis not for naught;
Thy earthly loss is heavenly gain;
Men heed thee, love thee, praise thee not;
The Master praises—what are men?
HORATIUS BONAR

* * *

Rest Awhile

Said Leonardo da Vinci, "Every now and then go away, have a little relaxation, for when you come back to your work your judgment will be surer. To remain constantly at work will cause you to lose power of judgment. Go some distance away, because then the work appears smaller, and more of it can be taken in at a glance, and lack of harmony and proportion is more readily seen."

Said Christ to His busy disciples, "Come ye yourselves apart into a desert place, and rest a while" (Mark 6:31).

* * *

My Next Job

At the age of forty-five, the Reverend A. R. Petty, pastor of the First Baptist Church, Kansas City, Missouri, was stricken with a fatal illness.

On the night of his death, he asked his physician if the end was near.

The physician replied, "I believe it is."

A smile wreathed the dying pastor's face as he said, "The records are all in! In glory, I am going to salute my Saviour and say, 'Lord, I am ready for my next job!'"

* * *

If I Knew

Said Stephen Girard, philanthropist, "When death comes to me, it will find me busy, unless I am asleep. If I thought I were going to die tomorrow, I would nevertheless plant a tree today."

* * *

Less Competition

Said Indira Gandhi, "My grandfather once told me that there are two kinds of people—those who do the work and those who take the credit. He told me to try to be in the first group, for there is much less competition there."

* * *

Unwanted Leisure

After Sir Winston Churchill was removed from his post as First Lord of the Admiralty in 1915, he grew restless in his inactivity. Said he dejectedly, "I have nothing to do. How terrible it would be to get resigned to such a state as this. I have long hours of utterly unwanted leisure in which to contemplate the unfolding of the war."

What It Takes

Said Roger Babson, famed statistician, "It takes a person who is wide awake to make his dreams come true."

All honest work is honorable: "Whatsoever thy hand findeth to do, do it with thy might" (Eccl. 9:10a).

* * *

Tiny Pushes

Said Helen Keller, "I long to accomplish a great and noble task, but it is my chief duty to accomplish tasks as though they were great and noble. The world is moved along, not only with the mighty shoves of its heroes, but also by the aggregate of the tiny shoves of each honest worker."

If we are faithful in small things, we are not small Christians.

* * *

Equal to Tasks

Said Philip Brooks, "Don't pray for easy lives. Pray to be stronger men. Don't pray for tasks equal to your powers. Pray for powers equal to your tasks."

* * *

Do for Yourself

Said Lincoln, "You can't help men permanently by doing for them what they can and should do for themselves."

Paul said, "If any would not work, neither should he eat" (II Thess. 3:10b).

WORSHIP

Devil Worship

A recent AP dispatch from London affirmed, "Black magic is spreading across England. Church leaders are frightened by what seems to be a steady and continuing growth of witchcraft and devil worship. It is frightening to realize it is attracting young people. There have been a number of bizarre events in England, apparently linked to the black magic craze: A child's body was stolen from a grave. A young man hanged himself after his girl friend hexed him. Another youth was charged with murder after the body of an earl's grandson was found next to a bloodstained letter containing the words,

'Hail Satan!'"

Rev. Tom Willis told an Anglican Church synod, "This is a problem that the church has not met for the past two hundred years."

When people forsake the true and living God and His imperishable Word, they "[change] the truth of God into a lie, and [worship] and [serve] the creature more than the Creator" (Rom. 1:25).

Is the stage being set for the Antichrist, "whose coming is after the working of Satan . . . with all deceivableness of unrighteousness in them that perish . . . that they should believe a lie . . . who believed not the truth" (II Thess. 2:9-12)?

To the Moles and Bats!

Henri Sabet, an Iranian oilman, recently paid $415,800 for a Louis XVI table, said to be the most expensive piece of furniture in existence.

Large sums are also paid for extraordinary paintings. Recently $5,544,000 was paid for a Velasquez painting.

Paul Getty paid over $4,000,000 for *The Death of Actaeon*, by Titian.

A Renoir painting brought $1,959,200!

Commenting upon the fabulous prices paid for these works of art, *Time* stated in a July '71 issue, "It does not take a very puritanical conscience to deduce that this involves a grotesque inversion of values, a crisis in the function that past art can play in present culture."

Long ago the prophet Isaiah spoke of the worship of the works of men's hands: "A man shall cast his idols of silver, and his idols of gold, which they made each one for himself to worship, to the moles and to the bats" (Isa. 2:20).

* * *

The Dearest Idol

The dearest idol I have known,
Whate'er that idol be,
Help me to tear it from Thy throne,
And worship only Thee.

WILLIAM COWPER

* * *

"Sermons Are Out"

Said Dr. Roland W. Tapp, associate editor of Westminster Press, in commenting on Sunday worship, "Sermons are out! So is the morning worship service at 11 o'clock. The death rattle will be long and loud and gruesome!"

Editorializing upon this, *Moody Monthly* said, "What is the future of our patterned Sunday services? Perhaps we ought to ask ourselves some serious questions. If we are uneasy about this, it may be because we have a reason. Are we certain that our Sunday services are geared to the needs of individual Christians? Are our people coming because they find what they urgently need in the services, or because of loyalty or habit? Are they participants or merely spectators? There is no special virtue in an order of service or a three-point sermon if it does not do something for individuals!"

* * *

God Is Not a Luxury

Said J. F. Newton, "God is not a luxury. He is a necessity. When a man loses faith in God, he worships humanity. When that fails, he worships science. When science fails, man worships himself. At the altar of his own idolatry, he becomes vain. Self-centered and self-possessed, he is unable to get himself off his hands."

Dostoevsky, the Russian novelist, said, "A man who bows down to nothing can never bear the burden of himself."

* * *

Circumventing the Risks

Dr. George W. Comstock, a Johns Hopkins University medical researcher, said, "Men who attend church infrequently have almost twice the risk of fatal heart disease as those who attend once a week or more."

Long ago the psalmist said, "Those that be planted in the house of the Lord shall flourish in the courts of our God" (Ps. 92:13).

YOUTHS

Love—a Code Word for Hate

A hippie walked into a men's clothing store. The salesman greeted him cordially and said expectantly, "What can I show you?"

The hippie looked with apparent disdain at the salesman and said nonchalantly, "Boy, I don't need nothing."

Loathingly the salesman eyed the hippie and observed that his dirty shirt was about three sizes too big, his faded trousers were patched, and his scruffed-up shoes were worn out. The store was stocked

with popular-brand suits, good shirts, and fine shoes; but the tramplike hippie declared, "I don't need nothing."

Often the hippielike youths who say, "I don't need nothing," are in desperate need of the most essential things: a goal in life, self-respect, and genuine love for others, especially for their parents who are humiliated and crushed by the degrading way in which their sons and daughters are living. Love seems to be their code word for hate.

Often the spiritually impoverished ones are self-congratulatory and boastful, saying, "I am rich, and increased with goods, and have need of nothing" (Rev. 3:17a). They feel no need for spiritual riches which God offers to them freely.

* * *

Tired of Being Blamed . . . Maimed

Said K. Ross Toole, professor of history at the University of Montana: "I am forty-nine years old. It took me many years and considerable anguish to get where I am, which isn't much of any place except exurbia.

"I was nurtured in depression, lost four years to war, have had one coronary, am a liberal, a square, and a professor. I am sick of hippies, yippies, militants, and nonsense.

"I am a professor of history, and I am supposed to have liaison with the young. Worse still, I am the father of seven children.

"I am tired of being blamed, maimed, and contrite. I am tired of tolerance and of reaching out for understanding. I am sick of the total irrationality of the campus rebel, whose bearded visage, dirty hair, body odor, and tactics are childish but brutal, naive but dangerous, and the essence of arrogant tyranny, the tyranny of spoiled brats.

"I am terribly concerned that I may be incubating more of the same. Our household is permissive, our approach to discipline is an apology and a retreat from standards, usually accomplished by a gift in cash or kind.

"It is time to call a halt; time to live in an adult world where we belong and time to put these people in their places. We owe the younger generation what the older generations have owed younger generations: love, protection to a point, and respect when they deserve it. We do not owe them immunity from our mistakes or their own.

"I find that the great majority of our young people are fine, but I decry the pusillanimous capitulation to youth who haven't lived long enough to have either judgment or wisdom. Our country is full of decent, worried people like myself who are fed up with nonsense. We need to reassert our hard-won prerogatives. It is our country, too. We love it, fought for it, and bled for it. It is time to reclaim it!"

Orlando (Florida) *Reporter Star*

* * *

They Look Cuter

A reader wrote to a religious publication, "Teenage girls are all going to the dogs because they try to look older than they are."

The editor commented, "You are mistaken, Madam. They are not nearly so offensive as their overweight, gray-haired grandmothers who run around with bare backs, skin-tight pants or shorts, so short that they can barely sit down. If either group must delude itself, let the youngsters do it. At least they look cuter at it!"

* * *

Not a Matter of Years

Said Cornelia Rogers, "To be young is not a matter of years. Youth lives forever in a love for the beauty that is in the world—in the mountains, the sea, and sky, and in lovely faces through which shines the kindliness of the inner mind. It is the tuning into the orchestra of living sounds—the soughing of the wind in the trees, the whisper and flow of the tide on wide beaches, the pounding of the surf on the rocks, the chattering of brooks over the stones, the pattering of rain on leaves, the song of birds and of peepers in the spring marshes, and the joyous lilt of sweet laughter!"

A Pathetic Plea

A greatly-sinned-against teenager in seeking help wrote to a newspaper columnist, saying, "My mom and dad got a divorce last year, and our family is falling apart. Mom is drunk most of the time and can't hold a job. I'm fifteen and have two brothers and two sisters. I've tried my best to make a home for the younger kids, but it's a losing battle. Dad sends the support checks every month, but Mom drinks up most of it. On top of her own drinking problem, she has some thirsty friends.

"I work after school washing dishes in a cafe. I don't mind not having some social life or time to study as much as I should, but I don't think I should be away from the house so much. The little ones need me. Please tell me what to do."

What havoc is wrought upon children and youth by these merciless destroyers—alcoholic beverages!

* * *

High on Marijuana

A youth at a California rehabilitation center told what happened when he drove his car while he was high on marijuana: "The dividing lines on the highway began to jump around. Approaching cars seemed to be coming directly toward me. I crashed into a car driven by the bride-elect of a minister's son. She died instantly!"

* * *

A Big Ear

A young man said to William L. Self, "When I look at your generation all I see is one great big mouth—always talking!"

Self asked, "What would you like to see?"

The youth replied, "A big ear—always listening!"

If we fail to listen patiently, understandingly, and sympathetically to the youths, they may get the answers to their perplexing problems from the wrong source, and their lives may be shipwrecked and their characters besmirched.

"O Taste and See!"

Anna Freud, the daughter of Sigmund Freud, was asked, "Why do students riot and demonstrate?"

She replied, "The real reason is that fundamentally students are empty and alienated, and they have a burning quest for reality!"

To all sincere seekers for reality, God gives this challenging appeal, "O taste and see that the Lord is good: blessed is the man that trusteth in him" (Ps. 34:8).

* * *

"Dad, I Hate You!"

Said a dispirited, disillusioned student at the University of California in Berkeley, "Dad, I'm dropping out! I'm going to become a hippie!"

The astonished father asked, "Why?"

The son replied, "Well, Dad, I hate you!"

The father stood speechless for a moment and then asked, "My son, why do you hate me?"

"All right, Dad, I'll tell you. You've made it too easy for me. I've had everything. But *you didn't give me anything to believe in,* and I hate you for it!"

Heartbreaking sorrow is inevitable when parents fail to instill in their children the character-molding, hope-enkindling truths of the Bible.

* * *

Repentance or Rebellion

Said Professor Herbert Marcuse of the University of California, "Whether in Berkeley or Berlin, today's youthful radicals, who are challenging the most basic premises of industrial society, increasingly turn to the writings of Karl Marx, the German-born philosopher, to find a satifactory rationale for rebellion."

God's prophet Isaiah criticized the corruption and emptiness of organized religion in the society of his day. He did not advocate, however, as does Marcuse, "a physical uprising as the primary way to overthrow the oppressive structure." He called the people to repent, forsake selfish,

225

sinful ways, and return to the God of righteousness and holiness.

Adapted from *The Prairie Overcomer*

* * *

Just Plain Happy!

A lad wrote a letter to Ann Landers in which he said, "My problem is that my mother understands me, and I have a father who cares.

"We live in a modest but comfortable home. My wardrobe is adequate, and I have just about everything I need. There are rules and regulations around here, and I am expected to obey them. There are also some great privileges.

"My mother doesn't work, and my father doesn't drink. When I do something wrong, I get punished. When I do something good, I get praised.

"I'm a fourteen-year-old boy, and I ask you—with a problem like that, who needs a solution?—Just Plain Happy!"

* * *

Don't Shave . . . Lie Down in Street

Said Dr. Hudson T. Armerding, "The dramatic and forceful behavior of a small minority has tended to obscure the wholesome and often idealistic performance of today's college students. In responding to a survey by The Research Institute of America, a twenty-one-year-old student asked, 'Why should I work hard to be recognized by society when all I have to do is not shave for a few days, lie down in the street, and become a national personality overnight?' "

* * *

Lacking in Ethical Responsibility

In addressing a national convention of educators, a prominent educational leader said: "Whether or not a student burns a draft card, participates in a civil rights march, engages in premarital or extramarital sexual activity, becomes pregnant, attends church, sleeps all day, or drinks all night is not really the concern of a collegiate institution as an educational institution. Colleges and universities are not churches, clinics, or even parents. They are devices by which a limited number of skills, insights, and points of view are communicated to the young in the belief that possession of these somehow aid the individual to become a more skilled worker."

How distressingly permissive and lacking in concept of moral and ethical responsibility is this confused, character-destroying utterance!

* * *

They Wanted To Know

A religious survey was conducted in Germany's Erlangen University. Among the question asked thousands of students were these: *Who is Christ?* Only sixteen percent answered correctly. *How does one become a Christian?* Ninety-two percent didn't know. To the question, *Would you like to know more about how to become a Christian?*, seventy percent replied affirmatively.

* * *

Congenial for Christ

In the Miss America pageant in Atlantic City, August 1969, Jane Briggeman, twenty-one-year-old Miss Nebraska received the title Miss Congeniality.

"What an ideal time to give credit to the right Person—my Lord!" said the vivacious beauty.

"What an ideal time was the Miss America pageant to communicate the love of God with some very precious people! I realize that I could not do this by myself. I relied upon God's Spirit to really use me. This is what is so beautiful in living and working with God. It is not enough to give a pious profession. I know that Christ has redeemed me. I just want to express this love toward others and bring Christ to my neighbors and friends. This is done by loving, forgiving, and accepting Christ as a whole and total personality!"

"Let no man despise thy youth; but be thou an example of the believers, in word, in conversation, in charity, in spirit, in faith, in purity" (I Tim. 4:12).

226

Who Gets the Spotlight

While on a furlough from his hospital in Africa, Dr. Howard H. Hamlin addressed several student bodies in different colleges.

"During the week I spent on one campus," said Dr. Hamlin, "six students were suspended for behavior incompatible with life on a Christian college campus. But in the last chapel service, six hundred students moved to the front of the chapel in public commitment to the will of God for their future.

"As the president of the college drove me to the airport, I ventured an observation to him: 'Six suspended—six hundred affirmed their unqualified commitment to a Christ-directed future! The happenings on campus this week would seem to be a microscopic example of what is happening throughout the world during this period of dissent. We allow the six—the rebels, the undisciplined, the confused, the lunatic fringe—to grab the spotlight, to dominate the communication media, to flout recognized authority, and to frighten us in the belief that the total youth of our nation has suddenly hit the skids. We have forgotten or overlooked the six hundred who have never smoked pot, never attended a sleep-in, never been treated in a VD clinic, never destroyed another's property or hurled a rock in defiance of established law and order.'"

* * *

Only Three Percent

Said Dr. Carl F. Winters, educator and criminologist, "Only three percent of the younger generation (in our universities) constitutes the most brutal and destructive force ever created, while ninety percent are most wonderful and wholesome amid the campus revolts. Some eight hundred students are trying to wreck the University of California at Berkeley while 32,000 want to take an education there."

* * *

Children of God

Jack L. Gritz editorialized in *The Baptist Messenger:* "Twelve young people are living in a farmhouse near El Reno, Oklahoma. They are members of the new denomination called 'Children of God'. Their leader is nineteen-year-old Joseph Ruben.

"Ruben told a news correspondent, 'We live wherever we can and we eat whatever we can. When a new member joins, he gives all his possessions to the group. Each new member is expected to write letters to his family and friends and tell them to think of him as *dead*, take a new name, and renounce all former ties. Our main mission is to warn people of the coming judgment of God and the impending doom of a wicked nation which has forgotten God.'

"We do not doubt the sincerity of these youths. We know, however, that it is possible to be completely sincere and badly mistaken at the same time. A careful study of the New Testament reveals that Jesus does not require His followers to give all of their possessions to a commune, or become as dead to their parents and friends.

"These young people are sadly uninformed concerning God's Word, and are badly bewildered about its teachings. They need our love and prayers and our effort to lead them into a full understanding of the Christian faith."

In speaking of her former identification with the Children of God, Miss Linda Train, a twenty-three-year-old New York City bookkeeper said, "Those still with the group may not be able to think for themselves. When I was a member of the Children of God, I would feel one way, but when I opened my mouth to speak, the opposite meaning would come out. I had eaten rotten food and hadn't bathed for two weeks. But I told another member that I had never been happier. When I said that, I thought to myself, 'Why am I saying that? I'm miserable.'

"At prayer meetings, they began with the leader saying, 'Everybody hate their parents,' and we would shout, 'Amen!'"

Who can fathom the sorrow of parents whose son or daughter informs them to think of them as *dead* and who renounce the family name?

In published letters in *Time* (Feb. 14, 1972), Mrs. B. W. Parmeter of Houston,

YOUTHS

Texas, warned: "Parents who think it can't happen to their children had better wake up! Within a twenty-four-hour period, the Children of God had my son converted (to their way). It was a frightful experience!"

Mrs. Betty F. Gehr, of New Orleans, wrote: "The Children of God brainwashed my young daughter in mid-December, and I have not received a letter nor seen her alone since!"